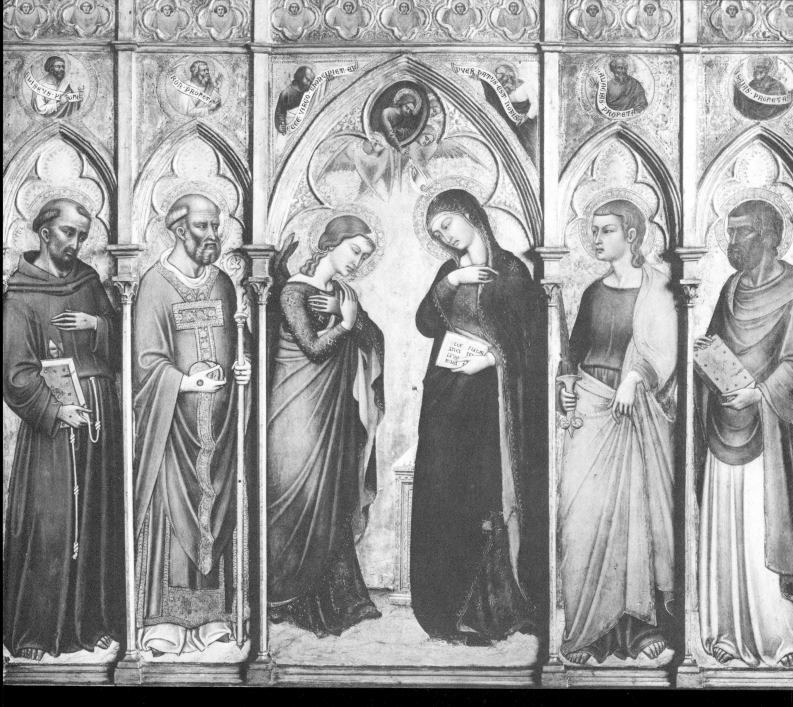

Annunciation with Saints Francis, Nicholas of Bari, Thomas, and Matthew; prophets in tondi *Elisha, Aaron, Malachi, and Isaiah*; and two unidentified prophets in the spandrels.

Luca di Tommè

A Sienese Fourteenth-Century Painter

By Sherwood A. Fehm, Jr.

Foreword by Anthony F. Janson

Southern Illinois University Press

Carbondale and Edwardsville

Copyright © 1986 by the Board of Trustees,
Southern Illinois University
All rights reserved
Printed in the United States of America
Designed by Edward D. King
Production supervised by Kathleen Giencke

88 87 86 85 4 3 2 1

Library of Congress Cataloging in Publication Data

Fehm, Sherwood A.
 Luca di Tommè.

 Bibliography: p.

 1. Luca, di Tomme, 1330?–1389. 2. Painters
—Italy—Biography. 3. Siena (Italy)—Biography.
4. Luca, di Tommè, 1330?–1389—Catalogs.
I. Title.
ND623.L84F43 1984 759.5 [B] 83-20400
ISBN 0-8093-0941-6

To the Memory of
Millard Meiss
Charles Seymour, Jr.,
and
Esther Watrous Hendricks

Publication of this book has been aided by a grant from The Millard Meiss Publication Fund of the College Art Association of America.

MM

Publication of this book has also been aided by grants from the Samuel H. Kress Foundation, Mrs. Dora Jane Janson, Mr. Neil F. Phillips, and Mr. Ivan Phillips.

Contents

Foreword

When Sherwood A. Fehm died on July 9, 1983, at the age of 43, art history lost one of its finest young scholars. Thus, the present monograph represents the work of a life tragically cut short. Dr. Fehm had devoted his doctoral dissertation and numerous articles to Luca di Tommè. The manuscript for this book was completed in August, 1981. My involvement began in the spring of 1982 when Tony, as he was known to his friends, asked me to read the text and to offer suggestions for improving it and practical advice for seeing to its publication. I have confined my role as literary executor to carrying out his last wishes. In its final form, the book incorporates most of the changes we had discussed only hours before he died. Only a minor alteration to one passage and updating a few footnotes were left undone on the grounds that the information postdates the manuscript, which can otherwise stand on its own merits as he left it. The remaining changes were taken care of by Nancy van Itallie, who has edited the text with great care and discretion.

Dr. Fehm was encouraged in his scholarship by my father, H. W. Janson, who also supported grant applications on behalf of this book. *Luca di Tommè* is being published with the aid of substantial grants from the Samuel H. Kress Foundation and the Millard Meiss Publication Fund of the College Art Association; Neil and Ivan Phillips have also contributed generously. I would like to take this opportunity to express the gratitude Tony felt to these organizations and contributors. The greatest debt is owed to Southern Illinois University Press for its continuing commitment to this important project following the author's death. Their decision demonstrates the respect and affection Tony's colleagues and students felt for him.

Anthony F. Janson

Ringling Museum of Art
Sarasota, Florida

Preface

Luca di Tommè was an important Sienese painter during the second half of the fourteenth century. Although many of the major trends in Sienese painting have been analyzed by Millard Meiss in his *Painting in Florence and Siena after the Black Death* (1951) and H. W. van Os in his *Marias Demut und Verherrlichung in der sienesischen Malerei, 1300–1450* (1969), we lack detailed knowledge of many of these lesser known artists. Earlier in the century Bernard Berenson, Raimond van Marle and F. Mason Perkins sought to reconstruct Luca di Tommè's artistic personality by grouping pictures around a series of signed, documented or otherwise authenticated works, while a number of individual studies, particularly those by Cesare Brandi, Millard Meiss and Federico Zeri, have attempted to establish a chronological development among these works and have offered interpretations regarding iconographic significance. There has been little agreement as to Luca's exact oeuvre. The latest Berenson list (1968), for example, contains fifty-seven paintings attributed to the artist, but many of these have been rejected by Meiss, while some have been accepted by Zeri. The major documentary source for the artist is Gaetano Milanesi's *Documenti per la storia dell'arte senese* (Siena, 1854–56); however his notes often lack accurate citations. The specific archival study by Pèleo Bacci, which dealt with the first third of the painter's life, never reached completion.

The aims here have been to assess Luca di Tommè's place within the context of fourteenth-century Sienese painting and to establish an accurate chronology for his life and works. I have also tried to examine in detail Luca's partnership with Niccolò di Ser Sozzo, as well as to study the artist's own stylistic sources, his influence, and something of the workings of his shop. The photographic record of Luca's works, in addition to both the catalogue and documents presented here, should aid in a re-evaluation of an artist whose importance has been overlooked for too long.

The study begins with a general evaluation of the artist's earliest works, from 1356 to 1361, and his stylistic sources in earlier Sienese painting traditions, especially Pietro Lorenzetti. The second chapter assesses his relationship with Niccolò di Ser Sozzo, a Sienese miniaturist and panel painter, somewhat older than Luca, while Chapter Three presents the artist's mature works, executed from 1366 to 1373 when his shop production increased considerably. Chapter Four focuses on the artist's Saint Paul altarpiece of 1374, formerly in the Chapel of the *Calzolai* in Siena Cathedral. His later works, as well as his dramatic shift in aesthetic approach to painting, are also discussed. Finally, included is a general evaluation of Luca di Tommè's work within the ambiance of Sienese painting during the last half of the fourteenth century.

The Catalogue is composed of the following subdivisions: Accepted Works; Doubtful Attributions and Shopworks; Lost Works. Technical data, inscriptions and their sources, a condition report, provenance, exhibitions, attributions, bibliography, and photographic sources are included for each entry. Following this are those documents that concern the artist's life and career. A complete bibliography and précis follows each. I have found it convenient to group related or virtually identical documents together. Often when there has been no substantial difference among various documents or when a series of short documents refers to the same matter, the précis follows the final document. The photographic material comprises all works that I accept to be by the artist. These are arranged chronologically and include photographic montages of those altarpieces that can be reconstructed with more than two panels. Works from the artist's shop and comparative material are brought together afterward.

It would be impossible to acknowledge all those who have helped with this work. It began at Yale University as a doctoral dissertation under the direction of the late Professor Charles Seymour, Jr., who provided a great deal of advice and understanding. I owe a special debt to Mr. Andrew Petryn of the Yale University Art Gallery. With his guidance I began to understand some of the rudiments of Italian Medieval and Renaissance painting.

The librarians at the Yale University Art Library and the Frick Art Reference Library aided my work greatly, and grants from the Samuel H. Kress Foundation enabled me to prolong my research in Europe and to purchase photographs. Miss Mary Davis of the Kress Foundation has continually been very encouraging to me. A number of collectors, including Sir Harold Acton, Mrs. Robert Bowler, the late Mr. Robert von Hirsch, the late Mrs. Jesse I. Straus and the late Mr. A. Welker very generously enabled me to obtain photographs of paintings in their collections.

To several colleagues and friends I am very grateful for suggestions and criticisms: Mirella Levi d'Ancona, James Beck, Miklós Boskovits, Joel Brink, Alessandro Contini-Bonacossi, Marvin Eisenburg, Elizabeth Gardiner, H. W. van Os, Joseph Polzer and Carlo Volpe. Dr. Everett Fahy has been helpful especially in the matter of photographs and Mr. Burton Fredericksen has helped me in a number of ways. The late Professor Millard Meiss was a continual source of inspiration, and his interest, wide knowledge, and enthusiasm for the fourteenth century helped clarify several difficult problems. His work stands as a model for succeeding students.

Grants from the Fulbright Commission and the Italian Government permitted me to work in Italy in 1967–68, and a fellowship at Villa I Tatti enabled me to continue abroad until August, 1969. I am grateful to the late Professor Myron P. Gilmore, then director of Villa I Tatti, for his generosity. At I Tatti, Dott.*ssa* Fiorella Gioffredi-Superbi was very helpful and Sig. Luigi Artini spent many long hours and holidays in the field making new and often very difficult-to-obtain photographs for me. Also in Florence, I must thank Dott. Umberto Baldini, the late Dott. Arturo Grassi and the late Sig. Rudolfo Reali for their friendly assistance. The late Dott.*ssa* Klara Steinweg gave me much time and inspiration. Dr. Ulrich Middledorf and Dr. Irene Heuck of the Kunsthistorisches Institut in Florence have also shared their knowledge with me. The staffs of the Archivio di Stato, the Archivio dell'Opera del Duomo and the Biblioteca Comunale in Siena have been kind to me and, in particular, Dott.*ssa* Sonia Fines-

chi spent a good deal of time assisting with the transcription of documents. Professor Enzo Carli kindly granted me permission to take photographs in many otherwise inaccessible places in Siena and the surrounding countryside, and shared his knowledge with me. Dott. Piero Torriti and his staff have been very helpful in a number of ways.

At Southern Illinois University I should like to acknowledge the continual support of the Office of Research Development and Administration and its Director, Dr. Michael R. Dingerson. The staff of Morris Library, especially the I.L.L. division and Mr. Alan Cohn, Humanities Librarian *par excellence*, have helped immensely. I would like to acknowledge those special people at SIU-C whose contributions to this work were invaluable. Mr. Phillip Woolley helped in the initial stages of revision. Judith Carmel read and criticized the manuscript and while asking often provocative questions, shared a number of her ideas with me. Finally, Jeffrey Erickson has been involved with this work on a day-to-day basis for the last two years and I would like to acknowledge in particular his contribution.

My family has shared much of this work along the way. Gretchen Fehm has been eager for this manuscript to be finished for a long time, while Saide Fehm has listened and patiently endured ideas with the right blend of skepticism and enthusiasm.

Carbondale, Illinois
August 1981

Introduction

Luca di Tommè's career as a painter was based mainly in Siena and spanned some three and one half decades. Although there has been speculation that Luca made one or more trips to Umbria or the Marches in connection with some of his commissions, the evidence points to his almost continual presence in his native city, especially after 1373. Furthermore, there is no documentary evidence of his actual residence elsewhere. During the course of some thirty-five years as an artist and head of a prominent workshop he must have produced a great many paintings, of which a good-sized corpus survives, enabling us to draw certain conclusions regarding the sources of his compositions, influences on his style, and his maturation as an artist. In making an assessment of him I have divided his career into four parts, for convenience's sake. These division points are, of course, somewhat arbitrary and there are a number of themes common throughout his work. However, certain paintings or documents that seem pivotal to his evolution as an artist have dictated where breaks ought to be made. These considerations justify the devotion of three chapters to the first half of Luca's career, from 1356 to 1373, and only one chapter to the remainder. Furthermore, the bulk of his surviving paintings, and indeed some of his most important works, came from a period of a little over ten years (1362–1373).

The early phase of Luca's career is still shrouded in mystery, and I have followed earlier critics in using the date 1356 as a beginning, for the simple reason that this is the first reference to him that we have. There is no clear indication as to how he got his initial training, or with whom, or indeed, for that matter, how long he had been painting before he was enrolled in the local painters' guild in Siena. On the basis of his surviving work we see that his first efforts were on a modest scale and that he was deeply indebted to Pietro Lorenzetti, in particular, for his compositional and figural style—as evidenced by the *Crucifixion* in San Francisco (Pl. 7). Because of this influence, Luca's earliest paintings seem derivative and, hence, conservative. His figures—often based on Pietro's—are robust and solid, although occasionally awkward and indicative of an as yet immature understanding of anatomy.

On the other hand, his compositional sense was already very good—again as seen in the San Francisco *Crucifixion*. His figural groups balanced each other, worked well in the space within which they were placed, and often were bound together effectively by architectural or landscape elements in the background. Luca's subtle manipulation of color also played an important part in holding these early narratives together, as vibrant yellows were played off against bright reds or deep blues. In keeping with the Sienese decorative tradition, Luca advanced the use of line as a compositional and ornamental element, exploiting and developing this device in countless folds and hems throughout his professional life. His mastery of surface articulation extended to the use of punchwork, which appeared over and over again in halos and along the borders of panels, as well as in clothing and drapery. Finally, in some of the works from Luca's early phase, the painted frame was used to heighten illusion and create compositional nuances, as seen, for example, in his *Flagellation* (Pl. 5) in Amsterdam.

The 1362 Saint Thomas altarpiece (Pls. 11-1–13-6) represents a new phase of Luca's activity. Luca's role in the work was clearly essential to its ultimate effectiveness as an image. Beyond this, however, is the fact that the altarpiece reveals a new sense of design that was extremely sophisticated at this point, and that was reaffirmed from then on, as at Rieti (Pl. 27), Cascina (Pls. 47-1–47-7) or at Venano (Pls. 48-1 and 48-2). An additional consideration in this phase of Luca's career is, of course, his brief partnership with Niccolò di Ser Sozzo, whose stylistic influence on Luca was a strong one, and aspects of which Luca assimilated gradually and melded with what he had learned from Pietro Lorenzetti.

In the Yale *Assumption of the Virgin* (Pls. 15-1–15-5) we are treated to another view of Luca's real com-

positional genius. The figures work beautifully within their stage set and props to create an effective retelling of the event, aided by gesture and glance, and heightened by color and decoration. This painting also shows Luca's ability to deal with physiognomy in a more credible way, as his figures become much more sure, suave and graceful. Here, too, we begin to see their characteristic dusky pallor, and to sense something of the smoldering, emotive quality that we encounter so often in the *dramatis personae* of his next phase.

Luca's Pisa *Crucifixion* (Pls. 19-1–19-3) stands as a watershed in his career, signaling his arrival at full artistic maturity. The composition is subtle and uncrowded. There is a clear message to be understood here that is conveyed in a bold and straightforward way. The figures of the Virgin and John the Evangelist are filled with pathos while communicating to us forcefully the whole notion of Christ's sacrifice for our redemption. Luca brought together and blended all of his elements here with consummate skill in what is one of his most successful paintings.

Over the next eight years Luca's production was prodigious. It was a period marked by such large and important altarpieces as the *Saint Anne* (Pls. 22-1–22-5) and *Mystic Marriage of Saint Catherine* (Pls. 30-1–30-3), both in Siena. His keen awareness of current church doctrine is revealed in this set of images, which thus contribute to the development of these and a number of other themes. During this time his shop grew, and the hands of a number of assistants are visible in some of his large-scale works. It was a time, too, when Luca's works themselves served as models for a number of other, lesser artists—such as the Master of the Panzano Triptych and the Master of the Magdalen Legend—and it is through examining their work that we learn more about their mentor. Luca's autograph figures at this time were solid, well modeled and convincing as, for example, the *Saint Paul* in Rieti (Pl. 27) or in Oxford (Pl. 65).

Toward the end of this period Luca painted an altarpiece (Pls. 32-1–32-4), now in Siena, that foreshadowed much of his later production. His interests had clearly changed, and his experiments here with compartment shapes and proportions, figures and ground, and ornament were repeated often over the next two decades.

Luca's final phase is well represented by his polyptych from Venano, now in the Siena Pinacoteca Nazionale (Pls. 48-1 and 48-2). Here his figures fill the picture plane, their halos deeply overlapped by the ornate multilobed molding surmounting them. The surrounding frame presses in on them, constricting their movements. They are posed on deeply receding, raised marble steps, and occasionally appear to step over the edges of them. The figures, brought into the forefront of the picture plane by this device, frequently seem to extend into the space beyond them, creating an uneasy tension. Increasingly, Luca painted large areas of flat, looping drapery, within and along the edges of which he added decorative geometric patterns and exquisitely punched details worked in gold. Anatomical details became indistinct, while areas of flesh were no longer crisply modeled but became soft and imprecise. Consequently his figures became less convincing as they came more and more to resemble mannequins, their potential for expressiveness totally gone.

Frequently Luca stylized his forms so that the rhythms of line and pattern seemed almost to overwhelm his figures. At the same time the shape of his altarpieces continued to vary as his panels became increasingly narrow and vertically oriented. High-peaked and scalloped moldings appeared together with gossamer punching in the spandrels. His colors, while bright, did not have the tonal character that they had possessed earlier; nor did they bind the composition together in the way they once had. Luca seems to have become almost preoccupied with ornament. Throughout all the works from this period the alternation of pattern and shapes, and use of elegant materials with gold and silver leaf, created forms unprecedented in earlier Sienese painting.

These later works do not overshadow the fact that Luca di Tommè was an artist of great imagination, power and flexibility. He was adept at the dramatic articulation of narrative, and excelled in the use of design and orchestration, and as such, he constituted a major innovational force in Siena for more than a generation. The variety and quality of his works were not surpassed by any of his peers. Perhaps Masaccio paid Luca di Tommè his greatest compliment when he quoted Luca's masterpiece in Pisa in one of his own in Santa Maria Novella in Florence several decades later.

A brief survey of a few representative works by Luca's peers in Siena is helpful in gaining a clearer

understanding of Luca's achievement and in assessing more accurately, in however a cursory way, the common debt all these painters owed Simone and the Lorenzetti.

One of the most fascinating figures of this period was Andrea Vanni, whose artistic career of more than fifty years was punctuated with a number of diplomatic assignments and governmental appointments at the behest of the Sienese Commune. We know from the documents that he rented a shop in Siena in 1353 with his fellow artist Bartolo di Fredi, and that he died about 1413.[1] His *Crucifixion with Two Prophets* in the Siena Pinacoteca Nazionale (no. 111) is a good example of his art, and it can be dated to the mid-1390s. In it we see his delicate, precise style, indicating that he was deeply influenced by Simone's earlier works. The exact brushstrokes in the hair and beards of the prophets, the deep, looping folds of their cloaks, and the choice and disposition of colors indicate his almost slavish dependence on Simone. His altarpiece of 1400 in Santo Stefano in Siena is of inferior quality, perhaps due to extensive shop intervention, but also reveals his attachment to Simone.[2] The Christ Child standing in His mother's lap is taken directly from Simone's *Maestà* in the Palazzo Pubblico (Fig. 1-1). (This same motif had been used some forty years earlier in the 1362 Saint Thomas altarpiece by Luca and Ser Sozzo.) Furthermore, many of the attitudes and gestures of the figures depend on Simone's Pisa polyptych now in the Museo Nazionale. Andrea's 1400 Santo Spirito altarpiece is of particular interest because it contains several of the same elements that Luca had dealt with earlier. We see the emphasis on flattened forms and surface detail, figures crowded into their compartments, and the vertical elongation of panels. What is more, Andrea experimented with the placement and disposition of spandrel and pinnacle figures vis-à-vis his major characters below them. Luca also dealt with these problems, but in a more convincing and successful way.

Lippo Vanni left a more varied legacy than An-

drea, as he worked in miniature and fresco. The style and composition of his paintings are directly dependent upon the Lorenzetti, just as Luca's early works were.[3] This is especially clear in his miniatures from the mid-1340s in the Siena Cathedral Library, which show his free adaptation of earlier Lorenzettian types for his own use. A triptych in Rome, dated 1358, is a good example of his panel painting.[4] The *Madonna and Child Enthroned with Two Angels, Saint Dominic and the Holy Martyr, Aurea* are depicted in the central panel. A small figure of Eve, with a serpent close by, is placed at the base of the throne. Lorenzettian elements are evident here also: the composition of the central panel is based on Pietro's *Virgin and Child Enthroned* (no. 445) now in the Uffizi,[5] while the recumbent Eve placed below the enthroned Virgin can be traced to Ambrogio.[6] The panel, if not inspiring, is well painted, but more important, it shows the tremendous influence paintings such as Pietro's Uffizi panel exerted on a group of younger Sienese artists.

Lippo's depiction of the *Madonna and Child Enthroned with Saints Francis, John the Baptist, Catherine of Alexandria and Anthony* in the chapel of the Pontificio Seminario Regionale Pio XII in Siena is one of the few polyptychs painted alfresco that have survived from this period.[7] Most scholars now agree on Lippo's authorship of this painting, and in it we see distinct stylistic similarities to some of Luca's works of the late 1360s and 1370s. The figures of John the Baptist and Catherine are quite akin to Luca's renditions in both Siena and Florence (cf. Pls. 22-1 and 44). However Lippo's figures are painted with a much lighter, more delicate palette than Lu-

1. For documents regarding Andrea Vanni see Milanesi, 1854, vol. I, pp. 302–7, and Borghesi and Banchi, 1898, pp. 54–55. The basic chronology presented by van Marle, 1924, vol. II, pp. 432–51, is still useful, but it must be used with caution.

2. For illustrations of these two paintings see B. Berenson, 1968, vol. II, pls. 393 and 398, and also Torriti, 1977, pp. 188–89, for a discussion of the triptych in the Pinacoteca Nazionale.

3. For documents concerning Lippo Vanni see Milanesi, 1854, vol. I, p. 27, and for a brief overview of this activity see van Marle, 1924, vol. II, pp. 452–65.

4. For illustrations of two of the miniatures and the 1358 triptych see van Marle, 1924, vol. II, figs. 296–99.

5. For an illustration see Cole, 1980, p. 130.

6. Compare this figure with, for example, Ambrogio's Eve in the Chapel of San Galgano at Monte Siepi. For an illustration see Rowley, 1958, vol. II, pls. 72 and 73.

7. For an illustration of the fresco see Boorsook, 1960, pl. 30. The fresco was attributed to Luca di Tommè by E. Jacobsen, 1907, p. 97, but Lippo is now generally accepted as the author. The survival of frescoed polyptychs in Sienese territory is extremely rare and this one is probably the best preserved of the trio known to us. The others are located in Compagnia del Beato Patrizi in Monticiano and in Sant'-Agnese at Montepulciano. See The *Mostra di Opera d'Arte Restaurate nelle Provincie di Siena e Grosseto*, Genoa, 1979, pp. 86 and 87.

ca's. He made his faces more rounded and sweet, while the drapery of his figures is more developed and linear. Altogether his figures are highly decorative, and generate a feeling of elegance far beyond anything found in Luca's works.

Bartolo di Fredi was one of the most prolific and important painters of this period, and he has been considered a bridge from the achievements of the previous generation to the refined art of Sassetta in the fifteenth century.[8] While none of his works described in the documents survive, numerous signed and dated panels and frescoes exist and permit us to trace his development.[9] He is first recorded in 1353 when he opened a shop with Andrea Vanni. He married shortly thereafter, was active in communal affairs almost continually for the next forty years, and died in 1410. Unfortunately, our concept of Bartolo is obscured by a number of false attributions, but what emerges from the accepted works is the picture of an eclectic artist. He drew on the Lorenzetti and Simone Martini alike and we perceive in his work the frequent intervention of shop assistants.

His frescoes in thirty-five episodes depicting scenes from the Old Testament in the Collegiata in San Gimignano are signed and dated 1367.[10] Here we notice the work of Bartolo's helpers in the awkward, flattened figures and animals in several of the scenes. In the *Death of the Children of Job* the exotic beasts in the background, presumably camels, move off to the left. Their extremities and those of their attendants seem almost to be made of rubber due to the lack of a supportive skeletal structure beneath their flesh. The series of fleeing or crushed figures in the foreground are coarse and unconvincing, while overall the scene seems disjointed and unimaginative. In contrast, a number of the figures in the scenes of *Joseph Lowered into the Well* are quite ably painted.[11] In particular the figure of the man slaughtering the ram is very well drawn.

Bartolo's *Adoration of the Magi* from 1367 is a magnificent document of the Sienese countryside with the city itself in the background.[12] There is a tre-

mendous feeling of pageantry here that is equaled only some fifty years afterward in Gentile da Fabriano's famous version in the Uffizi.[13] The colors are rich, deep and vibrant as reds are played off against blues and gold in a subtle way. One can almost feel the strain and tension in the foreground crowd as they push forward to adore the Child. The viewer hardly cares whether the foreshortening of the horses is accurate or not, as his attention is fixed on this festive group and particularly on the Magi, two of whom eagerly look at the Christ Child. One sees, too, the growing desire for sumptuous materials in this altarpiece.

One of Bartolo's most successful works is his signed and dated (1388) *Coronation of the Virgin* in Montalcino. With its other components in the Siena Pinacoteca Nazionale (nos. 97/99-102, 106) and Los Angeles (nos. L. 2100.44-1072, 1073),[14] the original ensemble must have been impressive. Here Bartolo's forms are much more suave and lyrical. The awkward and disproportionate figures have been replaced by more harmonious and orderly ones. His angels have a great deal of charm and grace. Above them Christ and the Virgin are entirely comfortable in the space they occupy. In the lateral scenes the artist skillfully uses architecture to establish a real space for his figures and bind them together. They move easily within it and tend to be clustered, yet the gazes of the figures at the sides of the scenes help focus attention on the center groups. Undoubtedly this is one of Bartolo's masterpieces, and in his compositions we see the inspiration of the Lorenzetti. It is tantalizing to imagine what the results of his collaboration with Luca and his son, Andrea di Bartolo, would have been. One is tempted to ask whether there would have been a melding of two quite diverse styles—Luca's and Bartolo's (we know nothing of Andrea's art at this time; presumably he was still working in his father's shop)—or would the differences have been strident and immediately obvious?

The last Sienese contemporary of Luca's we should consider is Paolo di Giovanni Fei.[15] He ap-

8. C. Weigelt, 1930, p. 58.

9. See Chapter 4, note 10 above.

10. Again see Chapter 4, note 10 above.

11. For an illustration see Meiss, 1951, fig. 82.

12. For illustrations of this and the scene of Joseph see Berenson, 1968, vol. II, pls. 405 and 409, and also Torriti, 1977, pls. 164–65, for the *Adoration of the Magi*.

13. For an illustration see Hartt, *History of Italian Renaissance Art*, New York, 1974, pl. 15.

14. For illustrations of these see van Marle, 1924, vol. II, figs. 321 and 322, and Los Angeles, 1965, pp. 58 and 59.

15. For documents regarding Paolo di Giovanni Fei see Milanesi, 1854, vol. I, p. 37, and for a survey of works one may consult van Marle, 1924, vol. II, pp. 524–36, and also Mallory, 1965, *passim*.

pears in documents from 1369 until his death in 1411, and like his fellows, he held several governmental posts. A substantial number of pictures are attributed to him and it seems that he found a steady market for his small portable altars. His style represents a synthesis of the Lorenzetti and Simone.

His only signed altarpiece, now in the Siena Pinacoteca Nazionale (no. 300), can be dated on stylistic grounds around 1390 and is an excellent example of his art. Although the painting is in poor condition, one can see that the motif of the Child embracing the mother is derived from Ambrogio, while the tall, tubular figures flanking the Virgin are Simonesque in feeling. The Prophet Daniel looks out and away from the central group and also away from the viewer. His turning and slightly arched body echoes this movement while the deep folds of his cloak further emphasize it. One could imagine here that this figure, like many of Simone's later ones, could have been modeled after French Gothic jamb sculptures of the mid-thirteenth century. The multilobed framing and verticalization of the panels are characteristic of Sienese polyptychs from the 1380s and 1390s. However, none of the figures is crowded by the frame except for the robust Andrew, yet even here one does not feel any tension such as Luca created in his later paintings.

The central panel of Paolo's *Birth of the Virgin* in the Siena Pinacoteca Nazionale (no. 116) is clearly based on Pietro's earlier version now in the Siena Museo dell'Opera del Duomo.[16] But Paolo has altered and compressed the spatial arrangement of that triptych and, furthermore, has added two oversized and bulky saints with cascades of gilt-edged drapery to each side of the central panel. This juxtaposition of saints detracts from the integrity of the middle scene. One sees here Paolo's efforts at experimenting with the form of the polyptych. The changing scale of the figures, the rhythms generated by the varied heights of the side panels' pinnacles in contrast to the central panel, and those established by the alternating widths of the five painted compartments attest to this. However successful certain passages and individual figures are, the

overall effect here is strained and somewhat overwhelming.

These men as a group represented the outstanding artists active in Siena during the second half of the trecento, although none of them rivaled the great Sienese masters who flourished during the first half of the century. They were prolific and able practitioners of their art, and the influence of the preceding generation, particularly that of the Lorenzetti and Simone Martini, is evident among all their works. These influences were so strong that they persisted well into the fifteenth century in a variety of ways. Simone's very painterly style and compositional ideas were reflected in the paintings of Andrea Vanni and Niccolò di Ser Sozzo, while Paolo di Giovanni Fei borrowed something from Simone's figural mode. Almost all of these artists were indebted to the Lorenzetti brothers in one way or another, and quoted their figures and compositions liberally in later frescoes, panels and miniatures. Lippo Vanni and Paolo di Giovanni Fei were among the most frequent borrowers, as was Luca di Tommè, especially during the early years of his career.

Certain aspects of painting did change in Siena after 1350. For example, there were no further experiments in the use of perspective—with which the Lorenzetti had been so vitally involved. Furthermore, the few new iconographic types that appeared in Sienese territory were of a very hieratic nature, again contrary to the mood of many of Simone's and Ambrogio's paintings. With the exception of Bartolo di Fredi's frescoes at San Gimignano, there were no elaborate narrative cycles painted during this period. Judging from what survives, there seems instead to have been a preference for some modest, votive frescoes, small, portable diptychs and triptychs, and large-scale altarpieces.

Stylistic considerations also shifted during this period, as demonstrated by the fact that all these painters concerned themselves increasingly with ornamentation and drapery. In addition, they experimented with the representation of figures in space and the overall configuration of the altarpiece. Luca di Tommè as an artist was representative of his time, and his solutions to these problems helped to establish him, in his own right, as one of the major artists in Siena during this period.

16. For illustrations of this and the two preceding works by Paolo see Berenson, 1968, vol. II, pls. 89, 415, and 416. Also see Torriti, 1977, pp. 179–80.

The Early Works (1356–1361)

The late Middle Ages and Renaissance saw a revival and radical development of all the arts in central Italy, and nowhere else was this greater than in Tuscany, where her two principal cities, Florence and Siena, were in the vanguard.[1] Soon different traditions—as well as rivalries—were established as each vied with the other in the beautification of their cathedrals, palaces and parish churches. The high quality of what these Tuscan artists created is attested to in introductory art history surveys in which the names of Giotto, Simone Martini and the Lorenzetti brothers inevitably appear. But between them and the achievements of such early Renaissance masters as Masaccio, Donatello, Ghiberti and Brunelleschi there is an interval of some six or seven decades during which painting and sculpture continued in Tuscan workshops to meet the ongoing requirements of institutions and the public alike. That the artists of the latter half of the trecento have, however, been largely overshadowed by their more illustrious colleagues is due of course to the fact that they were men of lesser talent, as well as the more hieratic and conservative nature of their art.[2] Nonetheless they were men of considerable ability and skill who deserve to be appreciated on their own merits, and Siena was gifted with several such artists.

Among the most successful was Luca di Tommè. He is recorded in Siena during the mid-1350s, and over the course of the next decade he established a shop that continued to operate, under his direction, for a generation.[3] Working in his native city almost continually from the 1350s onward to at least 1390, he journeyed elsewhere only occasionally as commissions would require. He seems to have had continual dealings with the Siena Cathedral authorities throughout his career, both as an art consultant and as a painter in his own right. His connection with the local government is more difficult to establish given the paucity of the record, but it is clear that after 1373 he was almost constantly involved in communal affairs. Furthermore, we know that he married twice—his first wife having died in an outbreak of the plague—and also that he resided at a number of different locations throughout the city over the course of his lifetime, although we hear nothing of children. Judging from his links with the local Cathedral and government, and the volume, quality and content of his surviving works, he must have been one of the most influential and sought-after artist-entrepreneurs in Siena during this period.

Luca's artistic "persona" as revealed in his work owes a good deal not only to his predecessors but also to the cultural milieu of Tuscany in the period following the disasters of the 1330s and 1340s, which culminated with the advent of the plague in 1347/48. Before evaluating the paintings, however, it is worth our while to survey briefly some of the earlier scholarship in order to see how our perception of Luca has developed.[4]

1. Several handbooks have been written about this period of Italian art. Among the most useful are those by Robert Oertel, *Early Italian Painting to 1400*, New York, 1968, and John White, *Art and Architecture in Italy 1250–1400*, Baltimore, 1966. A very valuable overview of the period is provided in Frederick Hartt, *History of Italian Renaissance Art*, 2nd ed., Englewood Cliffs, New Jersey, 1979. Bruce Cole's *Sienese Painting From Its Origins to the Fifteenth Century*, New York, 1980, gives us a useful survey of developments in Siena. For Florence one may profitably consult Bruce Cole, *Giotto and Florentine Painting 1280–1375*, New York, 1976; Richard Fremantle, *Florentine Gothic Painting*, London, 1975, and also Miklòs Boskovits, *Pittura Fiorentina alla vigilia del Rinascimento, 1370–1400*, Florence, 1975.

2. Meiss, 1951, is the first scholar to have seriously addressed the nature and content of painting after the middle of the century and his pioneering study still stands as the definitive work in the field.

3. For an in-depth presentation and discussion of documents pertaining to Luca di Tommè see pp. 191–94.

4. For a more detailed look at the previous scholarship dealing with Luca see pp. 52–53.

The first critical mention we have of Luca di Tommè is provided by Giorgio Vasari in his *Le Vite de' più eccellenti pittori, scultori ed architettori* in 1568.[5] Writing more than a century and a half after the artist's death, Vasari tells us that Luca was a pupil of Barna da Siena, but a comparison of their works excludes the likelihood of any close affiliation between them. Probably the most important consideration in a comparison of the two is the emotional response each of their works generates within the viewer. If we take Barna's *Pact of Judas*[6] in the Collegiata in San Gimignano as a representative example of his art, we see that he was indebted both to Duccio and Simone Martini for the figural style and layout of his compositions, although he was more expressive than either of those two. He had a highly developed sense of drama. The viewer is disquieted by the feeling that something ominous is about to occur (which, of course, is the case), and many of Barna's figures have a sinister, menacing aura about them, particularly Judas. The disturbing quality in this, and a number of other scenes in this cycle, is strengthened by the masterful way in which the artist handled his palette, with its brilliant luminescence. One does not see any of these elements among any of Luca's works. His figures do not become brutalizing, and create no feeling of foreboding within the viewer. Furthermore, Luca's color is different from Barna's. Luca, when he was at his best, as in his Pisa *Crucifixion* (Pls. 19-1–19-3), played upon the emotions of the viewer, surely, but he reached his audience through the pathos inherent in the figures themselves, with no attempt to terrify the spectator. Taken altogether, these several fundamental differences would preclude a close link between Barna and Luca.

Gaetano Milanesi, in his critical edition of Vasari's *Lives* (1878–85), suggested that Luca should more properly be considered a follower of Simone Martini.[7] Luca indeed seems to have been more attracted to Simone's earlier works, and a look at two of these is useful in determining the influence of the older master. Simone's *Maestà* (Figs. 1-1 and 1-2) in the Palazzo Pubblico in Siena is his first extant signed and dated work. It is obvious that the composition of the Madonna and Child (Pl. 13-1), as well as the use of sumptuous fabric and jewels, in the central panel of Luca's 1362 Saint Thomas altarpiece can be traced to Simone's 1315 fresco. Furthermore, when we look at Simone's altarpiece in the Museo Nazionale di San Matteo in Pisa,[8] we see that Luca owed something of his sense of design and orchestration of gestures and figures to Simone. But Simone's was the greater talent and Luca never quite achieved the decorative, suave sophistication that the former projected in his earlier work, and from this one can only conclude that Luca's love of elegant line and feel for rich materials certainly stemmed from the former, but that it was probably no more than a common debt owed to Simone by virtually all of Siena's painters at this time.

Shortly after the turn of the century, F. Mason Perkins, a connoisseur of Sienese art, pointed out the direct influence of Pietro Lorenzetti on Luca.[9] This is abundantly clear in Luca's early paintings, so much so that it suggests that Luca not only had knowledge of Lorenzetti's works but made a careful study of a number of them. Pietro's *Crucifixion* in San Francesco in Siena (Figs. 2-1 and 2-2) is a good index of his art. The tone of the work is sober and restrained. The monumental and still body of the crucified Christ has a majestic quality. It is massive, modeled with deliberate care, and set off by the circle of almost raucous angels who are in anguish at the scene they witness. Below the angels the spectators are contemplative, their grief spent. The Virgin gazes up at the body of the crucified Christ but seemingly looks beyond it as if preoccupied. Her pain at His immediate physical death has been replaced by her comprehension of the significance of His sacrifice. John, isolated at the foot of the cross, is still overpowered by his sorrow, but one feels that he too has begun to grasp the profundity of the event he has just seen.

Pietro used his space brilliantly by balancing the mass of his figures, either singly or in groups, on either side of the cross. They are set quite close to the foreground as their varied poses, gestures and facial expressions reveal their emotions and serve to tie the composition together still further. These are solid, well-articulated beings whose faces are some-

5. Vasari, 1568, ed. Milanesi (1878–1885), vol. I, p. 651.
6. For an illustration see Cole, 1980, p. 182.
7. Vasari, *op. cit.*, p. 651 n. 3; and Milanesi, vol. I, p. 29 n. 1.

8. For an illustration see Paccagnini, 1957, p. 106, fig. 16.
9. Perkins made this point in a series of articles published over a period of more than twenty years. See Perkins, 1908b, p. 108, and Perkins, 1920, pp. 287–91; in particular also see the introduction to the Catalogue, p. 53, p. 52 n. 5 and the Bibliography, pp. 205–13.

what stylized. Although the color here is almost totally gone in some areas, Pietro showed us in other, better preserved works that he was a masterful colorist and fond of architectural detail and ornament as a means of enlivening his paintings. His *Birth of the Virgin*[10] in the Museo del Opera dell' Duomo in Siena provides us with a sparkling example of how he used these elements.

Luca was indebted to Pietro for his forms, sense of space, color, and figural style, especially within his earliest works. A close look also shows that he repeatedly turned to Pietro for thematic inspiration. While it seems that Luca must have learned these Lorenzettian elements through direct contact with the artist and his shop, lack of documentary evidence limits us to concluding that he knew Pietro through his art both in Siena and elsewhere. As the Lorenzetti were the only outstanding painters in Siena during the 1340s, their impact, through their own art and through that of their workshop, on the young painters of the next generation must have been enormous, and Luca must be counted as one of this group.

The other major influence on Luca came from Niccolò di Ser Sozzo, an artist older than he who seems to have begun his career during the 1340s.[11] Niccolò reflected aspects of Simone's early activity, but his influence on Luca occurred slightly later, in the early 1360s. After Niccolò's influence abated, Luca seemed finally to achieve an independent and recognizable style that remained free of other influences for the remainder of his career.

Less than a dozen paintings are all that remain, as far as we can tell, from the earliest phase of Luca's activity. They form a coherent group and represent the work of an immature artist whose development in compositional and figural skills, as well as his acknowledgment of the influence of Pietro Lorenzetti, they clearly document.

One of Luca's earliest surviving panels, now in Los Angeles, represents the *Madonna and Child Enthroned with Saints Louis of Toulouse and Michael* (Cat. 1, Pl. 1). Here, the Virgin is seated on a stepped throne backed with a delicately punched gold cloth of honor. The Child sits on His mother's left arm, His feet resting in her lap, while His attention is centered on the pomegranate in His right hand. In the foreground two full-length saints flank the throne. Saint Louis gazes reverently at the Christ Child, while his crozier draws our attention to his crown on the floor before him. An armored Saint Michael, displaying both sword and shield, stands with his right foot on the carcass of a vanquished dragon. While Saint Louis's attention is directed into the composition, Michael looks out at the viewer with apparent reserve. Behind the saints and still on either side of the throne stand two angels who seem to be looking directly at the pomegranate. The framing of the central image has a punched-band border, and overhead, Christ Blessing is depicted within an elaborately detailed pinnacle.

This panel is quite similar in some of its aspects to a work from the ambience of Pietro Lorenzetti, now in the Walters Art Gallery, Baltimore (Fig. 3).[12] The Madonna, seated on a stepped throne backed with a punched cloth of honor, holds the Child, who gazes intently at one of the bishop saints. As in the panel by Luca, the Virgin looks out at the observer, while the Child's attention is fixed within the composition. Full-length bishop saints stand just in front of and to either side of the throne. Two female saints act as additional flanking figures, while two angels with hands crossed appear behind the throne. At the top of the panel a band of punchwork runs parallel to the area originally reserved for the molding, a few fragments of which are still visible.

Although Luca based a portion of his composition on either this painting by a Pietro follower or one very similar to it, he made some important modifications. His reduction of the number of figures from six to four may reflect the use of another model or differences in the requirements of the commission for the work, obviously, but it also reflects distinctions in the handling of figures and space. Pietro's solid bishop saints have given way to slender, less well-defined figures. Luca's Madonna is an elongated, passive figure in comparison to the compact, robust Virgin in the Baltimore panel. Unlike Pietro's, Luca's grouping of figures has an additive quality: they could be withdrawn in pairs from each

10. For an illustration see Berenson, 1968, vol. II, pl. 89.
11. This was first suggested by Brandi, 1932, pp. 230–36.

12. Baltimore, Maryland, The Walters Art Gallery, no. 37.731. The panel was attributed to Pietro Lorenzetti by Berenson, in 1932, p. 292, who reaffirmed this in 1968, vol. I, p. 218. In a verbal opinion Professor Hayden Maginnis, who has worked extensively on Pietro and his followers, suggested to me that this panel is by one of the latter. Zeri, 1976, pp. 39–41 attributes the painting to Pietro himself.

side of the central image without altering the structural unity of the painting.

In Luca's panel the cloth of honor on the back of the throne extends under the punched border and just beyond it to the top of the arched molding. The result is a composition with a backdrop but without a firm background. In contrast to this lack of spatial definition are the clarity and depth produced by the graduation of figures in the Baltimore panel. Pietro's space as translated by his follower is clear and articulate, while Luca's, despite its openness, has a flat, nebulous quality.

The representation of the Child reaching for a pomegranate—an allusion to the Resurrection and the immortality of the soul—is unique to Siena. It is a variation of a theme that gained popularity toward the end of the thirteenth century in central Italy, in which the Virgin is shown holding a flower.[13] The first surviving example in Sienese painting is found among the followers of Duccio, in a picture attributed to the school of the Master of Badia a Isola. There, a seated, half-length Virgin holds a pomegranate.[14] She looks out at the viewer while the Child reaches forward with His right hand to grasp the fruit. The Virgin in Luca's representation has assumed a more human quality. Her hands support and protect the Christ Child whom she displays to the observer, while He holds and focuses on the fruit.

The panel in Los Angeles probably formed the center portion of a portable, folding triptych, the leaves of which are now lost. If this indeed was the case, then it may originally have been similar to a triptych by Luca now in the Timken Art Gallery in San Diego (Cat. 4, Pls. 4-1–4-9). Although on stylistic grounds the San Diego work is considered to have been painted slightly later than the Los Angeles panel, the dimensions of its central image are virtually identical to those of the latter. The wings of the

Los Angeles work may have contained scenes from the early life and Passion of Christ such as those portrayed in San Diego: The Nativity and Adoration on the left surmounted by the Archangel Gabriel; on the right the Flagellation or Way to Calvary, and the Crucifixion, Lamentation, or Resurrection surmounted by the Virgin Annunciate.

The Los Angeles panel contains many features that indicate how deeply Luca was influenced by Pietro Lorenzetti, and also how he reinterpreted Pietro's formulae to suit the demands of his patrons or himself. It is one of Luca di Tommè's first works, and quite possibly the earliest that survives.

The strong influence of Pietro and his following is seen in two other works that can be dated to this same period. They are a panel depicting the *Crucifixion*, located in the Staatliches Lindenau-Museum in Altenburg, and a processional crucifix, formerly in the collection of Mrs. Jesse Isidor Straus, New York, and now in the Fogg Art Museum in Cambridge, Massachusetts.

The Altenburg painting (Cat. 2, Pl. 2) must have originally formed part of a predella series, if one is to judge by both its size and its painted quatrefoil frame.[15] The importance given to the representation of the Crucifixion in Sienese painting during this period suggests that the panel probably would have been placed under the central panel of the main tier of saints in a modest polyptych. Several aspects of this composition are remarkable. The Virgin and John the Evangelist are seated on the ground, each with the leg nearer the frontal picture plane extending to the base of the cross. Behind these figures, symmetrical rock formations provide a dark ground for their silhouetted halos.[16] Further, the figures in

13. For a detailed discussion of this theme, its origins, and variants, see Shorr, 1954, pp. 110–15. A number of Italian examples are illustrated in her catalogue. She does not give the symbolic source for the pomegranate, but connects this type with the theme of the Virgin holding the rose or the lily in her right hand. She suggests that this identifies her as the Spouse of Solomon, as implied in Canticles (II:1), where the Virgin is referred to as the "rose of Sharon and the lily of the valleys."

14. The panel is illustrated in Shorr, 1954, p. 114, as "17 Siena I, School of Badia a Isola Master, whereabouts unknown." More than likely the original attribution is that of Richard Offner, as noted in the same work, p. viii.

15. I have not found any other panels that can be joined to this one.

The painted quatrefoil would have been complete at top and bottom, while the light colored lateral bands that pass behind it above and below probably would have been as wide as the frame of the quatrefoil. The lines running parallel to the painted frame on the left and right sides, when complete, would have added as much as three centimeters to the width of the original painted surfaces.

The quatrefoil was not popular in Siena during this period. There are earlier examples, however, and perhaps the best known occur in the framing of the border figures in Ambrogio Lorenzetti's *Allegory of Good and Bad Government* in the Palazzo Pubblico from the late 1330s. (See Rowley, 1958, vol. II, pls. 155–60 and 188–96.)

16. The placement of the Virgin and the Evangelist before two hills in silhouette at the base of the Crucifixion became increasingly popular as the fourteenth century progressed,

the foreground form a U shape echoed by the separation and curvature of the rocks. Outlined against the gold background, the torso and upper body of the crucified Christ is set in the fissure in the rocks, filling the upper zone of the composition. The counterpoint evident in the placement of the two witnesses extends even to the use of color. The yellow of the Evangelist's cloak and the deep blue of the Virgin's mantle are set off against the dark brown ground. All the colors within the composition are, in turn, contrasted against the green of the painted quatrefoil, which is built up in a series of half tones and shaded to create a sense of perspective.

The narrative tone of the panel is passive and contemplative. Neither the Virgin nor the Evangelist looks at Christ, each seeming instead to reflect on an event distant from them in time and space. The lack of animation in the figures, their self-contained postures, and their placement in the extreme foregound of the composition, securely backed up against the quatrefoil framing, prevent the observer from entering the scene. The viewer is further restrained by the absence of an area within the shallow space into which the eye may pass. This combination of elements achieves a poignant, delicate image, one intentionally made distant from the viewer.

The meditative quality of Luca's panel represents a dramatic change from the manner in which the Crucifixion had been traditionally depicted in Siena. Earlier examples during the 1330s and 1340s, and particularly those of the Lorenzetti,[17] allowed the viewer to pass easily into the scene and participate in the action. The exclusion of the viewer by means of a painted frame, as well as the use of the frame to create a sense of space that is frequently limited and flat, are devices that Luca used again and again. A series of predella panels for the jointly signed altarpiece in Siena, and another predella in the Yale University Art Gallery, show further developments of these ideas, and will be discussed in detail later.

A comparison of the Virgin in the Altenburg panel with a tondo of the *Virgin Mourning* (Fig. 4), from a dismembered altarpiece by Pietro Lorenzetti, clearly shows Luca's indebtedness to the latter.[18] In Pietro's painting the Virgin's head is shown in three-quarter profile and slightly bowed. The closely set eyes are narrow slits, drawn out toward the temples. The deep, heavily accentuated brows take an upturn at the bridge of the nose, which is straight and attenuated, with a touch of white at the tip for highlight. Small, almost rectangular lips are set very close to the nostrils and, finally, the cheekbones are high, accentuating a broad, expansive jaw. Luca has repeated Pietro's figure almost without change. His only innovation is to represent her with head bowed and resting on her palm, and yet this device could be an adaptation of Pietro's *Saint John the Evangelist* (Fig. 5) from the altarpiece.[19]

Further verification of Luca's continuing reliance on the works of Pietro Lorenzetti is to be seen in the small processional crucifix in the Fogg Art Museum (Cat. 3, Pls. 3-1 and 3-2). It is painted on both sides, with the *Crucified Christ with the Virgin, Saints John the Evangelist, Francis, and Christ Blessing* appearing on the recto (Pl. 3-1), and the *Crucified Christ with Saints Paul, Michael, Peter, and Louis of Toulouse* depicted on the verso (Pl. 3-2). (The presence of Saints Francis and Louis suggests that the work was commissioned by the Franciscans.)

In this panel Luca draws on several features from Pietro's monumental *Crucifixion* in the Museo Diocesano in Cortona (Figs. 6-1–6-3).[20] The sorrowful attitude of the Virgin, with her head slightly bowed and brows knitted, appears in both paintings (cf. Pl. 3–1 with Fig. 6–1). Even the gesture of the Virgin's right hand as it crosses over the left is copied by Luca. Moreover, the fingers of the right hand of Pietro's Virgin are slightly spread, as are those of Luca's figure. Luca also reproduces the way in which the earlier Madonna catches up the hem of her mantle with the index and middle fingers of her left hand, including the degree of bend and spread in the latter.

The way in which Christ is depicted on either side

perhaps because of its effectiveness in heightening the dramatic impact of the figures and making them more immediate to the viewer. By the beginning of the fifteenth century, the pair of figures is usually set well back from the picture plane and diminished in scale. (See, for example, the panel from the circle of Lorenzo Monaco, in the Yale University Art Gallery, no. 1871. 4, illustrations of which appear in both Sirén, 1916, pl. 24, and Seymour, 1970, p. 308, fig. 30.)

17. See, for example, the *Crucifixion* in Pietro's fresco cycle in the left-hand transept of the lower church of San Francesco, Assisi (illustrated in Cole, 1980, p. 124).

18. For a complete discussion and reconstruction of this altarpiece, formerly in the Church of San Giovanni Evangelista della Donna in Faenza, and dedicated to Saint Humility, see Marcucci, 1965, pp. 154–57.

19. See note 18 above.

20. The panel was attributed to Pietro by Berenson in 1932, p. 292, and again in 1968, vol. I, p. 218.

of the Cambridge work prompts yet another revealing comparison. Luca evidently did not have the ability to construct a solid, muscular, and monumental Christ in the manner of Pietro's. Instead, he made his figure less massive and ambitious, while nonetheless borrowing several prominent details from the Cortona *Crucifixion* of the earlier master. Luca attempted to construct a solid torso, giving close attention to the modeling of the rib cage. With great care he copied the pleats and folds of Christ's diaphanous loincloth. (His treatment of this motif is seen again in several later works.) The multiple folds on our left and the gathering and tuck at the right virtually duplicate Pietro's original. In all three, Christ's blood both gushes forth from His chest wound and runs down from His feet to the base of the cross. The extraordinarily long toes of the Cortona model likewise appear in Luca's processional piece. Of all the artist's early works, the Cambridge *Crucifix*, though a work of considerable quality and finesse in design and execution, is the most thoroughly derived from Lorenzettian models.

Stylistic elements drawn from Pietro's Cortona Cross also appear in Luca's triptych in the Timken Art Gallery in San Diego (Cat. 4, Pls. 4-1–4-9).[21] The *Crucifixion with the Trinity* surmounted by the *Resurrection* is shown in the central field. The left leaf contains the *Nativity* and *Adoration of the Magi*, surmounted by the *Angel Gabriel*; while the *Mocking of Christ* and the *Deposition* appear in the right leaf, below the *Virgin Annunciate*. As in the Cambridge *Crucifix*, Christ's blood both spurts forth and flows from His wounds, running down the cross. Here again the loincloth recalls its counterpart in the Cortona work, perhaps even more strongly than in the Cambridge painting. The Christ here is also somewhat more massive than either of the two versions in the Cambridge work. Luca has enlarged the chest, made the calves larger, pulled the head forward, and positioned the body slightly lower on the cross. The Virgin and John the Evangelist stand at its foot with Saint Francis, who kneels in adoration of the Saviour above him. He serves to direct our gaze upward to the three-headed Trinity that looks intently out at us.

While in the Altenburg panel (Pl. 2) the Virgin and John the Evangelist seem passive and divorced

from the central event, here their sorrow has an intensity and animation that help to unify the composition. The full-length standing Virgin, pressing the side of her grief-lined face with her palm, is more contorted in sorrow than the corresponding Altenburg figure. The Evangelist, his head bowed toward Christ and wringing his hands in despair, recalls a similar figure by Pietro Lorenzetti in a fresco of the *Crucifixion* in the church of San Francesco, Siena (Figs. 2-1 and 2-2).

The figures in the wings of the altarpiece are derived from Pietro, and reveal Luca's inability, at this point in his development, to render anatomical details beneath drapery in a convincing manner. The Archangel Gabriel in the left wing is clumsy and ill-defined, his right thigh and leg an oval mass almost without articulation. Luca has elongated the figure of the Virgin in the *Nativity*, just below Gabriel, but the swells in her mantle meant to define her legs are anatomically impossible. Moreover, her right arm seems to extend out from her chest instead of from her shoulder. In fact, virtually all of the figures in the triptych can be characterized by their relative awkwardness, a quality common to Luca's early works.

During the third quarter of the fourteenth century the theme of the Trinity became extremely popular in central Italian religious imagery, due in all probability to the renewed focus on Trinitarian doctrine and exaltation of the Church, following the succession of disasters that had befallen the preceding generation. Examples of the depiction of the Trinity before 1350 are abundant, both in frescoes and miniatures, but, with one exception, it does not occur in the altarpiece or tabernacle form until after mid-century.[22] Luca's San Diego triptych must be counted as the earliest surviving Sienese version, on panel, of this theme. In many ways it is an extraordinary work. The artist eliminates any individuality

21. I am indebted to Professor Joseph Polzer of Queens University, Toronto, who kindly shared with me many of his perceptive observations on this work.

22. Meiss, 1951, p. 34. The exception he mentioned appears in a compartment of the right wing of a triptych by Pacino di Bonaguida, which in 1951 belonged to Wildenstein and Company, New York.

A miniature from the shop of Pacino in the Morgan Library, New York, MS. 742, first published by Meiss (1951, p. 34 n. 82), has representations of four forms of the Trinity. The forms are as follows: God the Father holding the Crucifix, three identical men behind the altar, the three-headed figure, and Abraham with the three angels. The origin and development of the Trinity has been traced by Braunfels (1954). (See also Kirfel, 1948.) For further discussion of the Trinity, see Chapter III.

of dress or feature. The two outer figures are seated close together, in front of the third, central figure, who occupies a space not otherwise defined. Only two hands and feet are depicted, and the cloaks of both outer figures are joined at the center. This combination of elements creates an indefinite and ambiguous image: a visionary backdrop for the portrayal of Christ on the cross.

In this painting idea and narrative are separated in a conservative fashion. The traditional medieval shape of the mandorla dominates the central panel, almost to the point of overwhelming the figures of the Virgin, Francis, and the Evangelist below. The remarkable difference in the size of the Trinity and crucified Christ above and the sorrowing figures below is vital. The latter are of the same scale as the figures in the side panels and pinnacles. Thus, their function might be related to that of the small-scale figures who populate the historiated scenes in the aprons and terminals of dugento crucifixes, where they are shown adjacent to much larger figures of Christ.[23]

Here, the image of the Resurrection and the Crucifixion with the Trinity are axially aligned. The divine second member of the triad, Christ, is presented three times on this vertical axis. Both the narrative and compositional emphasis is on the Resurrection and Christ's role in the Trinity. A textual source for this representation may have been a prayer that followed the washing of the hands: "Receive, O Holy Trinity, this offering we present to You in memory of the Passion, of the Resurrection, and of the Ascension of our Lord Jesus Christ."[24] The emphasis in the Crucifixion scene is on Christ's dual nature, both human and divine, while the full iconography of the central panel is that of transubstantiation. In His crucifixion, Christ becomes "liturgically the victim sacrificed to God,"[25] and in fulfilling that act He returns to God. The three witnesses at the foot of the cross aid in the portrayal of a realistic setting for the representation of a metaphysical doctrine. The Evangelist and the Virgin provide historical witness to an event whose continuing validity and accessibility are embodied in the figure of Saint Francis, whose faith was rewarded by, among other things, his reception of the stigmata.[26]

In addition to the compositional and iconographic relationships present within the central panel of the San Diego triptych, the artist has established specific ties within and between its two wings, again perhaps reminiscent of dugento ideas. First Gabriel in the left pinnacle greets the Virgin in the right with his joyful news. Below him two of the Joys of the Virgin—the Nativity and the Adoration of the Magi—are presented. These are balanced on the right by two of her Sorrows: the Mocking of Christ and the Lamentation. Just as the Nativity prefigures the Lamentation, so, too, does the Adoration presage the Mocking, thus establishing a lateral intersecting relationship among the narrative episodes.[27]

Luca's developing technical ability is revealed in a *Flagellation* in Amsterdam (Cat. 5, Pl. 5). In this panel he constructs a shallow but well-defined space, into which a complex, interwoven figural group is set. These figures are more fully developed and substantial than in any of his previous works. Christ is placed before a column that divides the scene into two balanced halves. Compositional unity is maintained by the arrangement of His tormentors on either side of Him. The sharp, pointing gesture of Pilate, with his arm extended toward Christ, provides a dramatic horizontal emphasis. This movement is echoed by the arches above the figures, the moldings, and the series of loops formed by the border of the sagging tapestry. Christ's body turns to the tormentor on His right, yet His glance is directed to another figure preparing to strike Him from the left. Furthermore, the tormentor to the right repeats the *contrapposto* of Christ's figure by moving toward Him while glancing back at Pilate. These gestures initiate a staccato

23. For examples of this kind of Crucifix, see Dino Campini, *Giunta Pisano e le croce dipinte romaniche*, Milan, 1966, pls. I, III, IV, and V.

The mandorla itself is set off-center intentionally to increase the irrationality of the space. The artist used this same motif again in his *Assumption of the Virgin* in the Yale University Art Gallery, New Haven, Connecticut. (See discussion in Chapter II and Pls. 15-1–15-5.)

24. The suggestion was made by Mongan, 1969, p. 22.

25. Baltimore, Maryland, The Walters Art Gallery, *The International Style: The Arts in Europe Around 1400*, 1962, p. 18.

26. Luca seems to have been underscoring this point for the viewer by presenting the humble saint kneeling. He is often depicted in this position in paintings where he is shown receiving the stigmata.

27. This relationship was first pointed out in the exhibition catalogue cited above (see note 25), p. 18.

movement and considerable animation within the interconnected groups that pivot around the center image of Christ.

A curious detail in Luca's *Flagellation* is the painted architectural frame, of which only fragments survive. From what remains, however, one can deduce that this painted border originally surrounded the picture on three sides. A seemingly inexplicable break at the bottom transforms the frame into an illusionistic architectural element that restricts the viewer's passage into this space by any direction other than from the floor upward. The viewer can enter the composition only between the break in these jambs and is thus forced to focus on the central vertical element of Christ before the column. The curves of the two shallow arches springing from the column draw our attention out to the edges of the panel, down the lateral columns, through the gestures of Pilate and his henchmen, and back to the tortured Christ. This movement not only stresses further the interconnection of gestures and movements, but also brings us again to contemplate the pathetic Saviour. Here, for the first time in his career, Luca was more interested in the complexities of figural composition and its interaction with architecture. His concern was for the structural and narrative value of these elements rather than for their decorative appeal, and the result is the most complex of all of Luca's early compositions that have come down to us.

The theme of the Flagellation itself was extremely popular in Sienese painting from the end of the thirteenth century and throughout the fourteenth.[28] In the majority of representations Christ is situated behind the column. The earliest surviving Sienese version of Christ *before* the column occurs in the central compartment of the right wing of a triptych from Duccio's workshop, now in the Pinacoteca Nazionale, Siena (Fig. 7). In that painting Christ is being whipped while the Virgin and the Magdalen look on. In another panel from about 1325, Ugolino di Nerio, a student of Duccio, placed the event in an interior setting (Fig. 8). A panel in the predella of an altarpiece in Borgo San Sepolcro by one of Pietro Lorenzetti's followers draws from both sources, and may even reflect a lost prototype by that master

(Fig. 9). Christ is shown bound before the column, with only Pilate and two members of his entourage present. In order to provide a counterpoint to this stark representation, the painter introduced a profusion of highly ornamented architectural elements. Pattern is seen throughout: in the brightly tiled floor, the spandrels, the coffered ceiling, and the cloth of honor behind Pilate. Similar decorative elements also occur in Luca's panel, although in this instance Luca's invention of architectural framing seems far more important than his borrowing.

Two predella panels from a dismembered polyptych are no less inventive, and at the same time more accomplished. The altarpiece from which they came has not been identified; nor have any other panels from the original predella come to light.[29] In both of the surviving panels the problem of the juxtaposition of interrelated individual figures or figure groups within a finite space has been adroitly resolved. An assured facility has finally superseded the tentative and experimental character of Luca's earlier work—for example, the Amsterdam panel just discussed.

The *Adoration of the Magi* (Cat. 6, Pl. 6), now in Lugano, is a reworking of Luca's earlier composition in San Diego. Angels have been added at the right and the landscape elaborated. Both changes demonstrate the painter's increasing ability to articulate figures within a credible space. As in the Amsterdam *Flagellation*, his concern is with setting closely knit groups of figures in opposition to each other around a central figure or focus.

The *Crucifixion* in San Francisco (Cat. 7, Pl. 7) would have been the central panel of this series, primarily because the theme is more important than that of the Adoration, but also because its width is greater than that of the Lugano work. The central image of Christ Crucified divides the picture in two while remaining the focal point around which cohesive subordinate groups are placed. Paired auxiliary figures have been added in the margins in order

28. For a discussion of this theme, see Meiss, "A New Early Duccio," *The Art Bulletin*, XXXIII, 1951, pp. 95–103. A study by Monti, 1927, deals with the confraternity of the *Flagellanti*.

29. De Benedictis, 1979, p. 87, cited a *Nativity* and a *Presentation in the Temple* in a Florentine private collection that she feels are a part of this same predella.

I have not been able either to view or to obtain photographs of the works. Dr. De Benedictis, however, has kindly informed me that each panel measures approximately 40 × 42 cm. This means that their size, at least, would be thoroughly compatible with that of the *Adoration of the Magi* and the *Crucifixion*.

to maintain the compositional integrity of this wide rectangular space. On both sides the figures are in silhouette against a darkly accentuated background that anchors them in the foreground. The U shape of the inner profile of the rock formation helps further to control the increased number of figures. Luca has avoided the implicit monotony of a crowd scene by individualizing certain figures and also by the asymmetrical placement of a few of the groups. In the extreme right foreground two men, deep in conversation, are set off against the two women exchanging sorrowful glances at the opposite side of the composition, while the Magdalen's gesture of grief is balanced by the pose and gesticulations of the male pair immediately to the right of the cross.[30]

The source for the general arrangement of the central figure groups is Pietro's *Crucifixion* in the church of San Francesco, Siena (Fig. 2–1). Luca's Crucified Christ follows some of Pietro's earlier versions, except that here the more solidly constructed legs bend to a greater degree, while the hands and feet possess an exaggerated tautness.

Although processional banners were widely used throughout central Italy, very few have survived from the trecento. Luca's *Crucifixion* (Cat. 8, Pl. 8), now in Montepulciano, is not only unique among his own works, but is also practically the only surviving example of this art form from a Sienese workshop. The extreme delicacy of the support, often of silk or linen, would permit rapid deterioration: it is thus not surprising that Luca's banner has suffered extensive damage. It has also been repainted and restored a number of times, and many of the original forms are lost. From what remains, however, we can see that here again the artist utilized Lorenzettian sources.[31] The mourning John the Evangelist, the witnesses conversing energetically behind him, and the swooning Virgin are all encountered in Pietro's works.

One of Luca's major concerns continued to be the presentation of figures within a confined space. His increasing ability to control that space is seen in a panel depicting the *Madonna and Child with Saints John the Baptist and Catherine* in Polesden Lacey, Surrey (Cat. 9, Pl. 9). It is similar to the small panel in Los Angeles (Pl. 1). Here, however, the gestures and focus of the figures are carefully confined within the composition, giving it a self-contained quality. The two standing saints gaze at the faces of the Virgin and Child, who in turn are absorbed in each other's presence. The seated Virgin uses her left hand to support the Child in her lap. With His left hand He holds her right hand while tugging affectionately at her mantle with His right.[32] The Baptist and Catherine are situated significantly closer to the Virgin than are their counterparts in the Los Angeles panel. They turn toward her, in part overlapping her cloak. The frame, in its turn, seems to crowd and overlap saints and angels alike. Behind the throne the space is extremely shallow, which is due to the positioning of the angels who, holding the cloth of honor, do not recede gradually into space, but instead seem suspended vertically in mid-air. In order to see the holy pair the uppermost angel in the gable must lean far forward and bow his head. Yet despite the static and cramped nature of the figures, their gestures as well as the meticulous linear detailing in this exquisite little panel cause the eye to circulate freely and easily throughout the composition. For these reasons the Polesden Lacey picture is among the most accomplished of the early works of Luca di Tommè.

Another small painting, at one time in a private collection in Florence, is related to both the above work and the Los Angeles panel. The *Madonna and Child with Saints Peter and Paul* surmounted by *Christ as the Man of Sorrows* has been damaged and repainted somewhat, thus making an exact attribution and dating difficult (Cat. 51, Pl. 51).[33] The atten-

30. The prototype for the Magdalen's gesture is probably to be found in Cimabue's *Crucifixion* in San Francesco, at Assisi. (See Battisti, 1967, pl. 26.) It was taken over by Duccio and used in his *Maestà* for Siena Cathedral. (See Brandi, 1951, pl. 84, and Stubblebine, 1980, pls. 111 and 117.)

31. The only noteworthy elements in this otherwise routine work are the kneeling Magdalen who embraces the cross, and the crucified Christ whose body is diminished in scale. These two motifs were popularized in Siena in the 1360s by Andrea Vanni, a number of whose panels survive in which both of them appear. See also Fehm, 1969, pp. 574–77, and Chapter III.

32. For a discussion of this theme, its origin, and variants see Shorr, 1954, pp. 158–63. The theme of the Child grasping the Virgin's drapery seems to have originated in Byzantium. By the thirteenth century it occurs frequently in Gothic sculpture in the West. The first surviving Sienese example is found in a panel in Boston, attributed to Ugolino di Nerio. Shortly thereafter the motif was adopted by Simone Martini and the Master of San Pietro a Ovile. By the middle of the fourteenth century this theme had become well established in Siena.

33. A rare combination of elements in fourteenth-century Tuscan painting is the juxtaposition of *Christ as the Man of Sorrows* over the *Virgin and Child*. Interestingly enough a

uated proportions of the saints seem antithetical to Luca's style, and yet the design and rendering of the Virgin and Child, the meandering gold hem of her cloak, and the elaborate use of punchwork point to Luca di Tommè without any doubt. Saints Peter and Paul are posed on the same step occupied by the throne. They stand well forward of the Madonna and her Child. The extension of the step on either side of the latter in order to accommodate the saints creates an unusual effect, almost as if Paul and Peter had been placed on platforms. The void between them and in front of the central figures serves only to heighten this curious spatial effect. Furthermore, it is the Virgin alone who engages our eyes, as the two saints gaze off to their right, and the Christ Child to His left. The resultant spatial ambience is different from that in both the Polesden Lacey and Los Angeles paintings, which are more shallow and vertically oriented. This picture is akin only to the Amsterdam *Flagellation* among Luca's early works in terms of the artist's sophisticated play with compositional space.

Two works referred to in the Siena Cathedral treasury account books, and now lost, are of interest, as they provide us with at least a glimpse of Luca's earliest activity. The first, from 1357, involved the artist in the application of gold leaf to the halo of an apostle, for which he received a modest payment (Cat. 69).[34] The second work mentioned was a fresco situated above the central portal of the cathedral (Cat. 70),[35] on which, according to a cluster of documents from the following year, Luca made repairs in collaboration with a certain Cristofano di Stefano. These records are of great interest because they show, among other things, that Luca was working in fresco. They are all the more important in their being the *only* evidence of his having worked in that medium, as no frescoes have survived that can be attributed to him.

This group of less than a dozen paintings can be placed early in Luca's career. Stylistically they form a cohesive group, and each is related in some way to the work of Pietro Lorenzetti, whose considerable influence on Luca during this time is evident. No major altarpieces or frescoes survive or are mentioned in the documents. With the exception of one painting—the processional banner in Montepulciano—all of these works are small in format and reveal the hand of an artist not yet fully developed. An imaginative arrangement of figures in space seems often beyond Luca's grasp, and in a number of instances his figures appear awkward and clumsy due to his as yet immature understanding of anatomy. A further indication of Luca's inexperience is his repeated borrowing of specific compositional details from works of the preceding generation.

If a disjunctive feeling exists in some of these early works, nonetheless a real sense of narrative becomes apparent in others, as Luca developed the ability to place figures in space in a more convincing fashion. Gradually as his talent unfolded in working with compositional and anatomical details, he became more and more successful at infusing his scenes with a sense of the story or event they were supposed to illustrate.

During these early years of his career Luca seems to have been a conservative painter, as his themes were taken from a common stock then current in central Italy. The frequent appearance of specifically Franciscan saints in several of his works suggests an ongoing connection with that mendicant order. None of these paintings is signed, nor is there any documentation for them, and yet the stylistic evidence makes a sufficiently strong case for placing them within his early oeuvre. They share strong similarities with a number of works from his next phase, which began in 1362 when he joined Niccolò di Ser Sozzo in creating a major altarpiece. Their differences from his works done after 1366 further confirm their early dating. It was in this 1362 altarpiece that Luca finally achieved his artistic maturity.

panel whose whereabouts is unknown from Niccolò's shop presents this same combination.

I am indebted to Sig. Arturo Grassi of Florence for calling this panel to my attention. See De Benedictis, 1979, fig. 30.

34. See Document 2, p. 195.

35. See Documents 3a–3i, p. 195.

Niccolò di Ser Sozzo and Luca (1362–1365)

The year 1362 marked the completion of one of the largest and most important altarpieces created in Siena during the trecento.[1] Dedicated to Saint Thomas, it must originally have enjoyed a prominent place in the Cathedral or in one of the major religious foundations in the city. Fifty years ago, a routine cleaning brought to light the names of Luca di Tommè and Niccolò di Ser Sozzo on the molding of the work, thus sparking a lively debate that is still going on.[2] It revolves around the question of the design of the painting, the role that each artist had in its execution, and the nature and duration of their collaboration. Addressing these questions involves an examination of some of the working methods followed in a proto-Renaissance Italian workshop in a case where two masters collaborated on a more or less equal footing.[3] Moreover, as far as we know, this altarpiece was the most important commission in the early career of Luca di Tommè, and it is useful to establish the extent to which the stylistic influence of the older master manifested itself in Luca's later work.

One of the earliest of the surviving works of Niccolò di Ser Sozzo is found within a manuscript that has come to be called the *Caleffo dell'Assunta* after the artist's depiction of the Virgin's ascent into Heaven (Fig. 10).[4] His signed miniature has been dated between 1332 and 1336 on the supposition that it was completed at the same time as the transcription of various imperial privileges, papal bulls, and pacts with feudal families that accompany it. As further support for the 1336 date, it has been suggested that the hand of one of the three scribes employed

1. There are no known documents in either the Archivio dell'Opera del Duomo or the Archivio di Stato in Siena that mention the 1362 altarpiece or refer to the collaboration of Luca di Tommè and Niccolò di Ser Sozzo.

All of the components of the altarpiece, except the pinnacles, have survived and been identified, with Zeri making the initial reconstruction in 1958 (see Zeri, 1958, pp. 3–16).

A portion of this chapter dealing with the 1362 altarpiece has already appeared, in different form, in Fehm, 1973a, pp. 5–32.

2. The inscription was uncovered and published by Brandi, 1932, p. 230.

3. The approach to this kind of investigation has significant methodological implications. A literary and more expansive approach has developed in recent Italian criticism, while a more rational and analytical view has emerged in the United States. This dialogue, the essence of criticism, is healthy so long as it functions to develop further understanding of the artists and works involved. For an example of Italian criticism, see De Benedictis's study, which appeared in 1979 (especially pp. 38–40). For a different view see Meiss, 1963, pp. 47–48, or Fehm, 1973a, pp. 5–32.

4. There has not been a comprehensive study made of Niccolò di Ser Sozzo's life and work. The standard articles are those by Brandi, 1932, pp. 223–36; Zeri, 1958, pp. 3–16;

Meiss, 1963, pp. 47–48; and De Benedictis, 1974, pp. 51–61; 1976a, pp. 74–76; 1976b, pp. 103–120; 1976c, pp. 87–95; 1976d, pp. 67–78. To this list the following studies may be added, which, however, ought to be used with caution: Bucci, 1965, pp. 51–60; and Rotili, vol. II, 1968/69, pp. 15–18.

A large number of documents is presented in Brandi's study, with additional documentary material supplied by Moran and Fineschi, 1976, pp. 58–63. These last two pointed out the confusion of two separate personalities and suggested dropping the name "Tegliacci" from the painter Niccolò's name.

Niccolò's illumination is found on folio 8 recto of the *Caleffo dell'Assunta*, and is the only one in the manuscript. It is not dated, although an inscription on the verso of folio 8 states that the job of compilation and copying was finished in 1336. However, there is no specific reference to the miniature itself.

In a personal communication Professor Mirella Levi d'Ancona suggested to me that a cut illumination initialed "N.T." representing *Saint Paul* in the John Frederick Lewis Collection in the Free Library of Philadelphia (M:46.5) might be another signed work by Niccolò (if indeed the name "Tegliacci" can be appended to that of "Niccolò di Ser Sozzo"). The miniature may have been produced in Niccolò's shop, but the initials appear to have been tampered with, and may be a modern addition.

in this compilation appears on the verso of the illumination on folio 8.[5] That is, however, not the case. On the contrary, the script on folios 8 and 8 verso is entirely different from the rest of the manuscript. Moreover, nothing within the manuscript itself supports the date of 1336 for the miniature.

Millard Meiss has convincingly demonstrated that the return to a more geometric mode of composition, as seen in Niccolò's illumination, was a prime characteristic of Tuscan painting in the third quarter of the fourteenth century. The selection of one of the more miraculous episodes of the Maryological cycle—her corporeal levitation—is another representation characteristic of the period after 1350. Thus, both the theme and the format suggest that the *Assumption* dates much closer to 1350 than to 1330.

In this illumination the seated Virgin is positioned frontally and vertically within a mandorla and is borne aloft by a crowded flanking band of angels. These are arranged in sloping, symmetrical ranks of little depth. Characteristic of all the figures, but particularly of the Virgin, are the very closely set eyes whose lids are formed by absolutely straight lines. Tightly drawn, looping curls frame the rounded faces with their expressionless mouths. The flesh of the angular, squat bodies lacks definition, and the awkwardness of the figures and the artist's difficulty in making them fit easily into their surrounding space suggest the work of a painter not yet sure of his forms. The overall feeling created by this image is one of a rigidly controlled, two-dimensional geometric pattern, more reminiscent of late thirteenth and early fourteenth century compositions.

Niccolò demonstrated similar compositional and figural techniques in his Monteoliveto altarpiece now located in the Museo Civico in San Gimignano (Fig. 11).[6] The *Assumption of the Virgin* is presented in the central panel, flanked by *Saints Thomas, Benedict, Catherine of Alexandria, and Bartholomew*. As in the *Caleffo dell'Assunta*, the seated Virgin is represented frontally, with the attendant angels arranged in sloping ranks while bearing the mandorla upward. Here again are the same oval faces with closely set eyes and tightly looping curls. The Virgin and the surrounding figures, however, appear less cramped than in the manuscript version of the scene as a result of the elimination of the outermost band of angels. The composition is less forced, and there is also an obvious advance toward realism in figure style. Saint Catherine, who flanks the Virgin, is especially representative of Niccolò's treatment of the human figure. Although her limbs appear too short and her torso is not clearly defined, the handling of the face, eyes, and hair, and the quality of the brush strokes themselves all give a feeling of controlled intensity. The cloak is awkward, but technical clumsiness is not present to the same degree as in some of the figures in the *Caleffo*. Here Niccolò seems surer of himself, with a better understanding not only of the human figure, but also of the use of space.

Niccolò's continuing artistic development can be seen in another panel, at one time in a private collection in Milan, of the *Madonna and Child* (Fig. 12).[7] The Madonna is seated against a cloth of honor and a gold ground, in a slightly less than frontal pose, so that her left arm clearly reaches behind the Child sitting on her left knee. Her head inclines very slightly toward Him, and their hands touch as she holds a pomegranate and cherries for Him while He gazes up at her. The gentle meandering line of the hem of her cloak is balanced by the taut and controlled folds of the Child's mantle. Anatomical features are carefully articulated and modeled, and the elimination of an elaborately articulated throne and

5. Brandi, 1932, p. 223, originally proposed this date, which was generally accepted in the subsequent literature. Only Meiss suggested the more accurate date of close to 1350. (See Meiss, 1951, p. 169, and 1963, p. 47 n. 5. Also see Fehm, 1973a, p. 28 n. 13.)

6. This altarpiece has recently been cleaned and restored, and is included in the catalogue for the *Mostra di opere d'arte restaurate nelle province di Siena e Grosseto* (Genoa, 1979). The exhibition was held in the Pinacoteca Nazionale in Siena. In her catalogue entry regarding this painting De Benedictis (pp. 74–75) suggests that this altarpiece was originally commissioned by the Benedictine monks at Santa Maria di Monteoliveto in Barbiano, near San Gimignano. On the basis of evidence that came to light during the cleaning, she offered

a hypothetical reconstruction of the original form of the work. While I agree with her reconstruction of the missing pinnacles, I cannot accept her placement of Saint Benedict at the extreme left of the main tier of figures. Perhaps she has compelling evidence for this proposal, but for a variety of compositional and iconographic reasons I would be inclined to place Benedict to the immediate left of the Virgin. Also in De Benedictis' entry are a bibliography and technical data regarding the cleaning of the work.

7. This previously unknown panel was first published in Fehm, 1973a, pp. 12, 13, and 29, fig. 11. I would like to acknowledge once again Dr. Carlo Volpe's generosity in bringing the painting to my attention.

angels has made the composition less cramped and thus more monumental.

Throughout the 1350s Niccolò became more successful at simplifying his compositions and at rendering his figures more plastically. His Virgins, with one exception, remained frontal, but they were related to the Child more effectively.[8] He eliminated secondary figures, thereby avoiding spatial crowding. The resultant compositions displayed the Virgin and Child against sumptuous or, conversely, stark backgrounds.

The earlier paintings of Simone Martini were Niccolò's major artistic source, and he borrowed rather freely from them, while rarely going beyond a rather static and overly formal translation of his sources. Niccolò's sense of space was also reminiscent of his predecessor's work, although this element may just as well have had its origins in the work of Ambrogio Lorenzetti. Certainly, the latter's more imaginative depictions of the Christ Child must have appealed to Niccolò at times. Ultimately, Niccolò emerged from all this as an intensely prolific but basically conservative artist, and a man of sufficient talent and mastery to be considered, along with Luca di Tommè, for the responsibility of painting the 1362 Saint Thomas altarpiece.

The *Madonna and Child Enthroned with Saints John the Baptist, Thomas, Benedict, and Stephen* (Cat. 13, Pls. 11-1, 13-1, 13-6) had been attributed to various artists until 1932, when Cesare Brandi published an inscription found on the decorative framing beneath the Virgin and Child, proving beyond any doubt that the altarpiece was the joint work of Niccolò di Ser Sozzo and Luca di Tommè.[9] The original location and history of the work before its arrival in the Siena Pinacoteca Nazionale are unknown, although Gordon Moran has recently proposed that it may have come from the important and now destroyed church of the Umiliati in Siena.[10]

The polyptych was disassembled during the nineteenth century, but in 1958 Federico Zeri identified four panels representing scenes from the life of Saint Thomas in a private collection (Cat. 11, Pls. 11-2, 11-3, 11-4, and 11-5) and a *Crucifixion* in the Vatican (Cat. 12, Pl. 12-1) as constituting the original predella.[11] The current order of panels in the main tier was thought to be the original one, and subsequent scholarship has generally accepted this arrangement.[12] The figures to the left of the Virgin and Child are united by a common horizon. John the Baptist, who looks at the viewer while pointing toward the center of the composition with his right hand, occupies the end panel. Less active in stance, Thomas provides a transition from the animation of the Baptist to the stasis of the central group. Also, Thomas's important role in the predella would naturally require his being placed immediately to the left of the chief protagonists. The order of the main tier of figures to the right of the central group may not be correct, as a strong argument can be made for exchanging Saints Stephen and Benedict.[13] Stephen, like Thomas, looks out at the viewer while leaning very slightly in the direction of the Virgin and Child. Both saints were martyrs who died far from their homes, and both are shown holding a

8. The exception is a *Madonna and Child* in the Kress Collection at the University of Arizona, Tucson. For a discussion see Shapley, 1966, pp. 58–59, fig. 150; Meiss, 1951, p. 169; and Fehm, 1973a, pp. 29–30, n. 22.

9. Brandi, 1932, p. 230.

10. The first record of the polyptych is in the museum's 1842 catalogue. (See Pini, 1842, p. 6.) Moran's proposal was made orally to De Benedictis (1979, p. 67, n. 85). She offers no evidence either of Moran's or of her own for substantiating this suggestion.

11. Zeri, 1958, pp. 3–9.

12. A few examples follow: Meiss, 1963, pp. 47–48; Fehm, 1969, p. 574; Fehm, 1973a, pp. 7–8; Torriti, 1977, p. 150; and De Benedictis, 1979, pp. 52–54. Van Os, 1969a, no. 22, and 1969b, pp. 60–61, rejects Zeri's reconstruction. He contends that the predella series formed the base of a polyptych by Luca in Cascina, near Pisa (see Chapter IV), which he would date between 1362 and 1366. However, the predella panels are stylistically incompatible with the Cascina altarpiece, which can be dated some fifteen years later. Finally, the width of five predella panels precludes any connection, as the later work is considerably narrower.

These five predella panels would undoubtedly have been somewhat wider than they appear in their present state. Furthermore, the pattern of the framing that separates the panels in the upper zone would have been continued below. For these reasons I have chosen to leave a series of blanks separating each of the predella panels in the reconstruction drawing (Pl. 11–1).

The altarpiece would have been crowned by pinnacles, and although no trace remains of the latter, their probable configuration has been indicated by a series of broken lines. For their dimensions I have followed the proportions of Luca's nearly intact altarpiece of 1367, which is discussed in detail in Chapter III.

13. I am indebted to Judith Carmel, currently a graduate student in the History of Art at the University of Michigan, who very kindly shared her observations on these figures with me.

palm, an allusion to their violent end and subsequent salvation. Stylistically, Stephen is more akin to the figures in the central panel and to Thomas than he is to John the Baptist or Benedict. These last two would become terminal figures in this new arrangement. Both men were hermits and preachers who attracted a following, and each is depicted with his best-known text in hand. By means of their gaze, stance, and gesture the two saints direct the viewer back past the martyrs to the blessing Child at the center, and in this way help to close the composition. Thus, Stephen's placement to the immediate right of the Virgin and Child complements and strengthens the overall compositional and iconographic interrelationship of the main figures.

The predella consists of four scenes from the life of Saint Thomas (Pls. 11-2, 11-3, 11-4, and 11-5), originally placed below each of the four lateral saints, and the *Crucifixion* (Pl. 12-1), below the *Virgin and Child*. The scenes from Thomas's early career occur to the left of the *Crucifixion* and follow in sequence from left to right. The saint's upward glance in the second panel from the left draws the viewer's attention to his image in the panel above. The importance of Thomas is further, if indirectly, reinforced by the silhouetted hand of the centurion in the central predella panel. This gesture forms a diagonal by which the viewer is directed to Christ Crucified, then upward to the figure of Saint Thomas. Later scenes from the saint's life, including his martyrdom, occupy the two panels to the right of the *Crucifixion*. This arrangement (as reconstructed by Zeri) conforms to the iconographic emphasis of the polyptych, and provides a compositionally sound sequence of panels.

The respective roles played by Niccolò di Ser Sozzo and Luca di Tommè in the realization of the altarpiece have been the subject of controversy ever since Brandi's publication of the inscription. Stressing Niccolò's contribution, Brandi argued that Luca's share was limited to some of the detail work, the grinding and working up of pigments, and possibly the execution of the Baptist panel.[14] Later critics have accepted Luca's authorship of the Baptist, while differing in their assessments of his further contribution. For Zeri, who adopted Brandi's position without modification, the style of the predella posed a difficult problem. To avoid detracting from Niccolò's dominant role in the conception of the altarpiece, Zeri maintained that Luca had executed

14. Brandi, 1932, pp. 234–35.

the predella scenes after Niccolò's designs, and cited a mediocre *Annunciation* (Pls. 26-1 and 26-2), then in a private collection in Paris, as an index of Luca's ability.[15] Meiss, on the other hand, has convincingly characterized the same *Annunciation* as an inferior product of Luca's later workshop and has pointed instead to the 1366 *Crucifixion* (Pls. 19-1–19-3) or the Rieti polyptych (Pl. 27) as a true register of Luca's artistic merit. He concluded from these paintings that "Luca's share in the predella of the altarpiece of 1362 and in the panels related to it was larger than Zeri contended."[16]

Various factors have been overlooked that might explain the partnership. First of all, Niccolò was not a member of the Sienese painters' guild in 1362, the year of the completion of the altarpiece. His name was not among those enrolled in 1356; nor does it appear among those subsequently appended to the 1356 list. He was listed as a master in the guild only in 1363, just a few weeks before his death. (Luca had been a guild member since 1356.) Although the Sienese guild statutes are quite clear in prohibiting non-members and foreigners from maintaining workshops in the city,[17] there is no reason why Niccolò could not have been admitted into the guild, unless the bulk of his artistic activity, at least in the late 1350s, took place outside the city.[18] Perhaps he joined Luca simply to establish a shop acceptable to the local guild.

It is possible that Niccolò was incapacitated for a lengthy period, with the work on the altarpiece already at an advanced stage, and that Luca was called

15. Zeri, 1958, pp. 5–8.
16. Meiss, 1963, p. 48.
17. Milanesi, 1854, vol. I, pp. 4 and 22. See especially statutes X, XI, and LII–LIV. (See also Fehm, 1972, pp. 198–200.)
18. Niccolò must have spent a considerable amount of time in the area of San Gimignano during the 1350s. In addition to the Monteoliveto altarpiece discussed above (Fig. 11) a number of other panels and miniatures document his activity in that vicinity. A *Madonna and Child* now in the Uffizi was formerly located in the Augustinian Convent of Sant' Antonio in Bosco near Poggibonsi. (For a discussion and illustration, see Marcucci, 1965, pp. 168–69, fig. 114, and also Fehm, 1973a, p. 12, fig. 10.) A dismembered polyptych, of which only three side panels are known to us, can also be placed in this decade and area. (For the partial reconstruction see Fehm, 1973a, p. 29 n. 15, figs. 47–49.) Finally, the three large choir books originally in the Collegiata, and now in the Museo d'Arte Sacra, provide further confirmation of Niccolò's work in that city. (See the four De Benedictis articles from 1976 for a discussion and illustration of these last works.)

upon to finish the project.[19] But this is difficult to reconcile with the evidence of the polyptych itself. The work on all the panels would have proceeded more or less at the same pace: Niccolò would not have finished four of the five main panels, only to leave *Saint John the Baptist* and the predella series until last.

Undoubtedly the altarpiece would have taken a single master a fair amount of time to complete. Duccio, for example, required three years to finish his *Maestà*.[20] Perhaps the altarpiece was wanted quickly for the purpose of commemorating an important patron saint or an event within the community. It could have been connected with the plague, which had struck the city twice in less than fifteen years. The inclusion of Saint Thomas as an encouragement and example to the stricken populace might suggest such a connection.

The discovery of new documentation might tell us why the work was commissioned and by whom, and how much was paid, as well as indicate the nature of the collaboration. In the absence of such evidence, however, one must rely upon the physical proof of the altarpiece itself, a close scrutiny of which will show that, despite Luca's being the much younger man, and despite the fact that Niccolò's name appears first in the inscription, Luca's role in both the execution and design of the work was considerable.

Despite the stylistic homogeneity of the four saints in the altarpiece, only three of the four seem to be the work of Niccolò di Ser Sozzo. The figures of Thomas, Benedict, and Stephen exhibit the same method of handling as that used in the two lateral figures of his San Gimignano polyptych (cf. Pls. 13-3–13-5 with Fig. 11). Saint Catherine presents perhaps the best analogy, as she is such a fine example of Niccolò's art. The bulky, rather static figures are essentially frontal in pose, although Stephen and Benedict are depicted almost at three-quarters, as is the San Gimignano Benedict. In fact, the latter is virtually a mirror image of his later Siena counterpart. The heads are oval, the eyes have the straight lower lids, and the mouths are tight, narrow, and

pursed. The inclination of Stephen's head echoes that of Catherine's.

The clear, light, almost pastel colors employed by Niccolò in both the miniatures and the San Gimignano polyptych appear also in these three lateral figures, as well as in the *Madonna and Child*. The colors of the Baptist, on the other hand, are deeper, more intense, almost muddy (see Pl. 13-2). His flesh is dark and somewhat obscure, his hair tousled and askew, and his face more deeply lined than the faces of the other figures. Both the carefully articulated musculature of his arm and his large, awkward feet, with their curiously high instep, display a concern for anatomy that is foreign to Niccolò's work. Indeed, the artist avoids depicting feet at all, preferring instead to show the base of a figure enveloped in folds of drapery.

This exceptional figure is reminiscent of the Baptist in Luca's Polesden Lacey panel (Pl. 9). Their proportions and gestures are quite similar. Though on a smaller scale, the same curious feet are seen in the earlier panel, as well as the way in which the cloak is drawn up and gathered over the left arm, with the left hand holding a banderol.

One wonders whether Luca had a hand in the design of Saint Thomas as well (Pl. 13-3). The voluminous, heavy drapery is atypical of Niccolò's work and has a greater affinity with Luca's treatment of *Saint Louis of Toulouse* in the Los Angeles panel (Pl. 1) and *Saint Peter* in the Rieti polyptych of eight years later (Pl. 27). Other details in the Thomas panel also have more in common with Luca's general handling of figures in space. The horizon is especially noticeable in the two left-hand panels depicting Saints John and Thomas, where more of it appears than in the right-hand pair. Furthermore, unlike the feet of both Benedict and Stephen, those of Thomas are not only partially shown, but also, like John's, the toes of his right foot overlap the painted frame, heightening its illusionistic quality. This play upon the picture plane and space is a common feature in Luca's art. Piero Torriti has recognized Luca's hand in some parts of Saint Benedict, too, although he does not specify. If our new arrangement of panels is correct, then Luca would have been responsible for painting all of the Baptist and much of Thomas, on the left, while taking part in work on Benedict, now on the far right.[21]

The central image poses similar problems. While

19. Berenson, 1936, p. 269, suggests this.

20. For an up-to-date discussion of Duccio's *Maestà* and the assistance he may have had in its execution, see Stubblebine, 1973b, pp. 185–204.

21. Torriti, 1977, p. 150.

there is little doubt that Niccolò di Ser Sozzo painted the picture, the question of its design remains open. Most of Niccolò's images of the Madonna have her posed frontally, gazing out at the viewer. Only in his Siena *Assumption* (Fig. 10) is there a gesture which approaches that of the Virgin's right shoulder, arm, and hand in the 1362 altarpiece. All of his Madonnas are set in a cramped space of little depth, with the composition usually parallel to the picture plane. Also, as noted above, Niccolò gradually abandoned the use of auxiliary figures flanking the Madonna and Child.

The spatial qualities of the central panel have no parallels in Niccolò's previous compositions. Conversely, the type of recession that appears is typical of Luca's early experiments with space. The throne is mounted on a base, whose steps drop back in one-point perspective. The elaborate throne arms and molding recede into the background. The attendant angels are neither cramped nor restrained by the arms, but stand gracefully around and behind the throne. They are not only as a group smaller in scale than the two principal figures, but also the pair in back are somewhat smaller than those in the foreground, thus complying with the requirements of a perspectival arrangement. The result is an effective space that drops back unobtrusively around and behind the central group, thereby complementing and accentuating it. The central figures are parallel to the picture plane, but the throne and angels move back into space on an inclined oval form that suggests a half mandorla.

The attitude and gesture of the Madonna provide an additional clue to the authorship of the design. She is seated with the Child standing in her lap—a motif clearly based on Simone Martini's *Maestà* of 1315 (cf. Pl. 13-1 with Figs. 1-1 and 1-2).[22] He looks out at the viewer with His right hand raised in blessing and a banderol in His left. His left foot is forward and gives the impression of His being on the verge of taking a step if He were not restrained by His mother. While deeply inclining her head toward her Child, the Madonna at the same time appears to lean back and away from Him. The line of her mantle and cloak is carried by her right forearm and hand as she reaches for His feet. The coming together of the drapery at this point continues the line around behind the Child and up her left shoulder. Although both figures are silhouetted against the elegant cloth

of honor, this circular line helps dramatically to emphasize the Child's independence.

Such compositional skill is foreign to Niccolò di Ser Sozzo. His only attempt at the articulation of figures in a credible space of some depth is in his relatively unsuccessful miniature in the *Caleffo dell'Assunta*. His mature works, when they contain attendant figures at all, present them in overcrowded layers parallel to the plane of the picture. Luca's Polesden Lacey and Los Angeles panels, on the other hand, incorporate all the spatial variables of the 1362 altarpiece, save the receding throne arms. Furthermore, this manner of depicting the Virgin, with her head inclined, had appeared before in Luca's work and, indeed, is a hallmark of all his subsequent paintings of the Madonna.[23] More important, however, is the smooth, flowing gesture of the Virgin's shoulders, arms, and hands, particularly as she reaches for the Child with her right palm upturned, or, as in other examples, actually holds His foot in her hand. In an earlier work from his shop—the *Madonna and Child with Saints Peter and Paul*—Luca had utilized an almost identical gesture (Pl. 51). One should also note the strikingly similar incline of the Virgin's head in the two compositions.

The controlled animation that results from a combination of all these qualities is generally typical of the work of Luca di Tommè, and from this evidence it seems possible that he designed the central panel. In earlier works he had dealt successfully with problems of placement and the rational interrelationship of figures in space. None of Niccolò's earlier works suggests that he had these abilities, or that he could have created a composition such as the central panel of the 1362 altarpiece without help. Thus, although the figures display the older artist's color and modeling, we can only conclude that he followed Luca's design for the spatial arrangement and central group of this panel.

Bernard Berenson's initial attribution of the predella panels to Luca has been generally accepted, although there have been some reservations concerning the Vatican *Crucifixion*.[24] The validity of this

22. See Shorr, 1954, pp. 26–29, for a discussion of this type and for further examples.

23. See, for example, Pls. 14, 32–1, 33, 36, and 37.

24. Berenson, 1936, p. 269. Francia, 1960, pl. 92, follows the traditional attribution of the Vatican authorities and gives the *Crucifixion* to Lorenzo Monaco. Rotili, 1968/69, vol. II, p. 16, attributes the panel to Niccolò, and dates it at the same time as the *Caleffo dell'Assunta* illumination, i.e., the year 1336.

attribution is confirmed by the dark complexions and deep, vibrant colors of the participants. These are deeply emotive, active figures, playing their roles in an imaginative and dynamic, though sometimes awkward way, all of which is more characteristic of Luca di Tommè's work than of Niccolò's.

As mentioned above, Zeri demonstrated that the Thomas scenes would have flanked the *Crucifixion* and developed from left to right in the following way (details of the story not represented by the artist are parenthetically inserted). 1) *Christ orders Thomas to go and convert India and presents him to an envoy of Gundoferus, the King of India* (Pl. 11-2). (This envoy has been sent to Cesarea to find an architect for the building of a palace.) 2) *On his way to India, Thomas comes to a city where a king is celebrating his daughter's wedding. Seeing that the saint would not touch any food* (He sat looking up to Heaven in prayer.), *the butler strikes him on the cheek; soon after, as the butler goes to fetch water at the well, a lion comes and mauls him, and dogs tear his flesh, and one of them brings his hand into the hall* (Pl. 11-3). (Thomas arrives in India, meets King Gundoferus, who gives him a purse in order to construct a palace. The King departs and Thomas distributes the money to the poor.) 3) *The King's brother Gad dies, his body is brought to the apostle in prison, and he is raised by Thomas from the dead.* (Gad tells his brother of the palace he has seen in Heaven, which, in Saint Thomas's words, can be bought by the price of faith and by the alms of the rich.) *Seeing this miracle, the King had Thomas released.* (The saint had been interned for giving away in alms the treasure that was to be used for the building of the King's palace.) *The King is baptized* (Pl. 11-4). (Thomas performs several miracles and preaches to the natives, instructing them in Christian virtues. He is imprisoned by Carisius, who has the saint's feet burned with hot irons.) 4) *Idols fall at the saint's bidding and a pagan priest stabs him with a dagger* (Pl. 11-5).[25]

In addition to the style of painting, the design of the predella series helps to confirm Luca's exclusive authorship of the panels. The curved molding of the five quatrefoils containing the scenes complements the curved, arched frame of the saints and Virgin above. In contrast to those of Niccolò's paintings, the frame here does not constrict the figures, but acts as a vital part of the composition. The tri-lobed molding serves as a window, drawing the viewer into the scene, which apparently opens out behind it. Figures and architecture slip easily back into space beyond the lobes and angels. Luca had previously used this device in his Amsterdam *Flagellation*, as well as in one of his very earliest works, the *Crucifixion* in Altenburg (Pls. 5 and 2). As in these earlier panels, the horizon line is kept high in order to focus the viewer's attention at or above the middle of the picture. The principal figures in the series appear silhouetted against dark backgrounds, achieving two important results. Not only are the full-length figures made more monumental despite the limited or shallow space, but also the whole scene is brought forward to the viewer, because the dark ground reinforces the limited space. The panel depicting the servant slapping Saint Thomas at the King's banquet is a good example and is comparable to the earlier *Flagellation* (cf. Pls. 11-3 and 5). Both incidents take place in shallow, rectangular halls whose curtained backdrops set off the figures. The horizon lines are well above the center median, and in both paintings the looping movement of the gold border of the backdrop helps draw together and unify the lateral spread of the figures. In each case the principal figure, about to be struck from the right, is set just off-center and to the right. A balance is achieved by the intermediate figures who peer back from the central character to the closing one at the left. They are in turn balanced by a tightly knit group in the right rear.

Ordinarily Luca tends to make three closed groupings in scenes containing many figures. In the *Crucifixion* in San Francisco (Pl. 7) or the *Flagellation* in Amsterdam, for example, the artist had already employed these elements. The figures glance at and

25. Kaftal, 1952, pp. 969–70, presents the legend and its hagiographic sources. The saint is frequently depicted in fourteenth-century Tuscan painting as the "doubting Thomas." Thus he is often shown touching the wound in Christ's side or catching the Virgin's girdle in scenes of her Assumption. However, representations of him alone as a martyr in a panel or polyptych, or during his mission to India, are rare. The few known to us are all Sienese and can be dated around the third quarter of the fourteenth century. They are: Niccolò's San Gimignano polyptych (Fig. 11 herein); Luca and Niccolò's 1362 altarpiece in the Pinacoteca Nazionale, Siena (Cat. 11–13, Pls. 11-1-13-6 herein; and

Luca's Cascina polyptych (Cat. 47, Pls. 47-1-47-7 herein).

Thomas's sudden popularity in Siena as a martyr figure may be linked to the Franciscans. First, their ill-fated mission to Morocco, which ended in the death of seven brothers, had already been commemorated in Ambrogio Lorenzetti's fresco in the church of San Francesco, in Siena. Furthermore, a Sienese Franciscan had, in 1322, suffered a fate similar to Thomas's in India. (See van Os, 1969b, p. 63 n. 84, and Borsook, 1966, pp. 27–28.)

frequently turn toward each other. Usually they are interrelated by a dramatic gesture such as the king's pointing, the soldier's whipping of Christ, the servant's striking Saint Thomas, or the pagan priest's arguing with the king. The groups are further brought together and united by a single color, which appears in the garments of the figures within two, or sometimes all three groups.

A comparison of the Vatican *Crucifixion* (Pl. 12-1) with its counterpart in Altenburg (Pl. 2) shows yet another similarity between the works in the predella series of 1362 and an early Luca di Tommè. The attitude and position of the Virgin and Saint John the Evangelist in the earlier painting are repeated virtually without any change. The two figures sit at the base of the Crucifix against the same U-shaped background of hills. The Virgin draws up her left leg and rests her left elbow on it as she presses her cheek into her left hand. Her right hand is draped loosely over her right leg. John looks up in profile. He grasps his right leg with both hands knitted together, and his outstretched left leg parallels the frame in both paintings. The crosses are similar even in the detail of the footrest, although the Christ figures themselves show some differences. In the Altenburg panel Christ is shown more contorted in death, and his flesh tones have stronger shadow and contrast.

As noted earlier, Luca, unlike Niccolò, frequently used painted architecture in order to create unity within a composition. The Amsterdam *Flagellation*, the *Slapping of Saint Thomas*, and, more clearly, the *Stabbing of Saint Thomas* are cases in point (cf. Pls. 5, 11-3, and 11-5). He adopted the use of architecture in this way from the later works of Pietro and Ambrogio Lorenzetti—a further example of how much Luca was indebted to these two artists not only for the style and posture of his figures, but also for the way in which he tied his compositions together.[26]

Whether or not Luca actually played a greater part in the planning of the altarpiece, it is simply incorrect to suggest that his role was minimal or that he was no more than Niccolò's shop assistant. The fact that Niccolò's name does appear first in the inscription may signify nothing more than his being accorded the deference due the senior master. In any case, Luca's own work in the altarpiece is hardly inferior to that of his partner, as contended by

Brandi and Zeri. Nor, as suggested by Berenson, could Luca have been summoned to complete the work when it was already well under way. Although the two artists must have striven to make their work compatible, the homogeneity of style is not as great as some critics have claimed.

Whatever the initial reasons may have been for the collaboration of the two masters, their partnership was short-lived, as Niccolò died the following year. Nor do any works survive in which the hands of both painters are discernible with any degree of certainty, although there have been a few false attributions, and perhaps one curious exception discussed below.[27] However, a few of Luca's works do bear witness to this collaboration, and it was not until 1366 that he completely freed himself from Niccolò's influence.

A final scrutiny of the pre-collaboration efforts of both painters may answer the perplexing question that must enter the mind of anyone familiar with the scholarship concerning the two men: are their styles so similar that they must almost always be confused? The answer, of course, is that their styles are *not* that close, and that it is possible to define, with reasonable accuracy, the oeuvre of each artist. One key to distinguishing the work of Niccolò from that of Luca, and vice versa, is in the latter's continuation of the Lorenzettian tradition of spatial innovation, as opposed to Niccolò's reliance on the compositional methods of Simone Martini, where space is a secondary factor. Furthermore, a significant distinction prevails in the methods with which each painter articulates a narrative. Niccolò insists on static qualities, while Luca gives animation to his

26. See, for example, Ambrogio's *Presentation in the Temple*, Florence, Uffizi; or Pietro's *Birth of the Virgin*, Siena, Museo dell'Opera del Duomo (Berenson, 1968, vol. II, pls. 96 and 89).

27. Paintings by Luca di Tommè that have been wrongly attributed to Niccolò at one time or another are as follows: *Assumption of the Virgin*, New Haven, Yale University Art Gallery, no. 1871.12 (Cat. 15 herein); *Madonna and Child*, New York, Metropolitan Museum of Art, no. 41.100.34 (Cat. 14); and *Crucifixion*, Rome, Pinacoteca Vaticana, no. 195 (Cat. 12).

Niccolò's panels mistakenly attributed to Luca on occasion include: *Assumption of the Virgin*, Boston, Museum of Fine Arts, no. 83.174; *Madonna and Child*, Florence, Uffizi, no. 8439; *Madonna and Child*, Malibu, California, J. Paul Getty Museum; *Assumption of the Virgin with Saints Thomas, Benedict, Catherine of Alexandria, and Bartholomew*, San Gimignano, Pinacoteca Civica; *Madonna and Child*, Siena, Museo della Società Esecutori di Pie Disposizioni; and *Madonna and Child with Angels*, Tucson, Arizona, University of Arizona, no. 61.149.

figures whenever possible. Perhaps the greatest divergence of all is in the use of color. Intense, rich, and occasionally muddy hues appear in all of Luca's early works. Niccolò's use of clear, pastel shades is equally consistent.

A major difficulty, of course, has been the lack of a chronology for each artist. The respective works of both painters have never been thoroughly studied in sequence, and consequently critics have had to make stylistic interpolations by comparing works often separated by fifteen years or more in execution. Frequently, too, only the large-scale altarpieces have figured in their analyses. Meiss alone has given equal consideration to both small panels and larger polyptychs.

One problematic aspect of attempting to establish a chronology lies in the relative homogeneity of subjects depicted. The Virgin and Child, for example, is one of the most common themes in the Sienese tradition, to which both Niccolò di Ser Sozzo and Luca di Tommè contributed their interpretations. By the middle of the fourteenth century there was little room for innovation in such images, whose details had been thoroughly worked out over the five preceding generations of painters, among them artists of greater ability than either Niccolò or Luca. To define the elements of the two styles one must look beyond, and almost away from, the broad outlines of the major compositions to lesser panels, to tone and application of color, and to subsidiary details of drawing. In these secondary qualities of personal signature Niccolò and Luca are explicitly themselves.'

It is obvious in a number of the paintings he did in the next few years that Luca felt the influence of Niccolò's art for a good while after their collaboration on the 1362 Saint Thomas altarpiece. As to evaluating the extent of the elder master's influence, perhaps the best avenue of approach is through examination of a panel by Luca of the *Madonna and Child Enthroned* in the Metropolitan Museum of Art in New York (Cat. 14, Pl. 14). Its format is very similar to the central panel of the 1362 work (cf. Pls. 13-6 and 14). The cusped molding and punchwork, the posture and gesture of the Virgin, and even the folds of her drapery recall the earlier altarpiece. Even the intricate pattern in the cloth of honor and the garments, although of a somewhat different config-

uration, appears again here. But the artist has eliminated the admiring angels and the elaborate arms and base of the throne. The Child sits on His mother's arm instead of standing in her lap, as He grasps a banderol in His left hand and raises His right in blessing.

The panel, originally the central image of a polyptych,[28] was painted by Luca after the completion of his work with Niccolò. This dating is indicated by the fact that several details have been discarded and that the attitudes of the figures have been altered. The fluidity and grace of the figures, the subtle placement and modeling of their features, the palette, and the extensive use of shadow have much in common both with the central panel of the Saint Thomas altarpiece and with some of Niccolò's earlier works. The latter's faces, however, tend to have a hard, almost wooden quality, with the skin drawn tightly over the underlying structure, as, for example, in his *Madonna and Child* (Fig. 12). Although the New York panel has been touched up somewhat, the sense of the fleshiness in the features is still apparent. Nor is the imprint of Niccolò visible elsewhere in the work.

There is nothing among Luca's early efforts before 1362 that is comparable in size or format to this panel. Furthermore, the altarpiece in its original state, with flanking saints in lateral compartments, would have been similar in size to some of Luca's later commissions. It is possible that this panel represents all that remains of his first independent undertaking on such a scale following the collaborative work. Further, it is an indication both of his growing ability to handle such projects and of the increased desire and need for these works on the part of commissioning groups and individuals.

An exquisite panel from Seggiano depicting the *Madonna and Child* (Cat. 10, Pl. 10) has only recently come to light, and because of its close affinity to the *Madonna and Child* in New York, it ought to be placed in this same phase of Luca's activity.[29] Common to both are the facial expression and tilt of the Madonna's head, the gold tooling of the hem of her mantle and the top of her bodice, and the detailed punchwork in the halos of both pairs of figures.

28. Dowel holes at the sides and batten marks across the back of the panel suggest that the picture originally had flanking panels. Regarding the importance and use of this kind of technical evidence in the reconstruction of fourteenth-century altarpieces, see Fehm, 1967, pp. 16–29.

29. It is listed by De Benedictis, 1979, p. 88.

Luca had already employed the gesture of the Madonna's right hand in his earlier panel in Los Angeles (Pl. 1), and would again later, as in his Rieti polyptych (Pl. 27). Although the finch does not appear in the New York painting, Luca later increasingly favored the use of this motif, as in his Granaiola and Bruco panels (Pls. 28 and 36, respectively). Furthermore, the line of the silhouette formed by the Virgin's head, shoulder, and arm virtually duplicates its equivalent in New York, although here she is set against burnished gold instead of a cloth of honor.

Related to this group of paintings is one, known to us only in a photograph, in which several years ago we detected Niccolò's stylistic influence on Luca. De Benedictis has since published an overall photograph of the panel together with two companions and attributed the trio to Niccolò di Ser Sozzo.[30] Represented are the *Madonna and Child with Saints Francis and Catherine* (Cat. 67, Pls. 67-1 and 67-2). While it is not at all certain on the basis of the photographs that these three were intended to go together, it seems clear that the author of the two flanking panels must have been a prominent member of Niccolò's shop.[31] His hand is easily recognized and often appears prominently, as, for example, in Niccolò's Monteoliveto altarpiece (Fig. 11), now in San Gimignano. (See especially the figures of Saints Thomas and Bartholomew.) Perhaps the best analogy is provided by a comparison of the Saint Catherine here with another version done by this artist in a now dispersed polyptych (cf. Pl. 67-1 and Fig. 13). Common to both are the long, flowing, wavy golden tresses, elaborately bejeweled crown, thin, attenuated nose, elongated neck, and finally—what is perhaps the most salient characteristic of this artist's physiognomies—the narrow jaw with the chin drawn out almost to a point.

As to the central panel itself, it is difficult to determine whether it is the work of Luca, because of its damaged state. However, the Madonna has a good deal in common with her counterparts both in New York and in the 1362 altarpiece in Siena. There are the same facial features and inclination of the head, as well as similar punchwork and elaborately patterned backdrop. Not only does the line of

the hem of the Virgin's mantle repeat that of the other two, but also the arrangement of its folds on the base of the throne is similar to the others. These devices are sufficient to sustain an attribution to Luca, despite the condition of the painting. What is reminiscent of Niccolò's style in this work is the approach to detailing and the handling of light and shadow in the fleshtones, as well as the rather brittle, porcelain-like quality of the latter (although this may be due to retouching).

A remarkable aspect of this *Madonna and Child* is the composition itself. It is not found anywhere else—either in Niccolò's or Luca's works—and is so antithetical to the spirit of the 1360s that it may reflect an earlier Sienese prototype—perhaps by Ambrogio Lorenzetti—that is now lost. The Christ Child is shown reaching with His left hand across and down the top of the Virgin's dress, while at the same time looking sharply down and back over His left shoulder. The Virgin's glance follows His off to the right as she supports Him with her left elbow and elevated forearm circled around and behind Him. Note, too, the broad arm of the Child and His unusually round face and eyes.

A panel done by the Sienese painter Pietro di Giovanni Ambrosi some seventy-five years later, now in the Acton Collection in Florence, virtually reproduces this unique figural arrangement (Fig. 14).[32] The Madonna's left arm, the strikingly human and dramatic gesture of the child, their glances, and the elaborate floral background of the cloth of honor are the same. The only variation is in the pose of the Christ Child, who stands rather than sits. The Acton panel would seem to be a copy of an earlier work. Although Ambrosi's does not exactly duplicate Luca's, it must be more than mere coincidence that these two are the only paintings known to us that depict the Child in such a way.

The existence of an earlier prototype lying behind both is suggested by a number of details in Luca's version. The rounded head, ovoid eyes, and high hair line of the Child, as well as His undergarment and upturned right foot, refer to earlier compositions by Ambrogio Lorenzetti, although no panel by him survives in which this specific mode appears. The Christ Child in his Massa Marittima altarpiece has the same high forehead, rounded eyes, and upturned right foot, but grasps the top of the Virgin's dress with His right hand, rather than with

30. De Benedictis, 1979, p. 96, pls. 31 and 33. She states that the three were in a private collection in Siena at one time.

31. I first described this artist in 1973 (Fehm, 1973a, p. 29 n. 29), where I also connected the three dispersed panels (Figs. 47–49). De Benedictis, 1979, pp. 95–96, seems to be unaware of this partial reconstruction.

32. The panel is attributed to Ambrosi by Berenson, 1968, vol. I, p. 4.

the left. The position of the Virgin's left hand and arm as she supports the Child appears with but slight change in both Luca's and Ambrosi's versions. Finally, in a panel in the Pinacoteca Nazionale in Siena, Ambrogio depicted the Madonna and Child glancing down sharply and to the right;[33] these features as well are found intact in the two later works.

If Ambrogio was indeed responsible for the supposed prototype of this composition and theme—of which Luca's and Ambrosi's works would be variants—he probably painted it in Siena in the 1330s or 1340s. It goes without saying that this image must have been highly regarded for it to have engendered at least two copies, the one some fifteen to thirty years later, and the other after more than a century had passed.

An altarpiece that would have rivaled the 1362 Saint Thomas polyptych in its importance to Luca's oeuvre as a whole has been only partially reconstructed by Federico Zeri. He joined three diverse polyptych compartments with a number of others.[34] The three components known to me are *Saint John the Baptist* with *Elias* and *David* in the spandrels (Cat. 52, Pl. 52), in the J. Paul Getty Museum in Malibu, California; *Two Apostles* with an *Angel* in the tondo (Cat. 53, Pl. 53), in the Roberto Longhi Foundation in Florence; and the pinnacle figure of *Christ Blessing* (Cat. 54, Pl. 54), in the North Carolina Museum of Art in Raleigh. While I have not seen Zeri's proposed reconstruction of all the components known to him, there is no reason not to accept the association of these three. In terms of measurements, proportions, style, punchwork, and framing elements, they are all compatible with each other and can be dated within this period of Luca's career. The *Christ Blessing* and the *Saint John* panels have a soft intensity, clarity, light tonality, and luminescent quality about them that recall the *Madonna* in Seggiano (Pl. 10). The period in which Luca employed this brighter palette was of relatively short

duration, and he was soon to return to the more familiar dusky figural style that became emblematic of his prolific major phase.

The sharp angularity and the brittle texture of the *Two Apostles* preclude their being placed among Luca's accepted works.[35] The two figures seem rather to be by his shop assistants. Their compelling similarity to a number of pinnacle figures in several of the major altarpieces discussed in Chapter III supports this view.

Luca's *Assumption of the Virgin* in the Yale University Art Gallery (Cat. 15, Pls. 15-1–15-5) is a stunningly beautiful and well-preserved work dating from the 1360s. No doubt Luca was familiar with a similar scene that had been created in Siena—most likely by Simone Martini—some forty years earlier. The existence of such a model was first suggested by Meiss, who based his hypothesis on the number and quality of probable copies.[36] From them we can deduce that in the original the Virgin must have been borne up by angels singing and playing various instruments. The angels were probably grouped around her in a complete oval or circle and would have been seen in perspective from above. Luca's composition contains all of the essentials of this prototype, such as the Virgin being borne aloft and the angels arrayed in a circular format, but with a fundamental difference. The most prominent feature of this change was the reduction and compression of

35. Fehm, 1978, p. 163.
36. The point was first made by Meiss, 1951, p. 21. Among the copies he mentions are those by a follower of Simone Martini in the Alte Pinakothek in Munich (Meiss, 1951, fig. 22); a panel by Bartolomeo Bulgarini, Siena, Pinacoteca Nazionale (DeWald, 1929, fig. 68); a fresco in Siena, Santa Maria del Carmine, by the master of the late fourteenth-century frescoes in the sacristy of the Cathedral (Berenson, 1930b, fig. on p. 334); a panel partly by Sassetta, formerly in the Kaiser-Friedrich Museum (Pope-Hennessy, 1939, pl. 24); a panel by Pietro di Giovanni Ambrosi in the archiepiscopal museum at Esztergom, Hungary; one by Giovanni di Paolo in the Collegiata in Asciano; and, finally, one by Vecchietta in the Duomo in Pienza. To these examples we can add the following: a leaf of a diptych by Francesco di Vannuccio, Cambridge, Girton College (Wildenstein's *The Painting in Florence and Siena from 1250 to 1500*, February 24–April 10, 1965, pl. 90); already alluded to by Meiss but not included in his list: the central panel of an altarpiece by Taddeo di Bartolo, Montepulciano, Duomo

33. For illustrations of these two works by Ambrogio Lorenzetti, see Borsook, 1966, pls. 24, 25, and 30. Ambrogio was an innovator who delighted in and exploited this kind of composition with its vivid emphasis on the human aspect of the relationship between the Madonna and Child.
34. Zeri's reconstruction is cited by De Benedictis, 1979, p. 67 n. 80.

space, in contrast to the prototype and its copies done prior to the 1340s.[37]

There are two general variants of this new approach, which depicts the angels in a plane rather than in a circle around the Virgin. The first is best exemplified by Niccolò's miniature of the *Assumption* in the *Caleffo dell'Assunta* in Siena (Fig. 10), or by the center panel of his San Gimignano polyptych (Fig. 11).[38] In them the Virgin is depicted frontally and symmetrically, flanked by numerous ranks of angels in sloping lateral rows arrayed, as she is, parallel to the picture plane. The second variant is represented by Luca's *Assumption* (Pl. 15-1), and by the central panel of a polyptych in the Museum of Fine Arts in Boston, which Meiss attributed to Niccolò.[39] In these two panels the Virgin is surrounded by fluttering angels who are crowded into a shallow space between her and the frame, rather than being arranged in a vertical plane. They recede back into space very little, and in neither painting do they form the deep, receding circular choirs that the popular prototype seems to have inspired earlier in the century.

In the paintings in both groups of variants and particularly in those of the former group, the artists have returned to a late dugento and early trecento Sienese compositional mode, which depicts the Virgin in a mandorla accompanied by six or eight flying angels in a single plane. The innovative form developed in the second quarter of the century, which had placed the angels in a circle around the Virgin, was abandoned. As to the dugento Sienese source for this flattened, planar representation of the Virgin, one can probably find it in the circle of Duccio, the best-known example being contained in the oculus of the Cathedral, which was designed under his influence (Fig. 15).[40] Curiously, this older design, employed by both Niccolò and Luca, was avoided by other painters during the third quarter of the century, but was reused shortly thereafter and given currency during the early part of the quattrocento.

The pre-dugento origins and development of the depiction of the Assumption are much more difficult to ascertain. The Bible contains no reference to Mary's corporeal Assumption. By the thirteenth century, however, this legend had become widespread in the West. The Church considered it heretical and purged all such references from the writings of its theologians.[41] The position of the Church was clear: at the time of Mary's death Christ appeared and carried only her soul to Heaven. Her mortal remains were buried against the time of the Second Coming. Surviving Eastern representations portrayed the scene in this way, and Duccio followed the accepted version in two separate episodes in his Siena *Maestà*, both in the series of predella scenes from the life of the Virgin Mary.

The earliest surviving work in which the Virgin's corporeal Assumption is even implied is a very damaged fresco dating from the middle of the ninth century in the lower church of San Clemente in Rome. Here the Virgin is shown standing on a mountain top before the Apostles in an *orans* attitude, while Christ floats in a mandorla overhead. The Apostles imitate the Virgin's gesture and glance up at Christ. A similar Byzantine example dating from the tenth century is preserved in the Biblioteca Comunale in Siena.

Despite official opposition, the theme of the Assumption gained popularity in the West. The notion of the elect nature of the Virgin is expressed in the *chimasa* of a few painted crosses from the thirteenth

(Symeonides, 1965, pl. 20); and a panel depicting the same subject by Andrea di Bartolo in Richmond, Virginia, at The Virginia Museum of Fine Arts (V. M. F. A. neg. no. 610).

37. For a cogent discussion of this phenomenon see Meiss, 1951, pp. 21–26.

38. There are numerous examples of this form from the fourteenth century in miniatures. For a discussion and examples see van Os, 1969b, pp. 157–76, pls. 115 and 118–26.

39. This painting in the Museum of Fine Arts in Boston was first attributed to Niccolò by Meiss, 1951, p. 22, fig. 25; at the same time he cited Offner's similar, independent conclusion. There are other compositions of Sienese origin that are similar in design. The first is a miniature from the end of the fourteenth century in the Biblioteca Comunale in Siena (van Os, 1969b, pl. 120); the second is by Bartolo di Fredi in the Siena Pinacoteca Nazionale (van Os, 1969b, pl. 127); and a panel from the beginning of the fifteenth century in Santa Maria Maggiore, Bettone, which may be by the little-known master Gregorio di Cecco da Lucca (van Os, 1969b, pl. 130). A panel in the Pinacoteca Nazionale in Siena, by Cristoforo di Bindoccio detto Malabarba, seems to be similar in design, and is modeled after Luca's composition (Frick Art Reference Library, neg. no. 22082).

40. Another example cited by Meiss (1951, p. 22 n. 32), is a Ducciesque panel (cut down) in San Lorenzo, Terenzano.

41. Van Os, 1969b, p. 150. For an analysis of the development of the Assumption, see Jugie, 1954. The literature dealing with the iconography of the Virgin is enormous. A short survey by Guldan, 1966, pp. 338–39, is acceptable. Also of interest are the studies by Hecht, 1951, and Staedel, 1935.

century. The "Christus Salvator et Maria Electa," for example, is seen in a cross from mid-century by Coppo di Marcovaldo, who depicts the Virgin among the Apostles on the ground, but flanked by two angels, as Christ blesses the group from on high. The "setting apart" of the Virgin is also evident in a lateral scene in a *paliotto* from the shop of Margarito d'Arezzo at Monte San Savino. In this panel, dating from the 1280s, Mary is in an *orans* position standing on the rim of a sarcophagus. The Apostles flank her on either side while angels support the edge of the mandorla surrounding her. Finally, in a fresco from the end of the thirteenth century, in San Giovanni e Paolo in Spoleto, the Virgin is again presented in a mandorla with accompanying angels.[42] This time she is on a mountain top and offers her girdle to Saint Thomas kneeling below, as Saint Francis looks on.

Toward the end of the thirteenth century the Feast of the Assumption became one of the high points in the year. The celebration took on particular importance for the Sienese following their defeat of the Florentines at the battle of Montaperti in 1261.[43] The city fathers had dedicated their city to the Blessed Virgin on the eve of the conflict, and her intervention was cited as the deciding factor in the outcome of the battle. Because of this victory, depictions of events from the Maryological cycle, and in particular the Assumption, became very popular in Siena. This helps to explain why, despite the conflicting official views of the Church, so large a number of images depicting the Assumption survive from Siena.

Luca's own *Assumption of the Virgin* (Pls. 15-1–15-5) is one of his most subtly designed compositions. Two groups of angels, seen in perspective from above, flank the ascending Virgin. Both she and her attendants float over the open sarcophagus while Christ, holding a crown, waits in the trefoil above. The multiple arcs of the mandorla, each painted a different shade of blue, separate the Virgin from the angels in much the same way that the multiple arcs

of the frame separate her from Christ.[44] The elliptical shape of her hands, pressed together in prayer, echoes that of the mandorla in which she sits, off center to her right, with her head slightly inclined to her left. The mandorla itself is positioned slightly to the left of the central axis of the panel, perhaps in order to balance the tentative movement to the right suggested by the pose of the two principals in the center.

The elaborate costumes in the central field adopt Niccolò's use of opulent textures. Their effect is to tie the figures together and to give some depth to an otherwise quite shallow composition. The angels drop back in a V shape from the picture plane, thus helping to set off the Virgin at the forefront of the painting. Luca's use of the central mandorla and the framing at the edges in order to control the crowded composition recalls Niccolò's predilection for similar spatial devices, for example in the center panel of his polyptych in San Gimignano (Fig. 11). The sarcophagus provides a strong counterpoint to the shallow space of the figure group. The orthogonal lines of its rim converge just below the Virgin's right knee to form a triangular shape, which is picked up in turn by the upward thrust of the Virgin and the two foreground angels, and completed by the profile of the central gable. This vertical rhythm overlaps and opposes the V formed by the choir of angels, and the tension thus established by this directional ambiguity gives to the composition an oscillating movement. The angels alternately recede and project, and the Virgin is thrust forward as well as borne aloft.[45]

Although certain details reflect the influence of Niccolò di Ser Sozzo, Luca's overall figural and compositional style in this work nonetheless show a turning away from the aesthetic of the older master and a further development of techniques that Luca had employed before their collaborative effort of 1362. One senses Luca's increasing assurance and accuracy in the anatomical rendering of his figures. They are still interrelated in tight groups by posture

42. For illustrations of this and the other representations of the Death and Dormition of the Virgin discussed above, see van Os, 1969b, pls. 98–106.

43. Concerning the battle of Montaperti see Schevill, 1964 ed., pp. 179–86.

44. Seymour, 1970, p. 80, indicates that the frame is original. He dates the panel between 1355 and 1360, but it more properly belongs after the 1362 altarpiece and before the Pisa *Crucifixion* of 1366.

45. Meiss, 1951, p. 23. As he points out, Luca's *Assumption* shows a method of transforming earlier trecento space that becomes common after 1350. Space is compressed, as in the group of the Virgin and angels, but compressed areas are occasionally juxtaposed with forms, like the sarcophagus, that strike vehemently back into depth. The equilibrium (characteristic of the earlier period) between form and space, and between solid and void, gives way to a tension between the opposing elements.

and glance, but less obviously so than, for example, in either of his paintings in Amsterdam or San Francisco. The description of physiognomy is accomplished with greater facility, and his more skillful modeling of forms gives them better proportion and balance.

A comparison of the left-hand group of angels in the *Assumption* (Pl. 15-5) with the left-hand group in the *Flagellation* discussed (Pl. 5) demonstrates this development. The glances of the four angels looking toward the Virgin are countered by two looking back. Similarly in the *Flagellation*, Pilate and the two armed men who glare at Christ in an isocephalic line are balanced by the man looking backward and holding the whip. The position of the latter's head is almost exactly repeated in the *Assumption* by one of the backward-glancing angels at the left. However, although the line formed by the shoulder, garment, throat, and neck is present in both paintings, each of the angels is varied and individual, and unlike the *Flagellation* figures, which are additive, none could be removed from the *Assumption* without disrupting the composition. Thus we see Luca employing devices he had used previously, but now in a more subtle way.

Datable to the same time as the Yale *Assumption*—that is, between the years 1362 and 1366—is a group of five diamond-shaped panels. Before this author published the paintings of *Jeremiah*, *Amos*, *Elijah*, and *Isaiah* (Cat. 17, Pls. 17-1–17-4), formerly in a private collection in Florence, only the *Jonah* panel was known (Cat. 16, Pl. 16).[46] Their original function is uncertain, although their size, composition, and shape suggest that they once formed part of a group of predella panels, perhaps similar to those by Pietro Lorenzetti now in the Uffizi, discussed in Chapter I. The heavily shadowed physiognomy, robust modeling, and large, slightly awkward hands are characteristic of Luca's work during this period. Zeri has suggested that the *Jonah* panel belongs to the same series as the pinnacle figures—evidently from a dismembered polyptych—in the Pinacoteca Nazionale in Siena (Cat. 59, Pls. 59-1–59-4). The Siena works, however, are of a lesser quality and

clearly show the intervention of Luca's shop, thus indicating the strong possibility that they were done at a later time.

Another small painting by Luca dating from this period is a tondo depicting *Saint James* (Cat. 18, Pl. 18), now in the Pinacoteca Nazionale in Siena. While it may once have been part of a larger altarpiece, its size and shape argue against this possibility. Enzo Carli suggested to me privately that the panel may be a rare example of a simple, personal, votive picture complete in itself. This seems all the more plausible as the panel has not been cut down or otherwise altered. The firm, full lines and dark flesh tones characteristic of the artist's earlier works are also present in the *Saint James* painting.

A little-known panel in South Hadley, Massachusetts, representing *Saint Anthony Abbot* (Cat. 60, Pl. 60) has been attributed to Luca di Tommè, although this is difficult to accept, partly as a result of its poor condition. In terms of style, the flat modeling of the cloak with its rather unimaginative folds, and the listless, uninspired features of the saint point instead to one of Luca's assistants. A tantalizing problem is posed by the fact that the dimensions of the painting are identical to those of the Siena *Saint James*. In addition, the halos are the same: the alternation of incised lines and punches, as well as the absence of these elements on the outer rim at the edge of the molding, appears in both panels. Furthermore, the inner profile of the molding itself is identical in both. The question remains as to how these two paintings might have been connected, if at all. To be sure, their size, disparate shapes, and the position of each of the figures do not argue in favor of their having once been constituent parts of some now dispersed ensemble. Perhaps the *Anthony Abbot* panel also functioned as a personal votive image. If so, it would seem that Luca's workshop had a uniform size for such commissions. But this deduction is only a possibility, and in large part the circumstances surrounding the two panels remain a mystery.

During this four-year period from 1362 through 1365 Luca di Tommè produced several important works that document his growing artistic talent and bear witness to his participation in and reception of several important commissions. This phase of his

46. Fehm, 1969, p. 574.

activity began with his collaboration with fellow artist Niccolò di Ser Sozzo on the 1362 Saint Thomas altarpiece. Luca played a much more substantial role in its realization than had previously been supposed. The polyptych is important, not only in its being Luca's first signed and securely dated painting, but also as his earliest large-scale commission that survives. To the extent that we can define his contribution to this joint effort, it furnishes an indispensable aid to our assessment of his art as a whole.

One result of this brief partnership was that Luca absorbed elements of Niccolò's style, as demonstrated, for example, in the *Madonna and Child* in New York. These elements he combined with what he had already learned from looking at the art of Pietro Lorenzetti. Niccolò's imprint was not a long-lasting one, however, and within a very short time Luca developed a style that was to become his trademark during the major phase of his career, that is, from 1366 onward. His *Assumption of the Virgin* in New Haven, for example, is peopled with the solid, dusky, and emotive figures that appear later on. Furthermore, in this painting he demonstrates his competence in anatomical detailing, which has by now become sure. Here also we are given a glimpse of his original compositional ability in dealing with a stock theme that, in other hands, might have become merely another routine performance. All of these elements seem to come together in what must be considered one of Luca's masterpieces: his *Crucifixion* of 1366, in Pisa. This painting marks his emergence as a fully mature artist, inaugurating the major phase of his career.

The Major Phase (1366–1373)

Little attention has been given to Luca di Tommè's later work. Instead, interest has often been focused on specific problems relating to his earlier paintings, and in particular the 1362 altarpiece. Luca's major phase begins in 1366 and runs to 1373. The year 1366, the date of his powerful *Crucifixion*, marks the end of any discernible influence of Niccolò di Ser Sozzo on the master, while the year 1373 denotes the eve of Luca's reception of a major commission from the commune of Siena, and a seeming increase in his involvement in governmental affairs. During these eight years, to judge from the large number of surviving works, Luca's production was substantial, and he was at the height of his artistic powers. Five intact or reconstructed polyptychs and several large votive panels highlight this activity. These and a number of other, related pictures reveal that Luca's shop must have been large and his influence considerable among a younger generation of artists.[1] The hands of a number of assistants are evident within the former group, while the imprint of Luca's compositional and figural style appears with varying degrees of intensity among the latter.

Luca's unusual 1366 *Crucifixion* is located in the Museo Nazionale di San Matteo in Pisa (Cat. 19, Pls. 19-1–19-3). The panel is considerably damaged. The gold background has worn away and there are paint losses within the figures, but fortunately the original outlines remain strong and easily recognizable. The Virgin and John the Evangelist flank the crucified Christ. Depicted in the pointed gable above are the dove of the Holy Spirit within a painted rondel, and God the Father in an attitude of blessing.

Both the Virgin and John are similar to many of Luca's earlier figures, but here their expressions are more serious and contemplative. Standing very close to the forward picture plane, against what was originally a stark gold background with a low horizon line, these figures are both monumental and immediate to the viewer. The Virgin is similar to one of the angels in the Yale *Assumption* (Pl. 15-4), especially in the turn and inclination of her head— as well as in the oval facial structure—but unlike the angel she is frowning, her brow is wrinkled, and her eyes are heavily shaded and narrowed. John, echoing the Virgin's sorrow, looks out at the viewer and gestures upward with his right hand, thus drawing our attention to the crucified Christ. The attitude of the two mourners is one of self-control or reserve. Even the representation of their drapery reflects this mood: the hem of the Virgin's cloak and the folds of John's mantle fall gently to the ground.

The figure of Christ has the same restraint found in the Virgin and John. His body does not seem wracked with pain, nor his face filled with suffering; instead he is presented relaxed in death. Curiously, Christ is somewhat smaller in scale in comparison with the flanking figures, even though the cross appears in the same plane in which the Virgin and John are situated. It is quite common to find the figure of Christ diminished in those depictions of the Crucifixion that include God the Father appearing above or supporting his dead Son on the cross (cf. Fig. 16).[2] However, the use of this motif in a Crucifixion

1. For a detailed examination of Luca's influence on three of these painters, the Master of the Magdalen Legend, the Master of the Panzano Triptych, and the Master of the Pietà, see Fehm, 1976, pp. 333–50.

2. Among the numerous Sienese examples from this period are: a triptych by Paolo di Giovanni Fei, Naples, San Gennaro, Minutolo Chapel; a triptych by Andrea di Bartolo, Prague, Narodni Galerie (see Meiss, 1946, fig. 3); and a fresco by Martino di Bartolo, Siena, Ospedale di Santa Maria della Scala (Frick Art Reference Library, neg. no. 6283). Florentine examples include a panel by Jacopo di Cione, London, National Gallery, no. 570; a Cionesque panel in New Haven, Connecticut, Yale University Art Gallery, no. 1871.18 (Sirén, 1916, pl. 46 or Seymour, 1970, p. 308, no. 30); and a triptych by a follower of Nardo, Florence, Academy (Meiss, 1951, fig. 9). Outside of Tuscany this form oc-

scene where God the Father is *not* shown otherwise appears only in the work of Andrea Vanni. He employed a disproportionate Christ figure on at least two occasions during the third quarter of the century (cf. Fig. 17), but similar Sienese representations from the earlier trecento are unknown.[3] Luca's purpose would be similar to Andrea's, that is, to de-emphasize the physical reality of the Crucifixion. The physical manifestations of Christ's agony and pain are restrained, thus allowing a more symbolic reading of the event. This more hieratic form is in character with the change in pictorial representations that occurred in Tuscany after the events of the 1340s, defined by Millard Meiss in his *Painting in Florence and Siena after the Black Death*.

Luca's composition is an experimental variant of the *Gnadenstuhl*, one of the favored forms of presenting the Trinity and the Crucifixion together in Western European painting of the late Middle Ages and early Renaissance. The original scheme for this type may have developed out of a simple cross form, with the bust of God the Father made to fit into the quadrilateral upper member.[4] One of the earliest surviving representations of this type occurs in a French miniature from about 1120 or 1130 preserved in Cambrai.[5] There, God the Father, enclosed in a mandorla, supports his crucified Son with both hands, while the dove, symbolizing the Holy Spirit, hovers between them. The mouths of the two figures are symbolically joined by the dove's extended wingtips. Within the spandrels formed by the mandorla and its encompassing frame are symbols for the four Evangelists. A similar representation occurs in a portion of a small German portable altarpiece from Hildesheim dating from before 1131 and now in London.[6]

Before the early twelfth century the Trinity had been depicted in a number of different ways. The first type showed three men—symbolizing the Trinity—standing before Abraham. One of the earliest surviving examples of this is found in a mosaic from about A.D. 340 in Santa Maria Maggiore, Rome. Two variants of this occur within the same scene. In one form Abraham is shown standing, serving a meal before three aureoled men or angels. In the other he bows reverently before these same three figures. The former mode is repeated again in another mosaic in San Vitale, Ravenna, somewhat before A.D. 547. It appears yet once more in Monreale by A.D. 1182,[7] but by this time the three figures are clearly shown as angels, with powerful, multicolored wings. In the scene in the next compartment to the right, Abraham prostrates himself before this same trio.

Toward the middle of the fourteenth century the form of the three figures, either men or angels, who stand or sit behind the table is further transformed. In each of the four corners of an illuminated page from an antiphonary by Pacino di Bonaguida or his workshop, datable to around 1340 and now in the Morgan Library in New York, some of these new forms of the Trinity are depicted. The three haloed figures in the lower left portion of the sheet, similar in posture and appearance to the three in Santa Maria Maggiore, are painted in the likeness of Christ and positioned behind a table that is clearly to be construed as an altar (Fig. 18).

The Gnadenstuhl form of the Trinity does not appear in Italy in either altarpieces or tabernacles until the second half of the fourteenth century, although it is found somewhat earlier in miniature illuminations.[8] Again a miniature in the top right portion of Pacino's page in the Morgan Library is among the earliest examples of this motif in Tuscany. In Siena it occurs in a Gradual from the shop of Lippo Vanni, dated 1345 and preserved in the Museo dell'Opera del Duomo.[9] It also appears in a hitherto unpublished Sienese miniature in Philadelphia that must date from the first third of the century.[10] In any event, these miniatures establish the

curs in a detail from a panel by Barnaba da Modena, London, National Gallery, no. 2927 (Berenson, 1968, vol. II, pl. 273).

3. The two examples by Andrea Vanni are a single panel in Groningen, Instituut voor Kunstgeschiedenis (see Fig. 16 herein); and a triptych in Siena, Pinacoteca Nazionale, no. 114 (Fehm, 1969, pl. 55). An example from Andrea's shop is in Cambridge, Massachusetts, Fogg Art Museum, no. 1965.563 (Fehm, 1969, pl. 58).

4. Offner, 1930, Section III, vol. 6, suggests this origin.

5. Cambrai, Bibliothèque Municipale, no. 234, fol. 2r. For an illustration see Braunfels, 1954, pl. 38. He dates the miniature about 1120. The illumination is dated some ten years later by Kirschbaum, 1968, col. 529.

6. London, Victoria and Albert Museum, no. 10-1873 (Braunfels, 1954, pl. 37).

7. Braunfels, 1954, pls. 1–3.

8. For a discussion of the development of this theme in Tuscany during the fourteenth century see Meiss, 1946, p. 6.

9. Siena, Museo dell'Opera del Duomo, Graduale 4, folio 110r.

10. Philadelphia, The Free Library, M. 46:5. The minia-

motif in Siena well before 1366, the date of Luca's Pisa panel.

The need to stress the unity of the Trinity gave rise to another variant that may even be based on pagan sources.[11] In this form three heads are placed on a single body, or two heads on one body with a dove between the heads. This so-called *Dreifaltigkeit* type is first seen in Tuscany, again in the miniature by Pacino di Bonaguida, in the lower right-hand tondo. The same motif was employed in Siena, and appears among the works of Lippo Vanni and Nic-colò di Ser Sozzo (cf. Figs. 19 and 20).[12] The earliest representation on panel of this rather revolutionary form is Luca's triptych in San Diego (Pls. 4-1-4-9).

In Luca's Pisa composition the scene has been in-tentionally arranged to read vertically (Pl. 19-1). The central rectangular field is seemingly isolated from the triangular gable above by the indentations in the outline of the picture. This demarcation is heightened by the fact that the tops of the arms of the crucifix themselves touch and parallel these in-dentations. Only a small portion of Christ's halo breaks across this boundary. A blessing God the Father floats on clouds while looking down upon the scene. The curve of the cloud bank repeats the upward curve of Christ's arms, as well as that of the Virgin's clasped hands, the hem of the top of John's undergarment, and the line of Christ's loincloth. The turn and inclination of God the Father's head is echoed by that of both Christ and the Virgin, thus establishing the holy link between them pictorially. The dove is superimposed on the cross in a tondo. The shape of the latter is picked up by the witnesses' rounded faces and halos, as well as by the halo of Christ himself, while the horizontal *chimasa* behind the tondo duplicates the movement of the arms of the cross. Both God the Father and the Holy Spirit are in the same vertical plane as Christ. Only the

subtle repetition of linear forms ties the gable and its figures to the rectangular field below.

In this work Luca intentionally departed from an older mode of representing the Trinity, and should not be accused of misunderstanding the iconogra-phy of the Gnadenstuhl type. Rather, Luca's scene was an experiment in the combining of the two iconographic forms of the Trinity and the Crucifix-ion. The pathos of the witnesses at the Crucifixion is stressed and hence is unique. This emphasis seems to be greater than the importance given the Trinity and thus seems to underscore for the viewer the symbolic importance of Christ's sacrifice.

Although substantially smaller in scale than the 1366 Pisa *Crucifixion*, two other pictures by Luca are, in spirit, quite similar to it. The first is a predella portraying *Saint Francis, the Virgin, the Crucifixion, Saint John the Evangelist, and Saint Dominic*, now lo-cated in the Yale University Art Gallery (Cat. 20, Pls. 20-1–20-6). Here the figures alternate with painted quatrefoils separated by blue borders. The integration of a painted frame into a composition is a Lorenzettian device that Luca had used previously in his 1362 altarpiece (Pl. 13-1)[13] and in his Alten-burg *Crucifixion* (Pl. 2). In the predella the painted bands surrounding the figures are shadowed so that they appear to drop back in space. This illusion is heightened by the gold punchwork that runs parallel to the painted border while passing behind the fig-ures. The halos and upper portions of the figures' heads pass over and even beyond the painted fram-ing. Thus portrayed against a stark gold back-ground, the figures seem to rise up from just behind the frame to lean out past the forward picture plane created by the painted border, and this spatial ar-rangement results in a reversal of perspective.

There are similarities to this play of forms in the way the haloed head of Christ in the Pisa *Crucifixion* overlaps the zone of the gable above. Likewise, the highly articulated molding in the Yale *Assumption* breaks and penetrates the trefoil of the Christ figure (Pl. 15-1). In the Yale predella panel Luca rearranged the conventional relationship of the figure to its sur-rounding frame. Again, as at Pisa, he created a more intense and compelling image for the viewer as a result of experimentation with figures and space.

The two figures of the Virgin and John, gesturing toward the Crucifixion and insistently gazing out at

ture was called to my attention by Mirella Levi d'Ancona. The library dates it to the fourteenth century.

11. For a discussion of the possible pagan origins of the Three-headed Trinity see Pettazoni, 1946, pp. 135–51.

12. A useful discussion of this theme in Lippo Vanni's work is by van Os, 1968, pp. 117–33. Lippo's versions of this motif include one in Casole d'Elsa, Museo, Corale, fol. 169f (van Os, 1968, p. 123, fig. 11), and another in Cambridge, Massachusetts, Fogg Art Museum, no. 1928.117 A-C8 (Fig. 18 herein). An unpublished miniature containing this same motif from the circle of Niccolò di Ser Sozzo is in Philadel-phia, The Free Library, M. 25:5 (Fig. 19 herein).

13. See especially the figures of Saint John the Baptist and Saint Thomas (Pls. 13-2 and 13-3).

the viewer, dispel any misunderstanding as to their meaning. The postures of the two (Pls. 20-3 and 20-5) help direct one's glance toward the crucified Christ (Pl. 20-4), who is depicted in radically diminished scale. The two outermost saints also turn and gesture toward the central scene (Pls. 20-2 and 20-6). It is thus through the eyes of these witnesses and avid believers that we comprehend Christ's Passion.

The style of the figures is typical of Luca's work during this period. Physiognomy is sure and well defined; only occasionally are the hands awkwardly rendered while the figures are robust almost to the point of being too heavy. The deep, vibrant range of colors demonstrates Luca's return to the intense yellow, red, and brown of his earlier paintings.

Also similar to the Pisa altarpiece is Luca's damaged *Crucifixion*, formerly in the Hurd Collection in New York (Cat. 21, Pl. 21). Unfortunately the body of Christ is badly abraded, and the face of John and portions of the Virgin's cloak have been damaged. The background is most unusual in that it appears to be black rather than gold. If original, the black background is unique within fourteenth-century Sienese painting. Only one other trecento Tuscan panel, by Pacino di Bonaguida and now in Tucson, employs such a device.[14] Originally in the center of a custodial intended to house a religious object, Pacino's image was flanked by flexible shutters on which were painted various representations drawn from the life of Christ. The Hurd panel by Luca does not, however, seem to have served such a function. Judging from what remains on the surface of this small image, it appears that the Christ figure is a direct copy of his counterpart in the Pisa painting. The positions of his hands, arms, head, torso, and crossed feet are identical. Too, he is smaller in scale than the Virgin and John. The holy group is very close to the forward picture plane, and a similar hill rises up in the center background. Only the positions and gestures of the witnesses are different; nor, of course, is either the Holy Spirit or God the Father represented.

A large *Crucifix* (Cat. 58, Pls. 58-1 and 58-2) in Roccalbegna is related to the three works just discussed. Luca designed the work and painted, at least in large part, the figure of the dead Christ, while his assistants were responsible for the execution of the terminal figures of the Virgin and John the Evan-

gelist. The posture of the Christ figure in this work is quite similar to that in Pisa, and yet the distinctive top fold in the loincloth recalls that of the *Crucifixion* in New Haven. Because of the close connection to the Pisa and New Haven pictures this large *Crucifix*—the only surviving one of its kind that Luca painted on such a scale—should be dated around 1366.[15]

In 1367, the year following completion of his monumental Pisa work, Luca signed and dated a polyptych, now in the Pinacoteca Nazionale in Siena, containing representations of *The Madonna and Child with Saint Anne*, flanked by *Saints Catherine of Alexandria, John the Baptist, Anthony Abbot, and Agnes*. In the central pinnacle is *Saint Andrew*, and in the lateral pinnacles are *Saints Matthew, Mark, Luke, and John the Evangelist* (Cat. 22, Pls. 22-1–22-5). Much of the framing throughout the altarpiece is modern, and yet some of the original inscriptions remain. However, that below the female saint on the right is lost. Kaftal identified her as Mustiola, a seldom-portrayed young martyr from the early Christian period.[16] On that basis it was concluded that this painting was commissioned for and was housed in a small church in Siena dedicated to her and constructed in the fourteenth century. Recently, however, Torriti refuted this identification. He tentatively proposed instead that the young woman was Agnes in a rare depiction of her holding a delicate chain with a ring at the end.[17] Bacci pointed out that the altarpiece had been in the possession of the Sienese noble family Ercolani, who gave it to the Siena Capuchin friars in 1567, two hundred years after its completion.[18] On the basis of this donation Torriti concluded that the picture had been housed originally in a church or oratory in the city.[19]

According to Brandi the altarpiece arrived in Siena in a dismembered state, so it is difficult to judge whether the current arrangement of lateral panels and pinnacles is the original one.[20] The pres-

14. For an illustration see Shapley, 1966, fig. 50. She attributed the panel, now in Tucson, University of Arizona, no. 61.118, to Pacino (Shapley, 1966, p. 23).

15. Carli, 1955, p. 97, suggests that a certain Jacomellus Nini de Rocha had the oratory built at Roccalbegna in 1388, for the specific purpose of housing this work. Carli dates the painting anterior to 1366.

16. Kaftal, 1952, p. 752.

17. Torriti, 1977, p. 157.

18. Bacci, 1932, p. 182.

19. Della Valle, 1786, vol. II, pp. 118–19, reported that the altarpiece was (then) in San Quirica in Osenna (d'Orcia). See also Torriti, 1977, p. 158.

20. Brandi, 1933, pp. 158–59.

ent inner pair, Saints John and Anthony, could have been exchanged with the outer pair, Saints Catherine and Agnes. The two male saints, turning in toward the central image, would have closed the composition effectively, while the placement of the female saints next to the Virgin and Saint Anne would have been more complementary to the central group. The incline of Catherine's head is echoed in reverse by the tilt of the Virgin's head, while the more erect pose of Saint Anne is repeated by Agnes. Even the gestures of the latters' hands are similar to those of the central group.

In an old photograph the two left lateral pinnacles of Matthew and Mark are shown in reversal of their current arrangement. In their present order, which more than likely is correct, the pinnacle figures occur, beginning from the left, in the same sequence in which their works appear in the New Testament.

It has been suggested that the incongruous central pinnacle of *Saint Andrew*, which has the same dimensions as the lateral pinnacles, belongs to another altarpiece.[21] Although painted by a Sienese artist between the years 1365 and 1370, and possibly even within Luca's own shop, the *Saint Andrew* is, for many reasons, not the original central pinnacle. The modeling of the figure is completely different from that of the others, and its punchwork is also dissimilar. As with the central panel below, one would anticipate a proportionately larger central pinnacle. Thus its size would also argue against its connection with this work. Finally, Andrew would be highly inappropriate as the crowning pinnacle over the central image, a place ordinarily reserved for Christ.

A somewhat damaged pinnacle depicting *Christ Blessing* comprised the middle section of a made-up polyptych that was formerly in the Wallraf-Richartz Museum in Cologne.[22] As the panel was put on the art market in 1926, however, its location has remained unknown (Cat. 23, Pls. 23-1 and 23-2). Its width corresponds to that of the top of the central panel in Luca's 1367 Siena polyptych.[23] The outline of the original molding in the Christ panel is still visible; in proportion and angle this would have been similar to what remains of the original molding surrounding the figures in the other work. The gold punchwork of the hem of Christ's mantle and undergarment is exactly duplicated in the clothing of the figures of the central panel of this altarpiece. From what remains of the original paint surface, it would seem that the panel can be attributed with assurance to Luca. Many similarities with the figure of Saint Anne are apparent: the incline of the head, the shadowed facial features, the crisp line of the eyebrow, and the slightly awkward hands.

While the main tier of figures in the Siena polyptych and the displaced *Christ Blessing* are by Luca, the four Evangelists show the intervention of his shop (Pls. 22-4 and 22-5). Their style is remarkably homogeneous, and all the figures may well have been painted by the same assistant. The artist has retained Luca's robust, rather dusky figures, but has reduced the master's crisp modeling of features to a cursory acknowledgment of facial details and drapery folds. The faces of the four saints are dull and uninspired, and the lines of their cloaks limp and unimaginative.

It has been suggested that Luca may have been the first to introduce the motif of the Virgin, Child, and Saint Anne into Sienese art.[24] During the first half of the fourteenth century this theme, which symbolized the Immaculate Conception, became a popular subject for devotional images. Referred to frequently as the *Annaselbdritt* by students of iconography, the theme appears almost simultaneously in Italy and northern Europe. It is depicted, for example, in a miniature from the Cologne school dated 1324, and also in a stained glass window in Königsfeldn, Switzerland.[25]

In Tuscany at least three other representations, one of which is Sienese, can be dated earlier than Luca's version. The wide range in variation among

21. This suggestion was first made by Crowe and Cavalcaselle, 1908, vol. III, p. 87. Shapley, 1966, p. 59, accepted this notion and proposed that a *Christ Blessing* (Cat. 54, Pl. 54 herein) in Raleigh, North Carolina Museum of Art, no. GL.60.17.5, may have been the original central pinnacle for the 1367 altarpiece. This was rejected by Carli (Shapley, 1966, p. 59). Recently De Benedictis, 1979, p. 67 n. 80, cited Zeri's unpublished partial reconstruction of an altarpiece that also includes a *Saint John the Baptist* and *Two Apostles* (Cat. 52 and 53, Pls. 52 and 53, respectively, herein), and other panels in a private collection. (See Chapter II.)

22. The contrived altarpiece was broken up after it left the Cologne Museum. The side panels are by Niccolò di Segna and have found their way into private collections, while the central panel remains lost.

23. The width of the pinnacle is 27 cm.; the width of the top of the panel is 28 cm.

24. Künstle, 1926–28, p. 330. Künstle probably gives the best short account of the development of this theme. A number of other studies of interest are: Charland, 1911; Charland, 1921; Schaumkell, 1893.

25. For illustrations of these works see, respectively, Aldenhoven, 1923, p. 139, and Künstle, 1928, vol. I, p. 330.

the three examples indicates that there was then no set formula for representing the group. The first case is a polychromed wood sculpture in the Bargello in Florence (Fig. 21). The three figures are presented in a straightforward, frontal, and symmetrical arrangement. Only slight variations in the head positions are discernible. In dramatic contrast to this static ensemble, Francesco Traini created a formidable and imposing group in Pisa in the 1340s or 1350s (Fig. 22), and must be credited with the first Tuscan representation on panel of this theme. Here the Virgin and Child exchange intent glances as their heads touch and their hands grasp each other, apparently oblivious to the solid, otherworldly figure behind them.

The third of these depictions of the *Annaselbdritt* is found in a ruined fresco cycle at Cuna, just south of Siena (Fig. 23).[26] The Virgin and Child are relatively visible, but the headless standing figure of Saint Anne supporting them from behind is difficult to see in the absence of good lighting. While the cycle was attributed at various times to Luca di Tommè, the facial features are more reminiscent of the work of Pietro Lorenzetti. The staring, almond-shaped eyes, thin lips, and jaw line of the figures in this image and in the remainder of the frescoes in this cycle suggest the work of an immediate follower of Pietro, active during the 1350s.[27]

While the Bargello sculpture presents three separate and completely disconnected figures deposited one upon the other, Traini's Pisa composition draws the Virgin and Child together in a tender way. Here, however, they are juxtaposed between the viewer and the solemn and distant Saint Anne, whose disproportionate scale in relation to the Virgin and Child negates the reality of the group and suggests that Anne, in prophetic fashion, invites the viewer to judge the pair before her. At Cuna, on the other hand, the Lorenzetti follower related the three figures more satisfactorily in terms of realistic presen-

tation by setting the bulk of Saint Anne off to the side, lowering her, and bringing her more into scale with her daughter. The effect is that Anne is somewhat distanced physically from the others, while at the same time enveloping and protecting them in a unique way. In the central panel of his 1367 polyptych (Pl. 22-2) Luca followed this same scheme, but brought the Virgin and Child into proportion with Anne in a way that is more homogeneous in treatment than any of the others. Although this painting by Luca is the first surviving Sienese panel that treats the theme of the Virgin and Child with Saint Anne, he seems to have based his composition on the damaged fresco at Cuna.

Luca's peak of production occurred between 1366 and 1373. A number of perfunctory works survive that document his considerable output and the increased intervention of his shop. By this time Luca had become perhaps the most influential painter in Siena. At least three artists owe elements of their style to him. The Masters of the Pietà and of the Magdalen Legend, as well as the better-known Master of the Panzano Triptych, borrowed Luca's dark, vibrant colors, compositional forms, and physiognomic detailing.[28]

A marked change in Luca's handling of space and approach to detail occurred during this period, in addition to the increasing role of shop assistants. All these elements can be seen in the next, partially reconstructed, polyptych. Two panels, a *Madonna and Child* and *Saint Anthony Abbot* (Cat. 24, Pls. 24-1–24-3), are still preserved in the Church of San Francesco in Mercatello sul Metauro, but, unfortunately, both panels have lost most of their original framing and pinnacles. A third panel depicting *Saint Francis*, evidently from the same ensemble, had so deteriorated by the sixteenth century that a replica was

26. The cycle was first given to Luca di Tommè by Berenson, 1932, p. 313, who reaffirmed this in 1936, p. 269, and 1968, vol. I, p. 226. Van Marle, 1934, vol. II, p. 150, attributed the cycle to Niccolò di Segna. The frescoes are located in the church of Saints Jacopo and Bartolommeo, and include an *Adoration of the Magi, Circumcision,* and several unidentifiable saints. Sig. Artini of Florence photographed the cycle. Earlier photographs are available from the Gabinetto Fotografico Nazionale, Rome, neg. nos. C-5705, C-5706, and C-5707.

27. The damaged frescoes in the church of San Francesco at Monticello may be by the same hand.

28. Meiss first brought together the works of the Master of the Pietà in 1946, pp. 6–12. Works by the Master of the Magdalen Legend were first grouped by Zeri, 1958, pp. 14–16, although he attributed them to Luca di Tommè. Meiss, 1963, pp. 47–48, separated that master's pictures from Luca's oeuvre and grouped them together around a predella series dedicated to the Magdalen. The works of the Master of the Panzano Triptych were first defined by Berenson, 1930a, pp. 352–62, and this initial corpus was later added to in an anonymous article, Panzano, pp. 263–64. See also Fehm, 1976, pp. 333–50.

commissioned.[29] Until several years ago there was no report of any other panels that might have constituted part of the altarpiece. At that time I was able to add two previously unknown panels.[30] The pair, *Saint Peter and a Prophet* and *Saint Paul and a Prophet*, are complete with pinnacles and are now in Oxford (Cat. 25, Pls. 24-1, 25-1–25-4).[31] The profile and arc of the fragments of the original molding, the pattern and configuration of the punchwork, the spring points of the arches, and the height from the base of the panels to the break in the arches correspond exactly to respective details in the Mercatello panels. The width of the Oxford saints and the height to the peak of their arches are also similar to the corresponding dimension of the Mercatello *Saint Anthony Abbot*.

As in the 1367 altarpiece, each figure virtually fills the picture plane, to the extent that the frame seems to press in on them. Even the Madonna appears too large for the space in which the artist has placed her. Luca presents the Virgin seated in front of a cloth of honor with the Christ Child standing in her lap holding a banderol in one hand and blessing with his other. This latter motif had become a stock composition in Siena since Simone Martini's introduction of it in his *Maestà* of 1315 (Figs. 1-1 and 1-2).

The most successful figure in this reconstructed altarpiece and the most characteristic of Luca is the Oxford *Saint Paul* (Pl. 25-2). The saint is very close in spirit to his counterpart in the artist's slightly later Rieti altarpiece (Pl. 27), which he signed and dated in 1370. The sure modeling of the sturdy figure, the carefully constructed folds of the cloak, and the intent gaze are all foreshadowings of the Rieti work.

The Oxford pinnacle figures, although daubed over, show perhaps the hand of the same assistant who had worked on the pinnacles of the 1367 Siena polyptych (cf. Pls. 25-3 and 25-4 with 22-4 and 22-5). The bland, flattened drapery appears in both instances, while the accentuated arch of the eyebrows

in the Siena *Saint John the Evangelist*, for example, has become a pronounced ridge over the eyes of the figures in the later work. The Oxford *Saint Peter* (Pl. 25-1), which has the least affinity with Luca's other work, has the same accentuated ridge above the eyes and the uninspired, ill-defined drapery that hangs limp as it falls directly to the ground. Again, the stylistic parallels with the Siena pinnacle figures are obvious. Further, the two images of *Saint Anthony Abbot* at Siena and Mercatello are virtually interchangeable in terms of their style and composition; and, finally, the tilt and turn of Saint Anne's head is echoed by that of the Mercatello Virgin. This reconstructed altarpiece in Oxford and Mercatello, which is dependent on the Siena polyptych for a number of its stylistic and compositional details, can be dated sometime shortly after 1367.

If this work was painted after 1367, then a group of four detached pinnacles depicting *Saint John the Baptist*, *Patriarch Jacob*, *Isaiah*, and *Saint Catherine of Alexandria* (Cat. 59, Pls. 59-1–59-8) can be dated shortly before. All the pinnacles have been rubbed, consequently losing some of their paint film and thus making a final assessment of the extent of Luca's direct participation in their execution difficult. The composition, style, and handling of color suggest without any doubt their origin in his shop. Jacob and John the Baptist are the two strongest of the group, and hence one is tempted to see the master's hand in them. Presumably they are all from the same as yet unidentified and perhaps ruined altarpiece. Yet, curiously, Catherine and John are somewhat smaller than Jacob and Isaiah. Further, they lack the incised channels that originally would have accommodated the intersecting molding and that are present in the other two. Can this be explained by the hypothesis that they may have been taller and have been cut down and hence the framing marks lost? It is difficult to say. What does seem clear from these fragments is that the artist assigned at least two of them to assistants, and that he varied the configuration of his pinnacles here.[32]

The Annunciation is the subject of a pair of panels depicting respectively the *Angel Gabriel* and the *Virgin of the Annunciation* (Cat. 26, Pls. 26-1 and 26-2), formerly in a private collection in Paris. The attri-

29. Venturi, 1915, p. 10. De Benedictis, 1979, pp. 87 and 89, intimates that the original Saint Francis panel by Luca is still extant.

30. For the proposed reconstruction with the panels in Oxford, see Fehm, 1973, pp. 463–66.

31. The pair were given to the Exeter College Chapel, Oxford, in 1920 by George Ridley Robinson, together with the two pairs of pinnacles from a dismembered altarpiece by a follower of Pietro Lorenzetti. Robinson had been a Fellow at the college during the 1880s, and had purchased the panels in Italy at that time. There is no further record at the college concerning his acquisition of the panels.

32. Brandi, 1933, p. 160, suggested that the male figure (no. 124) was Benjamin because that name appears in his banderol. Torriti, 1977, p. 154, on the other hand, felt that he might be Jacob, who, in the *Book of Genesis* in the *Old Testament*, specifically warns his people against Benjamin.

bution to Luca, since the initial publication of the panels by Zeri, has been accepted without question.[33] Indeed, the bulk of the figures, the slightly awkward gestures of the oversized hands, and the shadowed features indicate Luca's authorship. The Virgin and Gabriel are painted on two separate panels, an unusual arrangement when depicted on this scale. The Annunciation usually occurs on a single field, with the two figures divided visually, if at all, by a column supporting the ceiling of the Virgin's chamber, as in, for example, Ambrogio Lorenzetti's 1344 *Annunciation* in Siena. On the other hand, Simone Martini's Florence *Annunciation* of eleven years earlier forgoes any such visual dividing element.

Precedents for Luca's version of the Annunciation exist, albeit on a much smaller scale, in two portable folding diptychs by Simone and his shop.[34] On a much larger scale Ambrogio had separated Gabriel from the Virgin Annunciate in his monumental fresco cycle at Montesiepi, although he was no doubt governed by the existence of a tall, round headed window located in the middle of the wall surface in this small chapel. A generation later Lippo Vanni faced a similar problem in an intervening window at San Leonardo al Lago.[35] He successfully solved it by means of an elaborately painted architectural construction. In Luca's work special attention is drawn to the separation of the two figures by surrounding them with a very ornate tri-lobed molding set within the high pointed arch of the framing. Yet, in spite of the disjunctive elements of frame and separate panels, the artist manages to join the two together across space in a powerful way by means of their poses and gestures. As to why Luca separated the Virgin and Gabriel in the first place, it is difficult to say, especially as no other panels that might have been a part of this group have come to light.

A fragmentary *Virgin Annunciate* (Cat. 29, Pl. 29), formerly in Vienna, is by Luca and dates from the same period as the pair just discussed. The tilt of the Virgin's head, the downward cast of her eyes, the tooled border of her cloak, and the elaborate punchwork of her halo are similar to their counterparts in the Paris *Virgin*. The panel has been cut down, and in its original form the Virgin very likely would have been presented full length and seated on a throne. If this was the case, then there may well have been a companion panel containing the image of Gabriel, although no such piece has come down to us. What is certain is that the survival of a number of large panel depictions of the Annunciation by Luca and his circle suggests more than a passing interest in venerating this event in Siena at this time.

In an altarpiece from 1370 Luca demonstrated his great modeling ability, with the result being one of his most memorable works from this period. The inscription—now lost—on a polyptych made for the convent of San Domenico in Rieti indicated that Luca made the altarpiece in honor of the souls of Andrea Pannelli and his wife, Vanna.[36] Depicted are the *Madonna and Child with Saints Dominic, Peter, Paul, and Peter Martyr* (Cat. 27, Pl. 27). The four saints stand on painted floors that recede rather

33. Zeri, 1958, p. 5.

34. The two diptychs are now dismembered. The *Angel of the Annunciation* is in Washington, National Gallery, no. 327; its companion is in Leningrad, the Hermitage. For illustrations, see Shapley, 1966, fig. 121 and van Os, 1969b, pl. 17. The diptych from Simone's shop is in Antwerp, The Royal Museum of Fine Arts, nos. 257 and 258 (van Marle, 1924, vol. II, fig. 161). Van Os, 1969b, fig. 117, has attributed another leaf of a diptych depicting the *Virgin of the Annunciation*, formerly in Brussels, Stoclet Collection, to Simone, but the panel is so damaged that a final assessment of the authorship is difficult.

The representation of the Annunciation on two panels was used also in Siena by Niccolò di Buonaccorso. Portable diptychs by him are located in Fiesole, Museo Bandini, and in Budapest, Museum of Fine Arts (van Marle, 1924, vol. II, figs. 333 and 334).

Luca utilized this format of visually paired panels in the crowning pinnacle of his triptych at Sovicille (Cat. 63, Pl. 63-1, and text below). He took this motif further in his late polyptych at Lucignano (Cat. 49, Pl. 49, and text below). There he set Gabriel and the Virgin Annunciate in the uppermost pinnacles of the lateral panels. (See also Fehm, 1976, p. 343 n. 20.)

In all probability Luca's *Annunciation* formerly in Paris served as a source for a similar composition by the Master of the Panzano Triptych. (Again, see Fehm, 1976, p. 343.) Luca returns to the subject of the Annunciation in another late work, an elaborate polyptych in Cascina, near Pisa (Cat. 47, Pls. 47-1–47-7, and text below). Here the holy pair stand in the central panel of the main tier of figures.

For a thorough discussion of the development of the representation of the *Annunciation* in Siena, see van Os, 1969b, chapter III, *passim*.

35. For illustrations see Borsook, 1969, pl. 44 and fig. 12, respectively.

36. The inscription is recorded in a manuscript in Rieti, Archivio Comunale, Fondo di S. Domenico, *Libro del Consigli del 1776,* "Consigli del Convento." The panel was first published by Crowe and Cavalcaselle, 1864, vol. II, p. 114, and subsequently it has been referred to frequently as the "Rieti polyptych" in the local guidebooks and in the literature on Luca di Tommè.

sharply back into space. The elaborate tri-lobed framing presses in on the figures, which fill the panels almost completely. Similarly crowded, the Virgin is presented in a large, high-backed throne whose parts are barely distinguishable. The same use of molding is to be seen in the Paris *Annunciation* (Pls. 26-1 and 26-2), where it is allowed to encroach on the picture plane.

The figures in the Rieti work all bear Luca's stamp in their familiar dark flesh tones, full and robust modeling, and a smoldering, emotive quality. Paul is perhaps most representative of Luca's evolving style. As mentioned, the Paul here is quite similar to his counterpart in Oxford (cf. Pl. 25-2), even down to such small details as the folds in his mantle. The outline of his garment as it falls over his left arm is duplicated in the Rieti figure, but with one important exception. Luca has emphasized the line of the hem of Paul's cloak with a gold border, unlike the more austere Oxford saint. This meandering, calligraphic line occurs in Paul's undergarment near his neck, hands, and feet. The emphasis on such details and worked patterns also appears in the *Virgin and Child*, and in the figure of Saint Peter. Luca's departure from his earlier and more stark representations, which were devoid of such patterning, occurs after 1366. This trend toward opulent detailing continued throughout the remainder of his career.

In the Rieti polyptych, as in the 1362 Siena altarpiece, the Christ Child stands in his mother's lap. Here, however, he holds a small cross. As Meiss pointed out, the appearance of the cross is extremely rare in such images, and in Sienese painting there are only three other instances in which the Christ Child is depicted in this way.[37] At about the same time the motif was also exploited by the Master of the Pietà, while another example is by Francesco di Vannuccio, and dates from about 1370. Luca himself employed it again in a slightly later polyptych now in the Siena Pinacoteca Nazionale.

This unusual composition would seem to have prophetic meaning similar to that found in certain representations of the Annunciation in which the Child holds a cross as He descends from Heaven.[38] Meiss, however, pointed out that there is another meaning for the motif. Significantly, in the central panels of Luca's polyptychs in Rieti (Pl. 27) and Siena (Pl. 32-1) the Virgin or the Child holds a banderol with the inscription: QVI · VVLT · VENIRE · POST · ME · ADNEGET · SEMETISV[M] · TOLLAT · CRVCE[M] · SVA[M] · ET · SEQVAT.[39] Meiss argued that the cross thus takes on "a specific didactic or hortatory significance, enjoining the religious life and imitation of Christ," and he concluded that "the representations of Christ exhorting his audience in this way may be related to the trend toward a more strenuous and orthodox form of religion bound up with the plague, and social struggles of the time, and the teachings of Saint Catherine."[40]

The next work from this period is *Madonna and Child, Bishop Saint, John the Baptist, Gregory, and Francis* in Siena (Cat. 32, Pls. 32-1–32-4).[41] They are surmounted in the pinnacles by *Christ the Redeemer, Two Evangelists, Paul, and Peter*. The altarpiece is stepped in a curious fashion. The two lateral figures of the *Bishop Saint* and *Francis* are depicted full length in panels that are the narrowest and shortest in the polyptych. *John* and *Gregory*, who flank the central image, are portrayed in three-quarter length, both wider and taller than the outermost pair. The central image of the *Madonna*, who is almost half length, is presented in the tallest and widest field. The arched molding surmounting the central pair extends exceptionally far down the sides of the panels. The spring point of the arches in the case of the *Bishop Saint* and *Francis* is at or below their elbows, and with *John* and *Gregory* it falls somewhat below their shoulders. This causes the arching above the first two to appear higher and more acutely pointed, and as a result the figures seem to stand higher in the picture plane, and thus farther back from the viewer.

38. This point is made by Robb, 1936, p. 523.

39. Matthew 16:24, "If any man will come after me, let him deny himself, and take up his cross, and follow me."

40. Meiss, 1946, p. 7.

41. It has been suggested that this altarpiece is identical to the one that Vasari reported in the Dragondelli Chapel in San Domenico, Arezzo (cf. Cat. 32 and 67). If the altar table currently in the chapel is the original, then the width of the painting now in the Siena Pinacoteca Nazionale would preclude this origin. It would jut well out over the edges of the altar. Perhaps the confusion arose with the Pisan art dealer Professor Francesco Manetti, who may have been attempting to establish a provenance for the work.

37. This point was first made by Meiss, 1946, p. 6, who listed three panels as follows: 1. a panel by Francesco di Vannuccio, the Hague, Meermanno-Westreenianum (Offner, 1932, fig. 5); 2. a diptych by the Master of the Pietà, Prague, Narodni Galerie, nos. D. O. 832 and 824 (Meiss, 1946, fig. 5); and 3. the central panel of a polyptych by Luca di Tommè, Siena, Pinacoteca Nazionale, no. 586 (Cat. 32, Pl. 32-2).

Through these adjustments of space and framing, Luca sought to reinforce the importance of the central image, with its unusual iconography. While following the time-honored tradition of placing the most important figures in the middle of the altarpiece, he has drawn even greater attention to the *Madonna and Child* not only through painting them proportionately larger than the other figures, but also through filling in more of their surrounding space. The *Bishop Saint* and *Francis* stand back from the picture plane on a painted floor in an ample space. They are dwarfed by *John* and *Gregory*, who have somewhat less room as they appear to press forward, urgently looking out at the viewer to guide his attention to the center of the altarpiece.

The style of the figures again shows the intervention of Luca's shop. The wistful, slight *Saint Francis*, for example, seems more akin to the *Saint John the Evangelist* pinnacle figure in the 1367 altarpiece (Pl. 22-5), than to the more deeply felt and emotive Rieti or Oxford *Saint Paul* figures (cf. Pls. 25-2 and 27). The pinnacle figures are also not characteristic of Luca. The cautious, alert face of *Peter* (Pl. 32-4) and that of the lefthandmost *Prophet* (Pl. 32-3), with their narrowed, slit-like eyes, furrowed brow, and clear countenance, seem to be the work of a sensitive artist whose hand is not seen in any of Luca's other work.

By the first third of the fourteenth century the mystic marriage of Saint Catherine of Alexandria had become a familiar theme in Tuscan art. Although the earliest known account of the event appeared in a manuscript dated 1337, there are several earlier versions of the Catherine legend that refer to her as the bride of Christ. In the earliest pictorial type, as shown for example in a detail of a panel by a follower of the Saint Cecilia Master,[42] the Virgin stands holding the infant Christ in her arms while He slips a ring onto Catherine's right hand, as she stands near him. This theme was introduced in Siena during the 1330s in a panel by a follower of Simone Martini, the so-called Master of the Palazzo Venezia, with a slight variation.[43] There, the Virgin is seated on a throne with the Child in her lap, while Catherine stands nearby to the left.

Luca himself painted this subject around 1370 (Cat. 30, Pls. 30-1–30-3). In his rendition, now in

the Pinacoteca Nazionale in Siena, Catherine stands at the right while the Virgin holds the Child as if presenting Him to her. Leaning forward toward the saint, He places a ring on her finger. This particular mode of the mystic marriage was evidently a popular one, for there are three other surviving paintings that duplicate Luca's image. They can be dated slightly later than Luca's altarpiece on stylistic grounds and, discounting the possibility of an earlier, now lost prototype, would seem to depend on it. This theme appears in the central panel of a triptych now in Perugia. Although attributed to Luca on occasion, the picture is one of the finest of a small number of works by Jacomo di Mino del Pelicciaio, who was active in Siena throughout the second half of the trecento.[44] While Jacomo based his composition and forms on those found in Luca's version, his delicate rendering of facial details and the quiet, restrained elegance of his figures set his work apart from the latter. The Master of the Pietà also used Luca's composition for the central portion of a portable triptych now in the Siena Pinacoteca Nazionale; and a third version of this theme is seen in the central panel of a triptych by the Master of the Panzano Triptych, in San Leolino, Panzano.[45]

We can tell by the dimensions of Luca's *Mystic Marriage of Saint Catherine* that it would originally have been a large altarpiece. Unfortunately it has not survived intact. *Saints Bartholomew and Blaise*, of the same provenance as the *Mystic Marriage*, and currently flanking the somewhat truncated central panel, undoubtedly formed part of the original ensemble.[46] Stylistic details such as the punchwork within the halos, the color and patterning in the spandrels above the figures, the dimensions, and lastly, the uniformly poor condition of all three parts would seem to confirm their initial association. A *Saint John the Baptist* and *Saint John the Evangelist*, formerly in Vienna, may also have been part

44. Van Marle, 1924, vol. II, p. 481, attributes the panel to Luca. There is also a brief profile of Jacomo on p. 508 of the same survey. All the known facts concerning the latter artist are brought together by Perkins, 1930, pp. 243–67. He is first mentioned in a Pistoiese document around 1349. He was admitted to the guild in 1356, and was subsequently enrolled in the list made up in 1389. This is the last mention of the artist, and by 1396 he was dead.

45. Fehm, 1976, figs. 11 and 4, respectively.

46. Saint Blaise's popularity increased enormously in Tuscany after the plague. He was associated with the healing of the sick, and his intervention was especially invoked against sore throat, one of the plague's symptoms.

42. For an illustration, see Meiss, 1951, fig. 100.

43. Siena, Pinacoteca Nazionale, no. 108. For an illustration, see Torriti, 1977, p. 91.

of the original polyptych (Cat. 31, Pls. 31-1 and 31-2). The two panels are in poor condition, and what remains of the original paint film has been retouched. It would seem, however, that the design of the Vienna pair is Luca's, and he may well have participated, at least to some extent, in their execution. The spandrels of the two saints have been cut away, indicating perhaps that the pair may have been transferred to new supports. Their dimensions are the same as those of the Siena saints. Moreover, the facial details of Bartholomew and the Evangelist (cf. Pls. 30-3 and 31-2) are quite alike: the almond-shaped eyes, the wrinkled brow, the flat C-like line of the ears, and the built-up cheekbones appear in both.

If John the Evangelist and John the Baptist did form part of the same polyptych, they would probably have flanked the Virgin, with the Baptist to the left and the Evangelist to the right. Both look out at the viewer as the Baptist gestures up toward the central image. In any case the positions of Blaise and Bartholomew would certainly have been the same as in the current arrangement in Siena, where they look toward, rather than away from, the central panel. Their turned-in, solid bulk would have closed the ends of the composition easily and would have balanced the more intent figures of the Baptist and the Evangelist.

This reconstructed polyptych is important for a number of reasons. It represents another large-scale altarpiece from the period, thereby further suggesting the artist's popularity and productivity. From what remains of the work, it can be seen that the general quality of painting is of a consistently high level. And finally, that it may have served as a model for other artists suggests its importance as a visual image in Sienese painting.

Several smaller pictures from this eight-year span, however, can be dealt with as a group, since they are of a lesser quality and of a similar subject matter. They all present the Madonna and Child Enthroned in a way that had by now become almost mechanical for Luca. As a group they are representative of the artist's basic stock of pictures painted probably without a specific patron or commission. These are the kinds of images that found their way into local parish churches and small, private family chapels, where a number of them are still located today.

One of these works is a panel in Los Angeles depicting the *Madonna and Child Enthroned with Saints Nicholas and Paul* (Cat. 33, Pl. 33). It has been suggested that this work was ordered by the commune of Siena not only to commemorate the 1363 defeat by Sienese troops of a band of marauding brigands known as the Company of the Hat (Cappellucci), but also to honor Saint Paul, who had been chosen as patron of the expedition.[47] However, certain evidence argues against this hypothesis. The Los Angeles painting is modest in scale, and here, seated in a high-backed throne against a very elaborate cloth of honor, the Virgin is flanked by two standing saints. It is true that Paul is given a prominent position next to the Virgin, but so is Nicholas, and it can be argued that Paul ought to occupy a more central spot. Furthermore, a record of the original contract for the work shows that one hundred five gold florins were paid for it.[48] This amount, when compared to other commissions, seems too great for the Los Angeles panel. The fact that transportation costs were also included indicates that the painting must have been a large one. Finally, the details of the contract suggest that another image by Luca, now in Perugia (cat. 39, Pls. 39-1–39-4) may be the work in question.

Two panels, one in the Fitzwilliam Museum in Cambridge (Cat. 34, Pl. 34), and the other in Foligno (Cat. 35, Pl. 35), are similar in format and share a number of significant details: the Virgin's position, the elaborately decorated throne with its triangulated top, the angels gazing out from behind it, the Virgin's facial features, the tilt of her head, the modeling of her neck, the curve and folds of her mantle over her face, and the rendering of its gold-tooled border. Common to both is the great attention given to detailing: the pattern of the cloth of honor, the garments of the angels, the swinging line of the gold borders of both the Virgin's and the Child's clothing. Also found in each is a cusped molding of rounded arches. Further, the flat and poorly defined facial features of the angels in both pictures suggest the intervention of assistants. The Foligno *Madonna and Child* has been cut at the top and bottom. Evidence of its having once been the

47. Wescher, 1954, p. 11. For further information see Schevill, 1964 (Harper Torchbook edition), pp. 218 and 246.
48. See Documents 18a and 18b. Document 18b was first alluded to by Della Valle, 1786, vol. II, p. 119, and again referred to in a note by Milanesi, 1854, vol. I, p. 28 n. 1; Document 18a is hitherto unknown. Also see Chapter IV, pp. 44–47 and Notes to Chapter IV, p. 44 n. 1.

center panel of a polyptych is suggested by the presence of numerous dowel holes on either side and batten marks across its back.

The Child in the Cambridge picture stands holding a finch, an increasingly common motif during this period. The goldfinch had come to be an accepted symbol for Christ's Passion, and when held by Him alludes to the close connection between the Passion and the Incarnation.[49] Around His neck He wears a cross and a piece of coral, which in medieval Italy was thought to ward off evil spirits.

This same talisman is employed again in another Luca panel now in Ponce, Puerto Rico (Cat. 37, Pl. 37). Here, the Madonna and Child are seated on a throne, but details have been minimized. The throne's arms are eliminated, its base broadened and flattened, and only a small portion of the upright back is revealed. The overall effect is one of richly colored geometric pattern surrounding the large, flat bulk of the figures.

In 1972 a *Madonna and Child* by the artist came to light at Granaiola, in the environs of Lucca (Cat. 28, Pl. 28). The composition closely resembles that of the panel in the Fitzwilliam Museum. Even such details as the coral talisman on the Child's neck and the finch are included. Here, however, the angels have been eliminated and the space around the Virgin and Child is constricted. We have seen this trend before during this period in some of Luca's more elaborate dated altarpieces, and for this reason the panel can be dated sometime after the Fitzwilliam *Madonna and Child*.

Two recently restored panels, now returned to their parish churches, have evidently been the object of great veneration for generations. Votive crowns, medallions, and good luck charms attached to the surface of these pictures had to be carefully removed before the delicate job of cleaning away the heavy overpaint could begin. In the *Madonna and Child* in the church of the contrada of Bruco in Siena (Cat. 36, Pl. 36), the Virgin supports the Child while He holds a finch in His hand.[50] Both figures look out at the viewer in a fashion similar to Luca's representation of the Madonna del Latte in Buonconvento (Cat. 38, Pl. 38). This image, which seems to have

been created by Simone Martini in a now-missing prototype, gained immense popularity throughout Italy during the fourteenth century.[51] Curiously, it appears only once among Luca's works. Here, as in the Bruco work, modeling has become two-dimensional, and there is a profusion of gold and jeweled patterning.

Two other panels have been so badly damaged or overpainted that it is difficult to assess the artist's exact role in them, although there is no doubt that they originally came from his shop. The *Madonna and Child* at Rapolano (Cat. 57, Pl. 57) and the central panel of the *Madonna and Child with Saints James and Andrew* at Sovicille (Cat. 63, Pls. 63-1 and 63-2) were apparently designed by Luca and resemble each other quite closely. The Virgin and Child look lovingly at one another. In both instances the Child is dressed in a long-sleeved, loose-fitting garment with a gold border that trails out behind Him. In addition, the Christ's foot is sharply upturned and the relative positions of his left and right hands are analogous to those of his feet.

There is a striking similarity between the face of the Saint James in the Sovicille panel and two of Luca's other works: the Saint Bartholomew in the Siena *Mystic Marriage* and the Saint John the Baptist formerly in Vienna (cf. Pl. 63-2 and Pls. 30-3 and 31-1). All three faces are attenuated and almost triangular in shape. Luca's characteristic dusky modeling of facial features is evident in all these panels, as are the narrow and piercing almond-shaped eyes. Also similar are the wrinkles at the corners of the eyes and on the forehead, the lines around the mouth, and the building up of the cheekbones. Thus, the face of the Saint James seems to be Luca's own work. But the same heavy-handed restoration that almost totally masked the other figures is also apparent here, making a final judgment impossible.

It is clear that, during the seven years following 1366 Luca di Tommè gradually outgrew any influ-

49. For more information regarding the iconography of this motif see Friedman, 1946.

50. The popular attribution of this painting is to either Sano di Pietro or Barna, and it was thus published in *Il Brucaiolo*, June 1967.

51. For a thorough discussion of this form of the Madonna of Humility theme in art see Meiss, 1951, chapter VI, *passim*. He points out that this was one of the most popular new subjects created in the late dugento or early trecento, to express a more human approach to religion and a new role for the Virgin as intercessor. Its infrequent representation after 1350 in Tuscany is an indication of a distinct shift in attitude toward this earlier imagery.

ence that Niccolò di Ser Sozzo might have exerted on his work. He also became highly productive and must have had a large shop, as well as an established reputation and clientele.

During these years Luca produced several highly imaginative works, such as his Pisa *Crucifixion*, the Siena *Saint Anne*, and the *Mystic Marriage of Saint Catherine* altarpieces. In each he demonstrated his keen awareness of current iconographic developments and in some instances, through judicious experimentation, he added a new dimension to the meaning inherent in a given image. It was at this time, too, that Luca vigorously explored and questioned basic painting traditions, as demonstrated by his often unexpected handling of figures and their relationship to their surrounding space, or the actual, physical articulation of his altarpieces. His figures themselves were made strong, solid, and convincing through his sure use of volume and anatomical detailing. His best works he imbued with deeply felt emotions intended to make a profound impression on the viewer.

To be sure, all these characteristics can be seen in his work from 1373 onward. But probably the single most important element that continued to develop during this next phase in Luca's work was his changing attitude toward pictorial representation. A shift can be seen before 1373, certainly, but only later does a decidedly different aesthetic become apparent.

The Later Works (1374–ca. 1390)

The final phase of the career of Luca di Tommè covered a span of nearly two decades, from 1374 to around 1390. A substantial body of works survives from this period, including six polyptychs—of which four are complete—and a number of smaller paintings. However, when compared to his output of the preceding ten years, this seems greatly diminished. On the one hand it can perhaps be explained simply in terms of the various factors that would be more favorable to the survival of art works from one period than from another. On the other hand, this apparently reduced production may have been due to Luca's involvement in the governmental affairs of the commune of Siena. His role in civic activities seems to have increased substantially after 1373, as did that of a number of his fellow artists—notably Andrea Vanni and Paolo di Giovanni Fei. Yet the volume of their work, insofar as we can determine, seems not to have been affected, or at least not to the same extent as in Luca's case.

On the evidence of some of his paintings, it seems that Luca maintained an active shop during this period. Contrary to what one might assume, the quality of the work is, for the most part, consistently high. He continued to deal with composition, space, and subject matter in an imaginative way, and his innovative experiments in articulating the relationship of his figures to their surrounding frame bear witness to a changing aesthetic. In addition to brightening his palette, he began to handle figures in such a way that they became highly stylized, flattened, and exaggerated anatomically. He seemed more concerned with such superficial considerations as the ornamentation and embellishment of his figures than with their substance. Finally, the increased feeling of tension in a number of his compositions from this period reflects a growing predilection for crowding and compressing his figures

into their compartments and making them seem to press against their frames.

In 1374 the commune of Siena commissioned Luca to paint an altarpiece commemorating the defeat of the Company of the Hat and honoring Saint Paul, the patron of the successful expedition against the brigands.[1] We do not know with any great degree of certainty whether or not the specific altarpiece mentioned in the documents survives, or even that it was completed. A likely candidate, however, is a polyptych, now in the Galleria Nazionale dell'Umbria in Perugia, depicting the *Madonna and Child Enthroned with Saints John the Baptist, Peter, Paul, and Apollinaris,* and in the pinnacles *Christ Blessing,* with *Saints Catherine, Anthony Abbot, Leonard, and Lucy* (Cat. 39, Pls. 39-1–39-4). Although its original location is unknown, evidence both internal

1. Documents 18a and 18b. The Saint Paul altarpiece was commissioned by the Sienese government to commemorate the defeat of the Breton Company of the Hat a decade earlier. Disobeying orders from the commune, which ordinarily met the demands of such bands, Roman Orsini, the general of the Sienese forces, defeated the mercenaries. For an account of the Sienese position with respect to mercenary bands in the trecento, see Professione, 1898. The Company of the Hat is discussed by Schevill, 1964, p. 246, and a first-hand report of the conflict is available in the Chronicle of Neri di Donati (Cronica Sanese) in Muratori, 1738–42, vol. XV, pl. 183E.

The government that took over in 1368 seems to have had a particular interest in this victory for they also commissioned in 1373 a large fresco of the battle, which took place in the Val di Chiana, for the *Sala del Mappamondo* of the Palazzo Pubblico. This fresco has often been attributed to Luca but is signed and dated by Lippo Vanni. It was first attributed to Luca by Perkins, 1909b, p. 49.

and external suggests that this may well be the work in question. (At the very least, the saint's prominent placement to the immediate right of the Virgin and Child would be consistent with the intentions of the commissioning agencies.)

Saint Paul is not often represented in Luca's paintings. He appears only five times within his major polyptychs. For a variety of reasons mentioned above (see Chapter III), the notion that the panel in Los Angeles (Cat. 33, Pl. 33) might be the work in question has already been dismissed. In addition to the Perugia work, only three other compositions, from among the major altarpiece panels, feature Paul in a prominent role. In all three cases either the original location or the date, or both, is known or can be ascertained with some assurance, and in all cases the data preclude their being connected with this commission. For example, the saint appears in the Rieti altarpiece (Chapter III, Cat. 27, Pl. 27), but the inscription on the painting proves that it was painted in 1370, four years before the work in question. Furthermore, the fact that it remained in the convent of San Domenico in Rieti until the end of the last century suggests that this was its original location.

Paul appears again in the Mercatello-Oxford polyptych (Cat. 24 and 25, Pls. 24-1–25-4). As shown, various stylistic elements permit us to date this work very near to the Rieti altarpiece. In addition, the survival to the present day of two of its components in the church of San Francesco in Mercatello would seem to establish a very strong link with that institution. We find Saint Paul once again, in a polyptych in the Pinacoteca Nazionale in Siena (Cat. 48, Pls. 48-1 and 48-2), but this too can be disqualified for two reasons. First, it should be grouped stylistically with Luca's very last works, that is, from the 1380s. Second, the original location of this work seems to have been the church of San Pietro a Venano, near Gaiole in the Chianti hills outside Siena. Thus, three of the five altarpieces with images of Saint Paul can be excluded from further consideration as the painting referred to in the 1374 payment records.

Other than the Perugia polyptych, Saint Paul occupies a special place in only one other known work. This altarpiece has been dismembered, and only a few of its components have come to light, specifically, four predella panels depicting episodes from the life of Saint Paul (Cat. 40–42, Pls. 40–42). Their large dimensions rule out their association with any of the four intact altars just mentioned, including that in Perugia. They can, however, be dated to this period on the basis of style, and it must be assumed that, as Saint Paul is the subject of at least the four known (lateral?) predella panels, he also would have occupied an important position in the main tier. Nonetheless, until further evidence comes to light—either in the form of additional panels that can be joined to this ensemble, or further documentation—it is necessary to reserve judgment on this work as having been the one ordered by the Siena commune in 1374.

To return to the Perugia polyptych itself, this can be dated for stylistic reasons to the 1370s. (An inscription located below the Madonna and Child—of which a fragment remains—once carried the name of Luca di Tommè and, presumably, the date as well.) Although the work is similar to the Rieti and Mercatello-Oxford altarpieces, there are notable differences. The principal figures are rendered in a flat, soft fashion. The face of Paul, for example, appears somewhat doughy in contrast to his earlier counterparts (cf. Pls. 39-2 with 27 and 25-2, respectively), and the coarse rendering of all the pinnacle figures indicates the intervention of Luca's shop.

In addition, a number of elements reveal the artist's changing attitude toward compositional variables and modes of representation. For one thing, the arched molding above the main figures is very carefully emphasized and highlighted by means of the intricate stamping on either side. This surface articulation is carried over into the punchwork of the halos, as well as into the delicately worked gold detailing of the hems of the garments, drawing the viewer's eye along their subtle curves. Luca's newfound interest in such decorative elements is further confirmed by his handling of the saints' names. Normally, in a work of this type and period, the names are lettered in black on the gold framing beneath each saint. Here, however, they are found in silver bands at the base of their compartments, proclaimed in vibrant red. Silver is used again in the backgrounds of all the pinnacle figures, and as far as we know, this is the first instance of the use of the metal in this fashion in Tuscan painting. Nor does it occur in other artists' work—perhaps because of its difficulty in working, or simply because of the weight of centuries of tradition behind the use of gold foil. In any case, Luca's use of silver is symptomatic of his experimentation with materials for

decorative ends. This is epitomized in the figure of Saint Apollinaris, whose mitre, cloak, rings, and brooch are ablaze with precious metal encrusted with gems. In fact, all the saints are visually sumptuous.

The composition itself brings forth another facet of Luca's changing aesthetic. All the figures seem compressed into their spaces, with only small portions of background visible above their shoulders and around their halos. Luca painted his figures as if they were in a confined space, thus creating the illusion that the frame was pressing in on them. This effect is heightened by the artist's handling of the pinnacle figures, and the intersecting molding beneath the latter represents an elaboration of the ideas at work in his previous experiments with the relationship of pinnacles to the field below. (See, for example, his polyptych in the Pinacoteca Nazionale in Siena—Cat. 32, Pls. 32-1–32-4.) Here, the overall effect of the molding is to constrict the space around the pinnacle figures and to depress that of the principal figures even more.

Viewed as a whole, these elements suggest that the artist had become more interested in surface pattern and superficiality than in substance and content. This is a significant departure from his primary interests of the previous decade, as exemplified in his Pisa *Crucifixion* (cf. Pls. 19-1–19-3). Pathos is replaced by prettiness, as lush detailing and an interest in form set the tone for his works to follow.

The scenes depicted in the four large predella panels mentioned earlier in this chapter read as follows: *Conversion of Saint Paul* (Cat. 40, Pl. 40), in Seattle; *Saint Paul Preaching Before the Areopagus* and *Saint Paul Being Led to His Martyrdom* (Cat. 41, Pls. 41-1 and 41-2), both in Siena; and the *Beheading of Saint Paul* (Cat. 42, Pl. 42), in Esztergom, Hungary. While the placement of this series within their original context is not known, one may safely assume that the narrative would have developed from left to right, as with the predella scenes from the life of Saint Thomas in the Siena altarpiece of 1362 (Cat. 11-13, Pls. 11-1–13-6). Using this earlier work as a model, it is probable that there would also have been a wider fifth panel, situated midway in the series and beneath the central panel of the original polyptych. While this panel has not yet been identified, its theme would probably have been either the Crucifixion or another episode from Paul's ministry.

The condition of the four panels varies considerably, making their attribution difficult. In fact, it was only in 1951 that Millard Meiss first suggested that they were painted by an associate of Luca di Tommè.[2] All four share certain characteristics seen in Luca's earlier works that assure their connection with Luca. Compare, for example, Luca's *Crucifixion* in San Francisco (Pl. 7) with the *Conversion* (Pl. 40), and the *Flagellation* in Amsterdam (Pl. 5) with *Paul Being Led to His Martyrdom* (Pls. 41-2 and 41-4). In each of the four panels, the figures tend to be placed in three distinct groups within a shallow space. In turn, these groups are held together compositionally by the landscape or architectural features, as well as by the gestures and gazes of the figures themselves. Also, the most dramatic gestural elements in the scene—for instance, a pointing figure—are frequently outlined in a dark hue and silhouetted against a vibrant color such as yellow or red. Figures at the outer edges of these compositions are often rendered in full profile and posed in such a way that they help draw the viewer's attention inward to the event itself. Concurrently, adjacent figures look out and away from the central action in order to balance this centralizing movement. In each of these panels the rendering of all the figures is robust and heavy, although at times somewhat flat in modeling, as in the case of the Pauline panels. Facial features are consistently dark and shadowed, and among other things give witness to the artist's preference for depicting eye sockets as more or less triangular slits.

A specific comparison of Luca's *Flagellation* painted before 1362 with his *Paul Being Led to His Martyrdom* (cf. Pl. 5 with Pl. 41-2) reveals how the artist repeated compositional and painterly devices from earlier paintings in his later works. In each panel a crowned figure is situated on the extreme left of the scene and in his left hand holds a rod, symbolizing the authority of pagan Rome. Moreover, the positions of the left arms and hands are virtually identical, and the attenuated and outstretched right arm pointing toward the prisoner in the center is common to both works. Further correspondences between the two panels are evident in the use of a tapestry with a looping border as a background element, as well as in architectural devices such as arches and columns, which serve to unite both compositions. The *Flagellation* figure in

2. Meiss, 1951, p. 34 n. 84.

exaggerated contrapposto who lays the whip on Christ while glancing back over his right shoulder toward Pilate is re-used in the later panel in the form of the soldier with winged helmet who looks back at the judge while pushing Saint Paul forward.[3]

The compositional structure of both panels is strengthened by a play of color, as in the juxtaposition of the dusky tones of the facial features against the warm, intense colors of the garments and architecture. While it is true that some of the facial and figural details seem to be less carefully painted in the Pauline series than in the earlier series, this might be explained by the uniformly damaged state of the panels, or by the intervention of Luca's shop. In any case their connection to Luca seems secure.

A pair of panels now in Florence can be dated to the 1370s or early 1380s and must have been side panels from a now dismembered polyptych. The numerous similarities between these two suggest that they originally constituted parts of the same ensemble. The postures and gestures of the two figures of *Saint Stephen* (Cat. 43, Pl. 43) and *Saint John the Baptist* (Cat. 44, Pl. 44) indicate that Stephen would have been located to the left of the central image while John would have been set to its right. Both saints are depicted in a similar format and the dimensions of their supporting panels are the same. The present frame around the Baptist is modern. Whatever decoration there may have been in the spandrels has been obliterated, although in its original state the topmost decoration would have been similar to that of the Saint Stephen image. However, the outline of the original molding, which was accentuated by a punched border, is still visible. The arc of the molding, which passed just over Saint John's head, also cuts off most of the upper part of his halo just as it does with Saint Stephen's halo. The profile of the capitals supporting the arch is also clearly outlined by a punched border, and the original columns that supported these capitals and arches passed very close to John, covering part of his cloak

and banderol. The Baptist stands on a marble floor with the toes of his left foot passing over its edge. His deep green mantle with its gold trim and red lining contrasts with the brown of his hair shirt and the darker brown of his tousled hair. His features are soft and graceful and complement the smooth, flowing lines in the folds of his drapery.

Stephen is similarly portrayed, and originally the molding above him intersected and continued on into the pinnacle area in a way similar to that in the Perugia polyptych; the area thus created in the spandrels still contains its painted decoration. The framing also constricted and covered a part of the saint's garments, judging from the outline of the punched border and paint film. Stephen's overgarment is flat with broad, looping folds while his features are softened and stylized much like the Baptist's. While this pair represents only a portion of a large, multi-paneled painting, it indicates that there was a continuing demand for such works by Luca throughout the 1370s and 1380s. It also shows that his flattened, decorative style, which first became defined in his earlier Perugia polyptych, seems to have been readily accepted in Siena. Further confirmation of this is offered in another fragmentary polyptych that survives from this period.

A *Madonna and Child with Christ Blessing* (Cat. 45, Pl. 45) and a *Saint Michael with Saint Peter* (Cat. 46, Pl. 46) are the only panels remaining from a polyptych that can probably be dated around 1380. The little-known pair had not been linked until recently. The similarity of such details as style, dimensions, molding and punchwork leave little doubt as to their original association. The Virgin holds the Christ Child in her lap while looking out at the viewer. Although shown playing with a finch, the Child seems distracted by something else off to the right, as if preoccupied with some premonition of His own Passion.

Saint Michael would have been placed to the left of the central panel and he is, indeed, a curious figure. The decoration of his cuirass is made up of exaggerated organic forms. His arms and hands are oversized, as is his sword hilt. In his left hand he holds a scale for the weighing of souls; but, in an image that is unique in fourteenth-century Tuscan painting as far as can be determined, the saved figure is balanced not by one of the condemned but by a fish, a symbol of man's redemption through Christ. It may be that the fish can be linked to the finch the Christ Child holds in his hands. As the finch stood

3. Other comparisons could be made to demonstrate further connections between Luca's earlier predella panels and the Saint Paul series but the consideration of this pair illustrates the point. Further adaptation of earlier forms appears, for example, in the unique device of the very low wall in the Amsterdam panel, which is similar in function to the step in the scene of *Paul Preaching Before the Areopagus* (Pl. 41-1).

for the close connection between the Passion and the Incarnation, the fish, rather than one of the damned, would have established a much stronger Christological link between the two panels, thus reinforcing their iconographic tie.

Several smaller panels have survived from this last period of Luca's activity, although all have been damaged—often to the extent that it is almost impossible to tell whether or not the master had a hand in painting them. Four of these works represent the *Madonna and Child Enthroned* and two depict *Saint Peter*. All share similar characteristics of figural style and emphasis on surface decoration and ornament.

Of the group the best preserved is the *Madonna and Child Enthroned with Saints Galganus and Ansanus* (Cat. 55, Pl. 55) now in the Yale University Art Gallery in New Haven. Here the Christ Child stands blessing in His mother's lap as they both look out at the viewer. The two Saints, both patrons of Siena, stand flanking them on either side, while a pair of angels hold a cloth of honor behind. In spite of the fact that the panel has sustained a great deal of abuse, the profusion of punchwork throughout it is almost overwhelming. It occurs at the edges of all the garments, in the halos and, from what is yet visible, along the top adjacent to the molding. As if this were not enough, the Virgin is portrayed with an elaborately bejeweled crown and posed against a richly textured cloth of honor. It would seem as if an over-zealous shop assistant had misunderstood the artist's controlled use of decoration, the result being a usage whose impact is diluted because it is so overdone.

The *Madonna and Child* in the Pieve of San Giovanni Battista in Pernina (Cat. 56, Pl. 56) shows a similar lack of restraint. Overly rich ornamentation appears in the Virgin's crown, the cloth of honor, her undergarment, and the hem of her cloak. Further, the Virgin is given a clasp for her cloak, as well as a ring. The Child, who is again depicted with a finch in His hand, is overdone in much the same way. Not only is His shirt highly decorated, but He is also shown wearing a piece of coral and a cross around the neck.

A *Madonna and Child* (Cat. 62, Pl. 62) in the Church of Santa Mustiola at Torri in Sovicille has been damaged and overpainted, although recent restoration has helped somewhat. Without doubt it can be connected to Luca's shop and, from what remains of the gold tooling, placed within the artist's later

phase of activity. The work seems especially derivative, with almost too much borrowing from Simone Martini's *Maestà*. But perhaps that again can be attributed to shop assistants' misunderstanding of earlier prototypes.

Another *Madonna and Child* (Cat. 64, Pl. 64) has suffered greatly, making a determination of date difficult.[4] One sees the by now familiar decorative elements from this period together with large flat areas of color. On the basis of photographs it seems to be still another shopwork from this phase of Luca's career.

Two panels, each containing representations of Saint Peter, disappeared during the course of World War II. The first (Cat. 65, Pl. 65) had originally been in the Sacristy of San Lorenzo at Bibbiano. It depicts a very solid, engaging figure who looks out from the composition and almost through the spectator. He displays his attributes of book and keys proudly in front of him. The tilt of his head, the line of his garment, and his silhouette make a very satisfactory composition. While there is again a strong emphasis on decoration here, it is now balanced successfully by the intent and sincere figure looking out at us.

His counterpart, formerly in San Pietro à Ovile in Siena (Cat. 66, Pl. 66), is somewhat less impressive, with none of the presence of the Bibbiano Peter. He is totally caught up in his own thoughts as he gazes down to his left and out of the painting. He does not make contact with us, leaving only the profusion of detailing to consider in his dress, halo, and keys. The net result is a feeling of emptiness.

Two final paintings can be dated in the 1370s or 1380s. They, too, have suffered greatly and were at one time parts of a predella, judging from their size and shape. *Saint Francis* and *Saint Catherine of Alexandria* (Cat. 61, Pl. 61-1 and 61-2) are depicted. Even in their ruined state one senses something of the powerful, emotive quality this pair originally possessed. Their massiveness reminds one of earlier compositions by Pietro Lorenzetti, which Luca favored so much at the beginning of his career. The determination of their date, given their condition, is difficult. Perhaps the profusion of stamping from the original quatrefoil, which surrounded them both at one time but is now visible only around Saint Catherine, can justify their inclusion in works done after 1374. Whatever the case, their expres-

4. The late Dr. Klara Steinweg kindly drew my attention to this work.

siveness and strength seem to us to warrant their inclusion in Luca's catalogue.

While some of the paintings just discussed may seem like perfunctory performances, they are nonetheless useful both as a gauge of the output of Luca's shop and as indications of how the artist's ideas were exaggerated or misinterpreted in the hands of assistants. The following group of paintings was produced during the 1380s and two polyptychs in particular, those from Cascina and Venano, are of high quality and eloquently represent the artist's last works.

One of Luca's finest achievements from this period is an unusual altarpiece that was for a number of years in Cascina, near Pisa, the *Annunciation with Saints Francis, Nicholas of Bari, Thomas, and Matthew*, with the prophets *Elisha, Aaron, Malachi*, and *Isaiah* in the tondi, and two unidentified prophets in the spandrels (Cat. 47, Pls. 47-1–47-7). Its date and original makeup have been the subject of some discussion. Ugo Procacci, for example, suggested that it was painted between 1362 and 1366. Hendrik van Os proposed a date of ca. 1365 for the altarpiece, arguing that it can be placed stylistically between the 1362 polyptych (Cat. 13, Pls. 11-1, 13-1–13-6) and Luca's 1366 *Crucifixion* in Pisa (Cat. 19, Pls. 19-1–19-3).[5] In addition, van Os contended that the predella panels depicting the life of Thomas (Cat. 11, Pls. 11-2–11-5) ought to be attached to the Cascina work and not to the Saint Thomas polyptych in Siena. But the four predella panels and the Vatican *Crucifixion* (Cat. 12, Pl. 12-1) with respect to both style and dimensions must be considered together as a series, and their total width exceeds that of the Cascina altarpiece, thereby precluding any such connection.[6] Even if one were to exclude the Vatican *Crucifixion*, the width of any one of the Saint Thomas predella scenes is greater than the width of any of the lateral panels in the Cascina polyptych. This discrepancy in scale and proportion alone is sufficient to negate any connection between the works. Moreover, the format of the altarpiece and the style of the figures are substantially different from corresponding aspects of Luca's work between 1362 and 1366. The artist's experiments with the form of the polyptych began only toward the end of the 1360s or the beginning of the 1370s. Furthermore, Luca used the tall, multilobed molding that appears above the figures here only from about 1370 onward as, for example, in the Rieti altarpiece of 1370 (Pl. 27) and the Paris *Annunciation* group (Pls. 26-1 and 26-2). Stylistically the Cascina altarpiece is also more compatible with these later works. In all of them we see large, more two-dimensional figures severely confined by their tight frames while their facial details have become more linear and stylized.

The representation of the Annunciation as the central theme of a large altarpiece was already unusual during this period, but Luca's version presented here is unique.[7] The Virgin and Gabriel stand in a very narrow, vertical space, each appearing almost unaware of the other's presence (Pl. 47-2). Dramatic elements have been eschewed in favor of a more contemplative mood. An atmosphere of restraint and humility seems thus to set the proper stage for the descent of the Holy Spirit. Van Os suggested that the Cascina altarpiece is a special variant of the Annunciation—the *unio mystica*—which emphasized the mystery of the Annunciation.[8] This unusual iconography, he felt, might connect the work to a circle of Franciscan spiritualists, who may well have commissioned it.

A polyptych depicting the *Madonna and Child with Saints Vincent, Peter, Paul, and Lawrence* (Cat. 48, Pls. 48-1 and 48-2) is strikingly similar to the Cascina painting and helps to confirm a late date for the latter. The altarpiece was formerly in the Church of San Pietro in Venano, Gaiole in Chianti, near Siena, and has only recently been recovered by the Italian

5. Van Os, 1969a, no. 22, and van Os, 1969b, p. 46 n. 37. This opinion was rejected by Fehm, 1969, p. 574.

6. The total width of the Cascina altar is 162.5 cm. and the width of the five panels from the Crawford Collection and from the Vatican is 181.4 cm.

7. The most notable earlier representations on this scale are those by Simone Martini in the Uffizi and by Ambrogio Lorenzetti in the Siena Pinacoteca Nazionale (illustrated in van Os, 1969b, pls. 1 and 5). For further discussion see Chapter III, pp. 37–39, and notes to Chapter III, no. 34.

8. The theme of the Annunciation in Sienese art is thoroughly discussed in Chapter Two of van Os's book (1969b). He proposes that Simone's version can be understood according to the inscription on the panel itself: "Ava gratia plena." The Virgin has already accepted Divine Grace with a gesture of gentle humility. A different meaning is present in Ambrogio's panel of 1344. Here the Virgin says: "Ecce ancilla Domini," thereby humbly assuming her role as the Mother of God. Van Os also discussed Luca's altar in this section of his book (van Os, 1969b, pp. 37–57).

government. Although it was cleaned and restored in 1979, the cloak of the Virgin is almost completely ruined. However, the condition of the paint surface in the rest of her panel, as well as throughout the four lateral ones, is generally very good. During the course of cleaning an inscription bearing the artist's name (but no date, unfortunately) on the framing came to light under the central panel. The lateral saints, each depicted with his own symbolic attribute, are shown standing on marble steps as they turn toward the Madonna and Child. She looks out at us engaging our attention, while the Christ Child, totally oblivious of us, focuses on the object He is holding. This formula, which we have seen Luca use time and again, here reveals its continuing effectiveness in drawing the viewer's eye into and throughout the various components of the altarpiece ending with the image of the youthful Saviour.

The *Saint Lawrence* is typical of all the lateral figures. Portrayed with his familiar attribute of the grill, he is crowded into his panel while the ornate, scalloped molding above cuts into his halo. In style and structure he could almost be the mirror image of the *Saint Stephen* in Florence, and his facial features virtually duplicate those of *Saint Thomas* in the Cascina polyptych (cf. Pls. 43, 47-4, and 48-2). The distinct C curve of the line of the ear, the high, sharp hairline, the crisp, pointed chin, the narrow, darkly outlined eyes and the thin, elongated neck are details common to both. Ornament plays an important role in the Lawrence panel as large areas of the surface of the picture are covered with silver and gold pattern. This profusion of pattern is duplicated at the opposite end of the altarpiece in the figure of *Saint Vincent*. Fortunately, parts of the original frame survive, on which we see the same use of geometric pattern worked out in contrasting bright colors. The similarities in the molding, figural details and surface ornamentation in the Cascina and Venano polyptychs indicate that they were made within a relatively short time of one another, probably in the 1380s.

The last polyptych dating from this period is from the convent of San Francesco, Lucignano, in Valdichiana, and is currently in the Pinacoteca there. The *Madonna and Child with Saints John the Baptist, Michael, Peter, and Catherine of Alexandria* are depicted, with *Christ Blessing and Two Angels, the Angel Gabriel, Saints Paul and Bartholomew and the Virgin Annunciate* in the pinnacles (Cat. 49, Pl. 49). Here,

Saint Michael is presented holding a small model of a city on whose wall appears the coat of arms of Lucignano. As Michael was the protector of that city it is probable that this work graced the high altar of one of its principal churches. Michael's role as protector and, indeed, the rather stridently militaristic character of the work is stressed by the fact that apart from Christ Blessing only the armed men look out at the viewer.[9]

The shape of the polyptych is similar in many respects to one in Siena discussed earlier (Cat. 32, Pls. 32-1–32-4): the height of the panels is stepped in an ascending order from the outermost to the center picture, and the panels in the lower field cut deeply into the area of the pinnacles surmounting them. Unlike the earlier Siena altarpiece, however, the width of the lateral panels is here uniform, and all the figures are portrayed full length. The figures have become more flattened and stylized than in Luca's earlier works. Curiously, the central panel is crowned by not one but three pinnacles, depicting Christ Blessing and two adoring angels. Equally unusual is the placement of the *Annunciation* in the outermost pinnacles. In no other altarpiece of this size does the scene occupy this position. It may be that Luca had the dynamics of a small, folding triptych in mind when he used this format in a polyptych. The effect would have been similar to that in Luca's portable altarpiece in San Diego where Gabriel greets Mary across a space in which the figure of the resurrected Christ intervenes (cf. Pl. 4-1). In the Lucignano work several figures are present in this interval across space from one side of the altarpiece to the other, but the image of the Madonna and Child surmounted by Christ Blessing makes a strong vertical axis between the two at either end and directs the viewer effectively downward to focus on the Madonna and Child.

A *Madonna and Child* formerly in the church of San Francesco, Montalcino, is a very late work by Luca (Cat. 50, Pl. 50). Its composition is quite similar to that of the central panel of the Lucignano altarpiece, and although it is in poor condition, the same stylistic elements present in the artist's other works from this period are discernible here. The holy pair seem on the point of bursting the confines of the panel, because the space they occupy is so exceedingly cramped. Another important detail

9. This was first suggested by G. Kaftal, 1952, p. 737.

unique within Luca's art is the raised floral decoration in the Child's halo. The thickness of this raised decoration in the halos is brought up to that of the shallow molding. In contrast to other works in which the molding intercepts and overlaps portions of the figures' halos (as, for example, in the Cascina and Venano works), here both the Virgin's and the Child's aureoles appear to pass in front of, rather than behind, the molding. These elements dramatically heighten the tension between the figures and their surrounding space. Here, as in others of his works of the 1370s and 1380s, the artist is experimenting with a rather limited vocabulary of forms within a highly restricted format. One feels again that Luca is trying to give his figures a real presence by having them press up against and even break out of their surrounding frames.

Among the last works we know of from this period is a polyptych in which Luca is said to have collaborated with Bartolo di Fredi and Bartolo's son Andrea. Although the work is lost, several documents concerning the commission remain. One record reports that on August 21, 1386, the Siena cathedral authorities allocated their chapel of Saint Agnes to the *Calzolai* or shoemakers' guild. A little less than three years later, on April 23, 1389, the cathedral works committee acceded to the guild's request to provide 130 gold florins for an altarpiece for their chapel. Two days later the terms of this contract were reiterated but in greater detail and the names of the three artists selected for the work were revealed. These were Luca di Tommè, Bartolo di Fredi, and Andrea di Bartolo. By its terms the contract stipulated that the artists were to be paid in installments over a period of a year and a quarter.[10]

One can speculate that the central panel would have contained the Madonna and Child enthroned. It is reasonable to assume, too, that Saint Agnes, to whom the chapel was dedicated, might have appeared, and it is likely that Saints Crispin and Crispinian, two early Christian martyrs who were themselves shoemakers and who were adopted as the patron saints of that guild, may have figured in the work. Perhaps the ensemble was completed by the inclusion of one of the patron saints of the city.

One final commission is reported in the last secure documentary reference we have concerning Luca. On May 5, 1390, the Sienese merchant, Marco Bindi Gini, made his last will and testament. By its terms he was to be buried in the chapel recently donated to the new Franciscan church in Siena that he had helped to fund. Furthermore, in his will, Gini provided 40 gold florins for an altarpiece to be made specifically by Luca for the altar of this chapel. Unfortunately, we know of no painting that can be connected to this contract.[11] After this commission there is no further trace of the artist in the archival record and it seems that he must have died in that year or shortly thereafter.

10. See Documents 25a–25g. For a good, brief survey of the activity of Bartolo di Fredi see van Marle, 1924, vol. II, pp. 483–508 and also Bush, 1947, *passim*, although her study is now dated. For a discussion of his important cycle of Old Testament frescoes in the Collegiata, San Gimignano, see Carli, 1949, pp. 75–76.

11. Document 28. Ettore Romagnoli, *Biografia*, vol. II, p. 297, reports that this panel was destroyed in the fire that swept the church of San Francesco in 1699. I have not been able to locate the fresco in the chapel of the Concezione in the same church that, according to Della Valle, bore Luca's name and the date 1392.

Catalogue

This catalogue of the oeuvre of Luca di Tommè, in addition to providing physical and bibliographic information, gives the literary and photographic sources and provenance for each of the paintings included herein. Of most interest to us is the way in which the catalogue reveals the changing, developing, and sharpening perceptions of the artist's work over the last four hundred years. The growth of literature on Luca reflects the increasing interest in Italian trecento artists in general, and distinguished scholars and connoisseurs such as Millard Meiss, Federico Zeri, Bernard Berenson, and Raimond van Marle—to name a few—have considered Luca's contribution and importance in their studies of pre-Renaissance Italian painting.

While Siena had no major propagandist for her art as Florence did in Giorgio Vasari, accounts of some of the more illustrious artistic figures do appear in the latter's *Le Vite de' più eccellenti pittori, scultori ed architettori*. The first mention of Luca di Tommè occurs in the second edition of Vasari's work, which appeared in 1568. In the biography devoted to Barna da Siena Luca is referred to not only as a former pupil of that artist, but also as a master painter in his own right. He is also reported to have been quite prolific. Among his works Vasari cites an altarpiece and frescoes in the chapel of the "Dragomanni" family in the Church of San Domenico at Arezzo.[1]

Luca di Tommè's name does not appear again until 1786 when, in an apology for Sienese art, Padre Guglielmo Della Valle claimed to have found an inscription bearing both Luca's name and a date in the Chapel of the Concezione in San Francesco in Siena. Della Valle made two other attributions to Luca.

These were the signed and dated altarpiece depicting the *Madonna and Child with Saint Anne* (Cat. 22) of 1367, and the *Crucifixion* (Cat. 19) in Pisa.[2] Here, in the last quarter of the eighteenth century, a touchstone for subsequent attributions was established.

Gaetano Milanesi, in his edition of Vasari's *Lives* (1878–85), suggested that Luca had been a follower of Simone Martini rather than of Barna.[3] In addition, Milanesi made one new attribution to Luca in his collection of Sienese documents—which had appeared in 1854—that of a signed stepped polyptych in the Oratorio of the Monastery of the Tolfe near Siena (Cat. 32).

Throughout the nineteenth century enthusiasm for Italian "primitives" increased greatly on both sides of the Atlantic. Toward the middle of the century James Jackson Jarves attempted unsuccessfully to establish a public art museum, first in Boston and then in New York, using his own collection as a nucleus. Although his idea came to naught, his efforts did play a major part in the generation of interest in early Italian painting in America. Housed with his large collection of thirteenth-, fourteenth-, and fifteenth-century Italian pictures was Luca's *Assumption of the Virgin* (Cat. 15). Jarves considered this work so important that he had it engraved for inclusion—one of the very few—in the 1861 catalogue of his own collection.[4]

The first real attempt to establish the extent of Luca's oeuvre was made by F. Mason Perkins, a specialist in Sienese painting, in a series of articles published between 1905 and 1938.[5] Perkins attributed seventeen pictures to the artist, the most important of which are the 1362 altarpiece (Cat. 13),

1. Vasari, 1568, ed. Milanesi (1878–1885) I, p. 651. Salmi, 1930, pp. 1–8, deals with the problem of the chapel and its frescoes at length. He shows that the chapel was the responsibility of the Dragondelli (not "Dragomanni") family, and that the frescoes are from the following of Barna da Siena. (See also Fehm, 1978, p. 159.)

2. Della Valle, 1786, II, p. 119. I have not been able to locate the inscription in San Francesco.

3. Vasari, *op. cit.*, p. 651 n. 3; and Milanesi, 1854, vol. I, p. 28 n. 1.

4. Jarves, 1861, plate B.

5. The numerous articles by Perkins appear in the Bibliography below. The more important of these are: Perkins,

the *Assumption of the Virgin* (Cat. 15), and the *Mystic Marriage of Saint Catherine* (Cat. 30). Perkins did not establish any internal chronology for the impressive body of paintings he had identified, although he did make a strong case for the influence of Pietro Lorenzetti in some of the works.

In 1924, Raimond van Marle published the second volume of his *The Development of the Italian Schools of Painting*, concurring with all of Perkins's attributions and adding two of his own. These are the *Madonna and Child* (Cat. 37) and the altarpiece now in Perugia (Cat. 39).[6]

Slightly later, in 1931, Cesare Brandi discovered a processional banner by Luca in Montepulciano (Cat. 8), in which he saw the influence of both Simone Martini and Pietro Lorenzetti.[7] In the following year he uncovered an inscription on the 1362 altarpiece[8] (Cat. 13), which unexpectedly contained the names of two painters: Niccolò di Ser Sozzo and Luca di Tommè.

That same year saw the appearance of Bernard Berenson's *Italian Pictures of the Renaissance*.[9] His list of works by Luca di Tommè is a resumé of earlier attributions, both accurate and inaccurate. Of the forty-seven paintings he assigned to Luca, only twenty are acceptable in our view as being the work of either the master or his shop. In the 1936 Italian version of his work, Berenson added four more pictures to the list, all of which are correct attributions.[10]

Ten years later, Millard Meiss reconstructed the work of a painter whom he designated as the Master of the Pietà,[11] and pointed out that the artist showed an affinity to Luca's work of the 1360s. In his *Painting in Florence and Siena after the Black Death*, of 1951, Meiss discussed two additional works that he felt were by Luca di Tommè himself.[12] He assigned the San Diego triptych (Cat. 4) to the pre-Niccolò period, while three predella panels depicting the life of Saint Paul (Cat. 40 and 41) he situated in a later phase of the painter's career, noting at the same time the possibility of their being the work of one of Luca's associates. Here at last an initial internal chronology for some of the works had been established.

Federico Zeri made a substantial contribution in 1958 when he proposed that four predella panels (Cat. 11) in a private collection could be joined with a fifth in the Vatican (Cat. 12), thus completing the predella of the jointly signed altarpiece of 1362 (Cat. 13).[13] He also added an *Annunciation* (Cat. 26) to Luca's oeuvre, along with several other pictures that are now thought to be the work of another artist. In response to Zeri, Meiss assigned the series of predella panels depicting events in the life of Mary Magdalen, and two panels from a dismembered polyptych, to an artist whom he called the Master of the Magdalen Legend.[14] At the same time Meiss also published a group of three pictures that he felt ought to be placed at the beginning of Luca's career (Cat. 1, 2, and 4).

The revised Berenson lists of 1968 attribute a total of fifty-seven pictures to Luca.[15] Of these I accept forty-three as the work of the painter or of his shop, and have expanded this with the inclusion of a disassembled predella series (Cat. 16 and 17), and the conjoining of two previously unknown pictures in Oxford (Cat. 25) with two others at Mercatello sul Metauro (Cat. 24).[16] Since then there have been other, individual panels assigned to Luca. Perhaps the most notable recent study is that by Cristina De Benedictis, in which a Luca *Madonna and Child* (Cat. 10) was published for the first time.[17] Undoubtedly, more of the work of Luca di Tommè will come to light, as scholars continue to fit together the various puzzle pieces.

The following catalogue is divided into three sections. The first portion contains those works I feel

1920, pp. 287–91, which deals with the 1362 altarpiece; Perkins, 1924, p. 15, which discusses the Yale *Assumption of the Virgin*; and Perkins, 1908b, p. 80, which treats the *Mystic Marriage of Saint Catherine*.

6. Van Marle, 1924, vol. II, pp. 470 and 476.

7. Brandi, 1931, p. 18.

8. Brandi, 1932, pp. 222–36.

9. Berenson, 1932, pp. 312–14.

10. Berenson, 1936, p. 269. The four further pictures that Berenson added to Luca's oeuvre are the Cascina altarpiece (Cat. 47); the four predella panels from a private collection (Cat. 11); a *Crucifixion* now in San Francisco (Cat. 7); and a panel depicting the *Virgin Annunciate* (Cat. 29).

11. Meiss, 1946, pp. 8–12.

12. Meiss, 1951, p. 34, and 34 n. 84.

13. Zeri, 1958, pp. 3–16.

14. Meiss, 1963, pp. 47–48.

15. Berenson, 1968, vol. I, pp. 224–26. From Berenson's list I have included here only those panels that I attribute to Luca di Tommè or to his shop.

16. Fehm, 1969, pp. 574–77; Fehm, 1973a, pp. 5–32; Fehm, 1973b, pp. 463–66.

17. De Benedictis, 1979, p. 88.

were painted entirely or primarily by Luca di Tommè. Section two contains those works that are closely related to the first and originated in his shop but which, for one reason or another, cannot be fully attributed to the artist. (In some instances the physical state alone of a work influenced this decision.) Finally, in section three, five works are listed that we have not been able to trace and therefore consider lost. One is mentioned by Vasari (Cat. 68), and the remainder appear in the documents (Cat. 69 through 72).

Each catalogue entry is made up of several paragraphs and is organized in the following way. Part one gives the complete title of the work, its original function, the date of execution, whether specific or approximate, an indication of other panels from the same ensemble contained in the catalogue, and, of course, the dimensions and illustration numbers. Part two provides the current location (when known) and an inventory or accession number. Part three then follows with any inscriptions that might be contained within the picture or on the original frame. A condition report is given in part four. In an attempt to establish some consistency in my assessment of the physical state of the works, I have assigned to each painting one of five designations, ranging from "poor" to "excellent."

The provenance for each picture is then given—where known—and is presented chronologically. Then follows a section dealing with the exhibition history of the work. When a painting is cited in an exhibition catalogue, this citation does not appear again in the bibliography. A separate paragraph is devoted to attributions where information is available. These are arranged alphabetically, and are of two sorts: those written by the critic himself, and those expressed to a second person who then recorded it.

The next-to-last section contains a bibliography. This is arranged chronologically and provides a complete list of references for each picture. Attributions are given only when they differ from my own. Finally photographic sources are listed and include negative numbers, when available.

Accepted Works

1. *Madonna and Child Enthroned with Saints Louis of Toulouse and Michael.* Central panel, portable triptych (ca. 1356–61).

55.4 × 26.7 cm. (21¾ × 10½ in.). Pl. 1.

Location: Los Angeles County Museum of Art, no. 57.68. Anonymous gift.

Condition: Very good. The panel has been cleaned recently. Some paint loss is noticeable in the cloth of honor directly above the Madonna and a few passages on her cloak. The framing is modern.

Provenance: Art Market, New York; Los Angeles County Museum of Art, 1957 (anonymous gift).

Attributions: R. Pallucchini (manuscript opinion, Los Angeles County Museum of Art: Ambrogio Lorenzetti); J. Pope-Hennessy (manuscript opinion, Los Angeles County Museum of Art: Ambrogio Lorenzetti); F. Zeri (verbal opinion, New York, Frick Art Reference Library, 20 June 1963).

Bibliography: *Gazette des Beaux Arts*, 1960, p. 30, fig. 103 (Ambrogio Lorenzetti); Meiss, 1963, p. 48, fig. 2; Los Angeles, 1965, p. 57; Fredericksen and Zeri, 1972, pp. 113, 317, 355, 424, 433, and 592; Fehm, 1973a, pp. 14, 16, 18–22, 27 n. 30, fig. 12; Muller, 1973, pp. 12–21, figs. 1, 3, 4, and 5; Fehm, 1976, p. 348 n. 31; Zeri, 1976, p. 41; Fehm, 1978, pp. 159 and 164 n. 17; De Benedictis, 1979, p. 87, fig. 69.

Photographs: Los Angeles County Museum of Art.

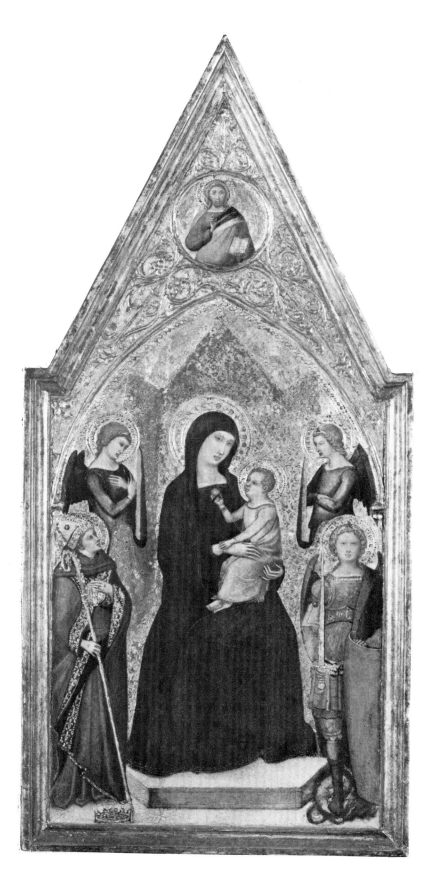

Pl. 1. *Madonna and Child Enthroned with Saints Louis of Toulouse and Michael.*

2. *Crucifixion*. Predella panel (ca. 1356–61).
19.8 × 20 cm. (7¹³⁄₁₆ × 7⅞ in.) without frame.
Pl. 2.

Location: Staatliches Lindenau-Museum, Altenburg,
East Germany, no. 33.

Inscription: INRI (John 19:19).

Condition: Fair. The panel has been cut down on all
sides, especially across the top and bottom. The gold
ground has been rubbed, and losses are particularly no-
ticeable near Christ's torso and upper legs. The halos
of the Madonna and John have been reinforced; some
of this repaint has begun to blister and fall away.

Provenance: Staatliches Lindenau-Museum, by 1898.

Attributions: E. Sandberg-Vavalà (quoted in R. Oer-
tel, 1961, p. 78).

Bibliography: Becker, 1898, p. 26 (Tuscan School of
the 14th century); Becker, 1915, p. 36 (Tuscan School
of the 14th century); Meiss, 1951, p. 34 n. 84 (associate
of Luca di Tommè); Oertel, 1961, p. 78, pl. 13; Meiss,
1963, p. 47 n. 7; Fehm, 1973a, pp. 15, 17–19, 24–25,
31 n. 28, fig. 28; De Benedictis, 1979, p. 86.

Photographs: Dresden, Deutsche Fotothek, negative
no. 96288.

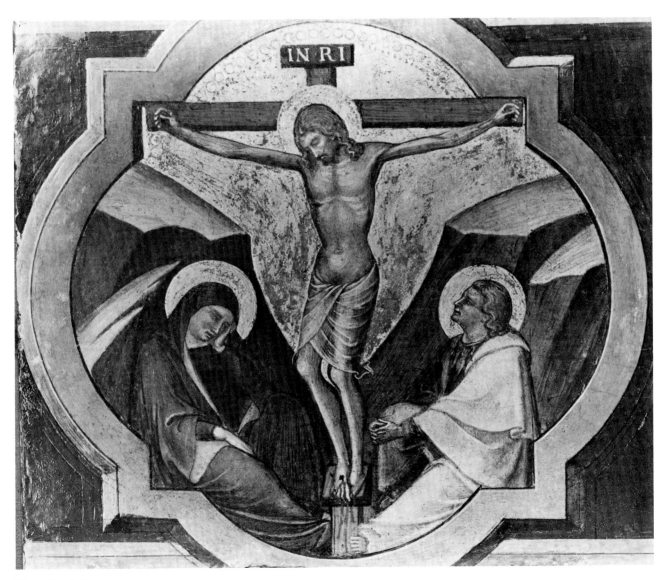

Pl. 2. *Crucifixion*.

3. *Crucified Christ with the Virgin, Saints John the Evangelist, Francis and Christ Blessing* (recto); *Crucified Christ with Saints Paul, Michael, Peter, and Louis of Toulouse* (verso). Processional crucifix (ca. 1356–61).

43.8 × 30.8 cm. (17¼ × 12⅛ in.). Pls. 3-1 and 3-2.

Location: Fogg Art Museum, Cambridge, Massachusetts, no. 1970.59. Bequest of Mrs. Jessie Isidor Straus.

Inscription: (Christ, recto) EGO / SVM / VIA / VER / ITAS / ET· VI / TA·Q / VI·C[REDIT·IN·ME] (conflation of parts of John 14:6 and 11:25); INRI (John 19:19).

Condition: Good. Small and uniform paint losses have occurred throughout the painted areas (recto and verso). Portions of the Madonna's cloak and the cross (recto) have been retouched. Vertical blistering and paint loss have occurred within the figure of the archangel (verso). Two vertical splits pass through Christ's arms (recto); two lateral splits pass over His head and through His stomach (verso). These last two splits have been filled and have begun to blister. The framing is largely original.

Provenance: R. von Kaufmann, Berlin; Jesse I. Straus, New York, 1917; Mrs. Jesse I. Straus, New York, 1936; Fogg Art Museum, 1970.

Bibliography: Sale Catalogue, M. Friedlander (ed.), Richard van Kaufmann Collection, Berlin, December 4, 1917, p. 32, no. 13, pl. opp. p. 32; Perkins, 1929, p. 427; Offner, 1930, vol. III, no. 6, p. 166 n. 1 (follower of Luca di Tommè); Berenson, 1932, p. 313; Berenson, 1936, p. 269; *New York Times Index*, 1936, p. 775; Meiss, 1963, p. 47, fig. 3; Berenson, 1968, vol. I, p. 225; van Os, 1969b, p. 69 n. 96; Fehm, 1973a, p. 30 n. 24; De Benedictis, 1979, p. 87.

Photographs: Fogg Art Museum; Soprintendenza alle Gallerie, Gabinetto Fotografico, Florence, negative no. 55219 (recto); Frick Art Reference Library, New York, negative no. 5522 (recto), negative no. 5523 (verso).

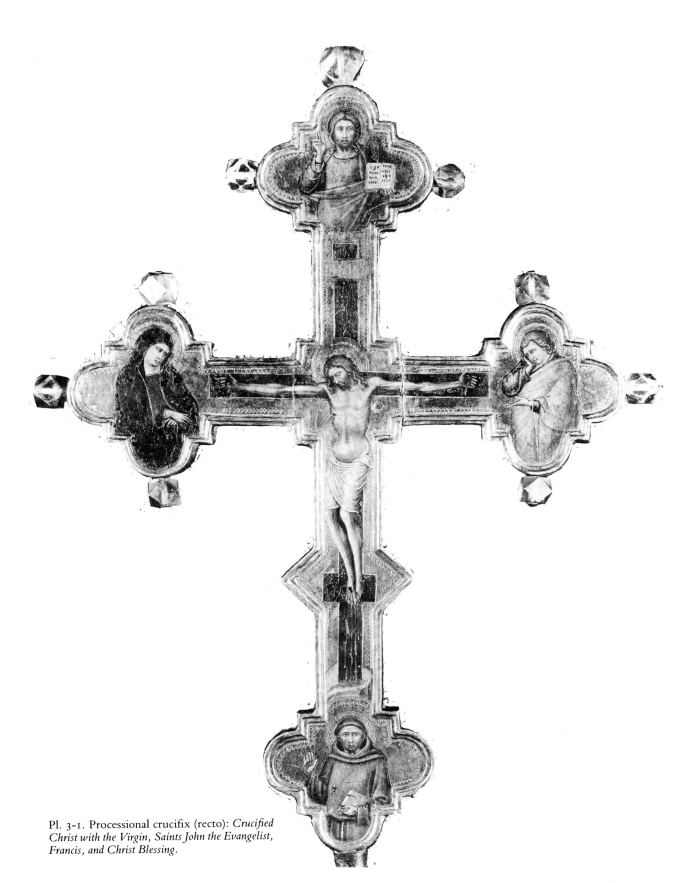

Pl. 3-1. Processional crucifix (recto): *Crucified Christ with the Virgin, Saints John the Evangelist, Francis, and Christ Blessing.*

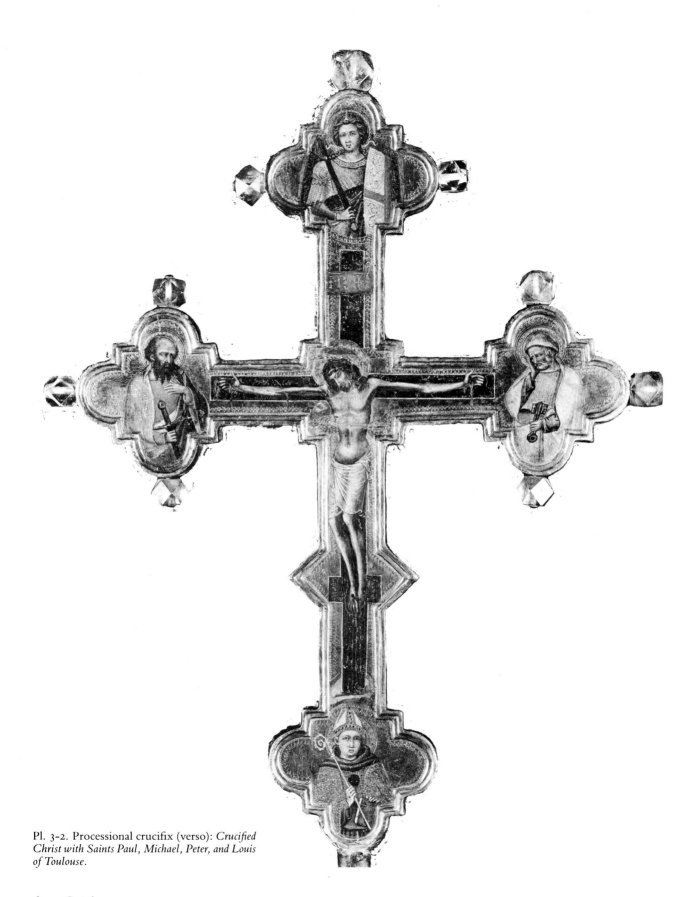

Pl. 3-2. Processional crucifix (verso): *Crucified Christ with Saints Paul, Michael, Peter, and Louis of Toulouse.*

60 · Catalogue

4. *Crucifixion with* Trinity, *Nativity*, *Adoration of the Magi*, *Mocking of Christ* and *Deposition*; in the pinnacles, *Resurrection* and *Annunciation*. Portable altarpiece (ca. 1356–61).

56.5 × 53.5 cm. (22¼ × 21 in.). Pls. 4-1–4-9.

Location: Timken Art Gallery, San Diego, California, no. 3.1967. The Putnam Foundation.

Inscription: (Angel Gabriel) AVE · [MARIA] · GRATIA · PLE[NA] (Luke 1:28).

Condition: Excellent. The triptych is well preserved. Only a few losses of gold trim are discernible in the garments of the figures in the lateral scenes. The framing is largely original; however, it has been regilded, and in a few areas small losses have occurred.

Provenance: Art Market, Paris, 1930; Duveen and Co., New York; T. S. Hyland, Greenwich, Connecticut; The Putnam Foundation, San Diego, California, 1967 (on loan to the Timken Art Gallery).

Exhibitions: the Walters Art Gallery, Baltimore, Mary-

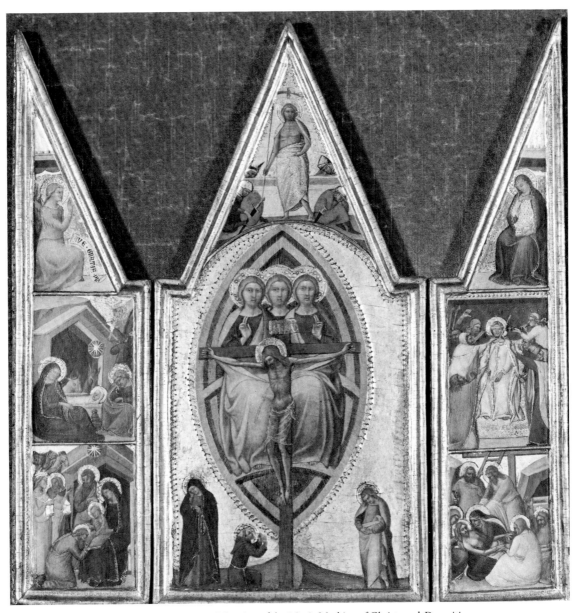

Pl. 4-1. *Crucifixion with* Trinity, *Nativity,* Adoration of the Magi, *Mocking of Christ,* and *Deposition;* in the pinnacles, *Resurrection* and *Annunciation.*

land, *The International Style*, October 23–December 2, 1962, p. 18, no. 17, pl. IX; the Wadsworth Atheneum, Hartford, Connecticut, *An Exhibition of Italian Panels and Manuscripts from the Thirteenth and Fourteenth Centuries in Honor of Richard Offner*, April 9–June 6, 1965, p. 23, no. 32; Fogg Art Museum, Cambridge, Massachusetts, on loan, 1967–68.

Attributions: (Manuscript opinion, Duveen and Co., New York: Lippo Vanni).

Bibliography: Meiss, 1951, pp. 34, 34 n. 84, 35, and 38 n. 104, fig. 50; Braunfels, 1954, XLI, fig. 42; Meiss, 1963, p. 47; Berenson, 1968, vol. I, p. 226; Mongan, 1969, pp. 22–24, 107–108, no. 3, ill. opp. p. 22; van Os, 1969b, pp. 68 n. 94, n. 96, and 71 n. 109; Fredericksen and Zeri, 1972, pp. 113, 268, 272, 284, 291, 295, 297, 302, 360, 396, and 632; Fehm, 1973a, p. 30 n. 24; *European Paintings* 1977, p. 9; De Benedictis, 1979, pp. 48, 67 n. 79, and 88, fig. 90.

Photographs: Fogg Art Museum (overall and details); Timken Art Gallery (overall).

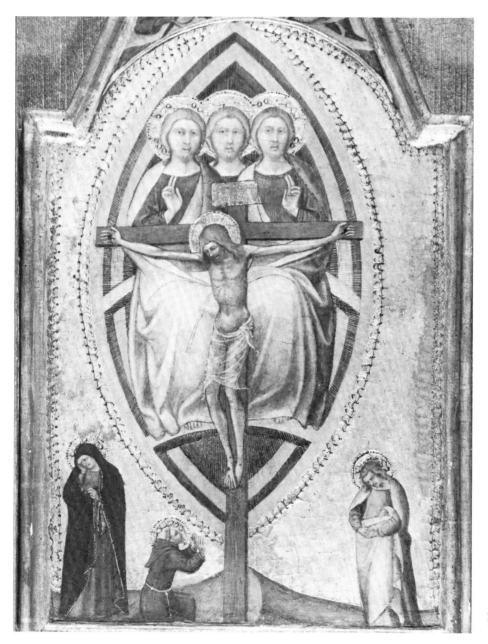

Pl. 4-2. *Crucifixion with Trinity* (detail of Pl. 4-1).

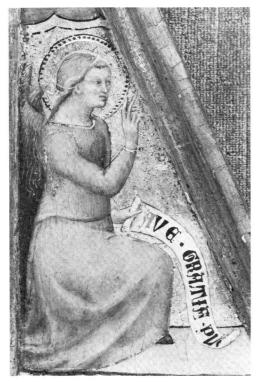

Pl. 4-3. *Angel Gabriel* (detail of Pl. 4-1).

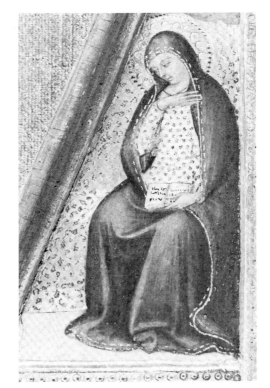

Pl. 4-4. *Virgin Annunciate* (detail of Pl. 4-1).

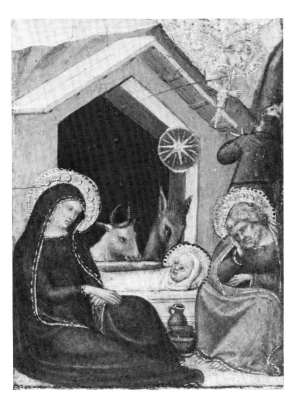

Pl. 4-5. *Nativity* (detail of Pl. 4-1).

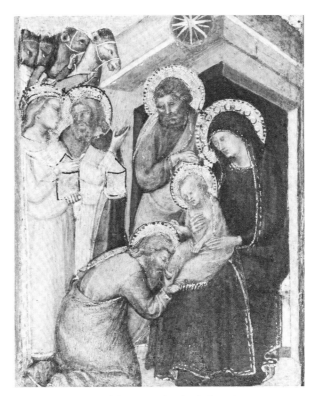

Pl. 4-6. *Adoration of the Magi* (detail of Pl. 4-1).

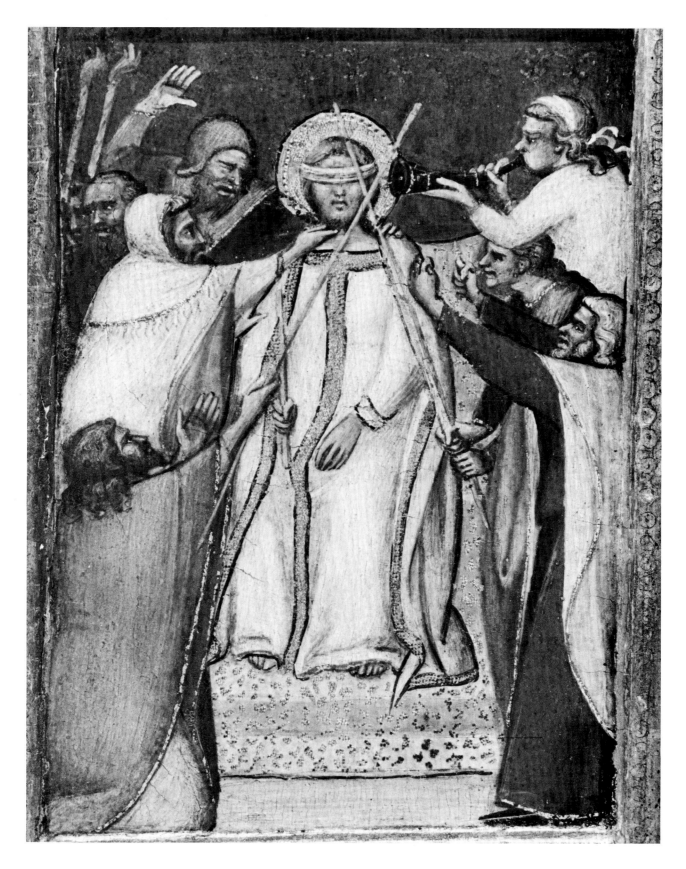

Pl. 4-8. *Deposition* (detail of Pl. 4-1).

Pl. 4-9. *Resurrection* (detail of Pl. 4-1).

Pl. 4-7. *Mocking of Christ* (detail of Pl. 4-1).

5. *Flagellation*. Predella panel (ca. 1356–61).

39 × 28.5 cm. (15⅜ × 11¼ in.). Pl. 5.

Location: Rijksmuseum, Amsterdam, no. 1489EI.

Condition: Very good. The panel has been cut down on all sides. A lateral split running from the left above the column capitals and diagonally upward from above the figure of Christ has been repaired during a recent cleaning.

Provenance: Dr. Otto Lanz, Amsterdam; Dienst voor's Rijks Verspreide Kunstvoorwerpen, The Hague; Rijksmuseum, 1960.

Exhibitions: Stedelijk Museum, Amsterdam, *Italiaansche Kunst in Nederlandsch Bezit*, July 1–October 1, 1934, 69, no. 134 (Angelo [*sic*] Gaddi); traveling exhibition: *Sienese Paintings in Holland*, no. 22, ill.; Museum voor Stad en Lande, Groningen, March 28–April 28, 1969; Aartsbisschoppelijk Museum, Utrecht, May 2–June 9, 1969; Dutch University Institute for the History of Art, Florence, June 17–July 14, 1969.

Attributions: M. Meiss (manuscript opinion, Frick Art Reference Library, New York, 1952); P. Pouncey (manuscript opinion, Rijksmuseum, 1957).

Bibliography: van Marle, 1924, vol. III, p. 556 n. 1 (Agnolo Gaddi); van Marle, 1935, p. 302 (Agnolo Gaddi); Fehm, 1969, p. 574; van Os, 1969a, no. 22, ill.; Fehm, 1973a, pp. 15–19, 24–26, 31 n. 32, fig. 26; De Benedictis, 1979, p. 86.

Photographs: Rijksmuseum, Amsterdam, negative no. 3426.

Pl. 5. *Flagellation*.

6. *Adoration of the Magi.* Predella panel (ca. 1356–61). Companion to Cat. 7.

37 × 38.5 cm. (14½ × 15¼ in.). Pl. 6.

Location: Thyssen-Bornemisza Gallery, Lugano, Switzerland.

Condition: Excellent. The panel has no distinguishable paint loss. A small area of the picture has been covered on each side by the modern framing.

Provenance: Maitland F. Griggs, New York (according to Berenson, 1930, p. 274); Thomas Agnew and Sons, London, 1924; Robert von Hirsch, Basel (resided formerly in Frankfurt a./M.), 1927; Thyssen-Bornemisza Gallery, 1978.

Exhibitions: Sotheby, Parke Bernet and Co., London, *The Robert von Hirsch Collection*, June, 1978, 4 vols., vol. I, pp. 156, 157, ill. cover, p. 156.

Bibliography: Perkins, 1924, p. 13; Perkins, 1929, p. 427; Berenson, 1930a, p. 274; Berenson, 1930b, p. 27; Berenson, 1932, p. 312; van Marle, 1934, vol. II, p. 527 n. 1; Berenson, 1936, p. 269; Meiss, 1963, p. 48, fig. 9; Wadsworth Atheneum, Hartford, Connecticut, *An Exhibition of Italian Panels and Manuscripts from the Thirteenth and Fourteenth Centuries in Honor of Richard Offner*, 1965, p. 27; Shapley, 1966, vol. I, p. 59; Berenson, 1968, vol. I, pp. 224 and 226; Fehm, 1969, p. 574; Keil, 1970, pp. 26 and 224; Fehm, 1973a, pp. 30 n. 24 and 31 n. 34; De Benedictis, 1979, pp. 87–89.

Photographs: Thyssen-Bornemisza Gallery.

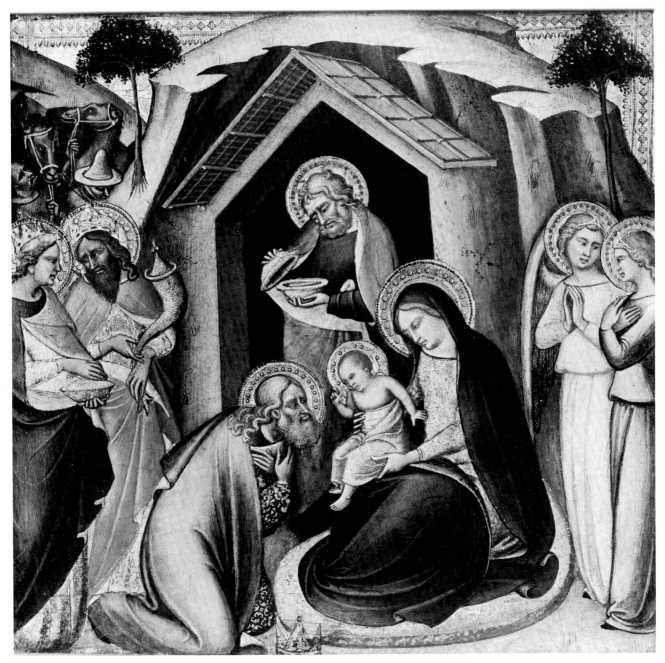

Pl. 6. *Adoration of the Magi.*

7. *Crucifixion*. Predella panel (ca. 1356–61). Companion to Cat. 6.

41 × 59.7 cm. (16⅛ × 23½ in.). Pl. 7.

Location: The Fine Arts Museums of San Francisco, California, no. 61.44.3. Gift of the Samuel H. Kress Foundation.

Inscription: SP [QR] .

Condition: Excellent. The panel was cleaned in 1954. There are no distinguishable paint losses, although some damage in the gold background is noticeable.

Provenance: Achillito Chiesa Collection, Milan; Contini Bonacossi, Rome; Samuel H. Kress, New York, 1927; Samuel H. Kress Foundation (K34), New York; M. H. de Young Memorial Museum, 1955 (name of museum changed in 1972 when the M. H. de Young Memorial Museum was officially combined with the California Palace of the Legion of Honor).

Exhibitions: Atlanta Art Association Galleries, *et al.*, Atlanta, Georgia, *An Exhibition of Italian Paintings from the Collection of Samuel H. Kress*, October, 1932–June, 1935, p. 5; Mint Museum of Art, Charlotte, North Carolina, *Italian Paintings Lent by Samuel H. Kress*, 1935, no. 3; National Gallery of Art, Washington, D. C., 1941–51, no. 136; Wadsworth Atheneum, Hartford, Connecticut, *An Exhibition of Italian Panels and Manuscripts from the Thirteenth and Fourteenth Centuries in Honor of Richard Offner*, April 9–June 6, 1965, p. 27, no. 31, fig. 31.

Attributions: B. Berenson, G. Fiocco, R. Longhi, F. M. Perkins, W. Suida, A. Venturi (manuscript opinions, Samuel H. Kress Foundation, New York).

Bibliography: Berenson, 1930a, p. 274, ill. p. 275; Berenson, 1930b, p. 27, fig. 1; Frankfurter, 1934, p. 8; Berenson, 1936, p. 269; *Preliminary Catalogue*, 1941, p. 117, no. 136; Larsen, 1955, p. 174; Neumeyer, 1955, p. 274; Suida, 1955, p. 32; Meiss, 1963, pp. 47–48, fig. 4; Davenport, 1966, p. 202, ill., and p. 315; San Francisco, 1966, p. 25, ill.; Shapley, 1966, vol. I, p. 59, fig. 157; Berenson, 1968, vol. I, pp. 224 and 226; Fehm, 1969, p. 574; Kiel, 1970, pp. 26 and 244, fig. 21; Fredericksen and Zeri, 1972, pp. 113, 291, and 633; Fehm, 1973a, pp. 17–19, 25, 30 n. 24, and 31 n. 34, fig. 14; *The Robert von Hirsch Collection*, 1978, vol. I, p. 157; De Benedictis, 1979, pp. 87–88; Siena, *Mostra*, 1979, p. 76; Manning, 1980, pp. 180–181, ill., pl. VIII.

Photographs: Samuel H. Kress Foundation; The Fine Arts Museums of San Francisco.

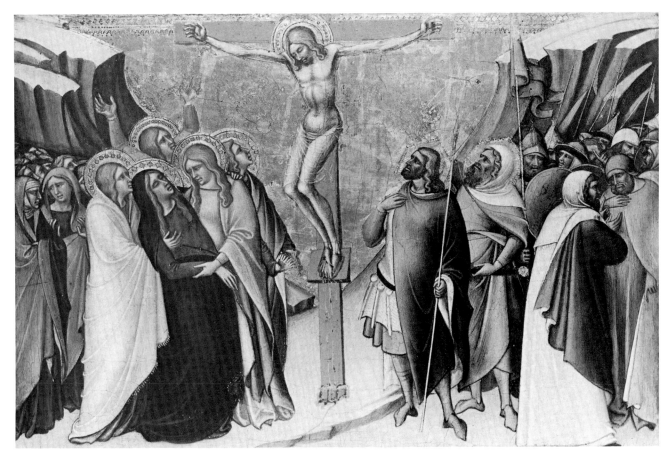

Pl. 7. *Crucifixion.*

8. *Crucifixion*. Processional banner (ca. 1356–61). 116 × 77 cm. (45¾ × 30¼ in.). Pl. 8.

Location: Museo Civico, Montepulciano, no. 203.

Inscription: INRI (John 19:19); SPQR; (inscriptions flanking the torso of Christ are too abraded to read).

Condition: Fair. The picture was originally a processional banner, painted on canvas. At some point early in this century it was mounted on a wooden panel. If the banner was painted on both sides no record has survived of what the image on the verso may have been. Recently Pietro Torriti (*Mostra*, 1979, p. 76) suggested that the physical evidence indicates that the banner was painted on only one side. Two tondi with representations of Saint Francis and Saint Clare, added in the eighteenth century by a follower of Raffaello Vanni and visible in early photographs, have been removed. The painting was touched up by a pair of local artists in 1967 and was recently restored by the Siena Soprintendenza. There has been a fair amount of paint loss throughout. The legs and feet of the centurion on the right, the lower part of the Evangelist's garment, the Magdalen's hands, and several portions of the Virgin's cloak have been lost and in some areas renewed. Several small losses are visible in the dark blue background. The recent restoration has brought to light evidence suggesting that originally there were gilded inscriptions flanking Christ. They are so badly rubbed that they are indecipherable. The modern framing has been removed.

Provenance: Convent of San Francesco, Montepulciano.

Exhibitions: Fortezza del Girifalco, Cortona, *Arte in Valdichiana*, August 9–October 10, 1970, p. 15, no. 18, fig. 18; Pinacoteca Nazionale, Siena, *Mostra di opere d'arte restaurate nelle province di Siena e Grosseto*, June–November, 1979, pp. 76–77, figs. 59 and 60.

Attributions: M. Meiss (verbal opinion, Frick Art Reference Library, New York, 1930).

Bibliography: Brandi, 1931, pp. 17–18, ill.; Berenson, 1932, p. 312; Brandi, 1932, p. 234 n. 1; van Marle, 1934, vol. II, p. 527 n. 1 (not Luca di Tommè); Berenson, 1936, p. 269; Zeri, 1958, p. 15; T. C. I. *Toscana*, 1959, p. 634; Zeri, 1965, p. 255; Berenson, 1968, vol. I, p. 225; Ventroni, 1972, Pl. 76 (Giovanni d'Ascrano, with question); Fehm, 1973a, p. 30 n. 24; T. C. I. *Toscana*, 1974, p. 586; Fehm, 1976, pp. 336–38, and 336 n. 8, fig. 3; De Benedictis, 1979, p. 88.

Photographs: Alinari, Florence, negative no. 42624; Artini, Florence (after restoration of 1967); Frick Art Reference Library, negative no. 22934; Soprintendenza per i beni artistici e storici per le province di Siena e Grosseto.

Pl. 8. *Crucifixion*.

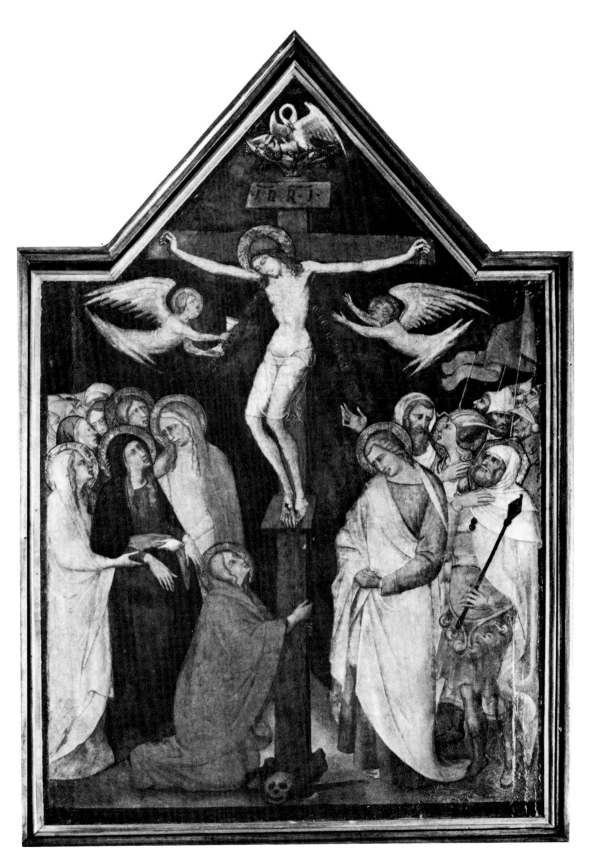

9. Madonna and Child with Saints John the Baptist and Catherine. (Ca. 1356–61.)

34.2 × 15.2 cm. (13½ × 6⅛ in.). Pl. 9.

Location: The National Trust, Polesden Lacey, Surrey, no. 22.

Inscription: (John the Baptist) ECCE·AGNVS·DEI (John 1:29).

Condition: Very good. The panel has been cut down slightly on the left and right sides. The Baptist's scroll has been rubbed, resulting in the loss of part of the inscription. Portions of the Madonna's drapery have been rubbed also, and the gold stars have been reinforced. The framing is modern.

Provenance: Prince André Gagarine, St. Petersburg; Braz Collection, Paris; Hon. Mrs. Ronald Grenville, Polesden Lacey, 1938; The National Trust, 1942.

Exhibitions: St. Petersburg, *Les anciennes Ecoles de Peinture dans les Palais et Collections privées Russes*, 1909, p. 21, ill. (Lippo Memmi, with question); Wildenstein, London, *The Art of Painting in Florence and Siena from 1250 to 1500*, February 24–April 10, 1965, p. 52, no. 91, pl. 83.

Bibliography: Sale Catalogue, Braz Collection, Charpentier, Paris, May 12, 1938, no. 21, pl. VII (Lippo Memmi); Catalogue, *Polesden Lacey*, 1955, p. 17; *Burlington Magazine*, 1957, p. 176; Catalogue, *Polesden Lacey*, 1960, pp. 17–18; Catalogue, *Polesden Lacey*, 1964, p. 19; Berenson, 1968, vol. I, p. 225; Fehm, 1973a, pp. 16–23, and 31 n. 33, fig. 13; Fehm, 1976, p. 348 n. 31; Zeri, 1976, p. 41; De Benedictis, 1979, p. 88.

Photographs: Wallace Heaton, Ltd., London, negative no. NT 22.

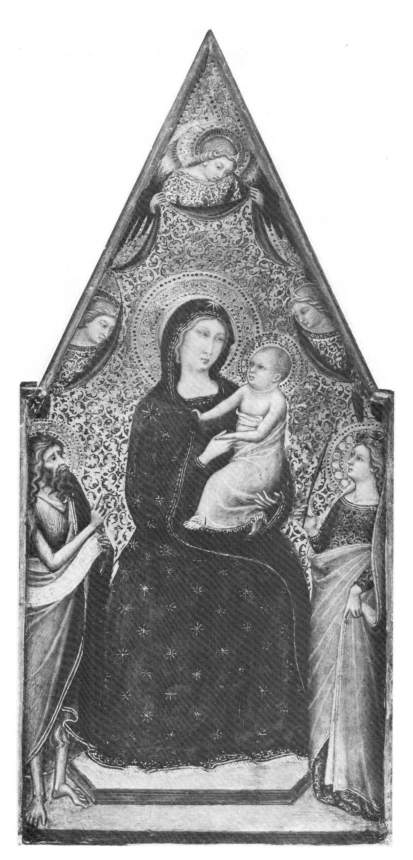

Pl. 9. *Madonna and Child with Saints John the Baptist and Catherine.*

10. *Madonna and Child.* (Ca. 1362–65.)

Dimensions unknown. Pl. 10.

Location: San Bartolommeo a Pescina, Seggiano, Grosseto.

Condition: Good. The panel has recently been cleaned. It appears to have been cut down at the bottom. Apart from some extensive areas of loss within the Virgin's cloak, the figures are well preserved.

Provenance: Original location.

Bibliography: De Benedictis, 1979, p. 88 (as located in S. Lorenzo a Pescina).

Photographs: Soprintendenza per i beni artistici e storici per le province di Siena e Grosseto.

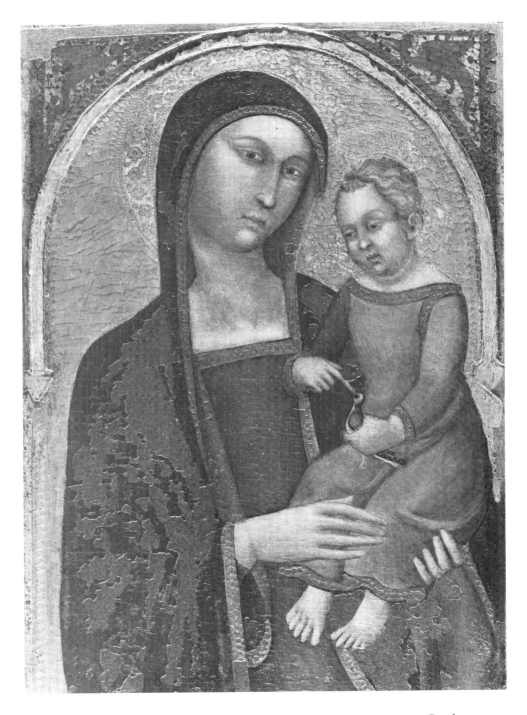

Pl. 10. *Madonna and Child.*

11. *Christ orders Thomas to go and convert India, and presents him to an envoy of Gundoferus, the King of India; on his way to India, Thomas comes to a city where a king is celebrating his daughter's wedding. Seeing that the saint would not touch any food the butler strikes him on the cheek; soon after, as the butler goes to fetch water at the well, a lion comes and mauls him, and dogs tear his flesh, and one of them brings his hand into the hall; the king's brother, Gad, dies, his body is brought to the Apostle in prison, and he is risen by Thomas from the dead. Seeing this miracle, the king has Thomas released. The king is baptized; idols fall at the saint's bidding and a pagan priest stabs him with a dagger.* Four predella panels (ca. 1362–65). Companions to Cat. 12 and 13.

31.3 cm. sq. (12⅜ in. sq.) each panel. Pls. 11-1–11-5.

Location: Private collection.

Condition: Very good. The first and fourth panels have been slightly cut down on the sides and all four are somewhat dirty. The quatrefoil framing is, for the most part, original, although it has been worn in some areas and regilded. The gold background of the third panel on the left is blistered, and some loss has resulted.

Provenance: Thomas Blaydes, London; Lord Lindsay (later 25th Earl of Crawford and Balcarres, Balcarres), London, 1849.

Exhibitions: Royal Academy of Arts, London, *Italian Art and Britain*, Winter, 1960, p. 103, no. 270.

Attributions: R. Longhi (manuscript opinion, Witt Library, London, September 2, 1929); R. Offner (manuscript opinion, Witt Library, January 19, 1927); J. P. Richter (manuscript opinion, Witt Library, July 12, 1890: Orcagna); J. P. Richter (manuscript opinion, Witt Library, June, 1891: Giotto); R. van Marle (manuscript opinion, Witt Library, July 17, 1927: Agnolo Gaddi, early work); L. Venturi (manuscript opinion, Witt Library, June 22, 1923: Lippo Vanni).

Bibliography: Sale Catalogue, Thomas Blaydes Collection, Christie's, London, January 31, 1849, nos. 192–93 and 198–99; Berenson, 1936, p. 269; Kaftal, 1952, p. 969, figs. 1095–98; Zeri, 1958, pp. 3–10, pls. 1a–b and 2a–b; Meiss, 1963, p. 48; Bucci, 1965, pp. 54–55; Berenson, 1968, vol. I, p. 224, pls. 366–67; Rotili, 1968/9, vol. II, p. 16; Fehm, 1969, pp. 574–77; van Os, 1969a, no. 22; van Os, 1969b, pp. 63–64, and 201, pls. 29–32; Fehm, 1973a, pp. 7–9, 17, 23–26, 27 nn. 3–4, and 32 n. 40, figs. 22–25; Torriti, 1977, p. 150; De Benedictis, 1979, pp. 67 n. 80, 87–89, 95, and 96, fig. 103 (illustrates one panel only: *Christ orders Thomas to go and convert India . . .*).

Photographs: Ideal Studios, Edinburgh.

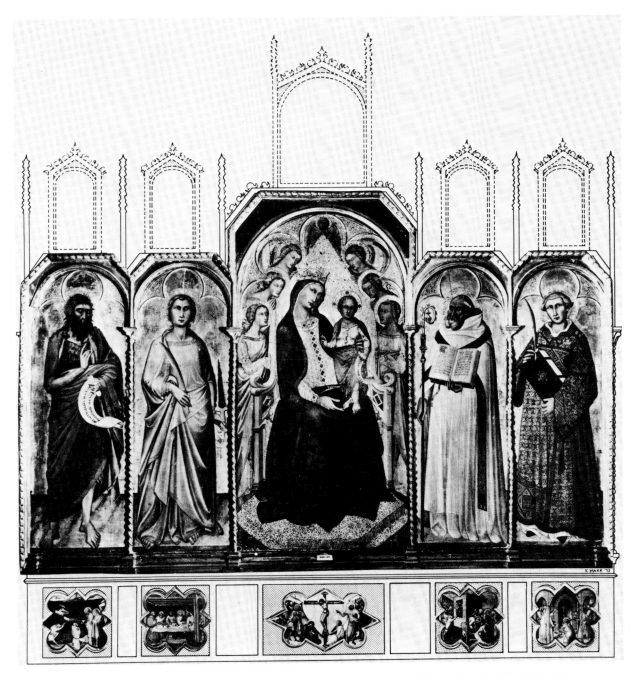

Pl. 11-1. Photo-montage, *Madonna and Child Enthroned with Saints, Crucifixion, and Scenes from the Life of Saint Thomas.*

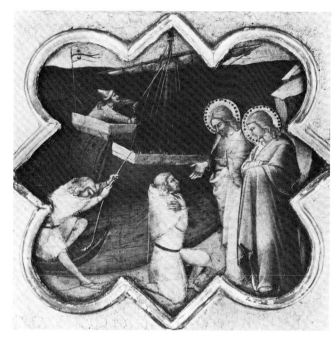

Pl. 11-2. *Christ orders Thomas to go and convert India, and presents him to an envoy of Gundoferus, the king of India (detail of Pl. 11-1).*

Pl. 11-3. *On his way to India, Thomas comes to a city where a king is celebrating his daughter's wedding. Seeing that the Saint would not touch any food, the butler strikes him on the cheek; soon after, as the butler goes to fetch water at the well, a lion comes and mauls him, and dogs tear his flesh, and one of them brings his hand into the hall (detail of Pl. 11-1).*

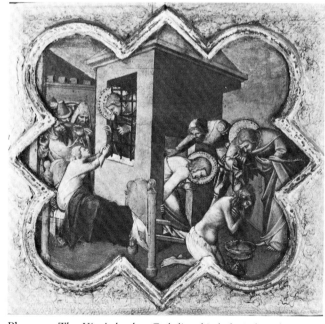

Pl. 11-4. *The King's brother Gad dies, his body is brought to the Apostle in prison, and his body is risen by Thomas from the dead. Seeing this miracle, the King has Thomas released. The King is baptized (detail of Pl. 11-1).*

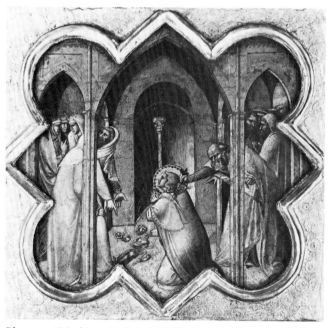

Pl. 11-5. *Idols fall at the Saint's bidding and a pagan priest stabs him with a dagger (detail of Pl. 11-1).*

12. *Crucifixion.* Predella panel (ca. 1362–65). Companion to Cat. 11 and 13.

32.1 × 56.2 cm. (12⅝ × 22⅛ in.). Pls. 11-1 and 12.

Location: Pinacoteca, Vatican, Rome, no. 195 (formerly inv. no. 78).

Inscription: INRI (John 19:19).

Condition: Very good. The panel has been cleaned recently, and the gold background repaired in several areas. A thick film of black paint that previously covered the area surrounding the modern quatrefoil framing has been removed, revealing delicate passages of rosette punchwork.

Provenance: Vatican Pinacoteca, by 1905.

Attributions: R. Offner (verbal opinion, Frick Art Reference Library, New York, 1928); F. M. Perkins (manuscript opinion, Frick Art Reference Library, 1925: close follower of Lorenzo Monaco).

Bibliography: Sirén, 1905, p. 189 (Lorenzo Monaco,

with question); Sirén, 1906, p. 323 (Lorenzo Monaco, with question); Perkins, 1906, p. 108 (Lorenzo Monaco); *Guida della Pinacoteca Vaticana*, 1914, p. 35 (Lorenzo Monaco); Sirén, 1921, p. 99 (painted after the design of Lorenzo Monaco); Perkins, 1929, p. 427 (not by Luca di Tommè); Berenson, 1932, p. 313; *Guida della Pinacoteca Vaticana*, 1933, p. 57 (Lorenzo Monaco); Berenson, 1936, p. 269; Zeri, 1958, pp. 3–9 (connects it to Catalogue nos. 11 and 13); Francia, 1960, pl. 92 (Lorenzo Monaco); Meiss, 1963, p. 48; Bucci, 1965, pp. 54–55; Berenson, 1968, vol. I, p. 226; Rotili, 1968/9, vol. II, p. 16 (Niccolò Tegliacci); Fehm, 1969, pp. 575–77; van Os, 1969a, p. 22; van Os, 1969b, pp. 63–64, and 204; Fehm, 1973a, pp. 7–9, 15, 23–25, and 31 n. 38, figs. 1 and 27; Torriti, 1977, pp. 27 n. 3, 28 n. 4, and 150; De Benedictis, 1979, pp. 67 n. 80, 87–89, 95, and 96, fig. 104; Siena, *Mostra*, 1979, p. 76.

Photographs: Alinari, Florence, negative no. 38066; Anderson, Rome, negative no. 23968; Archivio Fotografico Vaticano, Rome, negatives no. VI-26-18, and no. XXXI-35-5 (after cleaning).

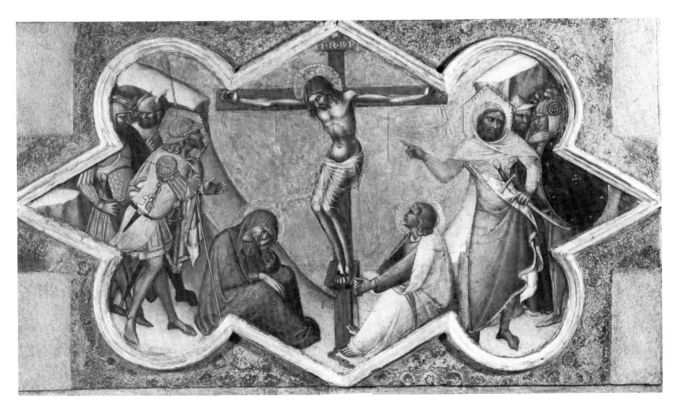

Pl. 12. *Crucifixion* (detail of Pl. 11-1).

13. *Madonna and Child Enthroned with Saints John the Baptist, Thomas, Benedict, and Stephen.* Polyptych (signed and dated 1362, by Luca di Tommè and Niccolò di Ser Sozzo). Companion to Cat. 11 and 12.

191 × 297 cm. (75³⁄₁₆ × 116¹⁵⁄₁₆ in.). Pls. 11-1 and 13-1–13-6.

Location: Pinacoteca Nazionale, Siena, no. 51.

Inscription: (on the central part of the frame) NICCHO-LAVS · SER · SOCCII · ET · LVCAS · TOMAS · DE · SENIS · HOC ·HOPVS · PINCERV[N]T · ANNI · MCCCLXII; (John the Baptist) ECCE · ANGNVS[*sic*] · D[EI] · ECCE · QVI · TOL-LIS[*sic*]·PE[CCATVM MVNDI] (John 1:29); (Saint Thomas, on frame) SANCTVS · THOMAS · APOSTOLVS; (Christ Child) EGO · SVM · VIA (John 14:6); (Saint Benedict) CLAMAT/NOBIS · SCR/IPTVRA · [DIVINA] · FR/ATRES · DI-CENS/OMNIS · QVI · SE/EXVLTAT · HVMIL/IABATVR · ET · QVI/SE · HVMILIAT · EX/ALTABITVR · EX · VND/E · FRATRES · SI · SVMNE · VOLVMVS · H/VMILITATIS · CVL/MEN · AT-TINGE/RE [*sic*]·ET·AD·EXAL/TATIONEM·ILLI[AM]/CELESTEM· AD/AQVAM [*sic*]·PER · PR/ESENTIS · VITE · H/VMILITATEM· ADCENDITVR [*sic*]·VO/LVMVS · VELOCI/TER [*sic*]·PERVI-NIRE (conflation of the Benedictine Rule, Chapter VII: 1–4 and 12–15).

Condition: Good. The polyptych was cleaned during the course of the rearrangement of the Gallery in 1930–31. Blistering has occurred in several areas and a good deal of minor paint loss has occurred. Vertical splits beginning in the heads of Saints Thomas and Benedict have opened. Repaint is limited to a few passages in the Virgin's cloak, where the paint has been rubbed. The framing is modern with the exception of a thin lateral strip extending the width of the polyptych at its base.

Provenance: Possibly from convent of San Tommaso degli Umiliati, Siena; Pinacoteca Nazionale (formerly La Regia Pinacoteca), Siena, by 1842.

Bibliography: Pini, 1842, p. 6 (school of Simone Martini); Milanesi, 1852, p. 19 (follower of Lippo Memmi); *Catalogo*, 1872, p. 21 (Lippo Memmi); *Catalogo*, 1895, p. 22 (Lippo Memmi); *Catalogo*, 1903, p. 22 (Lippo Memmi); Heywood and Olcott, 1903, pp. 321-22 (follower of Lippo Memmi and Lorenzetti); Jacobsen, 1907, p. 32 (follower of Lippo Memmi and Simone Martini, possibly Lippo Vanni); Crowe and Cavalcaselle, 1908, vol. III, p. 78 n. 1 and p. 89 n. 3 (unknown); *Catalogo*, 1909, p. 22 (Lippo Memmi); Berenson, 1909, p. 142 (Bartolo di Fredi); Perkins, 1920, pp. 287–88, and 291, ill.; Dami, 1924, p. 14 (Bartolo di Fredi); Heywood and Olcott, 1924, pp. 384 and 389n; van Marle, 1924, vol. II, p. 469, fig. 307; Perkins, 1929, p. 427; Berenson, 1932, p. 313; Brandi, 1932, pp. 230, 233–35, fig. 2; Procacci, 1932, pp. 471–74; Brandi, 1933, pp. 300–301; Perkins, 1933, p. 76; van Marle, 1934, vol. II, pp. 504, 509, 513, 514, and 520, fig. 329; Berenson, 1936, p. 269 (made by Luca for Niccolò); Meiss, 1951, pp. 54, 166, 169, and 170; Toesca, 1951, pp. 595 n. 111 and 597; Bologna, 1952, p. 39; Kaftal, 1952, pp. 145, 166, and 970, figs. 173 and 1090; Mazzini, 1952, p. 66 n. 11; Sandberg-Vavalà, 1953, pp. 194–95, fig. 75; Salmi, 1954, p. 240; Shorr, 1954, pp. 27 and 29, ill. (follower of Luca di Tommè); Carli, 1955b, pp. 80 and 81, ill. p. 81; Carli, 1958, p. 28, fig. 18; Zeri, 1958, pp. 8–12, pls. 5 and 6; T. C. I. *Toscana*, 1959, p. 566; Carli, 1961b, p. 127, ill.; Meiss, 1963, p. 47; Carli, 1964, p. 20; Zeri, 1964, p. 234; Bucci, 1965, pp. 52–55, figs. 45 and 46; White, 1966, p. 365; Goodison, 1967, p. 92; Klesse, 1967, pp. 60, 103, 248, and 406, pls. 65 and 135; Berenson, 1968, vol. I, p. 226, pl. 365; Rotili, 1968/9, vol. II, p. 16; Fehm, 1969, p. 577; Mongan, 1969, p. 22; van Os, 1969b, p. 60, pl. 26; Carli, 1971, pp. 20 and 22; Fredericksen, 1972, pp. 4 and 5; Pisa, *Mostra*, 1972, p. 93; Fehm, 1973a, pp. 6–10, 12, 14, 15, 20–23, 26, 27 n. 1, 31 nn. 37–38, and 32 n. 40, figs. 1, 17, and 19–21; Muller, 1973, p. 12; T. C. I. *Toscana*, 1974, pp. 517–18; Moran, 1976, pp. 58 and 61; Torriti, 1977, pp. 150 and 151, figs. 161 and 162; De Benedictis, 1979, pp. 49, 52–54, 87–89, 95, and 96, fig. 102; Siena, *Mostra*, 1979, p. 76; Sutton, 1979, p. 356, fig. 10; Cole, 1980, pp. 188–89, and 191, fig. 100; Zeri, 1981, p. 32.

Photographs: Alinari, Florence, negative no. 36663 (overall); Anderson, Rome, negative nos. 21055, 21056, and 21057 (details); Grassi, Siena, negative nos. 420 and 422 (details); Passerini, Siena (details); Soprintendenza per i beni artistici e storici per le province di Siena e Grosseto.

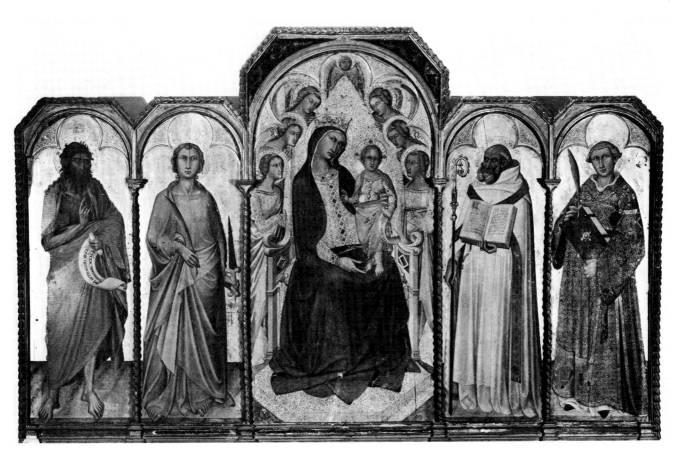

Pl. 13-1. *Madonna and Child with Saints* (detail of Pl. 11-1).

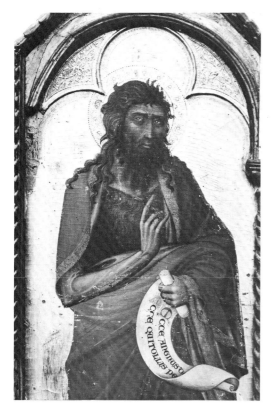

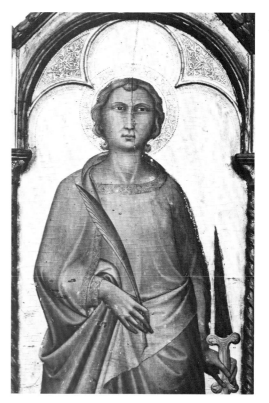

Pl. 13-2. *Saint John the Baptist* (detail of Pl. 11-1).

Pl. 13-3. *Saint Thomas* (detail of Pl. 11-1).

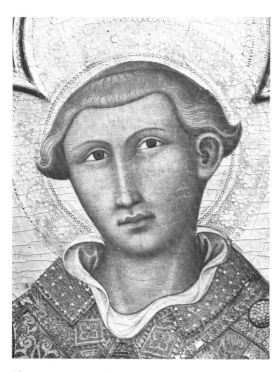

Pl. 13-4. *Saint Stephen* (detail of Pl. 11-1).

Pl. 13-5. *Saint Benedict* (detail of Pl. 11-1).

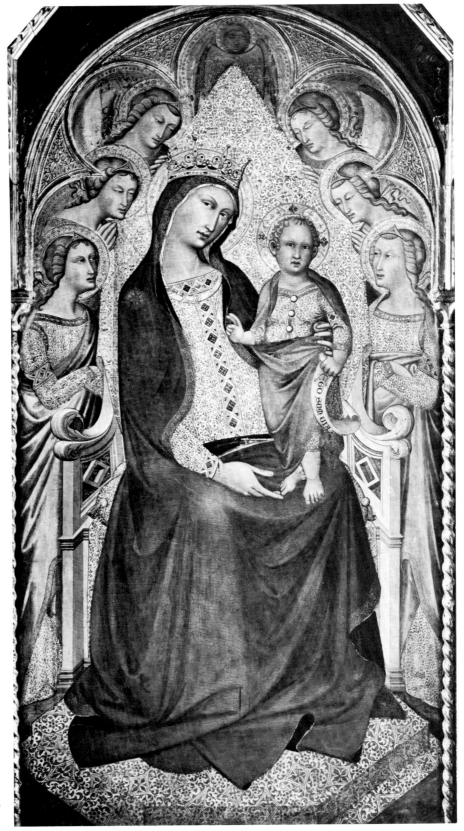

Pl. 13-6. *Madonna and Child Enthroned*
(detail of Pl. 11-1).

14. *Madonna and Child Enthroned.* Central panel of a polyptych (ca. 1362–65).

134.3 × 58.7 cm. (52⅞ × 23⅛ in.). Pl. 14.

Location: The Metropolitan Museum of Art, New York, no. 41.100.34. Gift of George Blumenthal.

Inscription: (Christ Child) EGO·SVM· VIA·VERI[TAS·ET·VITA] (John 14:6).

Condition: Good. Large areas of the Virgin's cloak are damaged and have been repainted. The flesh tones and especially the Virgin's face and hands have been retouched, while the letters of the inscription have been totally reinforced. The framing is original.

Provenance: George and Florence Blumenthal, New York, 1920; The Metropolitan Museum of Art, 1941.

Attributions: M. Laclotte (manuscript opinion, The Metropolitan Museum of Art, 1957: Niccolò Tegliacci); E. Sandberg-Vavalà (manuscript opinion, The Metropolitan Museum of Art); F. Zeri (manuscript opinion, The Metropolitan Museum of Art, 1958).

Bibliography: Perkins, 1920, pp. 287, 288, and 291, ill. p. 285; van Marle, 1924, vol. II, p. 472; Perkins, 1924, p. 14; Rubenstein-Block, 1926, pl. 23; Comstock, 1928, pp. 57, 58, and 60–62, ill.; Perkins, 1929, p. 427; Berenson, 1932, p. 313; Brandi, 1932, p. 234 n. 1; van Marle, 1934, vol. II, pp. 520 and 528n; Berenson, 1936, p. 269; Klesse, 1967, p. 408; Berenson, 1968, vol. I, p. 225, pl. 371; Fredericksen and Zeri, 1972, pp. 113, 318, and 608; Fehm, 1973a, p. 31 n. 35; Fehm, 1976, pp. 333 n. 2 and 348 n. 32; De Benedictis, 1979, p. 88; Zeri, 1981, p. 32.

Photographs: The Metropolitan Museum of Art, negative no. 124632.

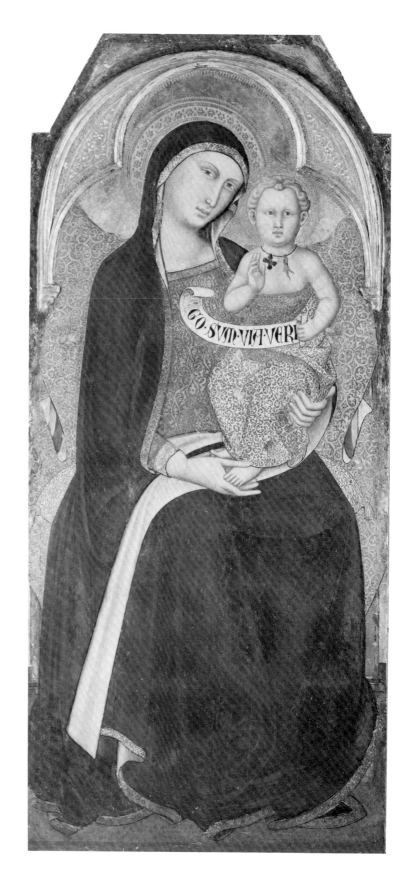

Pl. 14. *Madonna and Child Enthroned.*

15. *Assumption of the Virgin.* (Ca. 1362–65.)

147.7 × 68.8 cm. (58⅛ × 26¼ in.), including the original frame. Pls. 15-1–15-5.

Location: Yale University Art Gallery, New Haven, Connecticut, no. 1871.12.

Condition: Very good. The panel was cleaned in 1952 by Andrew F. Petryn. The major areas of loss discovered in the area of the sarcophagus have been consolidated. The frame, which has been regilded, is almost entirely original.

Provenance: Oratorio dal Pedere Gazzaja, Arezzo, environs, 1818; in 1818, permission was granted by the Bishop of Arezzo to the owners for removal to a private family chapel in Siena (according to a now lost record on the back of the panel, transcribed by James Jackson Jarves); James Jackson Jarves, New York, 1860; Yale University Art Gallery, 1868.

Exhibitions: Derby Gallery, New York, *Old Masters*, 1860, no. 40; Williams and Everett's Gallery, Boston, *Jarves's Collection of Old Masters*, 1861–62; The New-York Historical Society, New York, 1863; Yale University Art Gallery, *Italian Primitives*, April–September, 1972, no. 4, figs. 4a and 4b.

Bibliography: Jarves, 1860, p. 46 (Sienese School about 1350); Jarves, 1861, p. B, engraved by V. Stanghi (Sienese School about 1350); Sturgis, 1868, p. 40 (Sienese School about 1350); Sale Catalogue, *Catalogue of the Jarves Collection*, New Haven, Connecticut, 1871, p. 16 (Sienese School about 1350); Rankin, 1895, p. 142 (School of the Lorenzetti); Perkins, 1905, p. 76 (Bartolo di Fredi); Rankin, 1905, p. 9 (Sienese School of Lippo Memmi or of the Lorenzetti); Berenson, 1909, p. 141 (Bartolo di Fredi); Perkins, 1909a, p. 145; Mather, 1914, p. 967 (follower of the Lorenzetti about 1350); Sirén, 1916, pp. 37 and 38, fig. 12; Perkins, 1920, p. 288; van Marle, 1920a, p. 288; Mather, 1923, p. 86, fig. 54; van Marle, 1924, vol. II, p. 481, fig. 313; Offner, 1927, pp. 5, 38, and 39, figs. 29 and 29a; Cecchi, 1928b, p. 148, pl. CCXXIII; Comstock, 1928, pp. 58–59, ill.; Perkins, 1929, p. 427; *Handbook of the Gallery of Fine Arts*, New Haven, 1931, p. 28; Venturi, 1931, pl. LXXXIV; Berenson, 1932, p. 131; Edgell, 1932, p. 157; van Marle, 1934, vol. II, p. 512, fig. 334 (Niccolò Tegliacci); Berenson, 1936, p. 269; *New York Herald Tribune*, January 11, 1945, p. 1; Comstock, 1946, p. 50; *Yale Bulletin*, 1946, fig. 22; Meiss, 1951, pp. 21–23, fig. 21; Steegmuller, 1951, p. 297; Toesca, 1951, pp. 594 and 595, fig. 525 (Niccolò Tegliacci and Lippo Vanni); Mazzini, 1952, pp. 65 and 66 n. 18; Zeri, 1958, p. 9; Carli, 1961b, vol. II, p. 20; Walters Art Gallery, 1962, p. 18; Dalli Regoli, 1963, p. 56; Meiss, 1963, p. 47, fig. 7; Bucci, 1965, pp. 59 and 60 n. 2 (Niccolò Tegliacci); Klesse, 1967, pp. 259 and 407 (Niccolò di Ser Sozzo Tegliacci and Luca di Tommè); Berenson, 1968, vol. I, p. 225, pl. 368; Rotili, 1968/9, vol. II, p. 17 (Niccolò Tegliacci); Fehm, 1969, p. 574; Mongan, 1969, p. 22; van Os, 1969b, p. 166 n. 56 and p. 170 n. 65; Seymour, 1970, pp. 79–80, 262, 263, 278, 293, and 305, ill. p. 78; Fredericksen and Zeri, 1972, pp. 113, 307, and 599; Muller, 1973, p. 16; Fehm, 1976, p. 333 n. 2; De Benedictis, 1979, pp. 47, 48, and 88, fig. 89; Cole, 1980, pp. 191–92 and 195, fig. 101.

Photographs: Yale University Art Gallery.

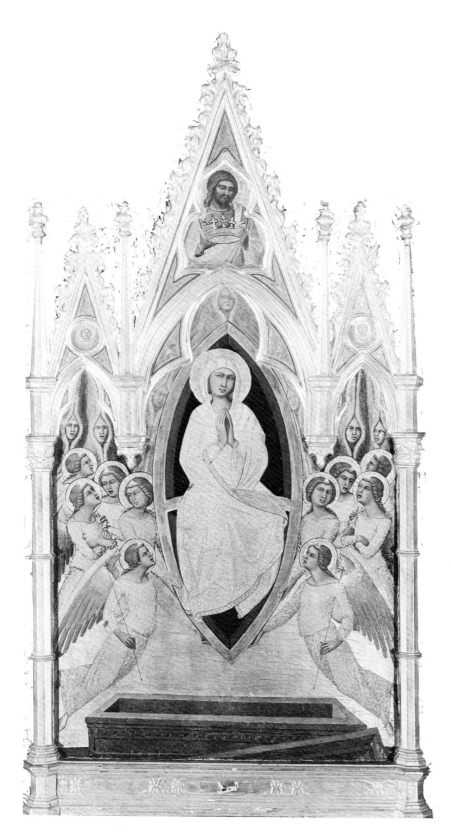

Pl. 15-1. *Assumption of the Virgin.*

86 · *Catalogue*

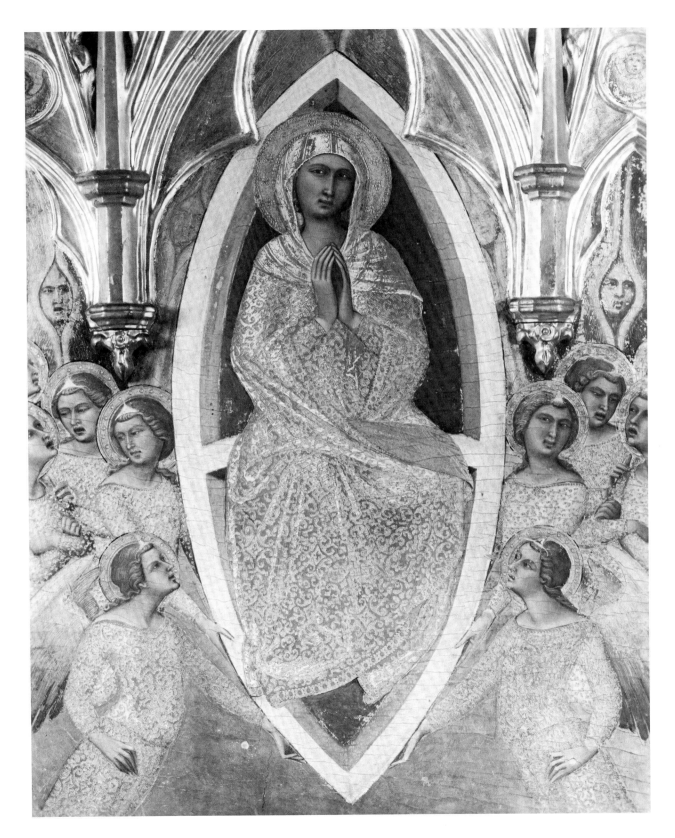

Pl. 15-2. *The Virgin* (detail of Pl. 15-1).

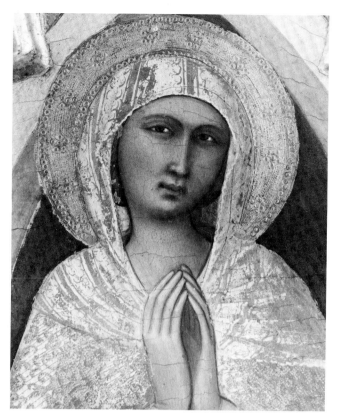

Pl. 15-3. *The Virgin* (detail of Pl. 15-1).

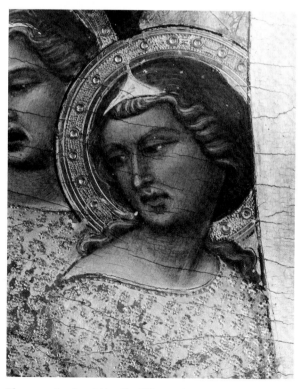

Pl. 15-4. *An Angel* (detail of Pl. 15-1).

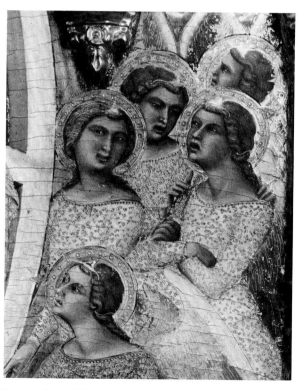

Pl. 15-5. *Angels* (detail of Pl. 15-1).

16. *Jonah*. Predella panel (ca. 1362–65). Companion to Cat. 17.

15 × 14.5 cm. (5¹⁵⁄₁₆ × 5¾ in.). Pl. 16.

Location: Rijksmuseum Het Catharijneconvent, Utrecht, no. 12.

Inscription: JONAS·PROFETAS.

Condition: Good. The panel is dirty. The letters of the inscription have been reinforced and a portion of the panel on the bottom right has been built up and reconstructed. Thin strips of the background adjoining the frame on the top left and right have been renewed, while the framing and surrounding area are modern.

Provenance: J. A. Ramboux, Cologne; Msgr. G. W. van Heukelum, Utrecht, 1867; Aartsbisschoppelijk Museum, Utrecht, by 1933 (name of museum changed in 1978).

Exhibitions: traveling exhibition: *Sienese Paintings in Holland*, no. 23, ill.: Museum voor Stad en Lande, Groningen, March 28–April 28, 1969; Aartsbisschoppelijk Museum, May 2–June 9, 1969; Dutch University Institute for the History of Art, Florence, June 17–July 14, 1969.

Attributions: F. Zeri (manuscript opinion, Rijksmuseum Het Catharijneconvent, October 3, 1958).

Bibliography: Milanesi, 1862, p. 15; Sale Catalogue, J. Heberle (ed.), Jean Anton Ramboux Collection, 1867, p. 21, no. 104; Schaepman, 1877, p. 47; *Schilderijen*, 1933, p. 12, no. 580; *Schilderijen*, 1948, p. 155; Fehm, 1969, p. 574, fig. 46; van Os, 1969a, no. 23, fig. 23; Fehm, 1976, p. 333 n. 2; De Benedictis, 1979, pp. 89 and 90.

Photographs: Rijksmuseum Het Catharijneconvent, negative no. AR 33065/13.

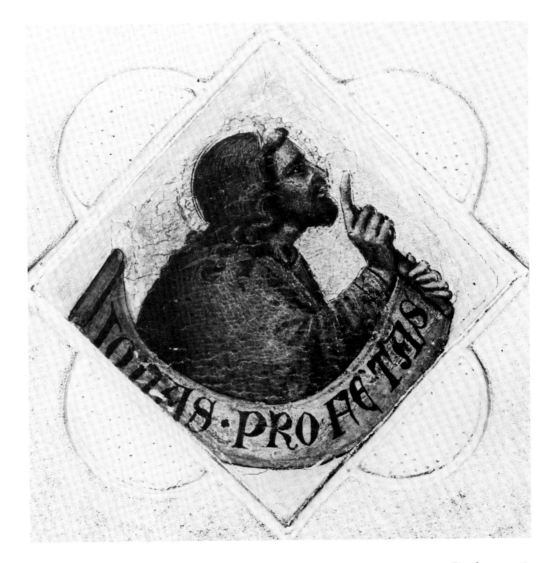

Pl. 16. *Jonah*.

17. *Amos*; *Jeremiah*; *Isaiah*; *Elijah*. Predella panels
(ca. 1362–65). Companions to Cat. 16.

18.5 × 17 cm. (7¼ × 6¾ in.) each panel.
Pls. 17-1–17-4.

Location: Unknown.

Inscription: AMOS·PROFETAS; JEREMIA·PROFETAS; IS-
AIAS·PROFETAS; ELIAS·PROFETAS.

Pl. 17-1. *Amos*.

Pl. 17-2. *Jeremiah*.

Condition: Very good. The inscriptions on all four panels have been reinforced and a small portion above Isaiah's halo has been reconstructed.

Provenance: Art Market, Florence, during the 1930s.

Bibliography: Fehm, 1969, p. 574, figs. 47–50; Fehm, 1976, p. 333 n. 2; De Benedictis, 1979, p. 89.

Photographs: Reali, Florence.

Pl. 17-3. *Isaiah*.

Pl. 17-4. *Elijah*.

18. *Saint James.* Tondo (ca. 1362–65).

24 cm. (9½ in.) diameter. Pl. 18.

Location: Pinacoteca Nazionale, Siena, no. 113 formerly inv. nos. 92 (1842, 1852, 1860); 107 (1864); 103 (1872).

Condition: Good. Several small paint losses are distinguishable, and the Saint's left shoulder has been damaged. The frame, which is blistered and chipped in many places, seems to be original.

Provenance: Pinacoteca Nazionale (formerly La Regia Pinacoteca, etc.), by 1842.

Bibliography: Pini, 1842, p. 7 (unknown artist); Milanesi, 1852, p. 21 (unknown artist); *Catalogo,* 1860, p. 24 (unknown artist); *Catalogo,* 1864, p. 24 (unknown artist); *Catalogo,* 1872, p. 23 (unknown artist); Micheli, 1872, p. 26 (unknown artist); *Catalogo,* 1903, p. 42 (unknown artist); Jacobsen, 1907, p. 17 (unknown artist); Perkins, 1908a, p. 55 (Andrea Vanni); Berenson, 1909, p. 261 (Andrea Vanni); *Catalogo,* 1909, p. 44 (unknown artist); Dami, 1924, p. 19 (unknown artist of the 14th century); van Marle, 1924, vol. II, p. 451 n. 2 (Andrea Vanni); Berenson, 1932, p. 313 (Luca di Tommè, with question); Brandi, 1933, p. 159; Berenson, 1936, p. 269; Berenson, 1968, vol. I, p. 226 (Luca di Tommè, with question); Torriti, 1977, p. 161, fig. 174; De Benedictis, 1979, p. 89.

Photographs: Artini, Florence; Frick Art Reference Library, negative no. 22064; Soprintendenza per i beni artistici e storici per le province di Siena e Grosseto.

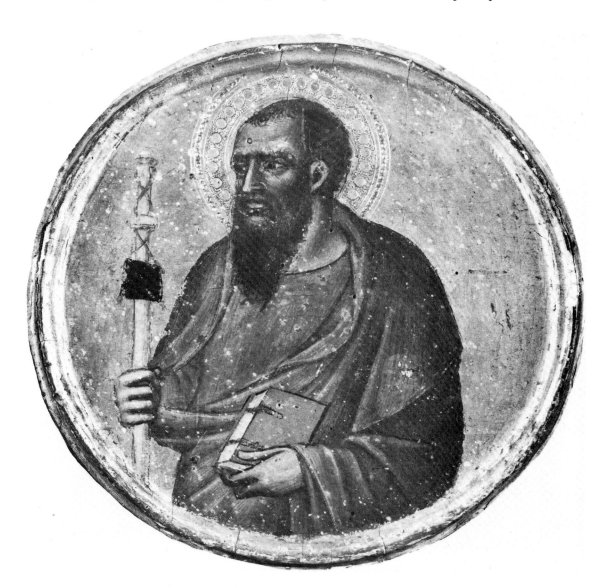

Pl. 18. *Saint James.*

19. *Crucifixion.* (Signed and dated by Luca di Tommè, 1366.)

201.5 × 82 cm. (79⅛ × 32¼ in.). Pls. 19-1–19-3.

Location: Museo Nazionale di San Matteo, Pisa, no. 8 (formerly inv. no. 5).

Inscription: LVCKAS·TOME·DE·SENIS·PINXIT·HOC· [OPV] S ·MCCCLXVI

Condition: Fair. The panel has been cleaned recently, but has suffered much over the years. The gold background is badly rubbed and is almost entirely gone. There are paint losses in the Virgin's cloak, especially to the lower left, and in the center of John's garment and near his left shoulder. The upper half of God the Father's head is also missing. Only the bottom portion of the framing is original.

Provenance: Canon Zucchetti, Pisa; Museo Nazionale di San Matteo (formerly Museo Civico), 1796.

Bibliography: Della Valle, 1786, vol. II, p. 119; Rosini, 1839, p. 27; Bonaini, 1846, p. 41; Milanesi, 1854, vol. I, p. 28 n. 1; Crowe and Cavalcaselle, 1864, vol. II, pp. 112, 113–14, and 114 n. 1; Milanesi, 1878, vol. I, p. 651 n. 3; Lupi, 1904, p. 408, no. 18; Rothes, 1904, p. 21; Modigliani, 1906, pp. 104 and 105; Jacobsen, 1907, p. 17; Crowe and Cavalcaselle, 1908, vol. III, pp. 86 and 157 n. 1; Perkins, 1909c, p. 83; Dami, 1915, p. 134; van Marle, 1920a, pp. 130 and 142; Lavagnino, 1923, p. 40, ill.; van Marle, 1924, vol. II, pp. 465–68, fig. 304; Bellini-Pietri, 1926, p. 114; Bacci, 1927, p. 61, ill.; Comstock, 1928, pp. 57 and 59; Serra, 1928a, p. 180; Perkins, 1929, p. 427; Serra, 1929, p. 303; Fattorusso, 1930, p. 328; Weigelt, 1930, p. 58, pl. 115; Brandi, 1931, pp. 17–18, 2 ills.; Berenson, 1932, p. 313; Procacci, 1932, pp. 473–74; van Marle, 1934, vol. II, pp. 513, 514–15, fig. 336; T. C. I. *Toscana*, 1935, p. 96; Berenson, 1936, p. 269; Vigni, 1950, p. 7; Meiss, 1951, pp. 35, 166, and 170; Toesca, 1951, p. 597; Carli, 1955a, p. 97; T. C. I. *Toscana*, 1959, p. 160; Carli, 1961b, vol. II, p. 20, pls. 26 and 27; Meiss, 1963, pp. 47 and 48, fig. 8; Carli, 1964, p. 20; Bucci, 1965, p. 56; Berenson, 1968, vol. I, p. 225, pl. 369; Fehm, 1969, p. 574; Mongan, 1969, p. 22; Polzer, 1971, pp. 49–50, fig. 23; Pisa, *Mostra*, 1972, p. 93; Fehm, 1973a, pp. 9, 17, and 28 n. 9; Fehm, 1973b, p. 463; Fehm, 1976, pp. 333, 342, and 333 n. 3, fig. 1; De Benedictis, 1979, pp. 54 and 88.

Photographs: Artini, Florence (overall and details after restoration); Brogi, Florence, negative no. 19411; Soprintendenza, Pisa, negative no. 1189 (after restoration); Anderson, Rome, negative nos. 28756 (before restoration) and 28757 (detail).

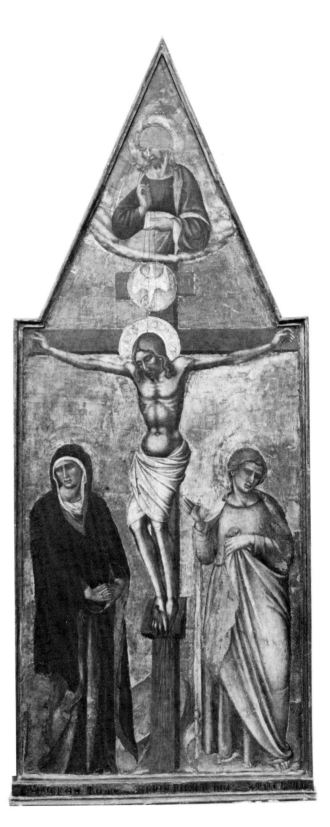

Pl. 19-1. *Crucifixion.*

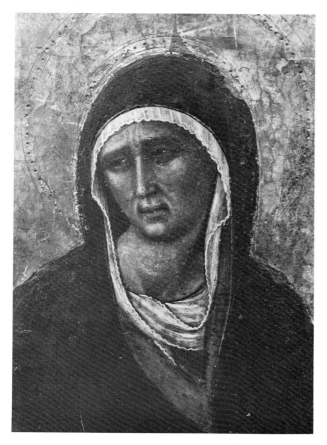 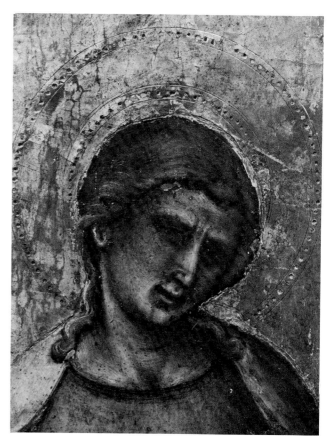

Pl. 19-2. *The Virgin* (detail of Pl. 19-1).

Pl. 19-3. *Saint John the Evangelist* (detail of Pl. 19-1).

20. *Saint Francis, the Virgin, Crucifixion, Saint John, and Saint Dominic.* Predella panel (ca. 1366–73).

27.3 × 201.1 cm. (10¾ × 81⅛ in.). Pls. 20-1–20-6.

Location: Yale University Art Gallery, New Haven, Connecticut, no. 1943.246. Bequest of Maitland F. Griggs.

Condition: Good. Cleaning and restoration were begun by Andrew F. Petryn in 1966. By means of X-ray tests and technical photography, it was determined that Christ's lower torso, legs, feet, the lower portion of the cross, the surrounding gold background, and the landscape were modern. These have been removed. The other figures are intact and, with the exception of Saint Francis, have been cleaned. The framing is modern.

Provenance: Ercole Canessa, Paris; Maitland F. Griggs, New York, 1924; Yale University Art Gallery, 1943.

Attributions: R. Offner (manuscript opinion, *in litteris* to Maitland F. Griggs, New York, February 28, 1924).

Bibliography: Sale Catalogue, Ercole Canessa Collection, American Art Galleries, New York, January 25–26, 1924, no. 152 (School of Simone Martini); Perkins, 1924, p. 15n.; Comstock, 1928, pp. 58 and 59, ill.; Perkins, 1929, p. 427; van Marle, 1931, p. 170, pl. 5; Berenson, 1932, p. 313; van Marle, 1934, vol. II, p. 527 n. 1; Berenson, 1936, p. 269; Berenson, 1968, vol. I, p. 225; Seymour, 1970, pp. 81, 278, 285, 290, 294, and 308, pl. 54; Fredericksen and Zeri, 1972, pp. 113, 289, 390, 395, and 600; Fehm, 1973a, pp. 15 and 31 n. 31; Muller, 1973, pp. 16–18, and 21 n. 33, fig. 8; Vertova, 1973, pp. 159 and 160; De Benedictis, 1979, p. 88.

Photographs: Yale University Art Gallery.

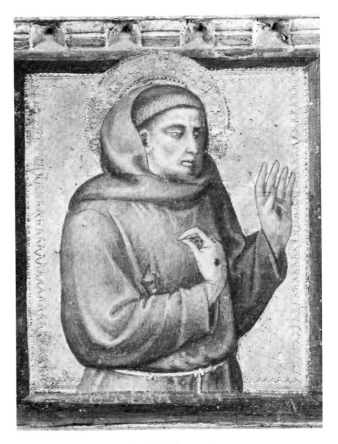

Pl. 20-2. *Saint Francis* (detail of Pl. 20-1).

Pl. 20-1. *Saint Francis, the Virgin, the Crucifixion, Saint John, and Saint Dominic.*

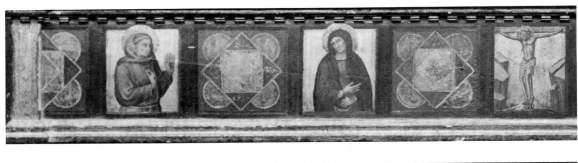

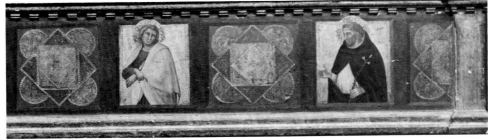

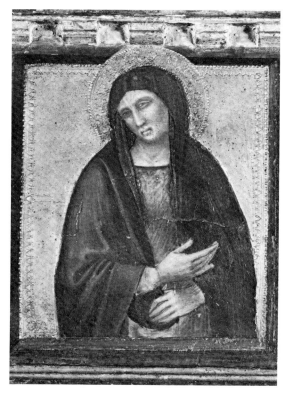

Pl. 20-3. *The Virgin* (detail of Pl. 20-1).

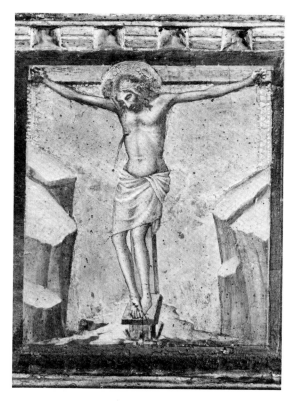

Pl. 20-4. *Crucifixion* (detail of Pl. 20-1).

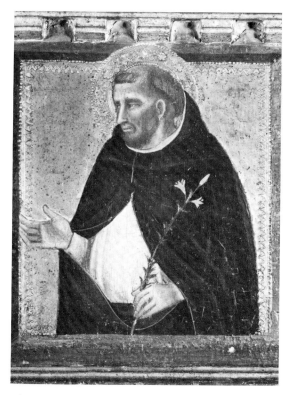

Pl. 20-5. *Saint John* (detail of Pl. 20-1).

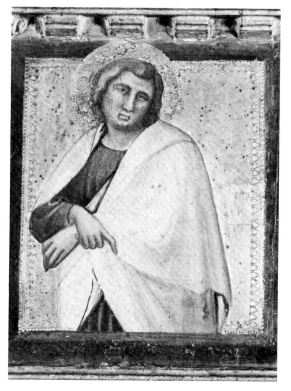

Pl. 20-6. *Saint Dominic* (detail of Pl. 20-1).

21. *Crucifixion.* (ca. 1366–73.)

60 × 46 cm. (26 × 18½ in.). Pl. 21.

Location: Art Market, London.

Condition: Poor. The face, torso, and legs of Christ are badly damaged and have been repainted. Other distinguishable losses are visible in the Evangelist's face and the Virgin's cloak. The original gold ground has been entirely lost and painted black. The frame is modern.

Provenance: Mori, Paris; Richard M. Hurd, New York, June 6, 1924; Clyde N. King, Washington, D.C., October 29, 1945; Julius Weitzner, London, May 17, 1961.

Exhibitions: *Richard M. Hurd Collection of Italian Primi-* *tives*, Newhouse Galleries, New York, May, 1937, no. 6.

Attributions: F. M. Perkins (manuscript opinion, Frick Art Reference Library, New York, 1926, Catalogue of the Richard M. Hurd Collection, p. 9).

Bibliography: Comstock, 1928, pp. 58–60, ill.; Perkins, 1929, p. 427; Berenson, 1932, p. 313; van Marle, 1934, vol. II, p. 515; Berenson, 1936, p. 269; Sale Catalogue, Richard M. Hurd Collection, Kende Galleries, New York, October 29, 1945, p. 15, no. 4; Sale Catalogue, Sotheby's, London, May 17, 1961, p. 31, no. 135; Fehm, 1973a, p. 31 n. 35; De Benedictis, 1979, p. 90.

Photographs: Fototeca Berenson, Florence (overall and details).

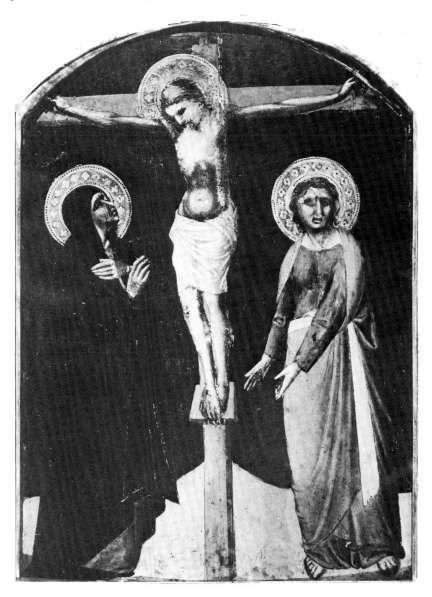

Pl. 21. *Crucifixion.*

22. *Madonna and Child with Saint Anne; Saints Catherine of Alexandria, John the Baptist, Anthony Abbot, and Agnes*; in the central pinnacle, *Saint Andrew*; in the lateral pinnacles, *Saints Matthew, Mark, Luke, and John the Evangelist*. Polyptych (signed and dated by Luca di Tommè, 1367).

210 × 232 cm. (82¹¹/₁₆ × 92⅛ in.). Pls. 22-1–22-5.

Location: Pinacoteca Nazionale, Siena, no. 109; formerly inv. nos. 297 (1872) and 54 (1895).

Inscription: (in frame below central panel) LVCAS·THOME · DE · SENIS · PINSIT · HOC · OPVS · M · CCC · LXVII; (John the Baptist) ECCE · AGNVS · DEI · ECCE · QVI · TOLLIS [*sic*] · P[ECCATVM · MVNDI] (John 1:29); (in frame below the Baptist) JOHANVS·BATTISTA; (in frame below Anthony Abbot) ANTHONIVS·ABAS.

Condition: Very good. The painting has been cleaned recently. Several minor losses are noticeable, especially in the pinnacles where there is a vertical split running the height of the Saint Matthew panel. The pinnacle

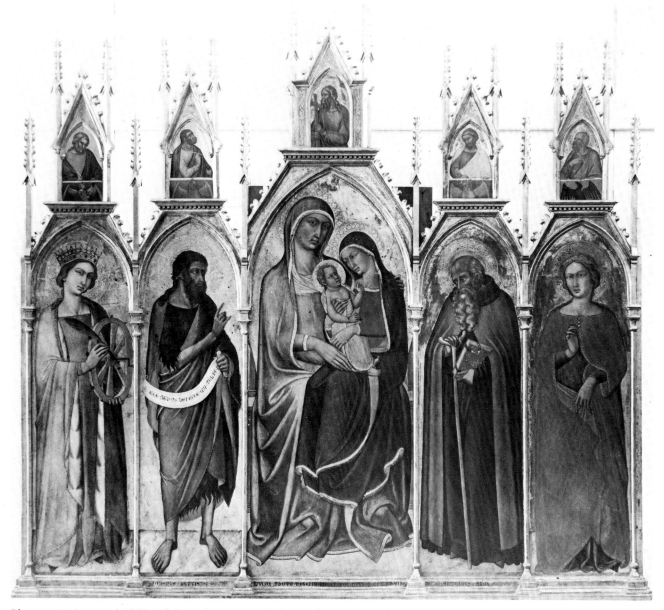

Pl. 22-1. *Madonna and Child with Saint Anne: Saints Catherine of Alexandria, John the Baptist, Anthony Abbot, and Agnes*; in the central pinnacle, *Saint Andrew*; in the lateral pinnacles, *Saints Matthew, Mark, Luke, and John the Evangelist*.

figure of Saint Andrew belongs to another altarpiece (cf. Catalogue no. 22). The gold background is abraded in several places, particularly in the two right-hand panels. The framing is entirely modern except for the strips at the bottom of the three interior panels, where original inscriptions are visible.

Provenance: Santa Mustiola alla Rosa (?), Siena; S. Quirico in Osenna (d'Orcia), Convent of the Capuchins, 1867 (donated by the Ercolani family in 1567); Pinacoteca Nazionale (formerly La Regia Pinacoteca), by 1872.

Bibliography: Della Valle, 1786, vol. II, pp. 118–19; Milanesi, 1854, vol. I, p. 28 n. 1; Crowe and Cavalcaselle, 1864, vol. II, p. 114; *Catalogo*, 1872, p. 53; Micheli, 1872, p. 31; *Catalogo*, 1895, p. 42; Brogi, 1897, p. 538; Douglas, 1902, p. 362; *Catalogo*, 1903, p. 41; Heywood and Olcott, 1903, p. 325; Rothes, 1904, p. 21; Modigliani, 1906, pp. 104 and 105; Jacobsen, 1907, pp. 47 and 49; Crowe and Cavalcaselle, 1908, vol. III, pp. 87 and 87 n. 2; Perkins, 1908b, pp. 80 and 83; *Catalogo*, 1909, p. 43; Perkins, 1909c, p. 83; Dami, 1915, pp. 43 and 134; Perkins, 1920, p. 291; van Marle, 1920a, pp.

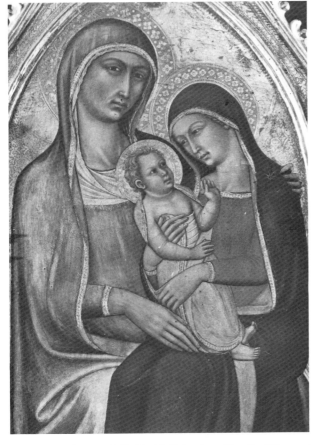

Pl. 22-2. *Madonna and Child with Saint Anne* (detail of Pl. 22-1).

Pl. 22-3. *Saint Andrew* (detail of Pl. 22-1).

142–43; Dami, 1924, p. 18; Heywood and Olcott, 1924, p. 389; van Marle, 1924, vol. II, pp. 468–69, fig. 305; Kunstle, 1926, p. 340; Bacci, 1927, p. 62; Comstock, 1928, p. 57; Serra, 1928a, p. 179; Perkins, 1929, p. 427; Serra, 1929, p. 303; Fattorusso, 1930, p. 347; Weigelt, 1930, p. 58, pl. 116; Brandi, 1931a, p. 18; Bacci, 1932, p. 182; Berenson, 1932, p. 313; Brandi, 1932, p. 234 n. 1; Procacci, 1932, p. 473; Brandi, 1933, pp. 158–59; Perkins, 1933, p. 76; van Marle, 1934, vol. II, pp. 513 and 515–17, fig. 337; T. C. I. *Toscana*, 1935, p. 436; Berenson, 1936, p. 269; Bacci, 1939, p. 207; Meiss, 1951, pp. 166 and 170; Toesca, 1951, p. 597; Kaftal, 1952, p. 752; Mazzini, 1952, p. 66; Sandberg-Vavalà, 1953, pp. 195–96, fig. 80; Carli, 1955a, p. 97; Carli, 1955b, p. 88; Carli, 1958, p. 27; Aurenhammer,

1959, p. 147; T. C. I. *Toscana*, 1959, p. 566; Carli, 1961a, vol. II, p. 20; Carli, 1964, p. 20; Goodison, 1967, p. 92; Berenson, 1968, vol. I, p. 226, pl. 364; Mongan, 1969, p. 22; van Os, 1969b, pp. 60 and 68, pl. 27; Cortona, *Mostra*, 1970, p. 15; Carli, 1971, p. 22; Pisa, *Mostra*, 1972, p. 93; Fehm, 1973a, p. 28 n. 4; Fehm, 1973b, p. 464, figs. 80 and 84; T. C. I. *Toscana*, 1974, p. 518; Torriti, 1977, pp. 157 and 158, fig. 170; De Benedictis, 1979, p. 89; Siena, *Mostra*, 1979, pp. 80 and 85.

Photographs: Alinari, Florence, negative no. 9894; Anderson, Rome, negative nos. 21123, 31942 (detail); Passerini, Siena (details); Soprintendenza per i beni artistici e storici per le province di Siena e Grosseto.

Pl. 22-4. *Saint Mark* (detail of Pl. 22-1).

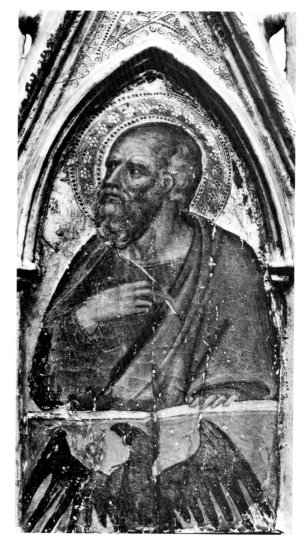

Pl. 22-5. *Saint John the Evangelist* (detail of Pl. 22-1).

23. *Christ Blessing.* Pinnacle figure (central pinnacle of Cat. 22, painted in 1367).

39 × 27 cm. (15⅜ × 10⅝ in.). Pls. 23-1 and 23-2.

Location: Unknown.

Inscription: (totally repainted) AN / DA / TVM · N / OVM · D / ONO·BIS/N·DILI/GATIS/IMNI/CEM/FIC·NT.

Condition: Fair. Christ's book has been totally repainted and the original inscriptions lost. The lower portion of His tunic, His face, and His hair have also been retouched. Thin bands and incised lines on either side of Christ's head indicate the former location of framing. The lateral saints belong to another altarpiece.

Provenance: J. A. Ramboux, Cologne (sold in 1867); Wallraf-Richartz Museum, Cologne, 1889 (sold in 1925); Ehrlich Galleries, New York, 1926.

Bibliography: Milanesi, 1862, p. 14; Sale Catalogue, J. Heberle (ed.), Jean Anton Ramboux Collection, 1867, p. 14, no. 105 (Taddeo di Bartolo); Niessen, 1869, p. 40, no. 767 (Taddeo di Bartolo); Niessen, 1873, p. 40, no. 767 (Taddeo di Bartolo); Niessen, 1875, p. 40, no. 767 (Taddeo di Bartolo); Niessen, 1877, p. 40, no. 767 (Taddeo di Bartolo); Niessen, 1888, p. 40, no. 767 (Taddeo di Bartolo); Thode, 1889, p. 51 (Taddeo di Bartolo); Perkins, 1913, p. 38 n. 4 (contemporary of Bartolo di Fredi or of Luca di Tommè); van Marle, 1924, vol. II, pp. 155 and 156 n. 1, fig. 106 (contemporary of Bartolo di Fredi or of Luca di Tommè); Berenson, 1930a, p. 263, ill. p. 266 (Niccolò di Segna); Berenson, 1930b, p. 31, fig. 2 (Niccolò di Segna); Kiel, 1970, pp. 20, 21, and 244, fig. 10; Stubblebine, 1979, p. 154, plate 486 (Niccolò di Segna).

Photographs: Rheinisches Bildarchiv, Cologne, negative no. 63158; Fototeca Berenson, Florence (detail).

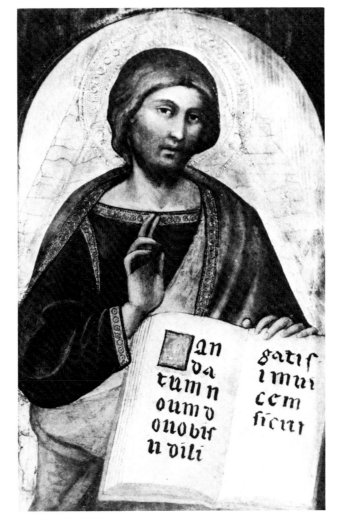

Pl. 23-2. *Christ Blessing* (detail of Pl. 23-1).

Pl. 23-1. *Christ Blessing.*

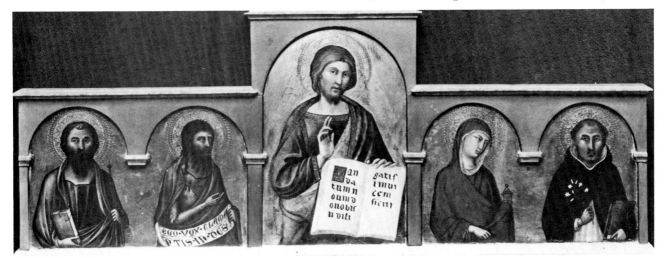

24. *Madonna and Child; Saint Anthony Abbot.* Panels of a polyptych (ca. 1366–73). Companions to Cat. 25.

120.1 × 42.3 cm. (47¼ × 16⅝ in.); 115 × 35.8 cm. (45¼ × 14⅛ in.). Pls. 24-1–24-3.

Location: Chiesa di San Francesco, Mercatello sul Metauro. Soprintendenza per i beni artistici e storici delle Marche.

Inscription: (Christ Child) EGO · SVM · LVX · MVNDI (John 8:12).

Condition: Fair. Both panels have suffered extensive damage throughout. Especially noticeable are the losses in the lower portion of the Virgin's cloak and above Saint Anthony's hands. The frame and arch above the Madonna and Child are modern.

Provenance: Original location.

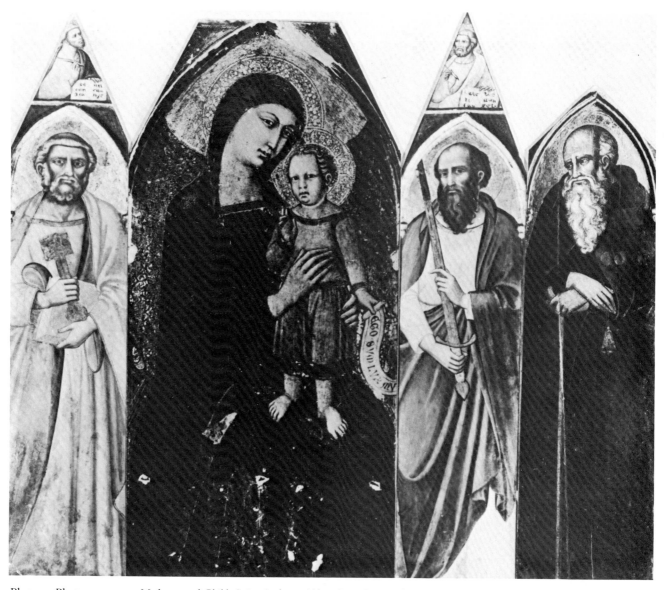

Pl. 24-1. Photo-montage, *Madonna and Child; Saint Anthony Abbot; Saint Peter and a Prophet;* and *Saint Paul and a Prophet.*

Bibliography: Venturi, 1915, p. 10, ill., figs. 11 and 12; van Marle, 1920, p. 144; *Rassegna Marchigiana*, 1924, vol. III; van Marle, 1924, vol. II, p. 476; Serra, 1925, p. 35; Serra, 1928a, pp. 178–80; Serra, 1928b, p. 33; Serra, 1929, p. 303, fig. 510; Perkins, 1931a, p. 91; Berenson, 1932, p. 312; Colasanti, 1932, p. 2; Perkins, 1933, p. 71; van Marle, 1934, vol. II, p. 523; Berenson, 1936, p. 269; T. C. I. *Marche*, 1937, p. 120; Mazzini, 1952, pp. 63 and 64, ill., fig. 6; Shorr, 1954, p. 27 n. 2; T. C. I. *Marche*, 1962, p. 175; Klesse, 1967, pp. 102 and 408–9; Berenson, 1968, vol. I, p. 225; Santi, 1969, p. 100; Fehm, 1973b, pp. 463, 464, and 463 nn. 3–5, figs. 75 and 76; Fehm, 1976, p. 341; De Benedictis, 1979, pp. 87–89.
Photographs: Gabinetto Fotografico Nazionale, Rome, negative nos. C. 8075 (*Madonna and Child* before restoration), and E8004 (*Saint Anthony*, before restoration).

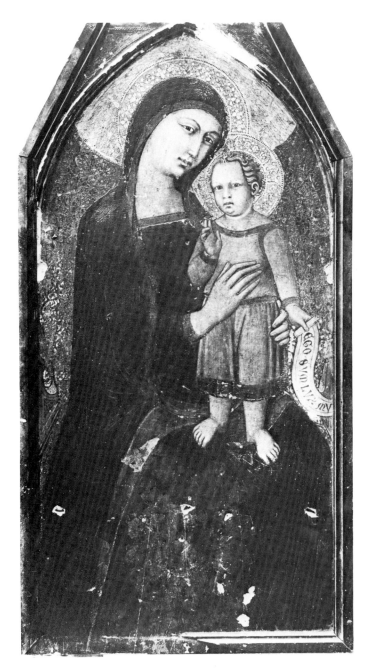

Pl. 24-2. *Madonna and Child* (detail of Pl. 24-1).

Pl. 24-3. *Saint Anthony Abbot* (detail of Pl. 24-1).

25. *Saint Peter and a Prophet*; *Saint Paul and a Prophet*. Parts of a polyptych (ca. 1366–73). Companions to Cat. 24.

142 × 34 cm. (55¹⁵⁄₁₆ × 13⅜ in.); 145 × 34 cm. (57⅛ × 13⅜ in.). Pls. 22-1 and 25-1–25-4.

Location: Exeter College Chapel, Oxford.

Inscription: (Saint Peter, totally repainted) SCQ / ENTI / AFA / NTI / ENA / NGC; (Saint Paul, totally repainted) SENE / TI / TAN / TIE / AAN / GCD.

Condition: Good. The Saint Peter panel has suffered somewhat more damage than the Saint Paul. Saint Peter's cloak has several areas that have been retouched. The books held by the prophets above the Saints have been totally repainted and the original inscriptions lost. The framing, column capitals, and for the most part the arches above the Saints are modern.

Provenance: George Gidley Robinson, Oxford; Exeter College Chapel, 1920.

Bibliography: Fehm, 1973b, pp. 463–64, and 463 n. 5, figs. 77–78 and 82–83; Fehm, 1976, pp. 340, 341, and 340 n. 12; De Benedictis, 1979, pp. 87–89.

Photographs: Thomas Photos, Oxford, negative nos. 42077 (Saint Peter, overall), 44045 (detail of prophet above Saint Peter), 42078 (Saint Paul, overall), and 44046 (detail of prophet above Saint Paul).

Pl. 25-1. *Saint Peter and a Prophet* (detail of Pl. 24-1).

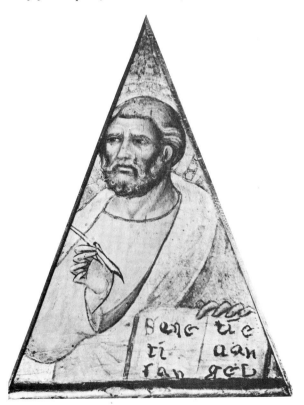

Pl. 25-3. *A Prophet* (detail of Pl. 24-1).

Pl. 25-2. *Saint Paul and a Prophet* (detail of Pl. 24-1).

Pl. 25-4. *A Prophet* (detail of Pl. 24-1).

26. *Angel Gabriel; Virgin of the Annunciation.*
(Ca. 1366–73.)

134 × 56 cm. (52¾ × 22⅛ in.) each panel. Pls.
26-1 and 26-2.

Location: Private Collection, Paris:

Inscription: AVE · [MARIA] · GRATIA · PLENA (Luke
1:28).

Condition: Very good. Both panels seem to
have been cut down on all sides, particularly at
the top. There is no evidence of repainting, and
the frames appear to be original.

Provenance: Private Collection, Paris, 1955.

Bibliography: Zeri, 1958, p. 5, figs. 4a and 4b;
Meiss, 1963, p. 48; Klesse, 1967, p. 407; Berenson, 1968, vol. I, p. 226; Fehm, 1973a, p. 9,
fig. 2; Fehm, 1976, pp. 343–45 and 343 n. 19,
fig. 7; De Benedictis, 1979, p. 87.

Photographs: Professor Federico Zeri, Rome.

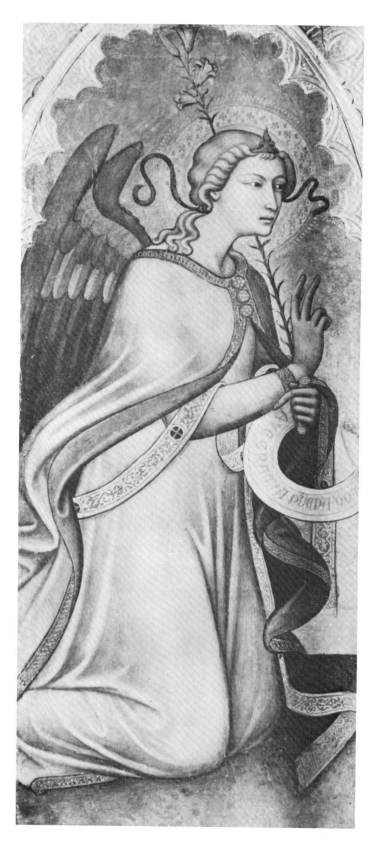

Pl. 26-1. *Angel Gabriel.*

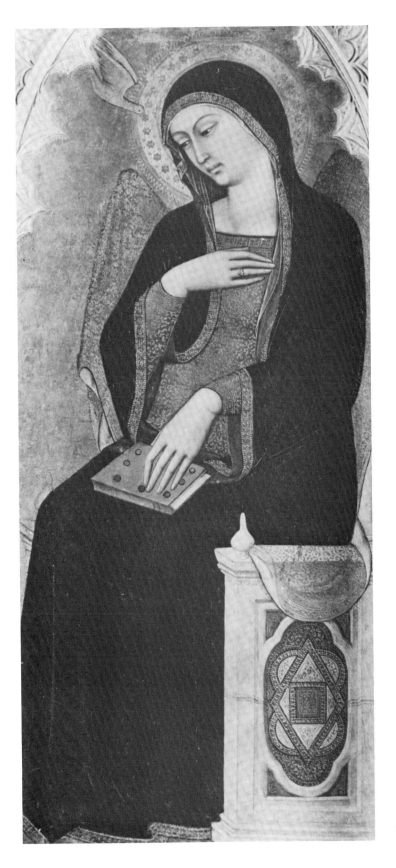

Pl. 26-2. *Virgin of the Annunciation.*

27. *Madonna and Child with Saints Dominic, Peter, Paul, and Peter Martyr.* Polyptych (signed and dated by Luca di Tommè, 1370).

198 × 278 cm. (77⅞ × 109¼ in.); (central panel)
198 × 82 cm. (77⅞ × 32¼ in.); (each lateral panel);
160 × 49 cm. (63⅜ × 19¼ in.). Pl. 27.

Location: Museo Civico, Rieti, no. 2.

Inscription: (below central panel) LVCAS · THOME · DE · SENIS · PINSIT · HOC · OPVS · MCCCLXX · [HAEC ·

TABVLA · FACTA · EST · PRO · ANIMA · ANDREA · PENNELLI · ET · VXORIS · SVAE · DONNAE · VANNAE]; (*Madonna*) QVI · VVLT · VENIRE · POST · ME · [AD]NEGET · SEMETILSVM · TOLLAT · CRVCEM · SVAM · ET · SQVAT (Matthew 16:24); (prophets above central panel) [P]VER · DATVS · EST · NOBIS (Isaiah 9:6), ECCE · VIRGO · CONCIPIET · ET · [PARIET · FILIVM] (Isaiah 7:14); (Saint Paul) BONV / M · CER / TAME / N · CER · / TAVI · / VM · CO[N] / SVM[M]A / VI · FIDEM · SE[RVAVI] (II Timothy 4:7).

Condition: Fair. Losses are noticeable throughout, par-

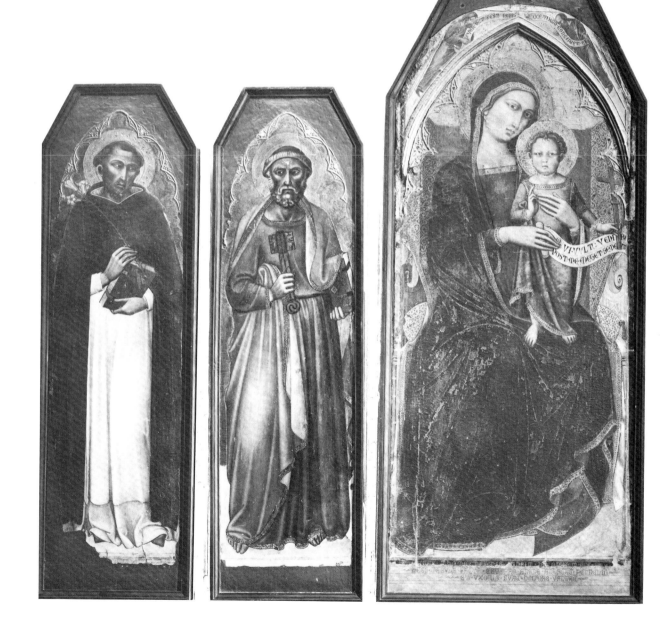

ticularly in the Virgin's cloak and in the gold backgrounds, which have been rubbed. The inscriptions under the Saints have been lost, together with the latter portion of the dedicatory inscription on the base of the Virgin's throne. The frame and arch above the Madonna and Child are modern. The polyptych was initially restored by Colarieti Tosti in 1911 and more recently by G. Matteucci of the Soprintendenza alle Gallerie of Lazio in 1957.

Provenance: San Domenico Convent, Rieti; Museo Civico, by 1898.

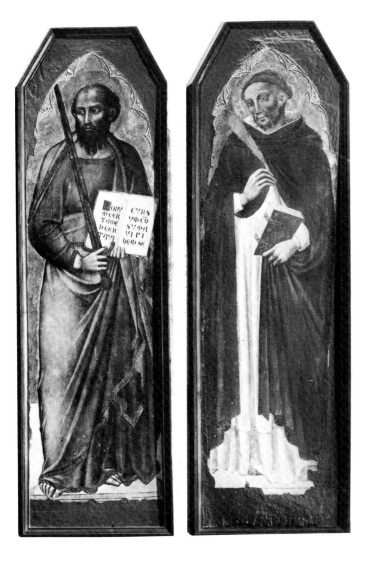

Pl. 27. *Madonna and Child with Saints Dominic, Peter, Paul, and Peter Martyr.*

Exhibitions: Museo Civico, Rieti, 1957, *Opere d'arte in Sabina dell' XI al XVII secolo*, p. 21, no. 6, pls. 7 and 8.

Bibliography: Fondo di S. Domenico, Archivio Comunale, Rieti, *Libro del Consigli del 1776,* "Consigle del Convento" (manuscript); Crowe and Cavalcaselle, 1864, vol. II, p. 114 and n. 4; Guardabassi, 1872, p. 30; Cavalcaselle and Morelli, 1896, vol. II, p. 192; Bellucci, 1901, p. 18; Petrini, 1904, pp. 178–81, ill.; Crowe and Cavalcaselle, 1908, vol. III, p. 87 and n. 3; Perkins, 1908b, p. 80; Perkins, 1909c, p. 83; Gnoli, 1911, pp. 325–26, pl. 1; *Rassegna d'Arte d'Umbria,* 1911, p. 70; van Marle, 1920, p. 142; van Marle, 1924, vol. II, pp. 465–66, 469, 472–73, and 476, fig. 306; van Marle, 1925, vol. V, pp. 372 and 462; Bacci, 1927, p. 62; Comstock, 1928, p. 57; Serra, 1928a, p. 179; Perkins, 1929, p. 427; Serra, 1929, p. 303; Salmi, 1930, p. 4; Brandi, 1931, p. 18; Perkins, 1931a, p. 91; Berenson, 1932, p. 313; Brandi, 1932, p. 234 n. 1; Procacci, 1932, pp. 473–74; Perkins, 1933, p. 71; van Marle, 1934, vol. II, pp. 514–15, 517–19, and 520–23, fig. 338; T. C. I. *Lazio,* 1935, p. 218; Zucchi, 1935, p. 22; Berenson, 1936, p. 269; T. C. I. *Umbria,* 1937, p. 218; Meiss, 1946, p. 7; Meiss, 1951, pp. 167 and 170; Kaftal, 1952, p. 788; Mazzini, 1952, p. 66 n. 11 and n. 14; Carli, 1955a, p. 97; Mortari, 1960, pp. 12–13, pls. 3–7; Carli, 1961a, vol. II, p. 20; Carli, 1964, p. 20; T. C. I. *Lazio,* 1964, p. 291; Goodison, 1967, p. 92; Klesse, 1967, p. 409; Berenson, 1968, vol. I, p. 225, pl. 373; Mongan, 1969, p. 22; Santi, 1969, p. 100; Cortona, *Mostra,* 1970, p. 16; Pisa, *Mostra,* 1972, pp. 93 and 95; Fehm, 1973a, pp. 9, 18, and 21, fig. 3; Fehm, 1973b, p. 464, figs. 79 and 81; Fehm, 1976, pp. 340, 341, 340 n. 12, and 347 n. 30; De Benedictis, 1979, p. 88; Siena, *Mostra,* 1979, p. 78; Zeri, 1981, p. 32.

Photographs: Alinari, Florence, negative no. 42331 (overall, before restoration); Gabinetto Fotografico Nazionale, Rome, negative nos. C5574, C5575, and C5576 (details, after restoration).

28. *Madonna and Child.* Central panel of a polyptych (ca. 1366–73).

121 × 60.5 cm. (47⅝ × 23⅜ in.). Pl. 28.

Location: San Michele Arcangelo, Granaiola (Lucca).

Inscription: (Christ Child) EGO · SVM · LVX · MVND[I] (John 8:12); (prophets above central panel) ECCE · VIRGO · CONCIPIET · ET · PER[IET · FILIVM] (Isaiah 7:14); [PV]ER · DATVS · EST · NOBIS · ET · F[ILIVS · DATVS · EST · NOBIS] (Isaiah 9:6).

Condition: Good. The panel was restored by Luciano Gazzi during 1972. The various paint losses—particularly noticeable throughout the Virgin's mantle at her head and knees—have been filled and repainted. The cloak was found to have been almost totally repainted, but has been left as is.

Provenance: Original location.

Exhibitions: Museo Nazionale di San Matteo, Pisa. *Mostra del Restauro*, September 16–November 5, 1972, pp. 92–97, no. 13, ill.

Bibliography: T. C. I. *Toscana*, 1959, p. 296 (trecento panel); Ardinghi, 1965 (Luca di Tommè, with question); T. C. I. *Toscana*, 1974, p. 268; Siena, *Mostra*, 1979, p. 78.

Photographs: *Mostra del Restauro*, 1972, ill.

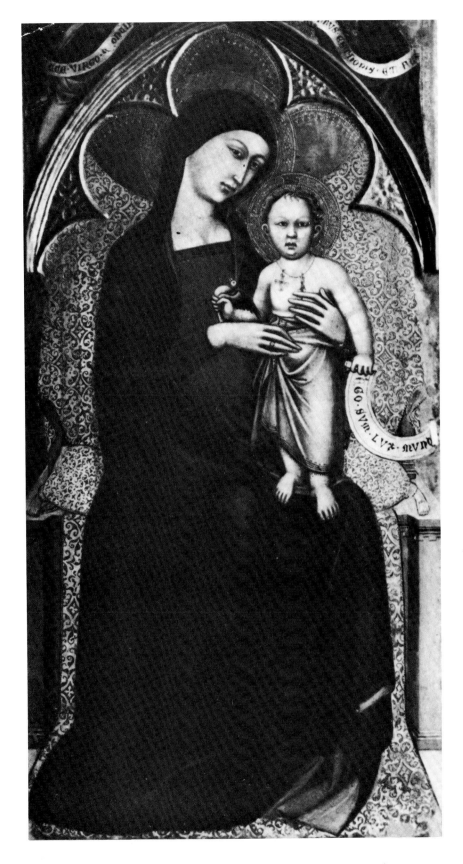

Pl. 28. *Madonna and Child.*

29. *Virgin Annunciate.* (Ca. 1366–73.)

50 × 40 cm. (19⅝ × 15¾ in.). Pl. 29.

Location: Unknown.

Condition: Fair. The panel has been cut down on all sides, particularly at the bottom. (It may well have been a full length of the Virgin Annunciate, such as the panels in Paris and Cascina.) The Virgin's cloak is worn and her hands and face somewhat retouched. The frame is modern.

Provenance: Dr. G. Arenz, Vienna, 1935.

Bibliography: Berenson, 1936, p. 269; Berenson, 1968, vol. I, p. 266; Fehm, 1976, pp. 345 and 345 n. 22, fig. 9; De Benedictis, 1979, p. 90.

Photographs: Fototeca Berenson, Florence.

Pl. 29. *Virgin Annunciate.*

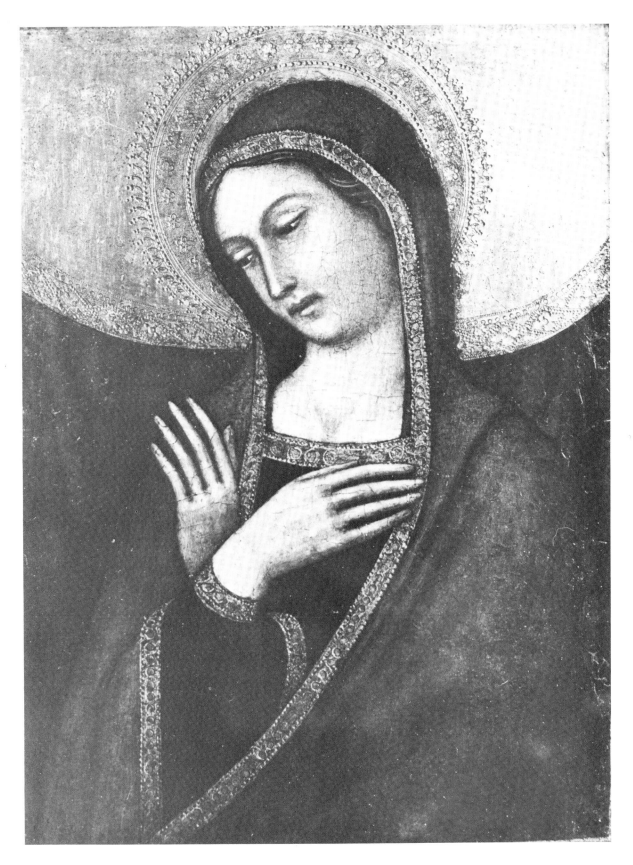

30. *Mystic Marriage of Saint Catherine; Saints Bartholomew and Blaise;* and *Saints John the Baptist and John the Evangelist.* Parts of a polyptych (ca. 1366–73). Companions to Cat. 31.

(central panel) 116 × 56.5 cm. (45¼ × 22 in.); (Bartholomew) 116.5 × 35.5 cm. (45½ × 13⅞ in.); (Blaise) 116.5 × 37 cm. (45½ × 14⁷⁄₁₆ in.)
Pls. 30-1–30-3.

Location: Pinacoteca Nazionale, Siena, no. 594.

Condition: Fair. The panels have been cleaned and restored recently. Extensive losses are noticeable, especially in the Virgin's face, the area above Saint Catherine's crown, and the middle area of Saint Bartholomew's cloak. Other damage is visible in Saint Blaise's mantle and here and there in the gold background. Areas of loss where the wood itself is exposed have been given a protective coating of wax and left visible. In the areas of lesser damage watercolor has been used to consolidate passages within the composition.

Provenance: Cappella di S. Biagio à Filetta, annex to S. Andrea à Frontignano, near Murlo; Pinacoteca Nazionale (formerly La Regia Pinacoteca, etc.), 1907.

Exhibitions: Pinacoteca Nazionale, *Mostra di opera d'arte restaurate nelle province di Siena e Grosseto,* June–November, 1979, p. 82, fig. 65, and plate IV.

Bibliography: Brogi, 1897, pp. 378–79 (manner of Pietro Lorenzetti); Franchi, 1907, p. 103; *Catalogo,* 1909, p. 185 (manner of Pietro Lorenzetti); Perkins, 1909c, p. 84; Perkins, 1909d, p. 80; Dami, 1915, pp. 43 and 134; van Marle, 1920a, p. 146n; Dami, 1924, p. 56; Heywood and Olcott, 1924, p. 406n (apparently refers to this work); van Marle, 1924, vol. II, p. 479; Bacci, 1927, p. 62 n. 1; Perkins, 1928b, p. 203; Perkins, 1929, p. 427; Bacci, 1932, p. 186; Berenson, 1932, p. 313; Brandi, 1933, p. 161; van Marle, 1934, vol. II, p. 526; Berenson, 1936, p. 269; Meiss, 1951, p. 112 n. 30; Kaftal, 1952, p. 201; Berenson, 1968, vol. I, p. 226; Fehm, 1976, pp. 340, 346, and 340 n. 10, fig. 5; Fehm, 1978, pp. 158 and 164 n. 12; Torriti, 1978, p. 394; De Benedictis, 1979, pp. 89 and 90; *Mostra,* 1979, p. 82, fig. 65, and pl. IV.

Photographs: Fototeca Berenson, Florence (overall and details, after restoration); Frick Art Reference Library, New York, negative no. 6280 (overall, before restoration); Soprintendenza per i beni artistici e storici per le province di Siena e Grosseto (after restoration).

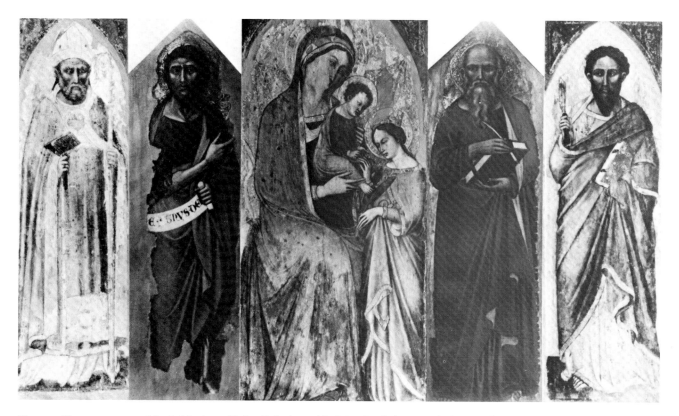

Pl. 30-1. Photo-montage, *Mystic Marriage of Saint Catherine;* with *Saints Bartholomew and Blaise;* and *Saints John the Baptist and John the Evangelist.*

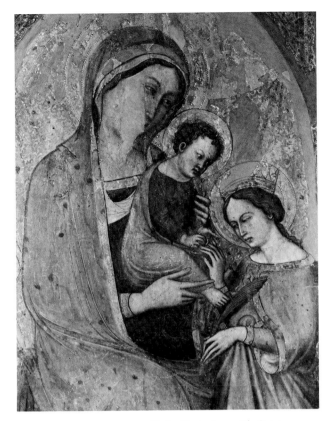 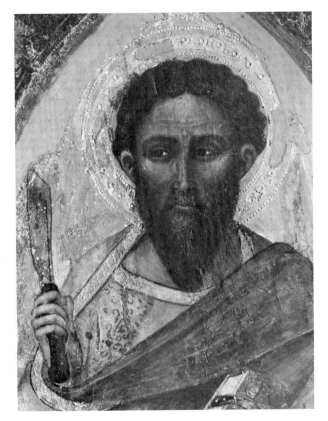

Pl. 30-2. *Mystic Marriage of Saint Catherine*, with *Saints Bartholomew and Blaise* (detail of Pl. 30-1).

Pl. 30-3. *Saint Bartholomew* (detail of Pl. 30-1).

31. *Saint John the Baptist; Saint John the Evangelist.* Parts of a polyptych (ca. 1366–73). Companions to Cat. 30.

125 × 36 cm. (45¼ × 14¼ in.). Pls. 31-1 and 31-2.

Location: Unknown.

Condition: Fair. Both panels have been damaged along their edges and cut at the top into gable shapes. *Saint John* has suffered particularly along the left edge and at the bottom; both figures have been retouched in the face and drapery.

Provenance: Lanckoronski Collection, Vienna, 1935.

Bibliography: Berenson, 1932, p. 314; van Marle, 1934, vol. II, p. 527 n. 1; Berenson, 1936, p. 269; Berenson, 1968, vol. I, p. 226; Fehm, 1976, p. 340 n. 10; Torriti, 1978, pp. 394–95, fig. 471 (during restoration); De Benedictis, 1979, p. 90; Siena, *Mostra*, 1979, p. 82.

Photographs: Fototeca Berenson, Florence.

Pl. 31-1. *Saint John the Baptist* (detail of Pl. 30-1).

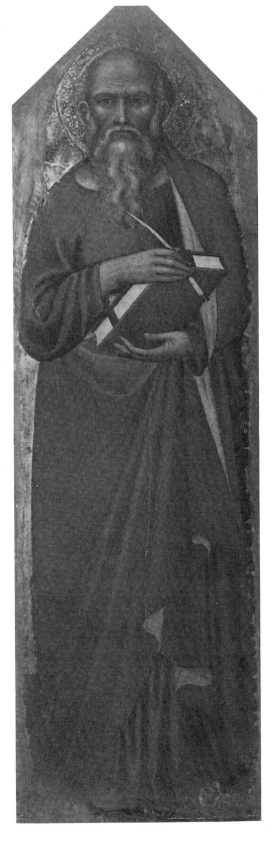

Pl. 31-2. *Saint John the Evangelist* (detail of Pl. 30-1).

32. *Madonna and Child, Bishop Saint, John the Baptist, Gregory, and Francis; (in the pinnacles) Redeemer, Two Evangelists, Paul, and Peter.* Polyptych (ca. 1366–73). See also Cat. 68.

130 × 183 cm. (50¾ × 71⅜ in.). Pls. 32-1–32-4.

Location: Pinacoteca Nazionale, Siena, no. 586.

Inscription: [LVCAS ·] THOME · [DE · SENIS · PINXIT ·H] OC · [H] OPVS; (Christ Child's scroll) QVI [*sic*] · VVLT · VENIRE · POST · ME · ADNEGET [*sic*] · SEMETISV[M] [*sic*] · TOLLAT · CRVCE[M] · SVA[M] · ET · SEQVAT[VR · ME] (Matthew 16:24); (Saint John the Baptist's scroll) ECCE · AGNVS · DEI · ECCE · Q[VI · TOLLIT · PECCATVM · MVNDI] (John 1:29); (on frame) S · JOHANES · BATISTA.

Condition: Fair. The altarpiece has suffered paint loss throughout. This is especially visible in certain passages of the Bishop Saint's and Saint Gregory's mantles. The gold background has been abraded particularly in the central panel, where the Virgin's cloak has been rubbed to the extent that the underdrawing is noticeable. The cleaning and restoration performed in Siena during 1967–68 have set down many small blisters in the paint film with a layer of varnish. The frame is original.

Provenance: Dragondelli Chapel (?), San Domenico, Arezzo; Chapel of the Monastery of the Tolfe, near the Porta San Viene, Siena; Fiori-Sansedoni family, Siena, 1869; Art Market, Rome and Pisa; Professor E. Modigliani, Rome, 1906; Pinacoteca Nazionale (formerly La Regia Pinacoteca, etc.), 1906.

Attributions: F. M. Perkins (verbal opinion, Frick Art Reference Library, New York, 1924).

Bibliography: Milanesi, 1854, vol. I, p. 28 n. 1; Crowe and Cavalcaselle, 1864, vol. II, pp. 114–15; Milanesi, 1878, vol. I, p. 651 n. 3; Brogi, 1897, p. 228; Lupi, 1904, p. 408 n. 2; Franchi, 1906, pp. 111–15; Modigliani, 1906, pp. 104–5; Franchi, 1907, p. 104; Jacobsen, 1907, p. 48; Crowe and Cavalcaselle, 1908, vol. III, pp. 87–88, and n. 1 and n. 3; *Catalogo*, 1909, p. 111; Dami, 1915, p. 43; van Marle, 1920a, p. 145; Dami, 1924, p. 55; Heywood and Olcott, 1924, p. 399n; van Marle, 1924, vol. II, p. 479; Bacci, 1927, p. 62 n. 1; Perkins, 1929, p. 427; Fattorusso, 1930, p. 347; Bacci, 1932, p. 185; Berenson, 1932, p. 313; Brandi, 1933, pp. 160–61; van Marle, 1934, vol. II, pp. 513, 519–20, and 524–26; Berenson, 1936, p. 269; Meiss, 1946, p. 7, n. 47 and n. 48, fig. 2; Meiss, 1951, pp. 87 and 123, fig. 119; Sandberg-Vavalà, 1953, p. 196, fig. 81; Carli, 1958, p. 27; Cämmerer-George, 1966, pp. 144 and 220 n. 494, pl. 24a; Berenson, 1968, vol. I, p. 226; van Os, 1969a, cat. no. 7; van Os, 1969b, pp. 68, 69 n. 96, and 72, pl. 28; Fehm, 1973a, p. 31 n. 35; Fehm, 1976, pp. 341 n.

15, 347 n. 30, and 348 n. 32; Torriti, 1977, p. 158, fig. 171; De Benedictis, p. 89 (the author seems to confuse this polyptych, which is inv. no. 586, with a single panel, inv. no. 184, from the ambience of Ambrogio Lorenzetti. The latter panel depicts the *Mystic Marriage of Saint Catherine and Saints John the Baptist and Catherine of Alexandria.* The cusp contains the representation of Saint Peter or an evangelist.); Siena, *Mostra*, 1979, p. 80.

Photographs: Alinari, Florence, negative no. 36631; Frick Art Reference Library, New York, negative no. 22104; Anderson, Rome, negative no. 31941; Artini, Florence; Passerini, Siena (details); Soprintendenza per i beni artistici e storici per le province di Siena e Grosseto.

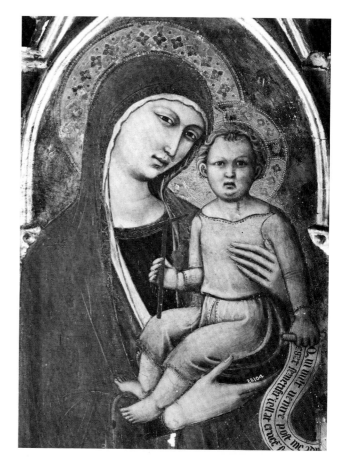

Pl. 32-2. *Madonna and Child* (detail of Pl. 32-1).

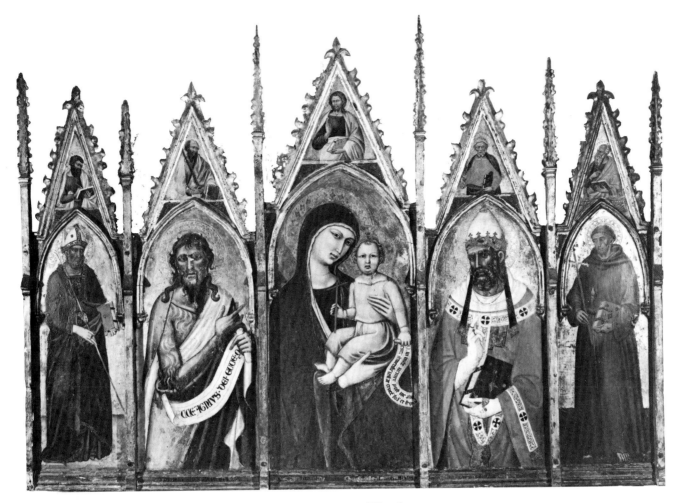

Pl. 32-1. *Madonna and Child, Bishop Saint, John the Baptist, Gregory, and Francis;*
in the pinnacles, *Redeemer, Two Evangelists, Paul, and Peter.*

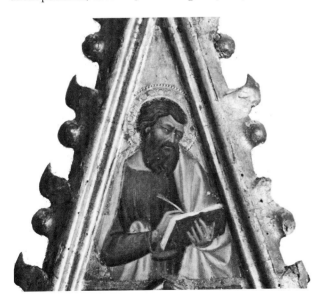

Pl. 32-3. *A Prophet* (detail of Pl. 32-1).

Pl. 32-4. *Saint Peter* (detail of Pl. 32-1).

33. *Madonna and Child Enthroned with Saints Nicholas and Paul.* (Ca. 1366–73.)

132.7 × 114.6 cm. (52¼ × 45⅛ in.). Pl. 33.

Location: Los Angeles County Museum of Art, no. 32.22. Gift of Samuel H. Kress.

Inscription: (Christ Child) EGO · SVM · LVX · MVNDI (John 8:12); S·NICOLAVS; S·PAVLV[S].

Condition: Fair. The panel has been substantially cut down. Large areas of pigment loss are noticeable adjacent to Saint Nicholas's left shoulder and Saint Paul's right shoulder. The Child's inscription has been reinforced and the faces of the central figures somewhat retouched. The Virgin's cloak has been repainted. A modern frame covers a portion of the picture on all sides and obscures part of the inscriptions along the bottom.

Provenance: Charles Fairfax Murray, London; Contini Bonacossi, Rome, 1930; Samuel H. Kress, New York; Samuel H. Kress Foundation (K69), New York; Los Angeles County Museum of Art, 1931.

Exhibitions: Scripps College, Claremont, California, *Scripps Christmas Exhibit,* November 13, 1952–January 15, 1953; Municipal Art Center, Long Beach, California, *Religious Art,* January 22–February 19, 1966.

Attributions: G. Fiocco, R. Longhi, F. M. Perkins, W. E. Suida, and A. Venturi (manuscript opinions, Samuel H. Kress Foundation).

Bibliography: Perkins, 1920, p. 292, no. 12; Perkins, 1929, p. 427; Los Angeles County Museum, 1930, p. 18; *The Antiquarian,* 1931, p. 39, ill.; *California Arts,* 1931, p. 8, ill.; Los Angeles County Museum, 1931, ill. on cover; Wescher, 1954, vol. II, pl. 4; Shapley, 1966, vol. I, p. 60, fig. 153; Berenson, 1968, vol. I, p. 225; Fredericksen and Zeri, 1972, pp. 113, 318, 435, 438, and 591; Pisa, *Mostra,* 1972, p. 95; Fehm, 1973a, p. 31 n. 35; Muller, 1973, pp. 12, 15–16, 18, 19, and 19 n. 5, figs. 2, 7, and 9; Fehm, 1976, p. 348 n. 32; De Benedictis, 1979, p. 87; Siena, *Mostra,* 1979, p. 78.

Photographs: Los Angeles County Museum of Art; Samuel H. Kress Foundation.

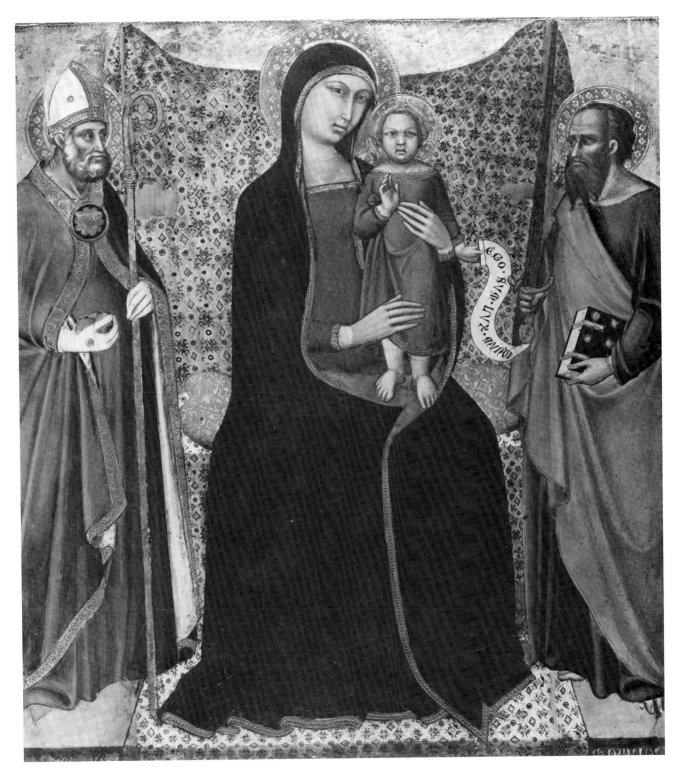

Pl. 33. *Madonna and Child Enthroned with Saints Nicholas and Paul.*

34. *Madonna and Child Enthroned with Four Angels.* (Ca. 1366–73.)

160 × 86.7 cm. (63 × 34⅛ in.). Pl. 34.

Location: Fitzwilliam Museum, Cambridge, England, no. 563.

Condition: Good. The panel has been cut down on all sides. The modern frame and molding cover part of the painted surface. Originally the halos and wings of the angels standing behind the cloth of honor would have been visible. The surface has been rubbed and repairs have been made to the Virgin's right cheek and neck. Her cloak has been considerably retouched.

Provenance: Cav. Giuseppe Toscanelli, Pisa; Charles Butler, London, 1883; Fitzwilliam Museum, 1893.

Exhibitions: Royal Academy, London, *Old Masters,* 1885, no. 232; Burlington Fine Arts Club, London, *Pictures of the School of Siena,* 1904, no. 68; Goldsmith's Hall, London, *Treasures of Cambridge,* 1959, no. 43.

Bibliography: Sale Catalogue, G. Milanesi (ed.), Giuseppe Toscanelli Collection, Florence, April 20, 1883, p. 28, no. 104; Earp, 1902, pp. 96 and 97; Perkins, 1908b, p. 80; *The Principal Pictures,* 1912, p. 177; van Marle, 1920a, p. 143, fig. 54; van Marle, 1924, vol. II, pp. 472–73, fig. 310; Perkins, 1929, p. 427; *The Principal Pictures,* 1929, p. 123; Berenson, 1932, p. 312; Brandi, 1932, p. 234 n. 1; van Marle, 1934, vol. II, p. 520, fig. 341; Berenson, 1936, p. 269; Goodison, 1967, pp. 91–92, pl. 13; Berenson, 1968, vol. I, p. 224; Pisa, *Mostra,* 1972, pp. 63 and 65; De Benedictis, 1979, p. 87; Siena, *Mostra,* 1979, p. 78.

Photographs: Fitzwilliam Museum, negative nos. S926 (overall), S5681, and S6682 (details).

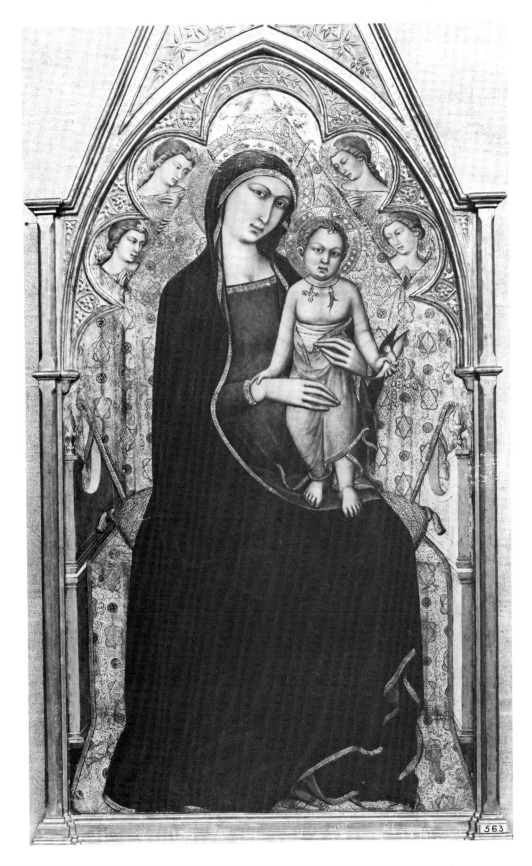

Pl. 34. *Madonna and Child Enthroned with Four Angels.*

35. *Madonna and Child with Four Angels.* Central panel of a polyptych (ca. 1366–73).

100 × 73 cm. (39⅜ × 28¾ in.). Pl. 35.

Location: San Niccolò Sacristy, Foligno. Soprintendenza per i beni ambientali, architettonici, artistici e storici, Perugia.

Condition: Good, although the panel is dirty and has been cut at the top and bottom. (Very likely the Virgin was originally depicted full length). The Virgin's cloak is somewhat damaged and a repair is visible on her right shoulder. There is damage to her halo at the left and right of her face. Areas on the Christ Child's throat and left arm have been poorly repaired. The entire painted surface is marked by worm holes.

Provenance: Original location.

Bibliography: Guardabassi, 1872, p. 31 (Sienese 14th century); Perkins, 1908b, pp. 79–80, ill.; van Marle, 1920a, p. 144; Perkins, 1920, pp. 288–91, ill.; van Marle, 1924, vol. II, pp. 476 and 479; Bacci, 1927, p. 52; Comstock, 1928, pp. 58 and 61; Perkins, 1929, p. 427; Perkins, 1931a, pp. 90–91, pl. 1; Berenson, 1932, p. 312; Brandi, 1932, p. 234 n. 1; Perkins, 1933, pp. 70–71, pl. 66; van Marle, 1934, vol. II, p. 523; Berenson, 1936, p. 269; T. C. I. *Umbria*, 1938, p. 195; T. C. I. *Umbria*, 1950, p. 203; Mazzini, 1952, p. 66 n. 14; Santi, 1956, p. 13; T. C. I. *Umbria*, 1966, p. 240; Klesse, 1967, pp. 102 and 408; Berenson, 1968, vol. I, p. 224; Santi, 1968, p. 13; Santi, 1969, p. 100; De Benedictis, 1979, p. 87.

Photographs: Frick Art Reference Library, New York, negative no. 6129.

Pl. 35. *Madonna and Child with Four Angels.*

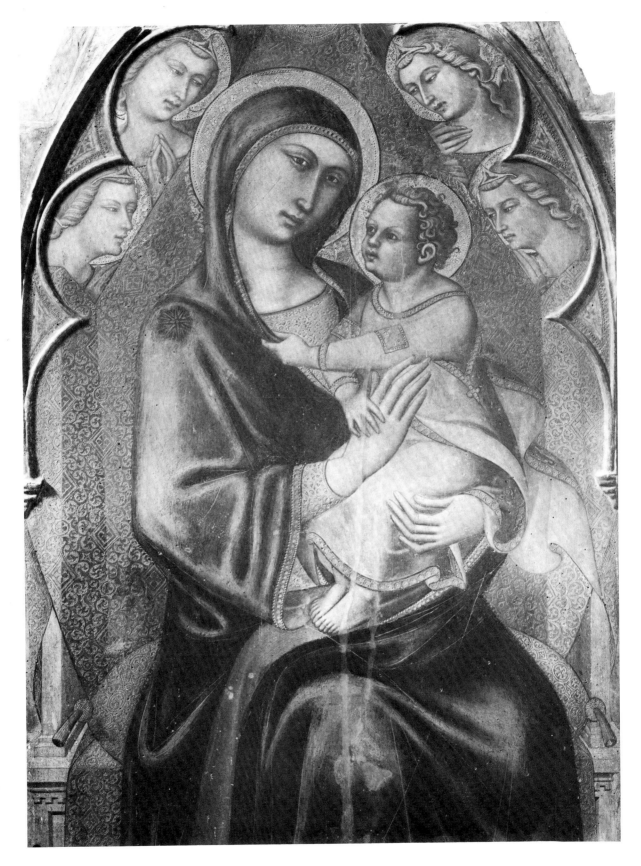

36. *Madonna and Child.* (Ca. 1366–73.)

107 × 57.5 cm. (42⅛ × 22⅝ in.). Pl. 36.

Location: Oratorio della Visitazione, Church of the Contrada of Bruco, Siena.

Condition: Fair. The panel has been cleaned and restored recently. Previous to this it had sustained a good deal of damage. There has been extensive paint loss in the Virgin's dress and cloak. The gold ground has been badly rubbed, and a vertical split extends the entire height of the right side of the panel.

Provenance: Pacciani family, Siena; Oratorio della Visitazione, 1792.

Bibliography: Heywood and Olcott, 1903, p. 303 (18th century); Perkins, 1908b, p. 81, ill.; Dami, 1915, p. 25; van Marle, 1920a, p. 145; Heywood and Olcott, 1924, p. 360; van Marle, 1924, vol. II, pp. 479 and 481; Bacci, 1927, p. 52; Comstock, 1928, p. 62; Perkins, 1929, p. 427; Berenson, 1932, p. 313; van Marle, 1934, vol. II, p. 526; T. C. I. *Toscana*, 1935, p. 449; Berenson, 1936, p. 269; T. C. I. *Toscana*, 1959, p. 582; *Il Brucaiolo*, June, 1967 (Sano di Pietro or Barna); Berenson, 1968, vol. I, p. 226; Fehm, 1973a, p. 31 n. 35; T. C. I. *Toscana*, 1974, p. 535; Fehm, 1976, p. 348 n. 32; De Benedictis, 1979, p. 89; Siena, *Mostra*, 1979, pp. 78 and 80.

Photographs: Artini, Florence (overall and details, present state); Frick Art Reference Library, New York, negative no. 7014; Soprintendenza per i beni artistici e storici per le province di Siena e Grosseto (after restoration).

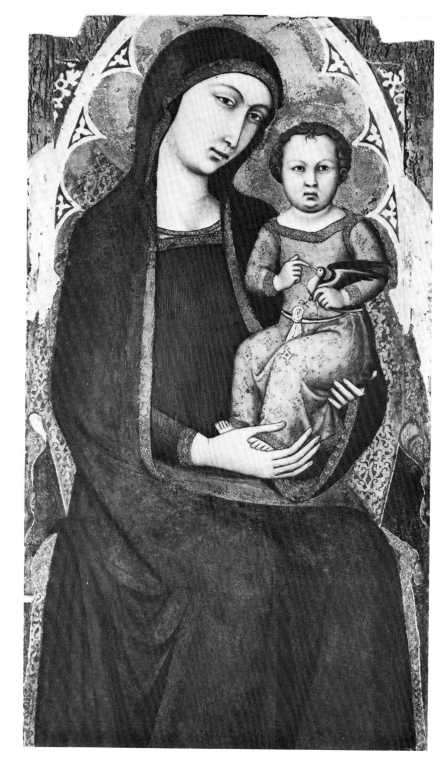

Pl. 36. *Madonna and Child.*

37. *Madonna and Child*. Central panel of a polyptych (ca. 1366–73).

148.6 × 62.2 cm. (58½ × 24½ in.). Pl. 37.

Location: Museo de Arte, Ponce, Puerto Rico, no. 64. 0270.

Inscription: EGO·SVM·LVX·MVNDI (John 8:12).

Condition: Fair. The Virgin's mantle is extensively abraded and the flesh tones, especially in her face and hands, have been retouched. The arch, spandrel decoration, and frame are not original. The panel was cleaned in New York in 1963.

Provenance: Contini Bonacossi, Rome; Samuel H. Kress, New York, 1927; Samuel H. Kress Foundation (KM-4), New York; Museo de Arte, 1961.

Exhibitions: The Metropolitan Museum of Art, New York, 1928–61, inv. no. 28.179.

Attributions: G. Fiocco, R. Longhi, F. M. Perkins, W. E. Suida, and A. Venturi (manuscript opinions, Samuel H. Kress Foundation).

Bibliography: van Marle, 1924, vol. II, p. 470, fig. 306; van Marle, 1925, vol. V, p. 462; Wehle, 1929, p. 9, ill.; Berenson, 1930a, p. 273, ill.; Berenson, 1930b, p. 27, fig. 6; Berenson, 1932, p. 313; van Marle, 1934, vol. II, p. 527 n. 1; Berenson, 1936, p. 269; Wehle, 1940, pp. 80–81, ill. p. 81; Held, 1964, p. 29, figs. 2a and 2b; Shapley, 1966, vol. I, p. 60, fig. 152; Klesse, 1967, pp. 102 and 409; Berenson, 1968, vol. I, p. 225; Kiel, 1970, pp. 25, 26, and 244, fig. 20; Fredericksen and Zeri, 1972, pp. 113, 318, 622, and 659; Pisa, *Mostra*, 1972, pp. 93 and 95; Fehm, 1973a, p. 31 n. 35; Fehm, 1976, p. 348 n. 32; De Benedictis, 1979, p. 88; Siena, *Mostra*, 1979, p. 78.

Photographs: The Metropolitan Museum of Art, negative no. 72117D; Samuel H. Kress Foundation (overall and details).

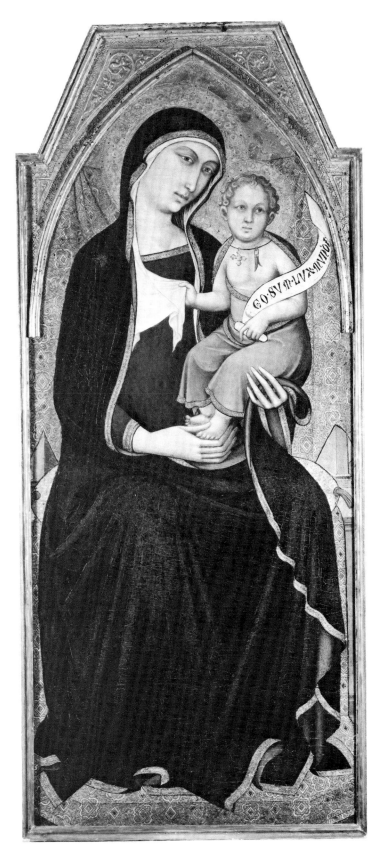

Pl. 37. *Madonna and Child.*

38. *Madonna and Child with Two Angels.* Central panel of a polyptych (ca. 1366–73).

80 × 53 cm. (31½ × 20⅞ in.). Pl. 38.

Location: Museo d'Arte Sacra della Valdarbia, Buonconvento.

Condition: Fair. The panel has been cleaned and restored recently. The paint surface on the left side of the panel has been entirely lost, and the Siena Soprintendenza has decided to leave the overpaint in that area for the time being. The votive crowns and the overpaint in the rest of the painted surface area have been removed. The flesh tones are intact except for a repair in the Christ Child's cheek. The panel has been cut at the top and bottom. The Virgin may have been full length originally, and the portion above her head probably contained a pointed arch. Physical evidence suggests that this was the central panel of a now dispersed polyptych.

Provenance: Pieve dei Ss. Innocenti a Piana, Buonconvento, 1978.

Exhibitions: Pinacoteca Nazionale, Siena, *Mostra di Opera d'arte restaurate nelle province di Siena e Grosseto*, June–November, 1979, pp. 80–81, figs. 63 and 64.

Bibliography: Brogi, 1897, p. 46 (manner of Lippo Memmi); Perkins, 1929, p. 427; Perkins, 1930, pp. 257 and 260 n. 266; Perkins, 1933, pp. 38 and 42, pl. 45; Berenson, 1968, vol. I, p. 224; De Benedictis, 1979, p. 87.

Photographs: Frick Art Reference Library, New York, negative no. 6233; Soprintendenza per i beni artistici e storici per le province di Siena e Grosseto (after restoration).

Pl. 38. *Madonna and Child with Two Angels.*

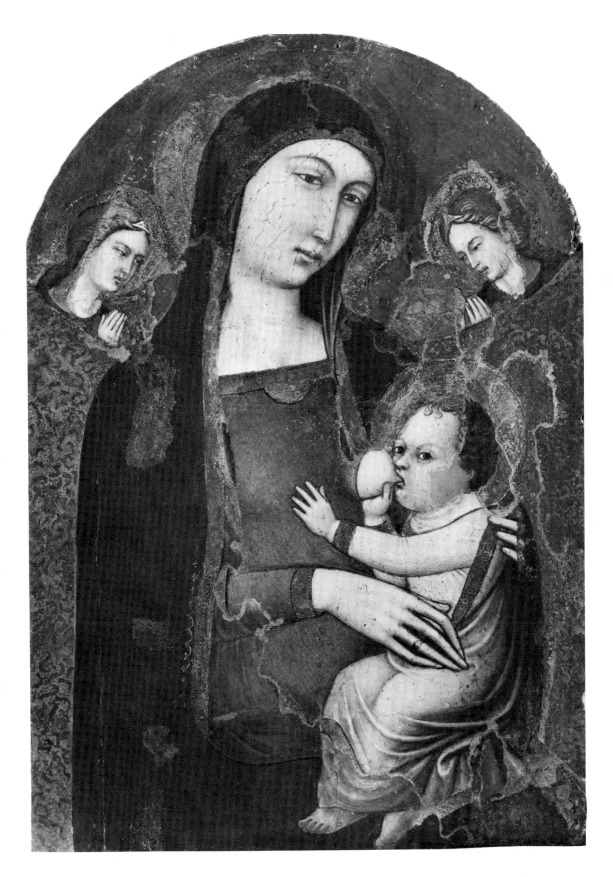

39. *Madonna and Child Enthroned with Saints John the Baptist, Peter, Paul, and Apollinaris*; in the pinnacles, *Christ Blessing*, with *Saints Catherine, Anthony Abbot, Leonard, and Lucy*. Polyptych (ca. 1374–90).

143 × 187 cm. (56⁵⁄₁₆ × 73⁵⁄₈ in.). Pls. 39-1–39-4.

Location: Galleria Nazionale dell'Umbria, Perugia, no. 947.

Inscription: (Christ Child) MANDATVM·NOVV[M]; (John the Baptist) ECCE·AGNVS·DE[I] (John 1:29); (framing under central panel) [LV]CAS·THO[ME]; (framing under Saints) S. JOHNES·BATTISTA; S·PAVLVS; S·APPOLINARIVS.

Condition: Good. Professor Giustino Cristofani cleaned the polyptych about 1920, and during 1953–54 extensive repairs were made. There are scattered losses in the Baptist's cloak and in his right hand, which have

been retouched. Some flaking is noticeable in the Saint Peter panel. The blue of the Madonna's mantle is quite abraded and repainted; losses in the Christ's face and chest have been consolidated. The vertical split running the length of the central panel on the right side has been filled. Occasional retouching in Saint Paul's undergarment is visible; the major losses in Saint Apollinaris's left shoulder and head have been filled and painted in a neutral color. The inscriptions in the base of the lateral panels are intact, while those in the scrolls held by the Baptist and Child have been reinforced. Only a fragment of the dedicatory inscription at the base of the central panel has been preserved. The arches are largely intact, but the framing is modern.

Provenance: Parrochiale, Forsivo (near Norcia); Pinacoteca, Spoleto, May 24, 1924; Galleria Nazionale dell'Umbria, Perugia, 1951.

Exhibitions: Galleria Nazionale dell'Umbria, 1945,

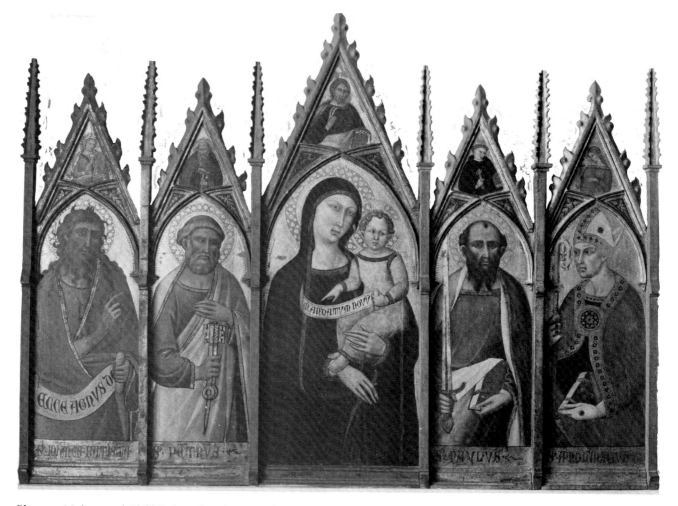

Pl. 39-1. *Madonna and Child Enthroned, with Saints John the Baptist, Peter, Paul, and Apollinaris*; in the pinnacles, *Christ Blessing*, with *Saints Catherine, Anthony Abbot, Leonard, and Lucy*.

Quatro secoli di pittura in Umbria—Mostra celebrativa del V centenario della nascita di Pietro Perugino, p. 13; Galleria Nazionale dell'Umbria, 1953, *Mostra di dipinti restaurati*, pp. 9–10; Museo Civico, Rieti, 1957, *Opere d'arte in Sabina dall' XI al XVII secolo*, pp. 22–23.

Bibliography: Gnoli, 1921a, p. 56; Gnoli, 1921b, p. 95; Salmi, 1922, p. 16; van Marle, 1924, vol. II, pp. 476 and 477; Perkins, 1929, p. 427; van Marle, 1931, pp. 170–71; Perkins, 1931a, p. 91; Berenson, 1932, p. 314; Perkins, 1933, p. 71; van Marle, 1934, vol. II, pp. 523–24; Berenson, 1936, p. 269; Toesca, 1951, p. 598 n. 116; Kaftal, 1952, pp. 95–97, fig. 94; Mazzini, 1952, p. 66 n. 14; Santi, 1956, p. 13, fig. 10; Cämmerer-George, 1966, pp. 143 and 220 n. 493; T. C. I. *Umbria*, 1966, p. 282; Berenson, 1968, vol. I, p. 255; Santi, 1968, p. 13, fig. 10; Santi, 1969, pp. 100–101, fig. 80; Fehm, 1973a, p. 30 n. 25; Fehm, 1976, p. 341 and n. 16; De Benedictis, 1979, p. 88; Santi, 1979, p. 14.

Photographs: Alinari, Florence, negative no. 51575 (overall after restoration); Artini, Florence (overall and details of lateral figures, heads, and pinnacles); Frick Art Reference Library, New York, negative no. 22524 (overall before restoration); Gabinetto Fotografico Nazionale, Rome, negative no. 6157.

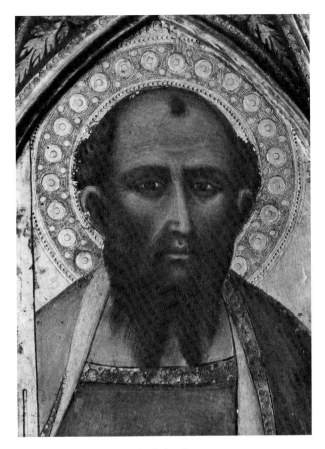

Pl. 39-2. *Saint Paul* (detail of Pl. 88).

Pl. 39-3. *Saint Leonard* (detail of Pl. 88).

Pl. 39-4. *Saint Lucy* (detail of Pl. 88).

40. *Conversion of Saint Paul.* Predella panel (ca. 1374–90). Companion to Cat. 41 and 42. 31.4 × 38.7 cm. (12⅜ × 15¼ in.). Pl. 40.

Location: Seattle Art Museum, no. 61.167; formerly inv. no. It37/Sp465.1).

Inscription: SALVE · SALVE · [QVID]CVR · ME · PESEQ[V]ERIS (Acts 9:14); SPQR.

Condition: Very good. Except for a few minor abrasions, the panel is well preserved. Two small losses under Christ's right hand have been filled, and a lateral crack running the width of the panel slightly below its center has been closed.

Provenance: Sterbini, Florence; Contini Bonacossi, Florence, 1935; Samuel H. Kress, New York; Samuel H. Kress Foundation (K373), New York; Seattle Art Museum, 1952.

Exhibitions: National Gallery of Art, Washington, D.C., 1941–51, no. 319.

Attributions: B. Berenson (Lippo Vanni); G. Fiocco (toward Giovanni dal Ponte); R. Longhi, W. Suida, and A. Venturi (Lorenzo di Bicci); F. M. Perkins and R. van Marle (close to Spinello Aretino); (manuscript opinions, Samuel H. Kress Foundation).

Bibliography: *Preliminary Catalogue,* 1941, p. 208, no. 319 (Lippo Vanni); Longhi, 1951, p. 55 (Parri Spinelli); Meiss, 1951, p. 34 n. 84 (associate of Luca di Tommè); Suida, 1952a, p. 12 (close follower of Spinello Aretino); Suida, 1954, p. 26 (close follower of Spinello Aretino); Meiss, 1963, p. 47 n. 7 (associate of Luca di Tommè); Boskovits, 1965, p. 46 (associate of Luca di Tommè); Boskovits, 1966a, p. 37 (associate of Luca di Tommè); Shapley, 1966, vol. I, p. 60, fig. 158 (studio of Luca di Tommè); Fredericksen and Zeri, 1972, pp. 113, 439, and 638; Torriti, 1977, p. 159; De Benedictis, 1979, pp. 87–89.

Photographs: Samuel H. Kress Foundation; Seattle Art Museum.

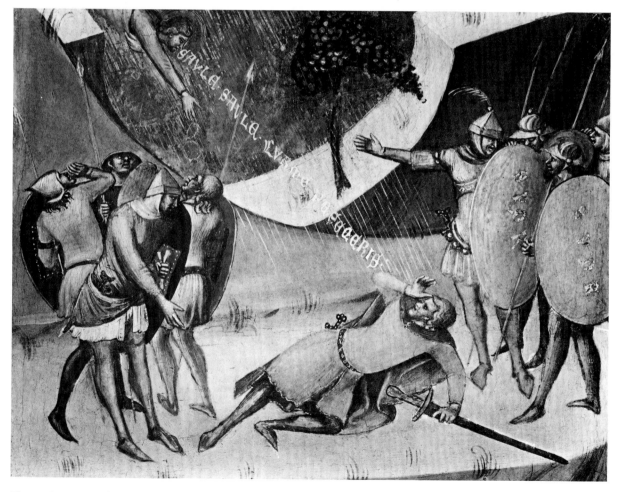

Pl. 40. *Conversion of Saint Paul.*

41. *Saint Paul Preaching Before the Areopagus; Saint Paul Being Led to His Martyrdom.* Predella panels (ca. 1374–90). Companions to Cat. 40 and 42.

36 × 42 cm. (14³⁄₁₆ × 16½ in.); 34.5 × 42 cm. (13⁹⁄₁₆ × 16½ in.). Pls. 41-1–41-4.

Location: Pinacoteca Nazionale, Siena, nos. 117 and 118; formerly inv. nos. 72 and 77 (1842); 78 and 79 (1864); and 73 and 74 (1872).

Inscription: SPQR.

Condition: Good. Both panels have recently been cleaned and restored. Abraded areas and minor paint losses are noticeable in each. Lateral splits extending the width of each panel (slightly below the center of no. 117 and near the top of no. 118) have caused some

loss of paint in adjacent areas. The splits have been closed and the losses repaired. The modern framing on each has been removed, and it is clear that the panels have not been cut down.

Provenance: Pinacoteca Nazionale (formerly La Regia Pinacoteca, etc.), by 1842.

Attributions: R. Longhi (manuscript opinion, Samuel H. Kress Foundation, New York: Lorenzo di Bicci); M. Meiss (verbal opinion, The Harvard University Center for Renaissance Studies, Villa I Tatti, Florence, October 5, 1967: late Luca di Tommè, approximately 1375).

Bibliography: Pini, 1842, p. 6 (unknown); Milanesi, 1852, p. 18 (unknown); *Catalogo*, 1860, p. 24 (manner of Spinello Aretino); *Catalogo*, 1864, p. 20 (manner of

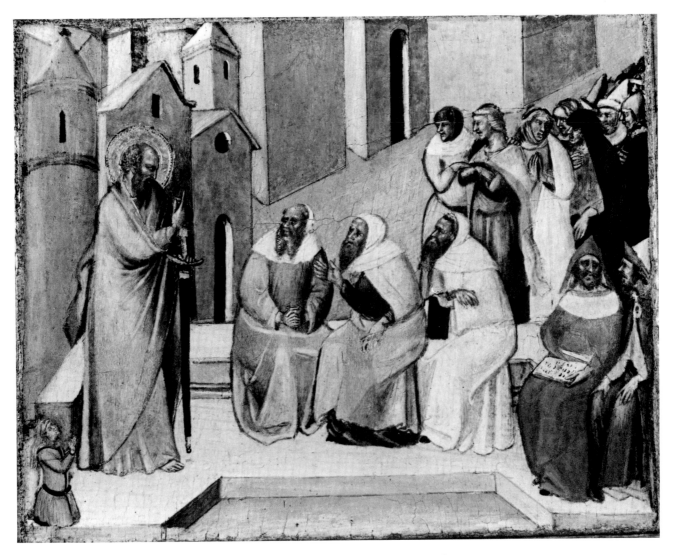

Pl. 41-1. *Saint Paul Preaching Before the Areopagus.*

Spinello Aretino); *Catalogo*, 1872, p. 19 (manner of Spinello Aretino); *Catalogo*, 1895, p. 44 (manner of Spinello Aretino); *Catalogo*, 1903, p. 44 (manner of Spinello Aretino); Jacobsen, 1907, p. 116 (school of Spinello Aretino); *Catalogo*, 1909, p. 46 (manner of Spinello Aretino); Dami, 1924, p. 19 (unknown follower of Spinello Aretino); van Marle, 1924, vol. III, p. 611 (school of Spinello Aretino); Gerevich, 1928, p. 227 (Sienese); Berenson, 1932, p. 549 (Spinello Aretino, with question); Brandi, 1933, pp. 365–66, ill. (Spinello Aretino, with question); Berenson, 1936, p. 473 (Spinello Aretino, with question); *Preliminary Catalogue*, 1941, pp. 208–9; *Mostra*, 1950, p. 101 (Sienese); Longhi, 1951, p. 55 (Parri Spinelli); Meiss, 1951a, p. 34 n. 84 (associate of Luca di Tommè); Salmi, 1951, p. 180; Kaftal, 1952, p. 788, figs. 883 and 884 (Spinello Aretino); Suida, 1952a, p. 12 (close follower of Spinello Aretino); Suida, 1954, p. 26 (close follower of Spinello Aretino); Carli, 1958, p. 43 (Luca di Tommè, with question); Berenson, 1963, p. 206 (Spinello Aretino, with question); Meiss, 1963, p. 47 n. 7; Boskovits, 1965, p. 46 (associate of Luca di Tommè); Boskovits, 1966a, p. 37 (associate of Luca di Tommè); Shapley, 1966, vol. I, p. 61; Torriti, 1977, pp. 159 and 160, figs. 172 and 173; De Benedictis, 1979, pp. 87–89; Siena, *Mostra*, 1979, p. 76.

Photographs: Alinari, Florence, negative no. 39994 (overall, before restoration); Artini, Florence; Fototeca Berenson, Florence (details, after restoration); Passerini, Siena (overall, after restoration); Soprintendenza per i beni artistici e storici per le province di Siena e Grosseto (after restoration).

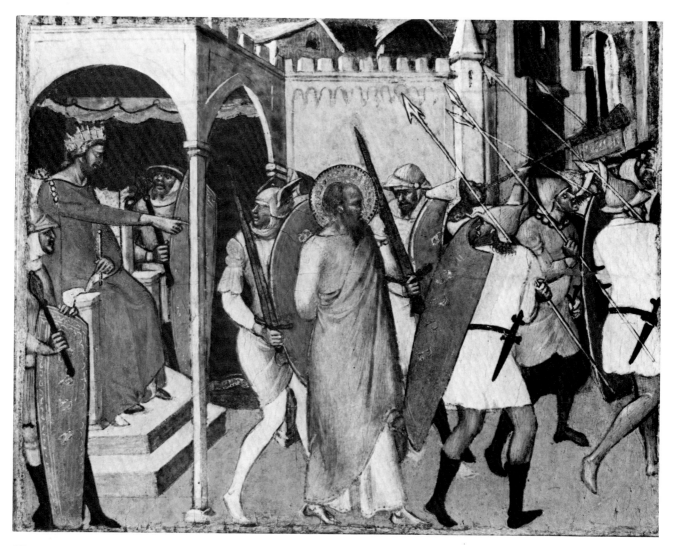

Pl. 41-2. *Saint Paul Being Led to His Martyrdom.*

Pl. 41-3. *Saint Paul Preaching Before the Areopagus* (detail of Pl. 41-1).

Pl. 41-4. *Saint Paul Being Led to His Martyrdom* (detail of Pl. 41-2).

42. *Beheading of Saint Paul.* Predella panel (ca. 1374–90). Companion to Cat. 40 and 41.

32 × 39.5 cm. (12⅝ × 15⁹⁄₁₆ in.). Pl. 42.

Location: Christian Museum, Esztergom, Hungary, no. 55.156.

Inscription: SPQR; GESV GESV GESV.

Condition: Good. The few areas of paint loss have been filled and retouched, and the two lateral splits below the center on the left have been closed.

Provenance: J. A. Ramboux, Cologne; A. Ipolyi, Budapest, 1867; Christian Museum, 1872.

Bibliography: Milanesi, 1862, p. 19; Sale Catalogue, J. Heberle (ed.), Jean Anton Ramboux Collection, 1867, p. 23; Gerevich, 1928, p. 227; Boskovits, 1965, p. 46, ill. (associate of Luca di Tommè); Boskovits, 1966a, p. 37, ill. (associate of Luca di Tommè); Shapley, 1966, vol. I, p. 61; Torriti, 1977, p. 159; De Benedictis, 1979, pp. 87–89.

Photographs: Christian Museum.

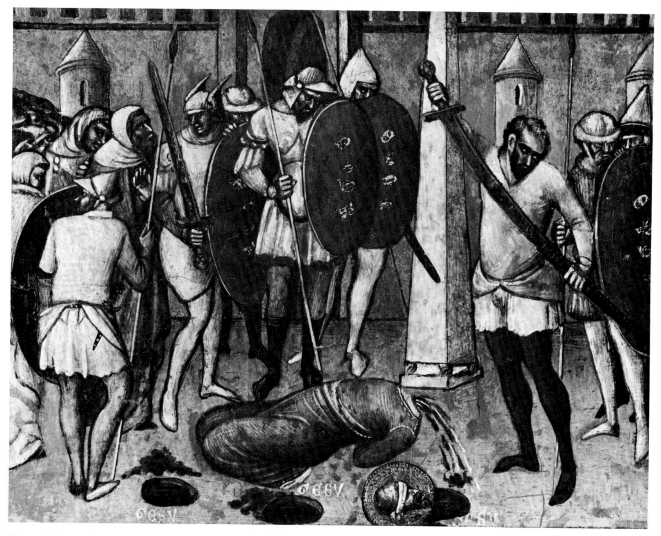

Pl. 42. *Beheading of Saint Paul.*

43. *Saint Stephen.* Panel from a polyptych (ca. 1374–90). Companion to Cat. 44.

131 × 42.5 cm. (51⅝ × 17 in.). Pl. 43.

Location: Estate of S. Bardini, Florence.

Inscription: SI·STE/FANVS·/NON·OR/AVISET·/ECLESIAM·/DEI·PAVL/VM·NON·/[H]ABVISSET.

Condition: Very good. The arch above the Saint and the frame are missing. The gold background is slightly damaged and a few paint losses are noticeable. The inscription has been reinforced.

Provenance: S. Bardini, 1935 (purchased in France); Estate of S. Bardini, 1967 (the estate was willed to the Swiss Government, which declined the bequest, in spring of 1969; it then became the property of the Italian Government, which passed ownership to the Commune of Florence).

Attributions: R. Offner (manuscript opinion, Kunsthistorisches Institut, Florence).

Bibliography: Kaftal, 1952, p. 949, fig. 1063 (as on New York art market, 1949); Berenson, 1968, vol. I, p. 226, pl. 370; De Benedictis, 1979, p. 89.

Photographs: Fototeca Berenson, Florence; Reali, Florence.

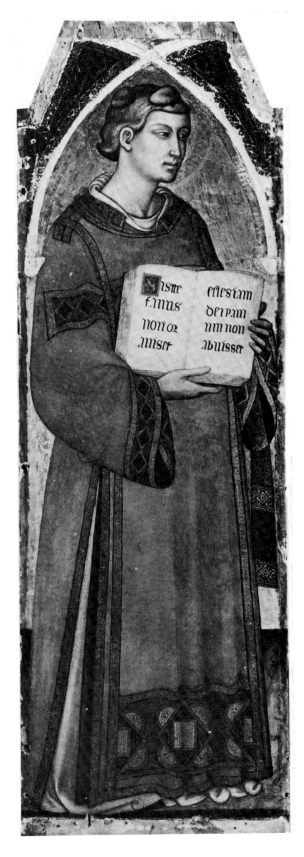

Pl. 43. *Saint Stephen.*

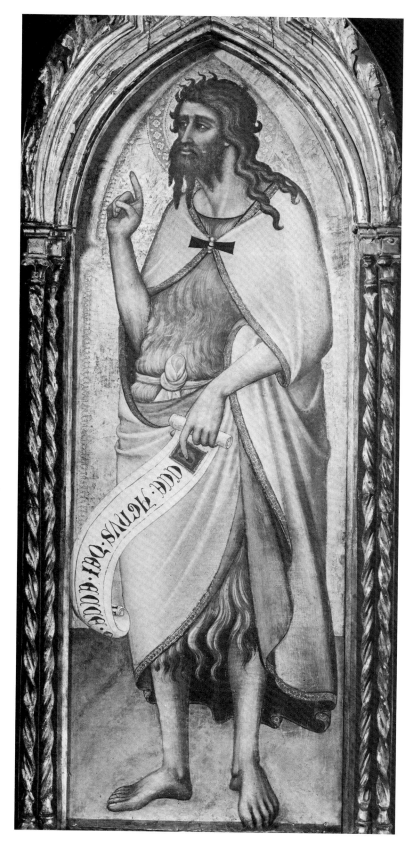

44. *Saint John the Baptist*. Panel from a polyptych (ca. 1374–90). Companion to Cat. 43.

131 × 42.5 cm. (51⅝ × 17 in.). Pl. 44.

Location: Museo Bardini, Florence.

Inscription: ECCE·AGNVS · DEI· ECCE · [QVI · TOLLIT · PECCATVM · MVNDI] (John 1:29).

Condition: Very good. The inscription has been retouched and the original arch above the Baptist, and frame, are lost. The painted surface is intact with only a slight bit of damage in the gold background noticeable.

Provenance: Stefano Bardini; bequeathed to Commune of Florence for Museo Bardini, 1923.

Attributions: R. Offner (manuscript opinion, Frick Art Reference Library, New York, 1928).

Bibliography: Berenson, 1932, p. 312; van Marle, 1934, vol. II, p. 527 n. 1; T. C. I. *Firenze*, 1950, p. 294; T. C. I. *Firenze*, 1964, p. 378; Berenson, 1968, vol. I, p. 224, pl. 372; T. C. I. *Firenze*, 1974, p. 360; De Benedictis, 1979, p. 87.

Pl. 44. *Saint John the Baptist.*

45. *Madonna and Child with Christ Blessing* (in the tondo). Center panel of a polyptych (ca. 1374–90). Companion to Cat. 46.

153.8 × 76.2 cm. (60½ × 30 in.). Pl. 45.

Location: Unknown.

Condition: Very good. The frame is modern as is the arch above the Virgin and Child. There is very limited paint loss and the flesh tones are practically untouched. A vertical split in the center of the panel and beginning at the base has been repaired.

Provenance: Archbishop Downey, Liverpool; A. Welker, Eastbourne, Sussex (3 Keymer House, Michael Grove); Barling, London, June, 1975.

Bibliography: Berenson, 1968, vol. I, p. 225; De Benedictis, 1979, pp. 87 and 90.

Photographs: A. Welker Collection, negative no. 217109.

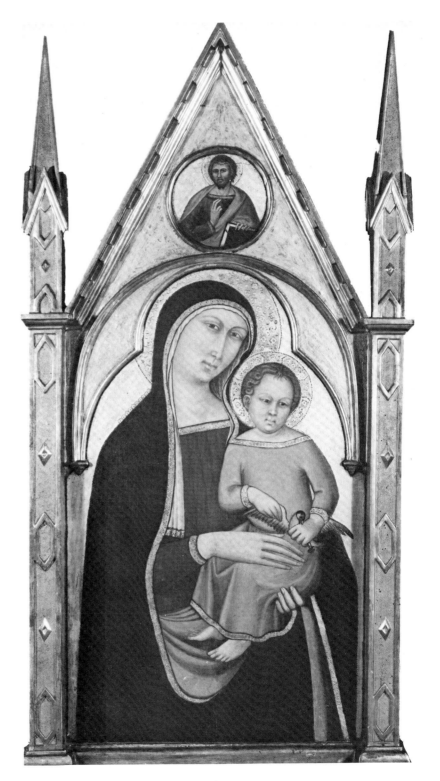

Pl. 45. *Madonna and Child with Christ Blessing.*

46. *Saint Michael with Saint Peter* (in the tondo). Side panel of a polyptych (ca. 1374–90). Companion to Cat. 45.

122 × 61 cm. (48 × 24 in.). Pl. 46.

Location: Sir Harold Acton Collection, Florence.

Condition: Very good. The paint loss is minimal and the flesh tones are intact. The frame and the arch above the saint are almost entirely modern.

Provenance: Arthur Acton Collection, Florence, 1895; Harold Acton, 1953.

Exhibitions: Palazzo Davanzati, Florence, 1924.

Attributions: F. Zeri (verbal opinion, Frick Art Reference Library, New York, March 3, 1959).

Bibliography: Perkins, 1924, pp. 12 and 13; Perkins, 1929, p. 427; van Marle, 1934, vol. II, p. 527 n. 1; De Benedictis, 1979, pp. 87 and 90.

Photographs: Brogi, Florence, negative no. 294; Reali, Florence (detail of *Saint Michael*).

Pl. 46. *Saint Michael with Saint Peter* (detail).

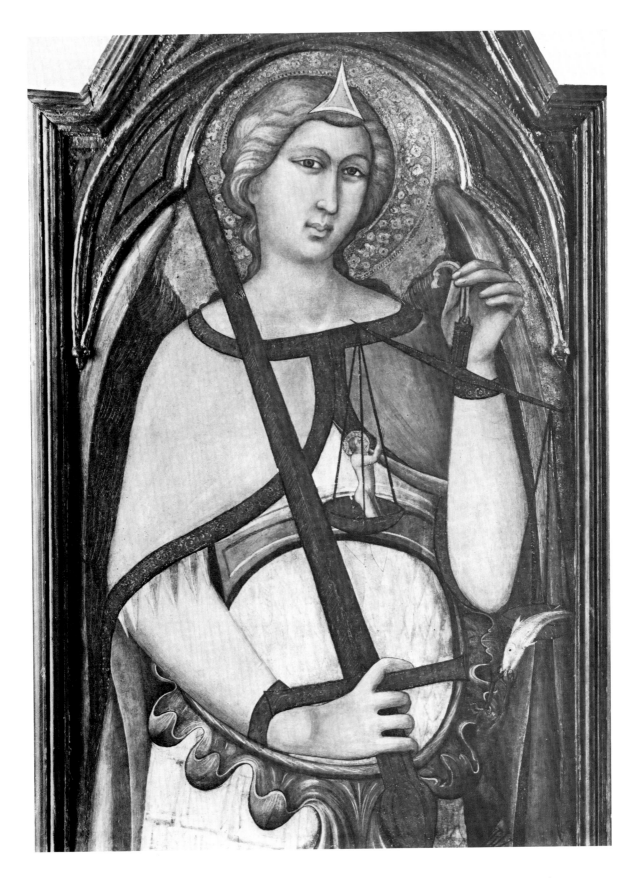

47. *Annunciation with Saints Francis, Nicholas of Bari, Thomas, and Matthew*; prophets in tondi, *Elisha, Aaron, Malachi, and Isaiah*; and two unidentified prophets in the spandrels. Polyptych (ca. 1374–90).

148 × 162.5 cm. (58¼ × 64 in.). Pls. 47-1–47-7.

Location: Oratorio di San Giovanni (formerly of the Knights of Rhodes; now of the Knights of Malta), Cascina, environs of Pisa.

Inscription: (Virgin) ECCE · / ANCI / L[L]A · DO / MINI · / FIAT · M / IHI · / [SECVNDNM · VERBVM] (Luke 1:38); (prophets' scrolls, from, left) ELISEVS · PROFE[TA]; A[A]RON · PROFETA; ECCE · VIRGO · CHONCIPIET [*sic*] · ET · [PARIET · FILIVM] · PVER · DATVS · EST · NOBIS (Isaiah 7:14); MALACIAS · PROFETA; ISAIAS · PROFETA.

Condition: Good. There are minor paint losses throughout. The Virgin's cloak has been damaged and repaired. The gold background, particularly in the central panel, has been renewed. The frame is modern.

Provenance: Palazzo Pitti (in a chapel), Florence, 1932; Oratorio di San Giovanni, 1935.

Bibliography: Procacci, 1932, pp. 468–74, ill.; van Marle, 1934, vol. II, p. 662; T. C. I. *Toscana*, 1935, p. 96; Berenson, 1936, p. 269; Stefanini, 1938, p. 3; Toesca, 1951, p. 598 n. 116 (very close to Niccolò Tegliacci); T. C. I. *Toscana*, 1959, p. 116; Berenson, 1968, vol. I, p. 224; Fehm, 1969, pp. 574–75; van Os, 1969b, pp. 46 n. 37, 58 n. 71, and 60–78, pl. 6; Fehm, 1973a, pp. 18, 28 n. 4, 30 n. 25, and 32 n. 40; T. C. I. *Toscana*, 1974, p. 115 (in storage in Florence since 1973); Fehm, 1976, pp. 345 and 345 n. 23; De Benedictis, 1979, pp. 48, 49, and 87, fig. 91.

Photographs: Soprintendenza alle Gallerie, Gabinetto Fotografico, Florence, negative nos. 21648–51 (overall and details).

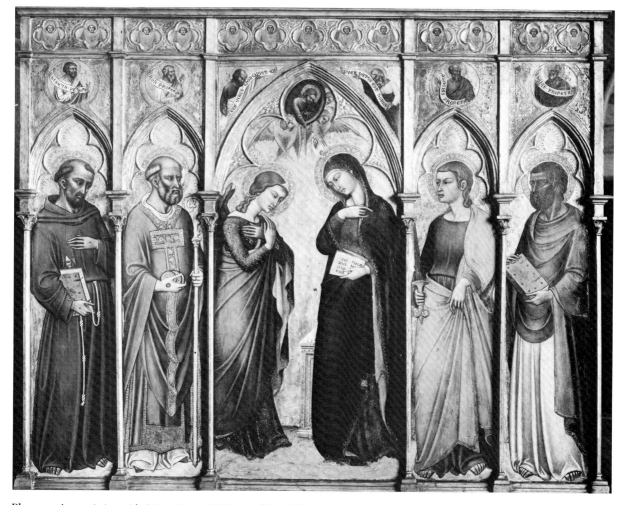

Pl. 47-1. *Annunciation with Saints Francis, Nicholas of Bari, Thomas, and Matthew*; prophets in tondi, *Elisha, Aaron, Malachi, and Isaiah*; and two unidentified prophets in the spandrels.

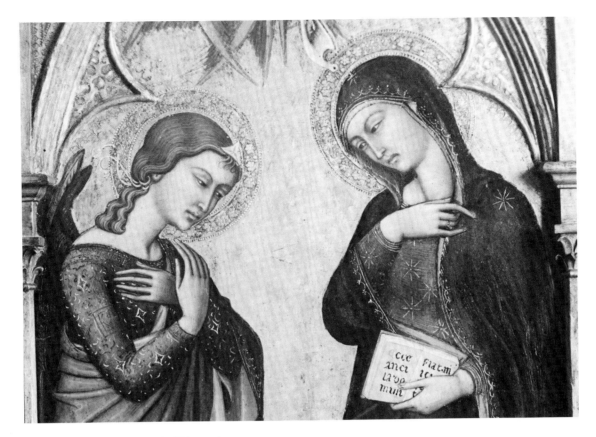

Pl. 47-2. *Annunciation* (detail of Pl. 47-1).

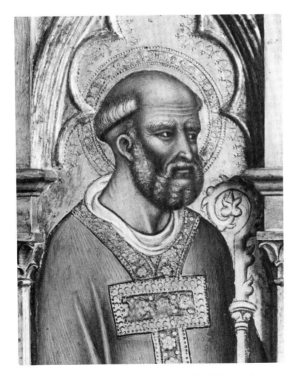

Pl. 47-3. *Saint Nicholas of Bari* (detail of Pl. 47-1).

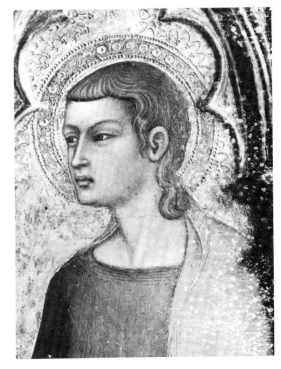

Pl. 47-4. *Saint Thomas* (detail of Pl. 47-1).

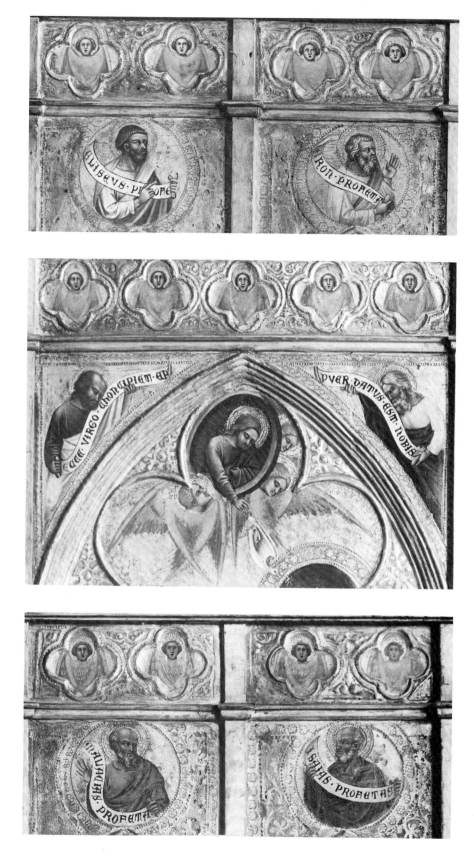

Pl. 47-5. *Elisha* and *Aaron* (detail of Pl. 47-1).

Pl. 47-6. *Two Prophets, God the Father, and the Holy Spirit* (detail of Pl. 47-1).

Pl. 47-7. *Malachi* and *Isaiah* (detail of Pl. 47-1).

48. *Madonna and Child with Saints Vincent, Peter, Paul, and Lawrence.* Polyptych (ca. 1374–90).

(Saint Lawrence) 150.5 × 42.3 cm. (59¼ × 16⅝ in.); (overall) 162 × 256 cm. (63³⁄₁₆ × 99⅞ in.). Pls. 48-1 and 48-2.

Location: Pinacoteca Nazionale, Siena, no inv. no.

Inscription: (Madonna and Child) LVCAS · THOME · DE · SENIS · PINSIT; (Vincent) VINCENTI · DABO · MANNA · ET · NOMEN·ASCONDITVM.

Condition: Fair. The polyptych has been cleaned and restored recently, but it has suffered a good deal of damage. The Virgin's mantle is almost all lost, and there are losses below Saint Vincent's feet and in some of the folds of Saint Paul's cloak. The gold background is in good condition. During the recent cleaning several inscriptions came to light, including all the saints'

names, except that of Vincent, and the artist's signature on the bases of the panels.

Provenance: San Pietro in Venano, Giaole, Chianti, 1862; Barone Bettino Ricasoli, 1975.

Exhibitions: Pinacoteca Nazionale, Siena, *Mostra di Opera d'arte restaurate nelle province di Siena e Grosseto*, June–November, 1979, p. 85, fig. 70.

Attributions: R. Offner (manuscript opinion, quoted in G. Kaftal, 1952, p. 1020).

Bibliography: Brogi, 1897, p. 174; Kaftal, 1952, p. 1020; Torriti, 1977, p. 156, fig. 169; De Benedictis, 1979, pp. 48, 67 n. 80, and 89, fig. 92.

Photographs: Soprintendenza alle Gallerie, Gabinetto Fotografico, Florence, negative no. 28762 (detail of Saint Lawrence); Soprintendenza per i beni artistici e storici per le province di Siena e Grosseto (after restoration).

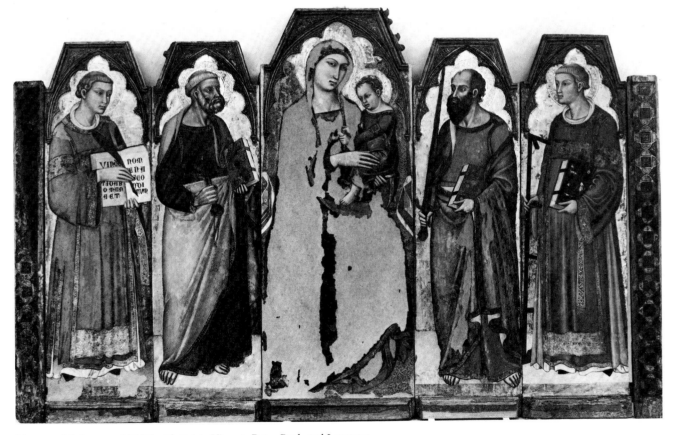

Pl. 48-1. *Madonna and Child with Saints Vincent, Peter, Paul, and Lawrence.*

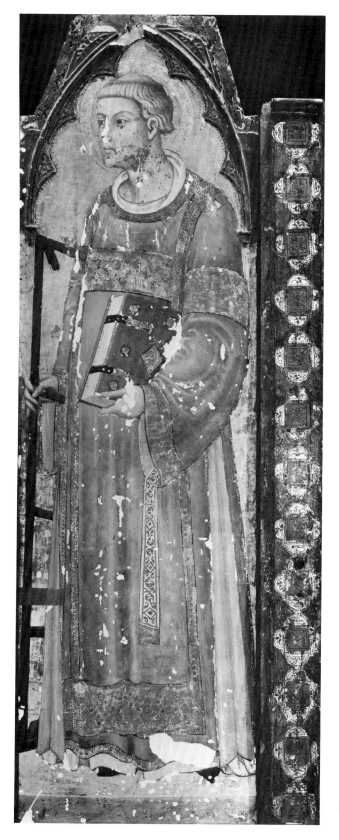

Pl. 48-2. *Saint Lawrence* (detail of Pl. 48-1).

49. *Madonna and Child with Saints John the Baptist, Michael, Peter, and Catherine of Alexandria*; in the pinnacles, *Christ Blessing and Two Angels, the Angel Gabriel, Saints Paul and Bartholomew, and the Virgin Annunciate*. Polyptych (ca. 1374–90).

170.5 × 201 cm. (67 × 79 in.). Pl. 49.

Location: Museo Comunale, Lucignano.

Inscription: (John the Baptist) ECCE · AGNVS · DEI · ECCE · QVI · [TOLLIT · PECCATVM · MVNDI] (John 1:29); (Gabriel) AVE·[MARIA]·GRATIA·[PLENA] (Luke 1:28).

Condition: Fair. The polyptych has suffered considerable damage. The cloak of the Baptist has been reworked as has the outer mantle of Michael. The red of the Virgin's undergarment is totally repainted and her cloak retouched. The gold ground has been badly rubbed and the orange of Gabriel's shirt is a later addition. The surviving fragments of arching above the figures, and the frame, are original.

Provenance: Convent of San Francesco, Lucignano; Pinacoteca, Lucignano.

Bibliography: Perkins, 1909c, p. 83; van Marle, 1920, p. 146n; Perkins, 1920, p. 292 n. 12; Dami, 1924, pp. 466–67, figs. 4–5; van Marle, 1924, vol. II, p. 479; Perkins, 1929, p. 427; Perkins, 1931a, p. 96, pl. 8; Berenson, 1932, p. 312; Brandi, 1932, p. 234 n. 1; Perkins, 1933, p. 76, pl. 73; van Marle, 1934, vol. II, p. 524, fig. 343; T. C. I. *Toscana*, 1935, p. 467; Berenson, 1936, p. 269; Kaftal, 1952, p. 737; Shorr, 1954, pp. 176 and 178, ill.; T. C. I. *Toscana*, 1959, p. 609; Klesse, 1967, p. 407; Berenson, 1968, vol. I, p. 225; T. C. I. *Toscana*, 1974, p. 563; De Benedictis, 1979, p. 87.

Photographs: Artini, Florence (details of pinnacle figures and head of *Saint Michael*); Soprintendenza alle Gallerie, Gabinetto Fotografico, Florence, negative no. 567 (before restoration) and 12001 (after restoration); Frick Art Reference Library, New York, negative nos. 22373 (overall after restoration) and 22374 (detail of Child after restoration).

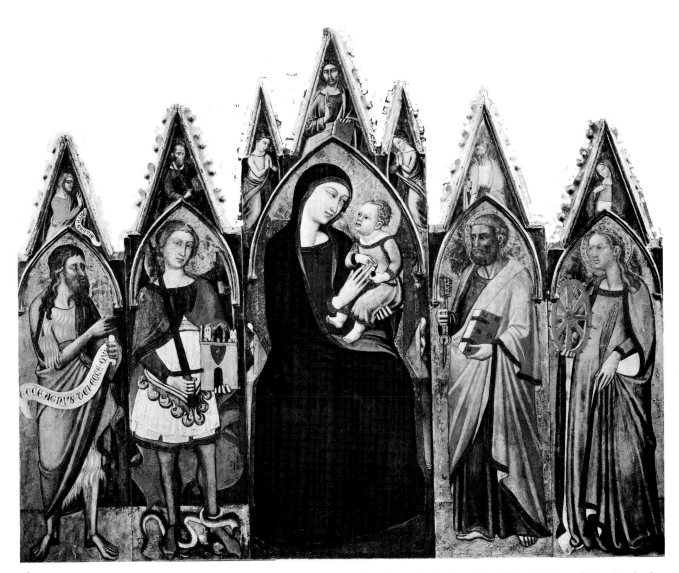

Pl. 49. *Madonna and Child with Saints John the Baptist, Michael, Peter, and Catherine; in the pinnacles,* Christ Blessing and Two Angels, *the Angel Gabriel, Saints Paul and Bartholomew and the Virgin Annunciate.*

50. *Madonna and Child.* (Ca. 1374–90.)

103 × 55.5 cm. (40½ × 21⅞ in.). Pl. 50.

Location: Museo Civico, Montalcino.

Condition: Poor. The blue of the Virgin's cloak has been uniformly rubbed down to the gesso. The gold background has been lost, and in part it has been renewed. The *sgraffito* decoration in the undergarments has been rubbed to the bole. In several areas the paint film has blistered and has begun to drop away.

Provenance: San Francesco, Montalcino, 1862; Pinacoteca, Montalcino, 1904.

Exhibitions: Palazzo Pubblico, Siena, *Mostra di Antica Arte Senese*, April–October, 1904, p. 310, no. 902 (manner of Simon [*sic*] Memmi); Museo Civico, Montalcino, *Arte Antica*, July–September, 1925.

Bibliography: Brogi, 1897, p. 249 (Sienese school of the 14th century, perhaps by Barna); Perkins, 1908b, pp. 82 n. 1 and 83, ill.; Perkins, 1920, p. 291; van Marle, 1920a, p. 144; van Marle, 1924, vol. II, pp. 477–79, fig. 312; Perkins, 1925, pp. 62–63, ill.; Bacci, 1927, p. 52, ill.; Comstock, 1928, pp. 61 and 62; Serra, 1928a, p. 179; Serra, 1929, p. 303; Perkins, 1931, p. 90; Berenson, 1932, p. 312; Brandi, 1932, p. 234 n. 1; Edgell, 1932, p. 157; Bargagli-Petrucci, 1933, p. 150, ill. (manner of Barna); van Marle, 1934, vol. II, p. 524, fig. 342; Berenson, 1936, p. 269; Shorr, 1954, pp. 27 n. 2, 134–35, and 169 n. 9, ill. p. 139; T. C. I. *Toscana*, 1959, p. 646; Klesse, 1967, p. 407; Berenson, 1968, vol. I, p. 225; Carli, 1972, pp. 10–11, pls. 23 and 24; T. C. I. *Toscana*, 1974, p. 603; Chelazzi Dini, 1975, p. 54 (as dated 1389); De Benedictis, 1979, p. 88.

Photographs: Artini, Florence (overall and details).

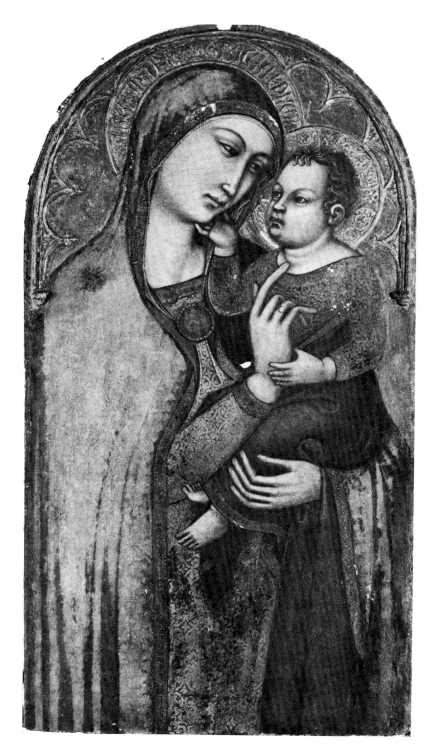

Pl. 50. *Madonna and Child.*

Doubtful Attributions
and Shopworks

51. *Madonna and Child with Saints Peter and Paul*; in the pinnacle, *Christ as the Man of Sorrows*.

53 × 25 cm. (20⅞ × 9⅞ in.). Pl. 51.

Location: Private collection, Florence.

Condition: Good. Although somewhat dirty, the painted surface and gold ground are in generally good condition. Minor losses have occurred at the base of the panel where the original framing has been lost.

Provenance: Arturo Grassi, Florence, 1946.

Attributions: M. Meiss (verbal opinion, The Harvard University Center for Renaissance Studies, Villa I Tatti, Florence, May, 1969: shop of Luca di Tommè).

Bibliography: Fehm, 1973a, pp. 23 and 31 n. 36, fig. 16; Fehm, 1976, p. 348 n. 32 (workshop of Luca di Tommè); De Benedictis, 1979, p. 87 (Luca di Tommè).

Photographs: Reali, Florence.

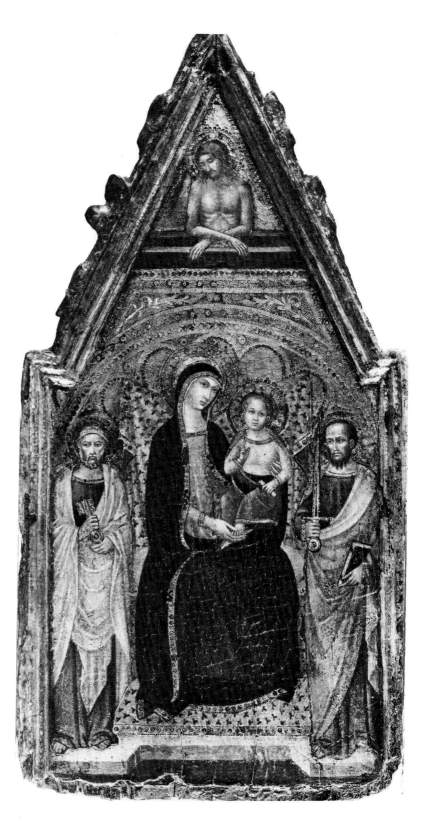

Pl. 51. Shop of Luca di Tommè, *Madonna and Child with Saints Peter and Paul*; in the pinnacle, *Christ as the Man of Sorrows*.

52. *Saint John the Baptist*; in the spandrels, *Elias* and *David*. Side panel of a polyptych.

100.3 × 49.5 cm. (39½ × 19½ in.). Pl. 52.

Location: J. Paul Getty Museum, Malibu, California, no. 72.PA.7.

Condition: Very good. The panel was cleaned and restored in London in 1972.

Provenance: Art Market, London; J. Paul Getty Museum, 1972.

Attributions: K. Steinweg (manuscript opinion, *in litteris* to the author, March, 1972: Luca di Tommè).

Bibliography: Sale Catalogue, Christie's, March 24, 1972, p. 37, no. 78, ill. (Luca di Tommè); De Benedictis, 1979, pp. 67 n. 80, 87, and 88 (Luca di Tommè).

Photographs: J. Paul Getty Museum; A. C. Cooper, London, negative no. 733987.

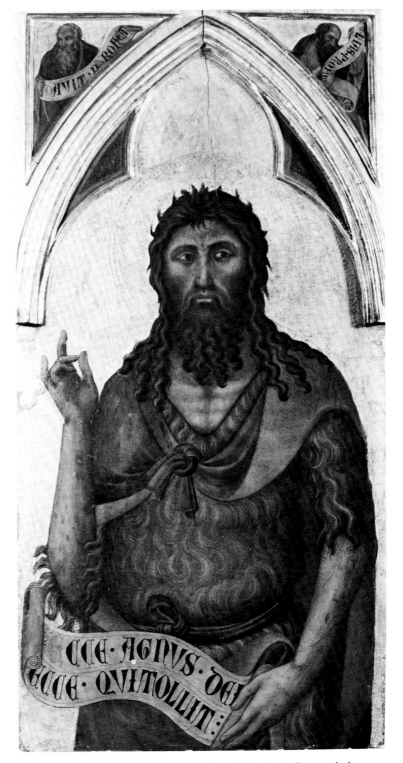

Pl. 52. Shop of Luca di Tommè, *Saint John the Baptist*; in the spandrels, *Elias* and *David*.

53. *Two Apostles*; in the tondo, *An Angel*. Part of a polyptych.

47.3 × 44.2 cm. (18⅝ × 17⅜ in.). Pl. 53.

Location: Fondazione Roberto Longhi, Florence.

Condition: Excellent. The surface of the panels is clean and unabraded.

Provenance: Roberto Longhi Foundation.

Bibliography: Boschetto, 1972, plate 5; Fehm, 1978, p. 163; De Benedictis, 1979, pp. 67 n. 80, 87, and 88 (Luca di Tommè).

Photographs: Brogi, Florence.

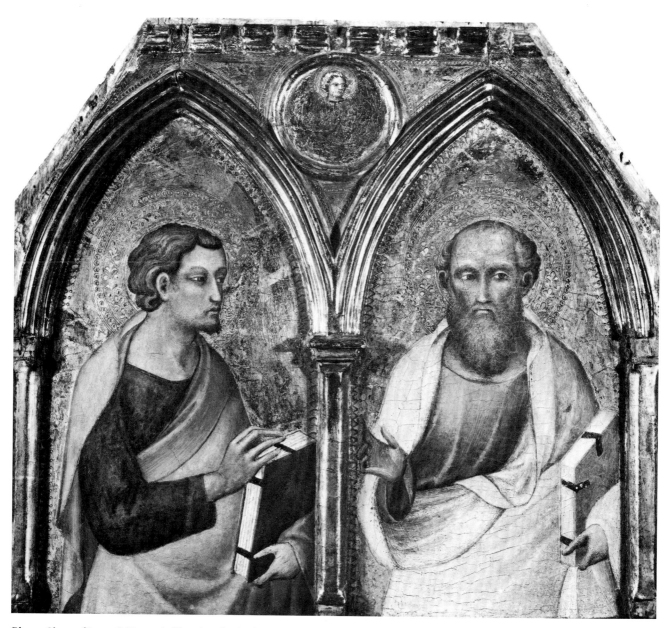

Pl. 53. Shop of Luca di Tommè, *Two Apostles*; in the tondo, *An Angel*.

54. *Christ Blessing.* Pinnacle figure from a polyptych.

58.1 × 33.7 cm. (22⅞ × 13¼ in.). Pl. 54.

Location: North Carolina Museum of Art, Raleigh, no. GL. 60.17.5. Gift of the Samuel H. Kress Foundation.

Inscription: EGO · / SVM · / VIA · / VERI / TAS · / ET · VI / TA QV · / I · CRE / DIT · IN · / ME (conflation of John 14:6 and John 11:25).

Condition: Very good. The panel was cleaned in 1949. Apart from some small retouching noticeable at Christ's elbow, the picture is well preserved.

Provenance: a convent, Siena; Contini Bonacossi, Florence; Samuel H. Kress, New York, 1950; Samuel H. Kress Foundation (K1741), New York; North Carolina Museum of Art, 1960.

Exhibitions: National Gallery of Art, Washington, D. C., *Paintings and Sculpture from the Kress Collection,* 1951, cat. no. 123, p. 273 (Luca di Tommè); Tucson, Arizona, *Paintings and Sculpture from the Kress Collection,* 1951–57, no. 1 (Luca di Tommè).

Attributions: B. Berenson, E. Carli, R. Longhi (manuscript opinions, Samuel H. Kress Foundation).

Bibliography: Shapley, 1960, p. 26 (Luca di Tommè); Shapley, 1966, vol. I, pp. 59–60, fig. 151 (Luca di Tommè); Berenson, 1968, vol. I, p. 225 (Luca di Tommè); Fredericksen and Zeri, 1972, pp. 113, 355, and 627 (Luca di Tommè); De Benedictis, 1979, pp. 48, 67 n. 80, 87, and 88 (Luca di Tommè).

Photographs: Samuel H. Kress Foundation; North Carolina Museum of Art.

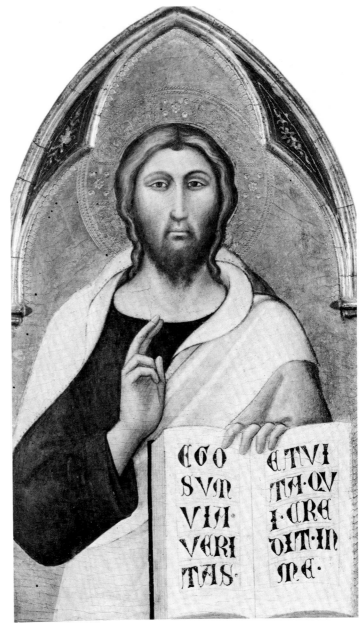

Pl. 54. Shop of Luca di Tommè, *Christ Blessing.*

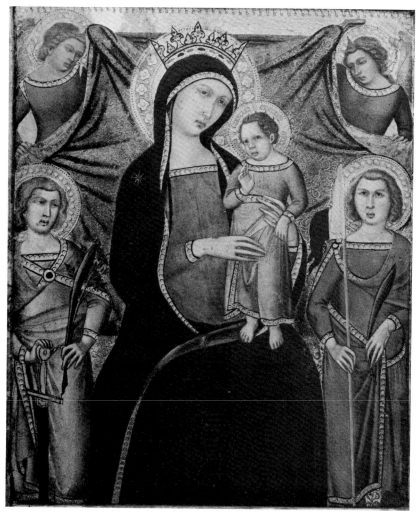

Pl. 55. Shop of Luca di Tommè, *Madonna and Child with Saints Galganus and Ansanus.*

55. *Madonna and Child Enthroned with Saints Galganus and Ansanus.*

61.7 × 49.7 cm. (24⁵⁄₁₆ × 19⁹⁄₁₆ in.). Pl. 55.

Location: Yale University Art Gallery, New Haven, Connecticut, no. 1943.245. Bequest of Maitland F. Griggs.

Condition: Fair. The panel has been cleaned recently by Andrew F. Petryn. He found that the base had been cut down by perhaps as much as one-fifth and that the cloak of the Madonna had been badly rubbed and retouched. The modern strip of frame at the base has been removed, together with the overpaint in the cloak.

Provenance: Maitland F. Griggs, New York; Yale University Art Gallery, 1943.

Exhibitions: Century Association, New York, *Exhibition of Italian Primitive Paintings Selected from the Collection of Maitland F. Griggs,* February 15–March 12, 1930, no. 20; Yale University Art Gallery, *Italian Primitives,* April–September, 1972, no. 43, ill. (Luca di Tommè and assistant, with question).

Attributions: R. Offner (verbal opinion, Frick Art Reference Library, New York, January 15, 1925: Luca di Tommè).

Bibliography: Perkins, 1924, p. 15 (Luca di Tommè); Comstock, 1928, p. 62, ill. (Luca di Tommè); Perkins, 1929, p. 427 (Luca di Tommè); Venturi, 1930, Pl. LXXI (Luca di Tommè); Berenson, 1932, p. 313 (Luca di Tommè); Brandi, 1932, p. 234 n. 1 (Luca di Tommè); van Marle, 1934, vol. II, p. 520; Berenson, 1936, p. 269 (Luca di Tommè); Klesse, 1967, p. 406 (Luca di Tommè); Berenson, 1968, vol. I, p. 225 (Luca di Tommè); Seymour, 1970, pp. 81–82, 280, and 308, ill., Pl. 55 (Luca di Tommè and assistant, with question); Fredericksen and Zeri, 1972, pp. 113, 317, 369, 400, and 600 (Luca di Tommè); Muller, 1973, p. 16, fig. 6 (Luca di Tommè); Vertova, 1973, pp. 159 and 160; De Benedictis, 1979, p. 88 (Luca di Tommè).

Photographs: Yale University Art Gallery.

56. Madonna and Child.

75 × 49 cm. (29½ × 19¼ in.).
Pl. 56.

Location: Pieve di San Giovanni Battista, Pernina.

Condition: Fair. The panel has been cut down considerably on all sides. Serious paint losses have occurred in the Madonna's forehead, face, throat, left shoulder, and waist. As well, her cloak has been badly rubbed and overpainted.

Provenance: Original location.

Attributions: R. Offner (manuscript opinion, Frick Art Reference Library, New York, 1946: shop of Luca di Tommè).

Bibliography: Brogi, 1897, p. 583 (Luca di Tommè); Shorr, 1954, pp. 173–74, ill. (Luca di Tommè); Klesse, 1967, p. 407 (Luca di Tommè); De Benedictis, 1979, p. 89 (Luca di Tommè).

Photographs: Frick Art Reference Library, negative nos. 22167 (overall) and 22192 (detail); Soprintendenza per i beni artistici e storici per le province di Siena e Grosseto.

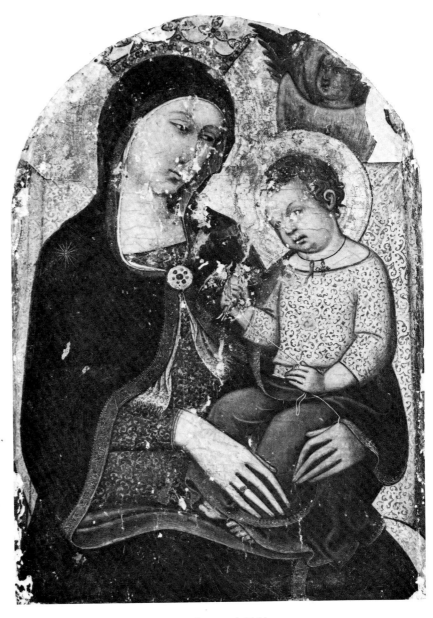

Pl. 56. Shop of Luca di Tommè, *Madonna and Child.*

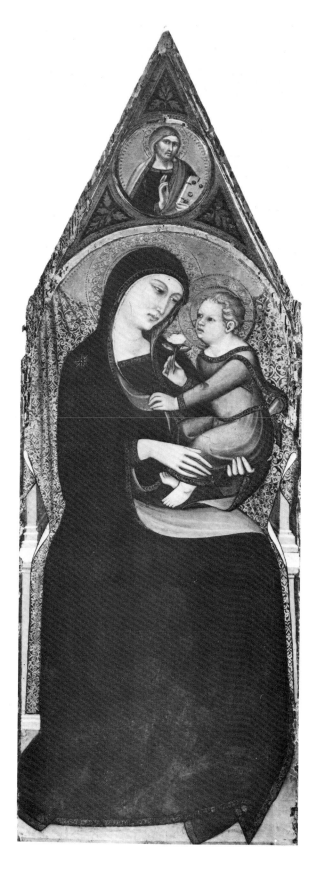

57. *Madonna and Child*; in tondo, *Christ Blessing*.

179 × 70 cm. (70½ × 27⁹⁄₁₆ in.). Pl. 57.

Location: Chiesa della Compagnia del Corpus Domini, Rapolano.

Condition: Good. The panel has been cleaned and restored recently. There is some damage noticeable throughout, but the central portion of the composition and, in particular, the areas of flesh, are in good condition. All the original framing has been lost.

Provenance: Original location (also known as the Chiesa della Fraternità).

Exhibitions: Fortezza del Girifalco, Cortona, *Arte in Valdichiana*, August 9–October 10, 1970, p. 16, no. 19, fig. 19.

Attributions: F. M. Perkins (verbal opinion, Frick Art Reference Library, New York, 1925: Luca di Tommè).

Bibliography: Brogi, 1897, p. 460 (Lippo Memmi); T. C. I. *Italia Centrale*, 1923, p. 276 (school of Pietro Lorenzetti); van Marle, 1925, vol. V, p. 462 (Luca di Tommè); Perkins, 1929, p. 427 (Luca di Tommè); DeWald, 1929, p. 166; Perkins, 1932, pp. 129 and 137; Perkins, 1933, pp. 129, 130, 137, pl. 134; van Marle, 1934, vol. II, p. 527 n. 1 (Luca di Tommè); T. C. I. *Toscana*, 1935, p. 465 (school of Pietro Lorenzetti); Rowley, 1958, pp. 43–44 (Luca di Tommè); T. C. I. *Toscana*, 1959, p. 607 (school of Pietro Lorenzetti); Klesse, 1967, p. 406 (Luca di Tommè); Berenson, 1968, vol. I, p. 225 (Luca di Tommè); T. C. I. *Toscana*, 1974, p. 561 (Luca di Tommè; located in the Arcipretura since 1973); De Benedictis, 1979, p. 88 (Luca di Tommè).

Photographs: Frick Art Reference Library, negative nos. 22407 (overall) and 22408 (detail); Soprintendenza per i beni artistici e storici per le province di Siena e Grosseto (after restoration).

Pl. 57. Shop of Luca di Tommè, *Madonna and Child*; in the tondo, *Christ Blessing*.

58. *Crucifix.*

226 × 235 cm. (104¾ × 92½ in.). Pls. 58-1 and 58-2.

Location: Oratorio del Crocifisso, Roccalbegna.

Condition: Good. While the figures of Mary and the Evangelist have been somewhat damaged, the *Crucifix* is in a good state of preservation. A lateral break across

Pl. 58-2. *Head of Christ* (detail of Pl. 58-1).

the panel extending through the chest of Christ has been consolidated with a minimum of loss. The frame has been almost entirely renewed.

Exhibitions: Museo d'Arte Sacra, Grosseto, *Arte Senese nella Maremma grossetana*, Summer 1964, pp. 20–21, no. 17, ill.

Bibliography: Nicolosi, 1911, pp. 63 and 67 (unknown

Pl. 58-1. Shop of Luca di Tommè, *Crucifix.*

artist); T. C. I. *Toscana*, 1935, p. 743 (unknown artist); Carli, 1955a, pp. 96–97, pls. 41 and 42, ill. (Luca di Tommè); Carli, 1955c, p. 180, figs. 11 and 12 (Luca di Tommè); T. C. I. *Toscana*, 1959, p. 790 (Luca di Tommè); Bucci, 1965, p. 56 (Luca di Tommè); Klesse, 1967, pp. 38 and 165 (Luca di Tommè); Mazzolai, 1967, p. 181, ill. (Luca di Tommè); van Os, 1969b, p. 63 n. 83 (Luca di Tommè); T. C. I. *Toscana*, 1974, p. 722 (Luca di Tommè); De Benedictis, 1979, p. 88 (Luca di Tommè).

Photographs: Grassi, Siena, negative nos. 173 (overall) and 26 (details); Soprintendenza per i beni artistici e storici per le province di Siena e Grossoto.

59. *John the Baptist*; *Patriarch Jacob*; *Isaiah*; and *Catherine of Alexandria*. Pinnacles from a polyptych.

30.5 × 25.5 cm. (12 × 10 in.); 34.6 × 26.8 cm. (13⅝ × 10⅝ in.); 35.5 × 26.8 cm. (13⅞ × 10⅜ in.); 30.3 × 25 cm. (11⅞ × 9⅞ in.). Pls. 59-1–59-4.

Location: Pinacoteca Nazionale, Siena, nos. 123, 124, 138, and 139. Formerly inv. nos. 80–83 (1860); 75–78 (1864 and 1872); and 83, 84, 68, and 69 (1895).

Inscription: EGO·VOX·CLAMANTI [S·IN·DESERTO] (John 1:23); BENIAMIN·LVPVS·RAPA[X] (Genesis 49:27); EC[C]E·VIRGO·CONCIPIE[T] (Isaiah 7:14).

Condition: Good. The panels have been cleaned and restored recently. All the inscriptions seem to have been reinforced, and there are minor paint losses in each due to abrasion. All of the modern framing has been removed from the panels.

Provenance: Pinacoteca Nazionale, Siena (formerly La Regia Pinacoteca, etc.), by 1860.

Exhibitions: Pinacoteca Nazionale, Siena, *Mostra di Opera d'arte restaurate nelle province di Siena e Grosseto*, June–November 1979, pp. 83 and 84, figs. 66–69, plate III (Saint John the Baptist).

Pl. 59-1. Shop of Luca di Tommè, *Patriarch Jacob*.

Pl. 59-2. Shop of Luca di Tommè, *John the Baptist*.

Attributions: M. Meiss (verbal opinion, The Harvard University Center for Renaissance Studies, Villa I Tatti, Florence, May 1969: shop of Luca di Tommè); F. Zeri (manuscript opinion, Aartsbisschoppelijk Museum, Utrecht, October 3, 1958: Luca di Tommè, part of series in same museum, no. 12).

Bibliography: *Catalogo*, 1860, p. 21 (unknown artist); *Catalogo*, 1864, p. 21 (unknown artist); *Catalogo*, 1872, p. 19 (unknown artist); *Catalogo*, 1895, p. 49 (unknown artist); *Catalogo*, 1903, pp. 45 and 49 (unknown artist); *Catalogo*, 1909, pp. 47 and 51 (unknown artist); Dami, 1924, pp. 20 and 21 (unknown artist); Perkins, 1924, pp. 13–14 (Luca di Tommè); Perkins, 1928a, p. 115 (Luca di Tommè); Berenson, 1932, p. 313 (Luca di Tommè); Brandi, 1933, p. 160 (Luca di Tommè); van Marle, 1934, vol. II, p. 527 n. 1 (Luca di Tommè); Berenson, 1936, p. 269 (Luca di Tommè); Berenson, 1968, vol. I, p. 226 (Luca di Tommè); Fehm, 1969, p. 574; van Os, 1969a, no. 23 (Luca di Tommè); Torriti, 1977, pp. 154 and 155, figs. 165–68 (Luca di Tommè); De Benedictis, 1979, pp. 89 and 90 (Luca di Tommè).

Photographs: Artini, Florence; Frick Art Reference Library, negative nos. 22067 and 22075; Soprintendenza per i beni artistici e storici per le province di Siena e Grosseto.

Pl. 59-3. Shop of Luca di Tommè, *Isaiah*.

Pl. 59-4. Shop of Luca di Tommè, *Catherine of Alexandria*.

60. *Saint Anthony Abbot.*

24.1 × 20.7 cm. (9½ × 8⅛ in.), with original framing. Pl. 60.

Location: Mt. Holyoke College Art Museum, South Hadley, Massachusetts.

Condition: Good. The panel is dirty. A vertical split through the Saint's right shoulder that runs the length of the panel has caused some loss of pigment in that area of the cloak. The gold leaf on the frame, which appears to be original, has cracked and come away in several places. As of 1980 the panel was undergoing conservation.

Provenance: Mrs. Caroline R. Hill, Manchester, New Hampshire; Mt. Holyoke College Art Museum, 1962.

Attributions: M. Meiss (verbal opinion, The Harvard University Center for Renaissance Studies, Villa I Tatti, Florence, May, 1969: shop of Luca di Tommè); R. Offner (manuscript opinion, Frick Art Reference Library, New York, 1930: Luca di Tommè).

Bibliography: Comstock, 1928, p. 62 (School of Luca); van Marle, 1934, vol. II, p. 527 n. 1; Fredericksen and Zeri, 1972, pp. 240, 370, and 639 (Sienese school of the 14th century).

Photographs: Mt. Holyoke College Art Museum.

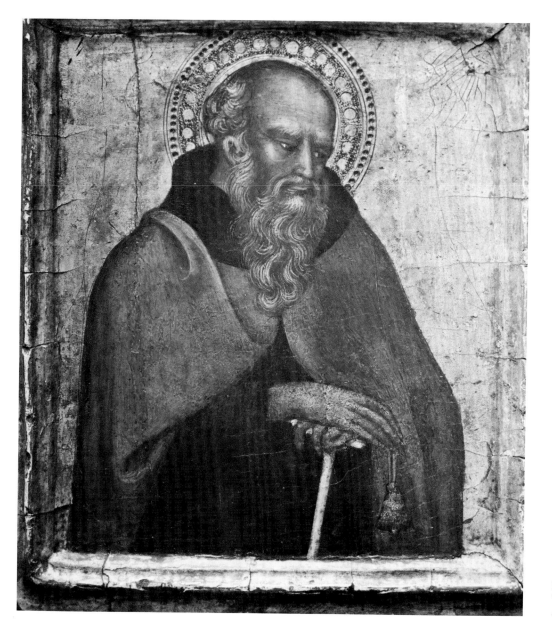

Pl. 60. Shop of Luca di Tommè, *Saint Anthony Abbot.*

61. *Saint Francis* and *Saint Catherine of Alexandria*.
Panels from a polyptych.

23 × 18.2 cm. (9¹⁄₁₆ × 7³⁄₁₆ in.); 22.5 × 18 cm. (8⅞ ×
7¹⁄₁₆ in.). Pls. 61-1 and 61-2.

Location: Private collection.

Condition: Poor. The panels have suffered extensive
losses throughout. The gold background has been lost,
and in some areas the gesso has been rubbed away.

Provenance: Unknown.

Photographs: S. Fehm.

Pl. 61-1. Shop of Luca di Tommè, *Saint Francis*.

Pl. 61-2. Shop of Luca di Tommè, *Saint Catherine*.

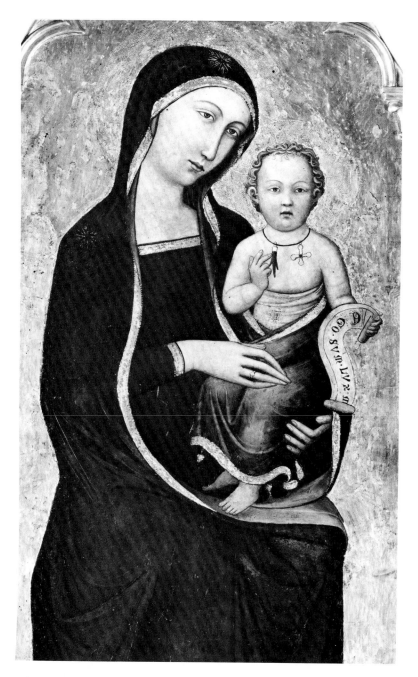

Pl. 62. Shop of Luca di Tommè, *Madonna and Child*.

62. *Madonna and Child.*

156 × 66.5 cm. (61⅜ × 36³⁄₁₆ in.). Pl. 62.

Location: SS. Trinità e Mustiola, Abbazia di Torri, Sovicille.

Inscription: EGO·SVM·LVX·[M]VNDI (John 8:12).

Condition: Fair. The panel, while suffering much damage over the years, has been cleaned and restored recently. The gold background is almost entirely gone, and there has been a fair amount of paint loss throughout. At some point in the nineteenth century the topmost portion of the panel was added so that it could be fit into a neogothic tabernacle. The Siena Soprintendenza has decided to leave this addition for the time being, given the fragile state of the painting, rather than attempt to remove it.

Provenance: Original location.

Exhibitions: Pinacoteca Nazionale, Siena, *Mostra di Opera d'arte restaurate nelle province di Siena e Grosseto*, June–November 1979, pp. 78–79, figs. 61 and 62 (Luca di Tommè).

Bibliography: Brogi, 1897, p. 586 (manner of Lippo Memmi); *Artistic Guide*, 1911, p. 135; *Guida Artistica*, 1912, p. 208 (Lippo Memmi); Berenson, 1932, p. 314 (Luca di Tommè); Berenson, 1936, p. 269 (Luca di Tommè); T. C. I. *Toscana*, 1959, p. 671 (Luca di Tommè); Berenson, 1968, vol. I, p. 226, pl. 371 (Luca di Tommè); Pisa, *Mostra*, 1972, pp. 93 and 95 (Luca di Tommè); T. C. I. *Toscana*, 1974, p. 623, (Luca di Tommè); De Benedictis, 1979, p. 86 (workshop of Ugolino Lorenzetti).

Photographs: Frick Art Reference Library, New York, negative no. 22807 (after removal of votive crown).

63. *Madonna and Child, Saints James and Andrew*; in the pinnacle, *Annunciation*. Panels of a polyptych.

195.5 × 150 cm. (76¹⁵⁄₁₆ × 59 in.). Pls. 63-1 and 63-2.

Location: Cappella dei SS. Filippo e Giacomo alle Segalaie, Villa Budini Gattai, Sovicille.

Condition: Poor. The altar has been almost entirely repainted along the original outlines; only portions of the faces of the lateral Saints and occasional parts of the gold ground are intact. The frame is a modern confection.

Provenance: Unknown (original location, with question).

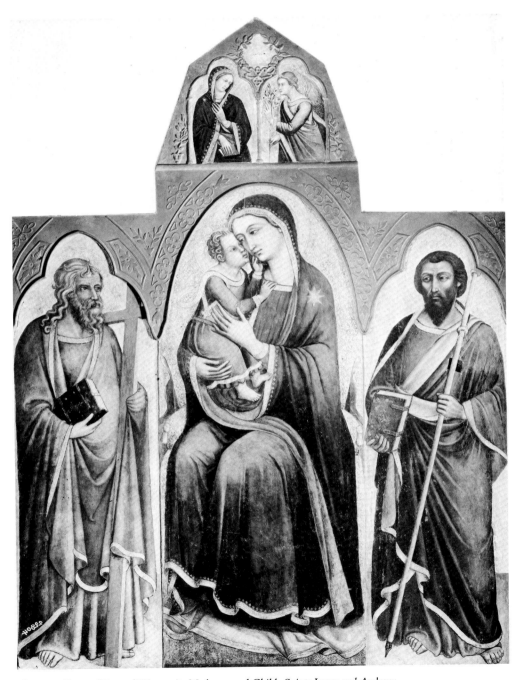

Pl. 63-1. Shop of Luca di Tommè, *Madonna and Child, Saints James and Andrew*; in the pinnacle, *Annunciation*.

Bibliography: Brogi, 1897, p. 585 (manner of Taddeo di Bartolo); Perkins, 1924, p. 13 (Luca di Tommè); Bacci, 1927, p. 51 (Luca di Tommè); Serra, 1929, p. 303 (Luca di Tommè); Berenson, 1932, p. 314 (Luca di Tommè); van Marle, 1934, vol. II, p. 524 (Luca di Tommè); Berenson, 1936, p. 269 (Luca di Tommè); Berenson, 1968, vol. I, p. 226 (Luca di Tommè, "ruined"); De Benedictis, 1979, p. 89 (Luca di Tommè); Siena, *Mostra*, 1979, p. 78 (Luca di Tommè).

Photographs: Frick Art Reference Library, New York, negative nos. 22804 (overall), 22805, 22806, 22928, and 22929 (details).

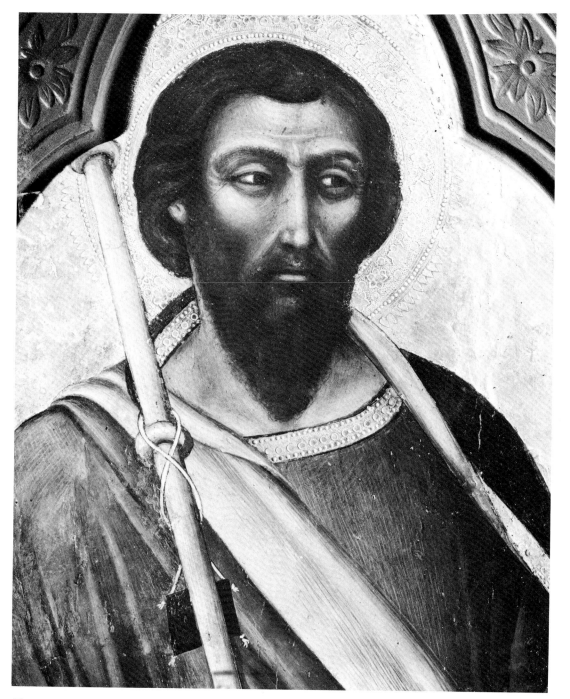

Pl. 63-2. *Saint James* (detail of Pl. 63-1).

64. *Madonna and Child.*

66 × 46 cm. (26 × 18⅛ in.). Pl. 64.

Location: Unknown.

Condition: Good. The panel has been cut on all sides. The Virgin's cloak is unusually flat, indicating areas of loss and repaint. Both faces have been retouched. A small split at the base running through the Madonna's right hand and through Christ's left foot has been poorly repaired.

Provenance: Florence, Vittorio Frascione, 1969.

Exhibitions: Palazzo Strozzi, Florence, *Mostra Mercato Internazionale dell'Antiquariato*, September 20–October 19, 1969, p. 425, ill. (Luca di Tommè).

Attributions: K. Steinweg (manuscript opinion, *in litteris* to the author, December, 1969: Luca di Tommè).

Bibliography: Gregori, 1969, p. 112 (Luca di Tommè); Fehm, 1976, p. 348 n. 32 (Luca di Tommè); De Benedictis, 1979, pp. 38, 66, and 89 (Luca di Tommè).

Photographs: *Mostra Mercato Internazionale dell'Antiquariato*, Catalogue, fig. 425.

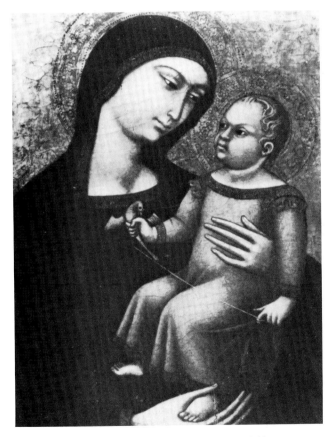

Pl. 64. Shop of Luca di Tommè, *Madonna and Child.*

65. *Saint Peter.*

43 × 29 cm. (16¹⁵⁄₁₆ × 11⁷⁄₁₆ in.). Pl. 65.

Location: Unknown.

Condition: Poor. The panel has suffered considerable damage and is obscured by overpaint and dirt. The gold ground appears to have been lost and painted over, and the Saint's halo has been reinforced. In several areas the paint has been rubbed away, revealing the gesso support.

Provenance: Bibbiano, San Lorenzo, Sacristy; Pinacoteca, Buonconvento (the panel was stolen from the museum during the Second World War).

Attributions: B. Berenson (manuscript opinion, The Harvard University Center for Renaissance Studies, Villa I Tatti, Florence: Luca di Tommè).

Bibliography: Brogi, 1897, p. 49 (Sienese school, 14th century); Perkins, 1933, pp. 37, 38, and 42 (Luca di Tommè).

Photographs: Gabinetto Fotografico Nazionale, Rome, negative no. E. 11781.

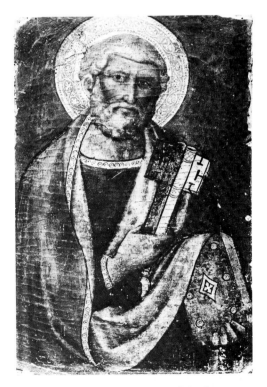

Pl. 65. Shop of Luca di Tommè, *Saint Peter.*

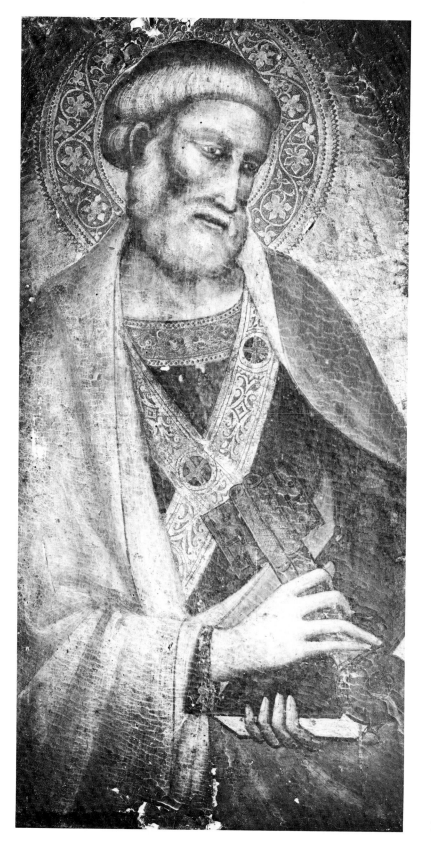

66. *Saint Peter.*

Dimensions unknown. Pl. 66.

Location: Unknown.

Condition: Fair. The panel has been cut down on all sides and has been obscured by dirt and repaint. Losses are noticeable along the bottom and top, and the Saint's cloak and hands have been daubed.

Provenance: San Pietro à Ovile, Siena (formerly).

Bibliography: Perkins, 1933, pl. 183 (Luca di Tommè); De Benedictis, 1979, p. 89 (Luca di Tommè).

Photographs: F. Mason Perkins, 1933, pl. 183.

Pl. 66. Shop of Luca di Tommè, *Saint Peter.*

67. *Madonna and Child, with Saints Francis and Catherine.* Triptych (in collaboration with Niccolò di Ser Sozzo).

Dimensions unknown. Pls. 67-1 and 67-2.

Location: Unknown.

Condition: Good. All of the panels appear to be in a healthy state of preservation. The faces of both the Virgin and the Christ Child have been retouched, and losses in the temple and throat of the former have been repaired. Her mantle has been extensively repainted.

Provenance: Private collection, Siena; Art Market, Florence (formerly).

Attributions: M. Meiss (verbal opinion, The Harvard University Center for Renaissance Studies, Villa I Tatti, Florence, May 1969: Luca di Tommè [Meiss saw only Pl. 67-2]).

Bibliography: De Benedictis, 1979, p. 96, figs. 31 and 33.

Photographs: Reali, Florence.

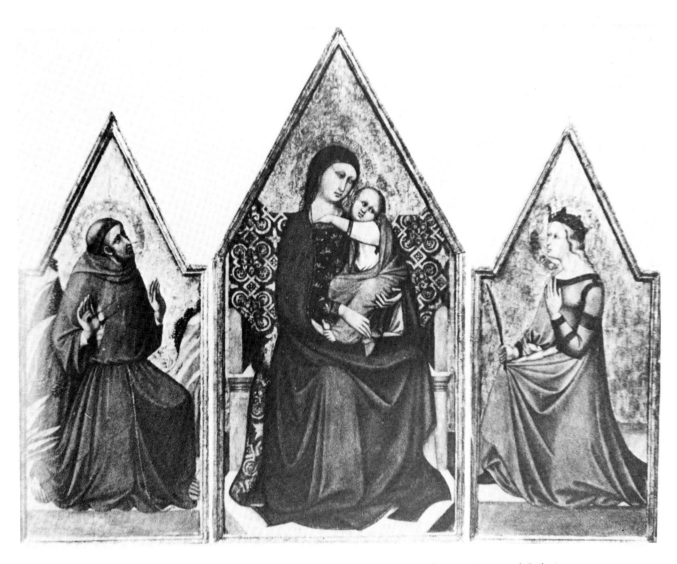

Pl. 67-1. Shop of Luca di Tommè, with Niccolò di Ser Sozzo, *Madonna and Child with Saints Francis and Catherine.*

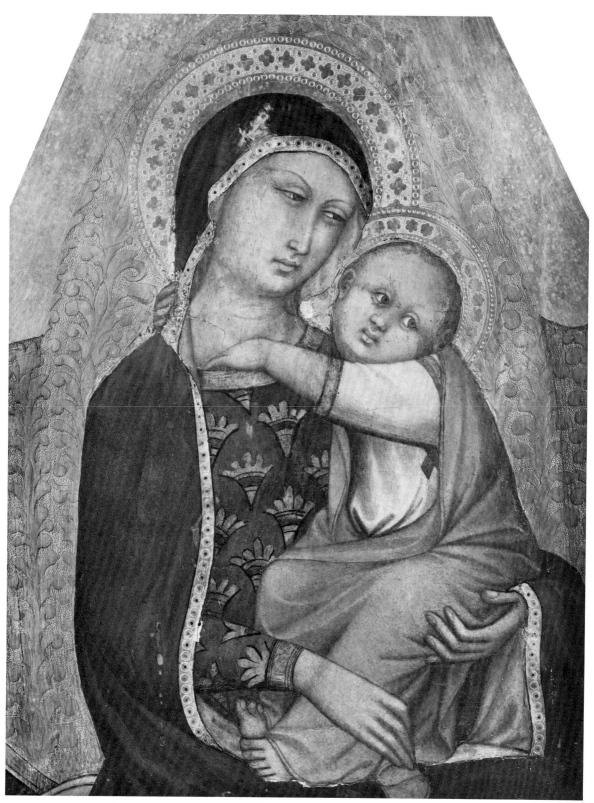

Pl. 67-2. *Madonna and Child* (detail of Pl. 67-1).

Lost Works

68. *Altarpiece* (ca. 1366–73). Possibly identical to Cat. 32.

Provenance: Dragondelli Chapel, San Domenico, Arezzo, until 1568, with question; current whereabouts unknown, unless identical to Catalogue no. 32.

Bibliography: Vasari, 1568, ed. Milanesi (1878–85), p. 651 (Luca di Tommè); Lupi, 1904, p. 408 n. 2 (he reports that, according to the Pisan art dealer Professor Francesco Manetti, a polyptych signed by Luca di Tommè, then in his possession—see Catalogue no. 32—came from the Dragomanni [*sic*] Chapel in Siena); Crowe and Cavalcaselle, 1908, vol. III, p. 86 n. 2 (Luca di Tommè); van Marle, 1924, vol. II, p. 466; Salmi, 1930, pp. 1–6; van Marle, 1934, vol. II, pp. 513 and 527 n. 1; Toesca, 1951, p. 598 n. 116; De Benedictis, 1979, p. 87 (Luca di Tommè).

Documentation: Vasari, 1568, ed. Milanesi (1878–85), p. 651.

69. *Head of a Saint*. Fresco (ca. 1356–61).

Provenance: Cathedral of Siena (now presumed destroyed).

Bibliography: Bacci, 1927, p. 56.

Documentation: AODS, 336 (*Entrata ed Uscità*), fol. 89r. (See Document 2.)

70. *Madonna and Child with Angels*. Fresco (ca. 1356–61). Executed in collaboration with Cristofano di Stefano.

Provenance: Façade, Cathedral of Siena (now presumed destroyed).

Bibliography: Milanesi, 1878, vol. I, p. 651 n. 3; Lusini, 1911, vol. I, p. 242 n. 36; Bacci, 1927, pp. 56–58; Lisini, 1927, p. 303; van Marle, 1934, vol. II, p. 513.

Documentation: AODS, 338 (*Entrata ed Uscità*), fols. 41v, 42r, 45v, 46r, and 58v. (See Documents 3a–3i.)

71. *Altarpiece* (ca. 1374–90). Executed in collaboration with Bartolo di Fredi and Andrea di Bartolo.

Location: Unknown.

Provenance: Chapel of the Shoemakers' Guild, Cathedral of Siena.

Bibliography: Milanesi, 1854, vol. I, pp. 28n–29; vol. II, p. 36n; Borghesi and Banchi, 1898, p. 28n; Rothes, 1904, p. 21; Lusini, 1911, vol. I, pp. 320 n. 67 and 321 n. 70; van Marle, 1934, vol. II, p. 513.

Documentation: AODS, 705 (*Libro Nero, dal 1349 al 1404*), fols. 89r, 108v, and 109r; 640 (*Memoriale*), fols. 89v and 90r; 369 (*Entrata ed Uscità*), fol. 52v; 368 (*Entrata ed Uscità*), fol. 162r. (See Documents 25a–25g.)

72. *Altarpiece* (ca. 1390).

Location: Unknown.

Provenance: Chapel of Marco Bindi Gini, San Francesco, Siena.

Bibliography: Lisini, 1927, p. 303; van Marle, 1934, vol. II, p. 513.

Documentation: ASS, *Diplomatico* (Ospedale Santa Maria della Scala), May 5, 1390. (See Document 28.)

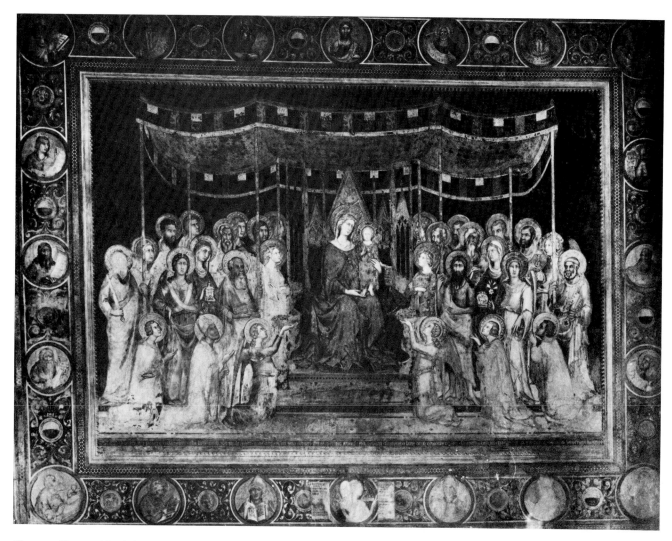

Fig. 1-1. Simone Martini, *Maestà*. Museo Civico, Siena.

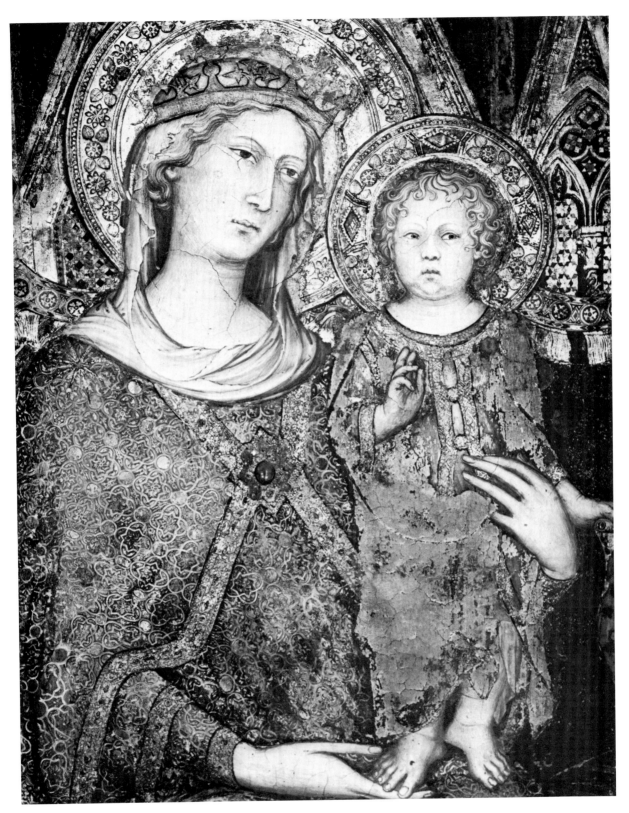

Fig. 1-2. *Madonna and Child* (detail of Fig. 1-1).

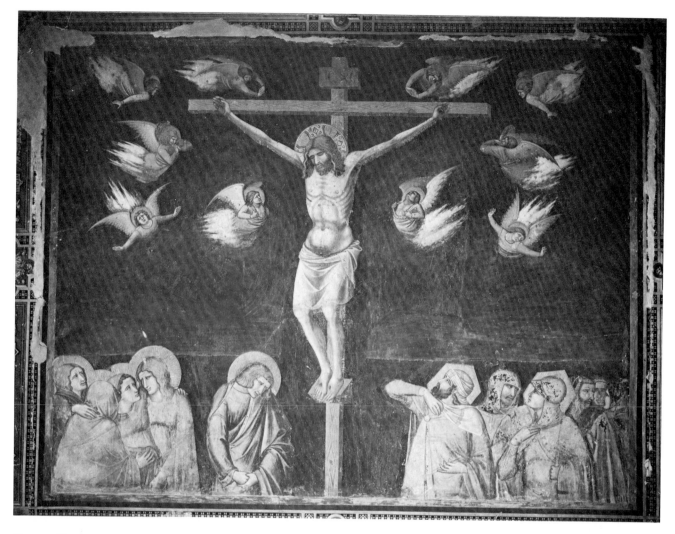

Fig. 2-1. Pietro Lorenzetti, *Crucifixion*. San Francesco, Siena.

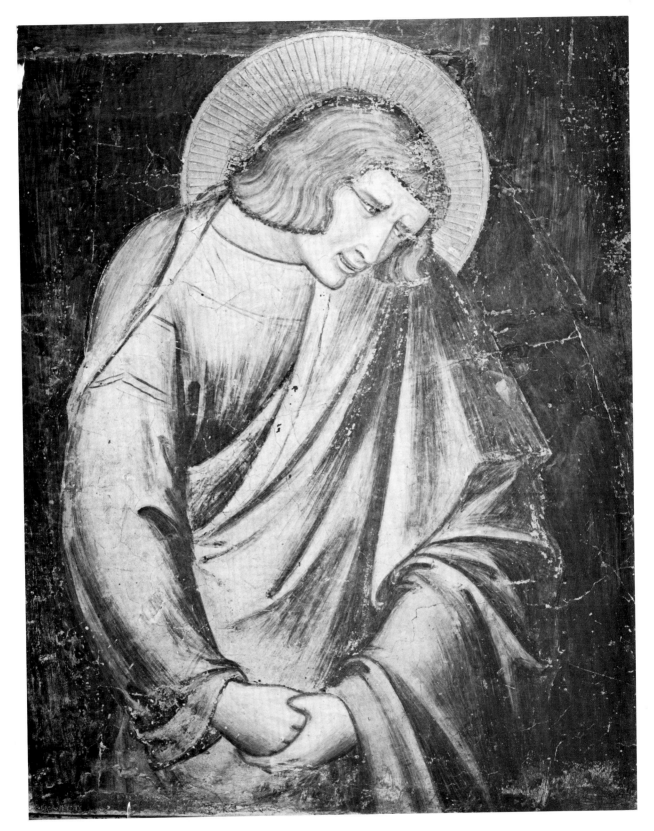

Fig. 2-2. *John the Evangelist* (detail of Fig. 2-1).

Fig. 3. Ambience of Pietro Lorenzetti, *Madonna and Child with Two Bishop Saints.*
Walters Art Gallery, Baltimore.

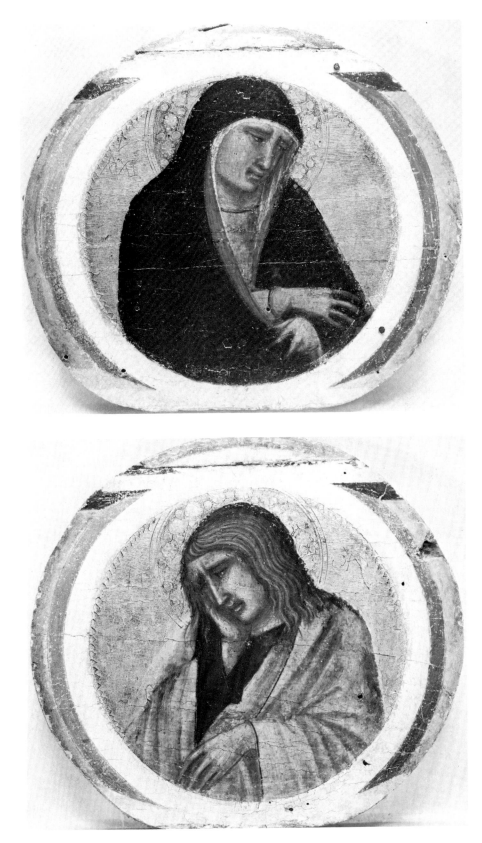

Fig. 4. Pietro Lorenzetti, *Virgin Mourning*. Uffizi, Florence.

Fig. 5. Pietro Lorenzetti, *John the Evangelist*. Uffizi, Florence.

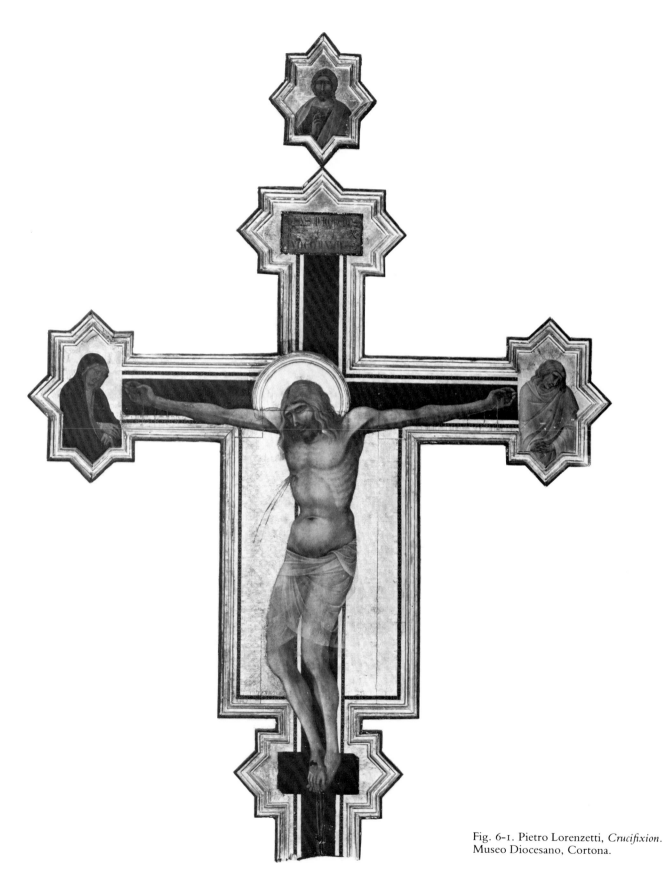

Fig. 6-1. Pietro Lorenzetti, *Crucifixion*.
Museo Diocesano, Cortona.

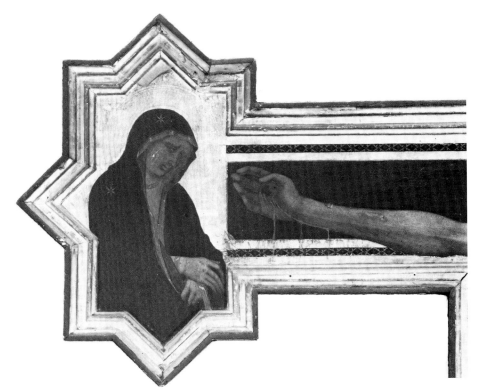

Fig. 6-2. *Virgin* (detail of Fig. 6-1).

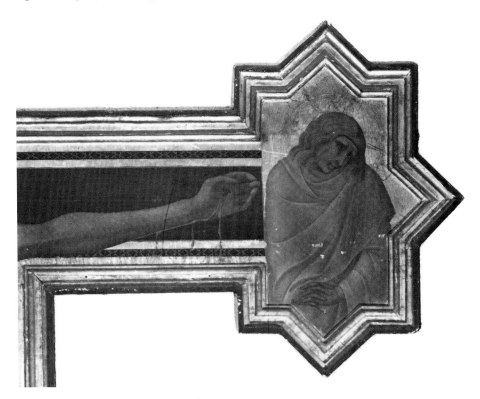

Fig. 6-3. *John the Evangelist* (detail of Fig. 6-1).

Fig. 7. Shop of Duccio, *Madonna and Child Enthroned with Saints Paul, Peter, and Donor*; surmounted by *Coronation of the Virgin*; in the spandrels, *Annunciation*; in the predella, *Eight Saints*; left wing: *Nativity, Flagellation,* and *Way to Calvary*; right wing: *Crucifixion, Deposition,* and *Entombment*. Pinacoteca Nazionale, Siena.

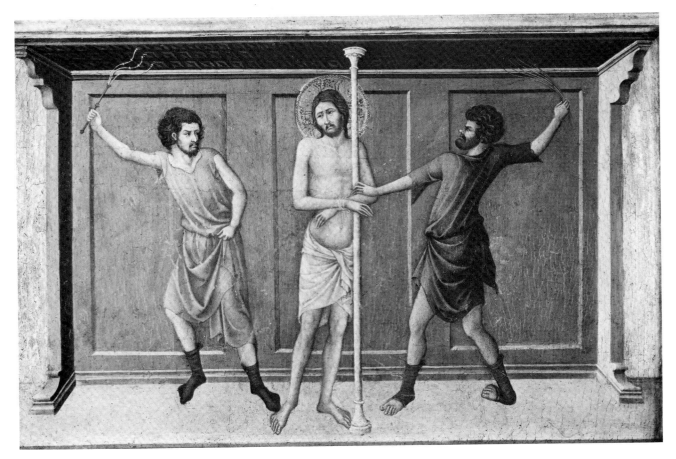

Fig. 8. Ugolino di Nerio, *Flagellation*. Gemäldegalerie, West Berlin.

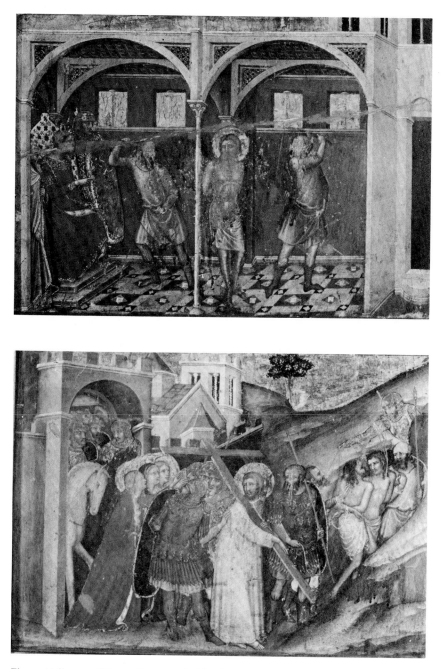

Fig. 9. Follower of Pietro Lorenzetti, *Flagellation* and *Way to Calvary.*
Pinacoteca, Borgo San Sepolcro.

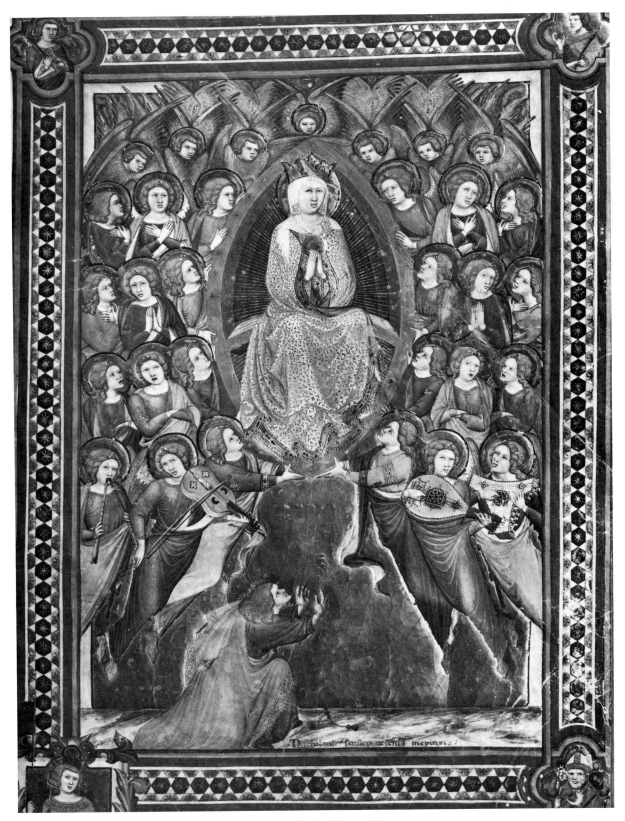

Fig. 10. Niccolò di Ser Sozzo, *Assumption of the Virgin*. Archivio di Stato, Siena.

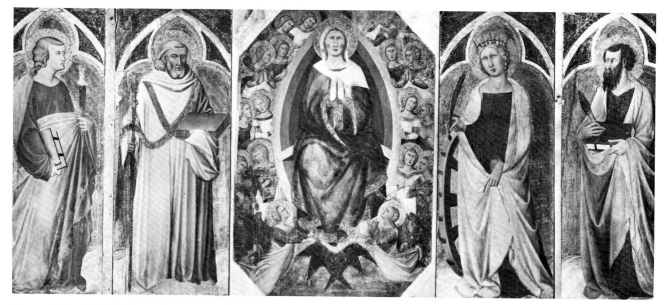

Fig. 11. Niccolò di Ser Sozzo, *Assumption of the Virgin with Saints Thomas, Benedict, Catherine of Alexandria, and Bartholomew.* Museo Civico, San Gimignano.

Fig. 12. Niccolò di Ser Sozzo, *Madonna and Child.* Location unknown.

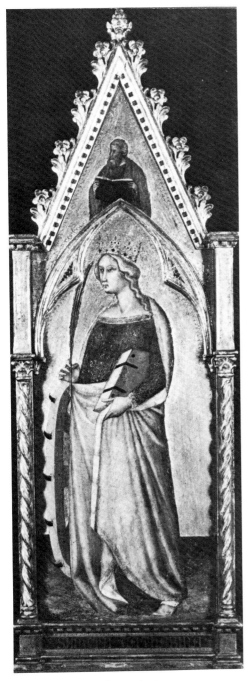

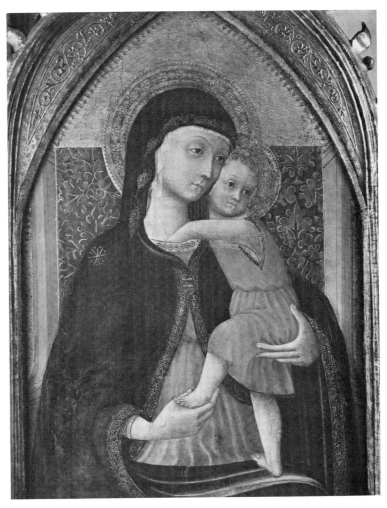

Fig. 14. Pietro di Giovannj Ambrosi, *Madonna and Child*.
Sir Harold Acton Collection, Florence.

Fig. 13. Follower of Niccolò di Ser Sozzo,
Saint Catherine of Alexandria. Location unknown.

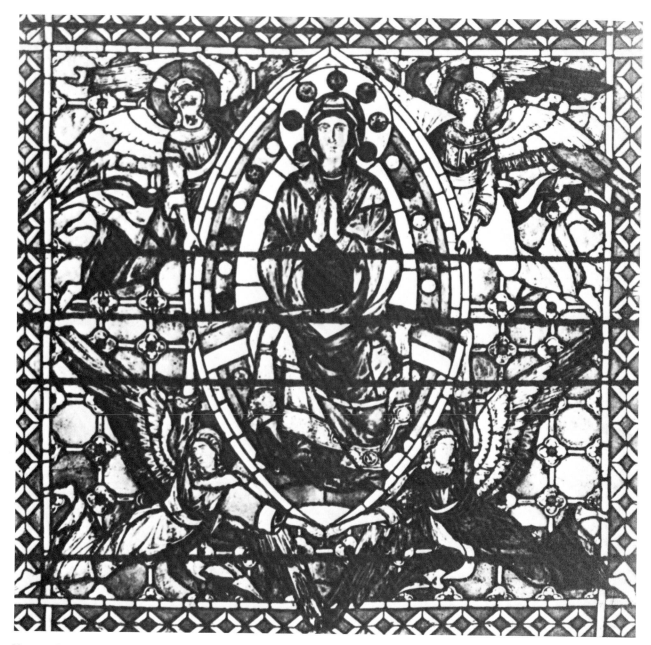

Fig. 15. Duccio (?), *Assumption of the Virgin* (detail of oculus). Opera della Metropolitana, Siena.

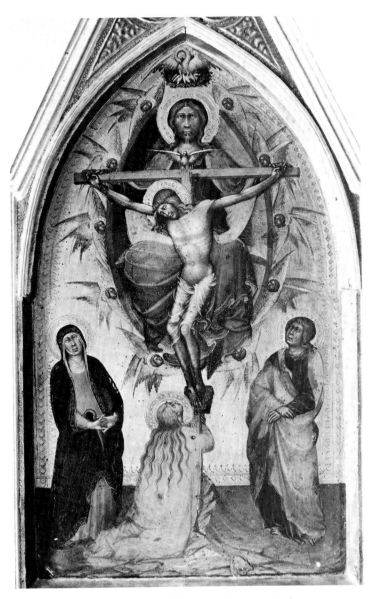

Fig. 16. Paolo di Giovanni Fei, *Trinity with Virgin, John the Evangelist, and Magdalen* (detail). Soprintendenza per i beni artistici e storici, Napoli.

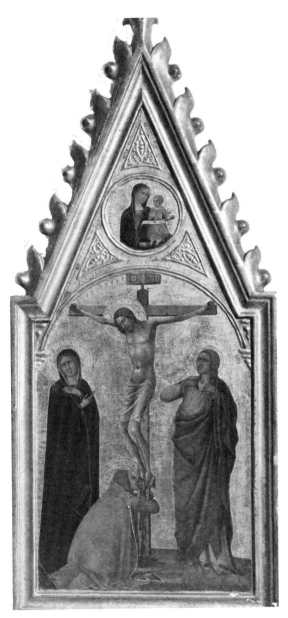

Fig. 17. Andrea Vanni, *Crucifixion with Virgin, John the Evangelist, and Magdalen*; in the tondo, *Madonna and Child*. Instituut voor Kunstgeschiedenis, Groningen.

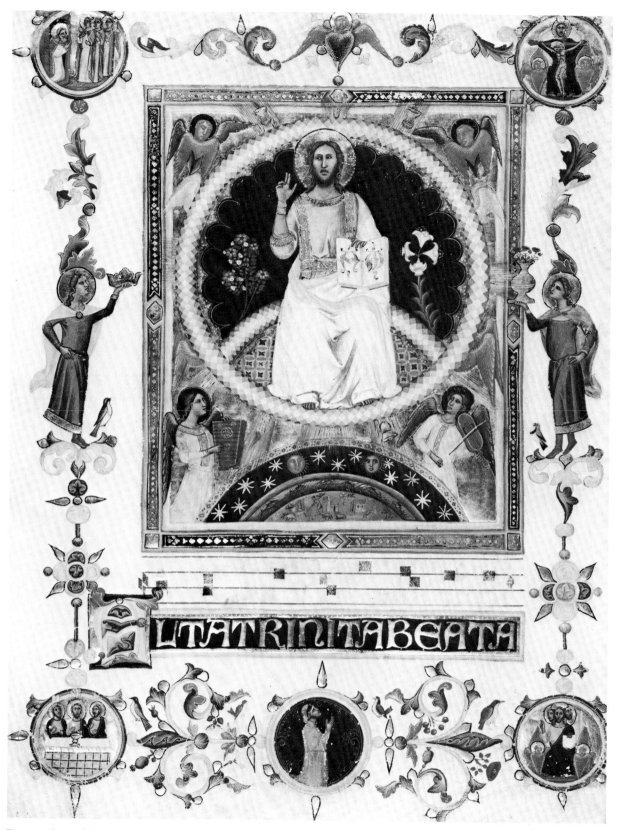

Fig. 18. Shop of Pacino di Bonaguida, *Christ Blessing: Four Versions of the Trinity.* The Pierpont Morgan Library, New York.

Fig. 19. Lippo Vanni, *Three-Headed Trinity* (detail of *Illuminated Antiphonary, No. 8*). Fogg Art Museum, Harvard University.

Fig. 20. Shop of Niccolò di Ser Sozzo, *Three-Headed Trinity*. The Free Library, Philadelphia.

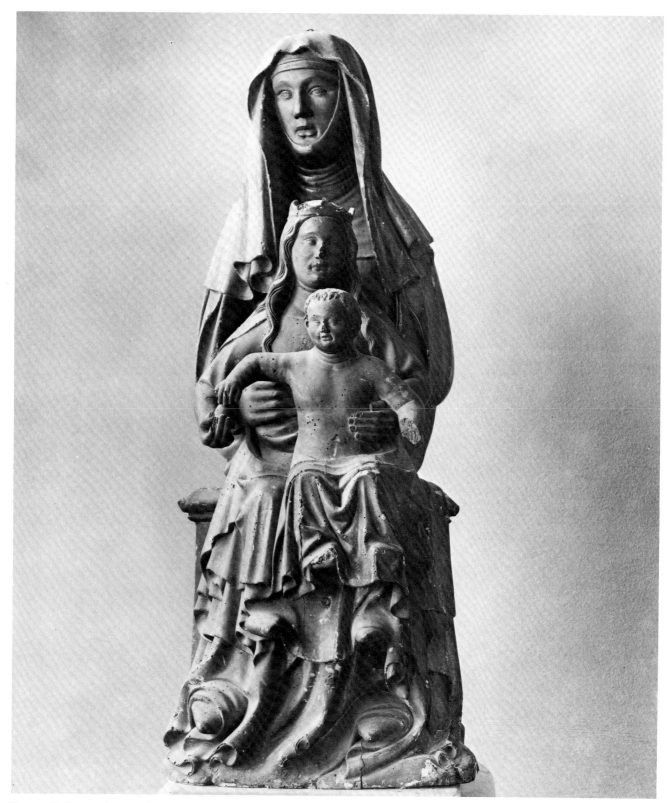

Fig. 21. Unknown fourteenth-century Tuscan artist, *Virgin and Child with Saint Anne*. Museo Nazionale del Bargello, Florence.

Fig. 22. Francesco Traini, *Virgin and Child with Saint Anne*. Art Museum, Princeton University.

Fig. 23. Follower of Pietro Lorenzetti, *Madonna and Child with Saint Anne*. Cuna.

Documents

Although the precise dates of Luca di Tommè's birth and death are so far unknown, his activity as both a painter and a citizen of his native Siena can be followed reasonably well between 1356 and 1390 through the surviving documents and paintings.[1] Documents referring to Luca—approximately fifty in number—are found principally in the two major archives in Siena: the Archivio di Stato (hereafter referred to as ASS) and the Archivio dell'Opera del Duomo in Siena (AODS). From these we can surmise that Luca was approximately twenty years old in 1356, and died sometime after 1390 in his late fifties or early sixties.

The first attempt to collect, transcribe, and interpret documents referring to artists who had worked in Siena was completed by Ettore Romagnoli in 1835. This author's work remains in manuscript form and is now in the Biblioteca Comunale in Siena. Romagnoli's work, which includes a section on Luca di Tommè, provides the basis for all subsequent documentary studies.[2] In turn, the first published collection of Sienese documents was compiled by Gaetano Milanesi, and appeared in 1854.[3] A wealth of evidence is contained in Milanesi's enormous study. His transcriptions, however, are often incomplete and inaccurate, while many documents alluded to in his notes lack precise or even adequate identification. His material on Luca di Tommè is no exception. In spite of this, it has been possible to identify and verify all the documents published or referred to by Milanesi regarding the artist. A more thorough study of Luca was undertaken during the 1920s by Pèleo Bacci, the archivist and superintendent of monuments in Siena. Only a third of Bacci's work was ever published.[4] Work in the Sienese archives has brought forth a number of items, principally from the latter period of Luca's life, to add to the information initially presented by Bacci.

Surviving documents referring to Luca di Tommè fall into two distinct groups. The greater portion deals with his private and public affairs as a Sienese citizen, while a smaller group relates to his activity as an artist. Together, both portions provide an insight into the artist's life in Siena and help to establish a chronology for his activities in that city.

Luca is first referred to at the time of the foundation of the painters' guild in Siena (Document 1).[5] In all probability the statutes of this organization were approved by the Commune in 1356. During the preceding year, the government of the Nine, an oligarchy of wealthy burghers who had governed Siena for some seventy years, was replaced and a new ruling coalition of nobles and artisans was formed. This change led to a more representative form of government, and here the artisans' assumption of a more active role in state affairs was most likely an immediate impetus for the formation of, for example, the painters' guild. Luca di Tommè is listed among the founding masters of this association. It is likely, then, that he was already an established artist by 1356.[6] There is, however, no indication of how long prior to this he had been in the upper ranks of Sienese painters.[7]

1. Luca di Tommè is the standardized modern form of the artist's name. In the documents it appears variously as Lucha di Tomè, Luce Tonis, or Lucha di Tonè. Tommè is the peculiarly Sienese diminutive of Tomasso. I have found no mention of Luca's father, Tommè di Nuto, whose name is known to us only from Document 20a.

2. Romagnoli, Siena, Biblioteca Comunale, MS. L.II.1–9, *Biografia Cronologica de Bellartisti Senesi*. His account of Luca di Tommè is found in vol. II, fols. 249–60.

3. Milanesi, 1854, vol. I, p. 28 n. 1. Lusini, 1911, vol. I, pp. 242 n. 36, 315 n. 19, and 320 n. 67, also gathered together a number of notices regarding Luca, and these are noted here.

4. Bacci, 1927, pp. 51–62.

5. This important compilation of statutes and register of masters provides insight into the structure of a medieval guild, as well as a list of the painters at work in Siena in 1356, 1389, 1414–17, and 1428. The statutes were corrected and approved for the Commune by the jurist Richo de Morrano of Modena on February 19, 1356.

6. The order in which the painters were enrolled seems to have been significant. The names of the senior and better-known artists appear at the beginning of this list, as well as that of 1389.

7. Although the statutes of the Sienese painters' guild survive intact, no age requirements are specified. As the minimum apprenticeship period was probably five years, Luca could hardly have been younger than the age of twenty in 1356. For a discussion of the concept of age during this period see Gilbert, 1967, pp. 7–32.

The next reference to Luca di Tommè occurs in March of 1357 in the *Entrata ed Uscità* of the Cathedral treasury, when the painter received twenty-five *soldi* from the Opera del Duomo for gilding the halo of an apostle (Document 2).[8] Most probably, this payment refers to work on a panel painting, as the use of a gold halo rarely occurs in fresco.

A cluster of documents from the next year refers to repairs made on a fresco originally painted by Pietro Lorenzetti, located above the central portal of the cathedral façade (Documents 3a–i). Luca undertook this work in collaboration with Cristofano di Stefano, who for some reason was not listed among the masters of the painters' guild either in 1356 or 1363 (when the statutes were updated for the first time). Most probably, Luca was included in this commission because he was a guild member and had previously worked for the cathedral authorities. He was, hence, known and respected locally. It would seem, however, that Cristofano was the senior of the pair; he is mentioned either alone or before Luca in the majority of documentary references.[9]

Five years later, the next hint of Luca's activity appears in the form of an inscription on a polyptych in the Siena Pinacoteca Nazionale (Document 4, Catalogue no. 13). According to this epigraph the altarpiece is the work of Niccolò di Ser Sozzo and Luca di Tommè, and is dated 1362. No other documents relating either to the collaboration of these two masters or to the polyptych itself have come to light.

In August of 1362 Luca di Tommè, Bartolommeo Bulgarini, and Jacopo di Mino del Pelliccaio were called upon to give advice on the temporary removal of Duccio's *Maestà* from the high altar of the cathedral during the extension of the choir (Document 5).[10] During the following year, 1363, the Commune ordered a new registration of all guild masters (Document 7).[11] This list includes the names of both Luca di Tommè

and Niccolò di Ser Sozzo. It must, therefore, have been composed within the first ten weeks of the Sienese year (which began on Annunciation Day: our March 25), for Niccolò was buried on June 15.[12]

There are no further notices about Luca's activity until 1366—the date inscribed on the frame of his Pisa *Crucifixion* (Document 8, Catalogue no. 19). Also from that year more evidence is available, but in this case it concerns Luca's business affairs and is in the form of payment records by the Opera del Duomo for various services rendered. Here, Luca received thirteen *soldi* and nine *denari* for colors to be used in the decoration of the vault of the baptistry of San Giovanni located under the cathedral. Later the same year he received another payment from the same authorities (Documents 9 and 10). In the following year Luca completed the signed and dated *Saint Anne* altarpiece (Document 11, Catalogue no. 22), for which no other documents have survived.

The government of the Twelve, which in 1355 had replaced an earlier faction, was driven from office in a series of crises during the turbulent autumn of 1368. In the census subsequently ordered by the new government, Luca di Tommè's name is recorded twice: first as a member of the Company of Saint Christopher in the Terzo di Camollia, and then as that district's representative to the General Council of the majority party (Documents 12a and 12b).[13]

From this year on Luca often participated in the government. During July and August of 1373, he was required to be in Siena, again representing the Terzo di Camollia, and in the capacity of one of the "twenty-four councillors for the protection of the public good" (Document 15). The only precise record of Luca's artistic production between 1369 and 1373 is found in an inscription on a polyptych in Rieti (Document 13; Catalogue 27). This indicates that the altarpiece was commissioned in 1370 for the church of San Domenico in Rieti by the executors of the estate of Andrea and Vanne Pannelli. Luca's name, the date, and the names of the donors have been partially obliterated, but the full text is preserved in a seventeenth-century description of the church.[14]

8. The *Entrata ed Uscità* were the daily account books into which every financial transaction, no matter how small, was entered. Both the cathedral and the Commune of Siena kept these sets of books, a large number of which have survived from the fourteenth century.

9. Cristofano's name occurs in other Sienese documents in the late 1350s and then disappears. In these other notices he is referred to neither as a foreigner nor as a master. In any case, guild statutes would have prohibited any non-Sienese artist from seeking work in Siena.

10. For the background and documentation of the entire procedure see Bacci, 1927, pp. 58–62. For an account of the activity of Bartolommeo Bulgarini see Meiss, 1936, pp. 113–36. For Jacomo di Mino del Pelliccaio see Perkins, 1930, pp. 243–67. For the proceedings and documentation see Lusini, 1911, pp. 151–87, and Milanesi, 1854, vol. I, pp. 251–53.

11. This volume lists all masters in all trades who were active during 1363.

12. Niccolò di Ser Sozzo presumably died in the same outbreak of the plague that took Luca's first wife (Document 6). Siena, Biblioteca Comunale, MS. C.III.2, *Necrologia di San Domenico*, fol. 17r. This is the only fourteenth-century Sienese death register that survives, and it lists only the burials of those who belonged to the congregation of San Domenico.

13. Siena is divided into three districts, or *terzi*: the Camollia in the north, the Città in the south, and San Martino in the east. In turn, each of these districts is subdivided into precincts, or *contrade*, which originally were military companies frequently named for animals. Currently there are seventeen such precincts.

14. The description is found in the Fondo di San Domen-

Luca's activities during 1374 can be easily followed. In February he was paid by the Opera del Duomo of Orvieto for nine hundred thirty-four sheets of gold leaf he sold to Ugolino de Prete Ilario, a local master (Document 17). This gold was to be used for the fresco decoration of the cathedral choir then in progress. Later that same month, Luca received one hundred five florins from the *Biccherna* (the major Sienese financial magistracy) for both salary and the cost of colors, wood, and gold for an altarpiece dedicated to Saint Paul (Documents 18a and 18b). The full expense of this altarpiece had been estimated by the Sienese artists Jacopo di Mino del Pellicciaio and Cristofano da Cosona, after approval for the project had been given by the general council of the Commune several days before. The altarpiece in question is possibly the polyptych now in the Pinacoteca Nazionale dell'Umbria in Perugia (Catalogue no. 39). Although the inscription on that polyptych is fragmentary, Luca's name can still be distinguished (Document 16), and Saint Paul, the patron of the expedition against the Company of the Hat, appears in a prominent position.[15]

On the thirty-first of May of 1374 one of Luca's shop assistants paid twenty-five florins to the *Biccherna* on his master's behalf (Documents 19a and 19b). This represents, perhaps, a tax levied, at least in part, on the Saint Paul commission. Later, on August 3, Luca received one hundred gold florins as a dowry for his second wife Miglia, and on this amount was also assessed a tax (Documents 20a and 20b).[16] By now Luca was recorded as a resident of the *contrada* of San Pellegrino in the Terzo di Camollia. We may infer from the documents, as well, that by this time his father had passed away.

Judging from the number of surviving panels, Luca's artistic production seems to have diminished greatly during and after the late 1370s. A series of notices

shows that he had become increasingly active in governmental affairs, which might account for this apparently reduced output. In September and October of 1379, Luca again numbered among the "defenders of the public good," though he now represented the Terzo di Città (Document 21).[17] During the first six months of 1383, he served as one of the *Provveditori*, or leading officials, of the *Biccherna* (Documents 22a–d). In the next year a modest tax of two *denari* was imposed on him by the Commune for an unknown reason, and it appears that only one *denaro* of this assessment was ever paid (Document 23).[18] This record also indicates that Luca had again changed his residence, this time to the *contrada* of San Pietro alla Scala in the Terzo di San Martino.

Throughout the second half of the fourteenth century the decoration of the extended chancel area of the Duomo consumed the interest and resources of the cathedral authorities. On March 13, 1388, Luca and several others were called upon to evaluate two different designs for carved wooden stalls and tabernacles in the choir (Documents 24a and b). These proposals were submitted by Jacomo Francesco del Tonglio and Mariano d'Agnolo Romanelli and on June 13 the results of this competition were recorded in the books of the Opera, the *Libro Nero* and the *Memoriale*.[19]

In 1389 the Opera commissioned Luca di Tommè, Bartolo di Fredi, and the latter's son Andrea to make an altarpiece for the confraternity of the *Calzolai* (shoemakers), to be situated in their chapel dedicated to Saint Agnes (Documents 25a–g). It appears that Luca must have had overall responsibility for the project, as his name appears first in the documents, and sometimes without those of his colleagues. The actual division of labor, however, is not specified. Five payments for the altarpiece were to be made at four-month intervals, with the sum increasing as the work progressed. The Opera called upon Taddeo di Bartolo and others to suggest a just price for the work on April 23, 1389. Two days later the contracts were drawn up and the initial payments made. The price agreed upon was one hundred thirty gold florins, of which the shoemakers were obligated to repay the whole sum to the Opera at the rate of twelve gold florins per year.[20]

ico (*Libro dei Consigli del 1776*) in the Archivio Communale of Rieti, among several pages bound together with the main text.

15. During the thirteenth and fourteenth centuries Italy was constantly ravaged by roving mercenary bands, some of which were powerful enough to hold a commune for ransom. The *Compagnia del Cappello* was one of the strongest and most notorious of these predators; hence, Siena's jubilation over their own success against them. Saint Paul had been invoked as the protector of the Sienese expedition against the "Company of the Hat," and thus had gained special reverence among the citizenry. On October 30, 1363, the decision had been reached to construct a chapel in the cathedral and furnish it with an altarpiece in the saint's honor, but more than a decade was to pass before the commune actually commissioned Luca to make the altarpiece.

16. The Commune of Siena kept a record of all contracts drawn up within its territory. A tax, or *Gabella*, was levied against these contracts in proportion to the amount or value of the transaction.

17. This document is found in the account books of the *Concistoro*, another but less powerful organ of the Sienese government.

18. The *Lira* was a series of tax records. For a description of these accounts see Siena, 1951.

19. The *Libro Nero* was a special account book in which any major sum spent on the fabric of the cathedral itself was recorded. The *Memoriale* was a parallel set of account books kept by the cathedral treasurer, and their function was similar to that of the *Entrata ed Uscità*.

20. It appears that prices were reasonably stable in Siena during the second half of the fourteenth century, judging

During this time Luca was also commissioned, according to the terms of the will of the Sienese merchant Marco Bindi Gini, to make a panel for the high altar of the latter's chapel in San Francesco, Siena (Document 28). This will, along with a tax record (Document 27), are the last notices we have of Luca, who had taken up residence once again in the Terzo di Camollia, this time in the *contrada* of Sant'Andrea.

It is difficult to ascertain when Luca died, but it can be assumed that his death occurred sometime afer 1390, and before the years 1414–17.[21] In 1389, Luca was recorded in a new registration of painters, which followed the addition of a group of new statutes to the guild's constitution (Document 26). This 1389 registration was not the only addition to this document before the next registration occurred in 1428. Many of the painters listed in 1389 are recorded twice on the same folio pages, the second time by a different hand. From other evidence it seems that a new list was compiled sometime between 1389 and 1414.[22] Without any doubt the name of Luca di Tommè would have been included in this new register had he still been alive. He must have died, then, sometime after 1390, and before 1414–17.

It seems certain that only a small number of the documents covering Luca's long and productive career have been preserved. In the absence of further evidence it is difficult to infer anything but the barest of biographical details. We have no record of him at the very beginning of his career, nor, probably, at the very end. We lack, for instance, any indication of the shop to which he was apprenticed. His earliest recorded commissions for the cathedral (for fresco repairs) show that he was trained in that medium as well as in tempera, yet no further record of his use of fresco exists.

We do know from the surviving documents and paintings, however, that Luca di Tommè was an extremely productive artist, whose output seems to have peaked in the sixties and early seventies. The documents indicate that he often collaborated with other masters, a practice quite common in the trecento. It is also clear that, like many other Sienese artists of his generation, Luca played an active role in the govern-

ment that came to power in 1368, and that his role in the government increased considerably over the next decade.

Moreover, the extant records indicate that Luca was almost continually in the employ of the Opera del Duomo of Siena, which implies of course that the cathedral bureaucracy considered him reliable, and that his work appealed to their tastes. Unlike at least one of his contemporaries, Bartolo di Fredi, he seems never to have left Siena for any considerable length of time.[23] The only record that suggests Luca's presence in another city is that concerning his sale of gold leaf to the Opera del Duomo in Orvieto, although he may have traveled also to the Marches in connection with the Rieti altarpiece. Beyond these very rudimentary facts little more can be gleaned from the records. Nonetheless, these documents, when viewed alongside the surviving works, do provide a solid point of departure for a discussion of Luca's training and development as an artist.

In the collection of documents that follows, related or virtually identical items have been grouped together under the same number, even though occasionally one of a series may be dated earlier than an item in a preceding group. A complete bibliography and a précis follow each. When there is no substantial difference among various documents, or when a series of short notices refers to the same matter, the précis follows the group of notices. I have given only a few names or paragraphs when a lengthy document has already been published in full. Unpublished items are presented in their entirety, with the exception of Document 28.

All documents have been transcribed from the original sources, and their original form maintained. Dates are given in modern style here, unless otherwise indicated. The Sienese year, as in Florence, began on Annunciation Day, our March 25. The fiscal year was divided, however, into two semesters, the first of which began on January 1, and the second on July 1.

from the fact that Luca had received a similar amount for his *Saint Paul* altarpiece fifteen years earlier.

21. Luca's name does not appear in the necrology of San Domenico (see note 12 above).

22. For a detailed discussion of this list see Fehm, 1972, pp. 198–200.

23. For Bartolo di Fredi's activity outside Siena, see Lillian Bush's "Bartolo di Fredi," an unpublished doctoral dissertation, Columbia University, 1947.

1

ASS, Arte, 59, *Breve dell'Arte de'Pittori Senesi*, fols. 20v, 21r.

19 February 1356.

. . .

Lippo Vanni
Iacomo di frate Mino
Lucha di Thomè
Christofano di Chosona
Fede di Nalduccio
. . .

Paolo del maestro Neri
. . .

Bartolo del maestro Fredi
. . .

Andrea di Vanni
Nicholò di Buonachorso
. . .

Christofano del maestro Bindoccio
. . .

Bibliography: Della Valle, 1782, vol. I, p. 158; Gaye, 1839, vol. I, p. 29; Milanesi, 1854, vol. I, pp. 1–56; Manzoni, 1904, p. 109; Bacci, 1927, p. 56; Fehm, 1972, p. 198; De Benedictis, 1979, pp. 37, 38, 65, and 66.

Together with several colleagues, Luca di Tommè was enrolled in the first painter's guild to be formed in Siena during the year 1356.

2

AODS, 336, *Entrata ed Uscità*, fol. 89r.

March 1357.

A Luca di Tome dipi[n]tore vi[n]tieci[n]que soldi per uno cappello d'apostolo ch' e d'oro. .1.libr.V.sol.

Bibliography: Bacci, 1927, p. 56.

In March 1357, the artist was paid twenty-five *soldi* by the cathedral authorities of Siena for making a halo of an apostle in gold.

3a–3i

AODS, 338, *Entrata ed Uscità*, fols. 41v, 42r, 45v, 46r, 58v.

3a August 1358

A Magio di Ceccho batteloro sei fiorini d'oro e trenta e sei soldi per cinquecento pezze d'oro fino per raconciare la Ma-

donna de la facciata di Duomo, sopra a la porta di mezzo, per 4 lib., 10 sol., el centonaio. lib. xxii, sol. x.

3b August 1358

A Cristofano di Stefano dipentore, cinque lib., sei sol., per azzurro e per laccha e altri colori per raconciare la detta Madonna. lib. v, sol. vi.

3c August 1358

Al detto maestro Cristofano e al compagno dipentori per raconciatura la detta Madonna; istettervi amenduoni sei di e altre dotte, cinque fiorini d'oro e vinti soldi. lib. xviii, sol. v.

3d September 1358

A Magio battelloro per secento pezze d'oro che compramo dallui per fare raconciare le figure e campi che sonno dal lato e d'intorno a la Nostra Donna da la facciata di Duomo, verso l'Ospedale, per quatro lib. e diece sol. el centonaio, vintisette libre. lib. xxvii.

3e September 1358

A Cristofano dipentore per cento dicesette pezze d'oro per lo detto lavorio, quatro lib. e quatordeci sol.

3f September 1358

A Cristofano e Lucha dipentori per azzurro oltremarino e altri colori che compraro per lo detto lavorio otto lib. lib. viii.

3g September 1358

A Cristofano e Lucha detti, dipentori, per quindici giornate per uno che stettero a dipegnare e adornare el detto lavorio per loro salario sette fiorini d'oro a 3 lib., 9 sol. el fiorino. lib. xxviiii, sol. iii.

3h December 1358

A Cristofano dipentore undici lib. dicenove sol. sei den., per dugento vinti e cinque pezze d'oro fino per iiii° lib. x, sol. el centonaio e per azzurro e stagno cholori per fare istelle intorno a la Madonna da la facciata del Duomo e mettare ad oro el l'ale degl'agnoli. lib. xi, sol. xviiii., den. 6.

3i December 1358

Al detto C[r]istofano otto lib. per otto giornate al detto lavorio chome fu istimato per . . . lib. viii., sol.

Bibliography: Milanesi, 1878, vol. I, p. 651 n. 3; Lusini, 1911, vol. I, p. 242 n. 36; Bacci, 1927, pp. 56–58; Lisini, 1927, p. 303.

In collaboration with Cristofano di Stefano, Luca was paid for repairing a fresco depicting the Madonna and Child with figures located on the façade of the Siena cathedral above the central portal. The documents, covering a five-month period from August to December 1358, include payments for gold leaf, azurite and tin.

4

Siena, Pinacoteca Nazionale, Inv. no. 51. (See Catalogue no. 13.)

1362.

NICCHOLAVS · SER · SOCCII · ET · LVCAS · TOMAS · DE · SENIS · HOC · HOPVS · PINCERV[N]T · ANNI · MCCCLXII

Niccolò di Ser Sozzo and Luca di Tommè signed and dated an altarpiece in 1362.

5

AODS, 343, *Entrata ed Uscità*, fol. 4v (2d part of volume).

August 1362.

A Bartolome di misser Bolgharino e Lucha dipentore e Iachomo dipentore ebero che furo arghomentare a levare la tavala de la Madona quando si trasmuto e posesi dal Crociefiso ebero xxx soldi per uno di loro, montò in tutto quattro lib. e diece soldi. iiii lib., x sol.

Bibliography: Bacci, 1927, p. 58; Moran, 1976, pp. 61, 63.

During the month of August 1362 Bartolommeo Bulgarini, Jacopo di Mino del Pellicciaio and Luca di Tommè were each paid 30 *soldi* for their recommendations regarding the transferral of Duccio's *Maestà* from the high altar to the altar of the Crucifix in the Cathedral of Siena.

6

Siena, Biblioteca Comunale, MS C. III. 2, *Necrologia di San Domenico*, fol. 14r.

28 February 1363.

Mensis februarii anno Domini 1363 Uxor Thome pictoris sepulta est die XXVIII februarii 1363.

The artist's wife was buried on February 28, 1363.

Bibliography: Moran, 1976, p. 63.

7a

ASS, Arte, 165, *Libro delle Capitudini delle Arti*, fols. 33r, 33v.

25 March–15 June 1363.
. . .
Pittores

Andreas Vannis
Lucas Tonis
. . .
Bartholus magistri Fredi
. . .
Bartholomeus domini Bolgarini
. . .
Nicholaus ser Soczi

Bibliography: Milanesi, 1854, vol. I, pp. 49–56; Manzoni, 1904, p. 113.

Luca's name appeared together with those of his colleagues in a register of the masters of the guilds in Siena compiled in 1363.

7b

ASS, Concistoro, 24, *Libro delle Capitudini delle Arti*, fol. 35r.

September–October 1363.
. . .
Lucas Thome pictor priore capitudine pictoris magiore Capitudinis

Bibliography: Moran, 1976, p. 61, fig. 78.

Luca's name appears as *Priore* of the *Arte dei Pittori* for September and October of 1363.

8

Pisa, Museo Nazionale di San Matteo, Inv. no. 8. (See Catalogue no. 19.)

1366.

LVCKAS · TOME · DE · SENIS · PINXIT · HOC · [OPV]S · MCCCLXVI

Luca di Tommè signed and dated a panel in 1366.

9

AODS, 347, *Entrata ed Uscità*, fol. 31v.

August 1366.

Ancho demo a Luca dipentore tredici soldi, nove denari per ii libre, sei once [di colori] per due sol., sei den. lib., per le volte. xiii sol., 9 den.

Bibliography: Lusini, 1911, vol. I, p. 315 n. 19; Bacci, 1927, p.61; van Marle, 1934, vol. II, p. 513.

During August 1366 the artist sold pigments to the Siena cathedral authorities. These were to be used for a vault of the baptistry of San Giovanni beneath the

main fabric of the cathedral. Luca was paid at the rate of 2 *soldi*, 6 *denari* per pound (*libra*). The total amount paid to him was 13 *soldi*, 9 *denari* for a total of 2 pounds (*libre*), 6 ounces (*once*) of color.

10

AODS, 347, *Entrata ed Uscità*, fol. 40v.

November 1366.

A maestro Luca di Tome vintti quatro soldi per due di che servi del deto messe, per dodici soldi el di, nel libro del nigro fo. 45. .I. libra, .IIII.soldi

Bibliography: Lusini, 1911, vol. I, p. 315 n. 19; Bacci, 1927, p. 61.

Luca di Tommè received the sum of 24 *soldi* for unspecified services rendered to the Siena cathedral authorities in November 1366.

11

Siena, Pinacoteca Nazionale, Inv. no. 109. (See Catalogue no. 22.)

1367.

LVCAS·THOME·DE·SENIS·PINSIT·HOC·OPVS·M·CCC·LXVII.

Luca di Tommè signed and dated an altarpiece in 1367.

12a

ASS, Concistoro, 1589, *Libro della Corona*, fol. 39r.

September–December 1368.

Libro de' Riformatori, Terzerio Kamollie, de Compagnia Sancti Christofani
Regolinus Boschi sellarius
Dardus Vannis spetiarius
Froczone Muccii cerdo
magister Iacomus Vannacchii
Christofanus Iohannis coraczarius
Soczinus Iusti borsarius
Franciscus Mini cerdo
Vannuccius magistri Pagni
Iohannes Beringuccii cerdo de dicto populo parvo
Agnolus Iacomi Nerii
Lucas Tomme pictor
Christofanus Ghinuccii Burghesi
Agnolus Biczochi magister lignaminis
. . .

Bibliography: Bacci, 1927, p. 62.

12b

ASS, Concistoro, 1589, *Libro della Corona*, fol. 128v.

September–December 1368.

Bonacorso di ser Berto lanaiuolo
Iacopo di frate Mino dipentore
Tomasso di Ceccharello
Bartalo di Iacopo tintore
Bartalo di Duccio lanaiuolo
Giovanni di Mino Del Buono
. . .

El consiglio generale del terzo di kamollia de la gente del popolo del magior numero
Giovanni di Vanino forniere
Lucha di Tome dipentore
. . .

In 1368 the artist's name was registered twice in the *Libro de' Riformatori* from the *terzo* of the Camollia, once as a member of the company of Saint Christopher within that *terzo*.

13

Rieti, Museo Civico, Inv. no. 2. (See Catalogue no. 27.)

1370.

LVCAS·THOME·DE·SENIS·PINSIT·HOC·OPVS·MCCCLXX·[HAEC· TABVLA·FACTA·EST·PRO·ANIMA·ANDREA·PENNELLI·ET· VXORIS·SVAE·DONNAE·VANNE·]

Luca di Tommè signed and dated an altar dedicated to the souls of Andrea and Vanne Pennelli in 1370.

14

Siena, Pinacoteca Nazionale, Inv. no. 586. (See Catalogue no. 32.)

1372–3[?].

. . . THOME . . . OC·OPVS

Luca di Tommè signed an altar.

15

ASS, Concistoro, 2333, *Libro del Leone*, fol. 7v.

July–August 1373.

In nomine Domini amen. Viri magnifici et prudentes cives Senenses infrascripti fuerunt de laudabili offitio dominorum defensorum populi civitatis Senarum in mensibus iulii et agusti currentibus annis ab incarnatione millesimo trecentisimo septuagesimo tertio, inditione .XI., videlicet:
. . .

Lucas Thomme picttor
Thosus Pietri de Marzis
Terzerii Kamollie
Ghuccius ser Salamonis domini Gualterotti Ianista
Francischus Andree dictus Ferraccio calzolarius
Thomassus Iohannis spadarius
Ser Iohannes Stephani Bindi notarius consistorii
Ser Brizius Pauli notarius cancellarius
Ser Iohannes Cechi notarius capitanei
. . .
Nicholaus Buonacursi pictor

Bibliography: Milanesi, 1854, vol. I, p. 28 n. 1.

Luca served as one of the defenders of the people with several other men from the *terzo* of the Camollia for the months of July and August 1373.

16

Perugia, Galleria Nazionale dell'Umbria, Inv. no. 947. (See Catalogue no. 39.)

[1374?]

. . . CAS·THO . . .

Luca signed an altarpiece.

17

AODO, Ivi, Cam. IX, no. XXXVIII.

4 February 1374.

M. Ugolino pictori, quos emit m. Luce Tome pro nomincentis triginta quatuor foleis auri bactuti pro picture tribune maioris ad rationem unius florenis, sex sol. et trium den. pro quolibet centinario —flor. decem.

Bibliography: Fumi, 1898, p. 389.

On February 4, 1374, the artist was paid 10 florins for 934 sheets of gold leaf at the rate of 1 florin, 6 soldi and 3 denari per 100 sheets to be used by Ugolino Ilario for the choir of Orvieto Cathedral.

18a

ASS, Biccherna, 252, *Entrata ed Uscità*, fol. 40v.

26 February 1374.

Exitus diei dominice die .XXVI. februarii ad libr. III. sol.X.flor.
Magistro Luce Tonis pictori pro eius salario unius tabule, que facta fuit ad honorem et reverentiam sancti Pauli apostoli tempore quo comune Senarum conflixit sotietatem Cappel-

luccii, pro eius salario et lignamine, auro et coloribus et portatura dictam tabulam et res alias necessarias circa ad dornamentum ipsius tabule; quod laborerium stimatum fuit per magistrum Iacobum *del Pelliciaio* et Christofanum de Cosona, sufficientes pictores, florenos centum quinque, et sicud obtentum fuit in generali consilio fieri facere dictam tabulam, ut apparet instrumentum manu ser Iohannis Ture reformationum et remissionem factam per dictum consilium generale in dominos, que remissio apparet manu ser Angeli Guidi *del Cotone* tunc notarii consistorii et de hiis habemus appodixam a dominis cum sigillo regolatorum, sine aliqua retentione kabelle ad memorialem fo.183. C Libr. IIILXVII.sol.X.den.0

18b

ASS, Biccherna, 253, *Entrata ed Uscità*, fol. 158r.

26 February 1374.

Escita di domenicha a di .XXVI. di feraio a lir.IIII.sol.X.fior.
A maestro Luca di Tome dipentore per suo salario di una tavola, la quale tavola fu fatta a onore e riverentia di santo Paolo apostolo al tempo che el comuno di Siena e sconfisse la compagnia la quale si chiamò del Capello, per suo salario e legniame e oro e colori e portatura la detta tavola e altre cose nicisarie intorno a la dorneza alla detta tavola; el quale lavoro fu stimato per maestro Iacomo del Pelliciaio e Christofano di Cosona, soficienti dipentori, di fiorini ciento cinque den. e come si prese di fare la detta tavola nel consiglio generale de la campana, come n'apare carta per mano di ser Giovanni di Tura de le riformagioni e rimesione fatta per vighor d'esso consiglio generale, la quale rimesione appare per mano di ser Angnolo di Ghuido del Cotone alora notaio del concistoro, e di ciò aviamo puliza di signori col sugiello de Regholatori al mimoriale fo. 183, senza alchuna retenzione di cabella. C Libr.IIILXVII.sol.X.den.0

Bibliography: Della Valle, 1782, vol. II, p. 119; Milanesi, 1854, vol. I, p. 28 n. 1.

Both documents indicate that on February 26, 1374, Luca di Tommè received from the commune of Siena 105 florins for his labor, expenses for wood, gold leaf, pigments and transportation of an altarpiece dedicated to Saint Paul and commemorating the defeat of the Company of the Hat. The anticipated expenses for the work were determined by Jacopo di Mino del Pelliciaio and Cristofano da Cosona.

19a

ASS, Biccherna, 252, *Entrata ed Uscità*, fol. 24r.

31 May 1374.

Introitus diei mercurii die .XXXI.madii ad libr.III.sol. X.flor.

A magistro lucha Thomme pictore florenos viginti quinque auri, quos denarios fecerunt michi mictere ad introitum regolatores occasione florenorum viginti quinque, quos denarios dare debebat ad librum Pauli Soczi zendadario signatum de uno p.fo.18, ad nostrum memoriale fo.183 et est scriptum ad librum Pauli Buonacorso Pacis sotius dicti magistri Luce. Libr.LXXXVII. sol.X.

19b

ASS, Biccherna, 253, *Entrata ed Uscità*, fol. 77r.

31 May 1374.

Entrata di medezima a di XXXI di magio a libr.III.sol. X.flor.
Da maestro Lucha di Tome dipentore fiorini vinticinque den., quagli denari m'anno fatto metare a entrata e regholatori per chagione di fiorini vinticinque e quagli denari doveva dare a liro di Pauolo di Sozo zondadorio segniato d'uno p. a fo.18, e al nostro mimoriale a fo. 183, e de uno schritto a liro di Pauolo Buonachorsso di Pacie, compagno del detto maestro Lucha. Libr.LXXXVII.sol.X.

Both documents indicate that on May 31, 1374, the artist paid the *Biccherna* of Siena 25 gold florins.

20a

ASS, Gabella dei Contratti, 88, *Memoriale*, fol. 41 (LVII)r.

3 August 1374.

Ser Paulus ser Herrigoli notarius denunptiavit quod die tertio augusti.
Lucas pictor olim Tomme Nuti civis Senensis, populi Sancti Peregrini, recepit in dotem et pro dotibus domine Miglie, uxoris sue quondam Iacobini centum florenos auri. C. florenos auri

Pagho a Giovanni Petri chamarlengo de chomprotori de la detta chabella chome apre al suo li[b]ro de dipositti a fo.62.

Bibliography: Milanesi, 1854, vol. I, p. 28 n. 1.

On August 3, 1374, the notary Ser Paulo Ser Herrigoli drew up a contract for a dowry. Luca di Tommè, a resident of the district of San Pellegrino, received 100 gold florins from his wife Miglie Jacobini. A tax on the dowry was to be paid to Giovanni Petri, the treasurer for the holders of the tax on contracts.

20b

ASS, Gabella dei Contratti, 90, *Memoriale*, fol. 164v.

1 September 1376.

Lucas Tomme pictor solvit Iohanni Petri camerario, pro dotibus .C. florenorum auri cum quinto pluri, quatuor florenos auri, die.I. settembris, ad librum depositorum fo.62. Habuit titulum.

On September 1, 1376, Luca di Tommè paid Giovanni Petri, treasurer for the tax on contracts, 4 gold florins for the dowry he received.

21

ASS, Concistoro, 2333, *Libro del Leone*, fol. 40r.

September–October 1379.

In nomine Domini amen. Infrascripti magnifici et honorandi viri domini fuerunt in et de offitio dominorum defensorum populi et civitatis Senarum de mensibus settembris et ottubris currentibus annis Domini millesimo trecentesimo septuagiesimo nono presenti inditione secunda et presenti inditione tertia, quorum haec sunt nomina, videlicet:
Magister Lucas Tomme pittor
Bartolus Bartolomei . . .
Iohannes domini Farinelle T[erzerii] C[ivitatis]
Bonifatius Cennis . . .
Mattheus Mini Pagliarensis aurifex

Bibliography: Milanesi, 1854, vol. I, p. 28 n. 1.

During September and October, 1379, Luca served as a member of the defenders of the people of Siena with other residents from the *terzo* of the Città.

22a

ASS, Biccherna, 265, *Entrata ed Uscità*, fol. 95r.

31 December 1382.

Entrata detta (di medezima a di 31 di deciembre 1382)
. . .
Da Giovanni di Iacomo Ghianderoni e da maestro Lucha di Tomme depentore e compagni, camarlengho e quattro di bicherna nostri succiessori, fiorini semiglia dugento quarantatre, lire semiglia setteciento otto, soldi quattordici, denari sei; lo significhamo che paghassero a più creditori di Comune; quegli lo significhamo a rischuotare come per partito apare al nostro memoriale a fo.133. mLire.XXVIIII. CCCCLXXXXV.[?], soldi.XIII., denari.VI.

22b

ASS, Biccherna, 429, *Memoriale*, fol. 1r.

1 January 1383.

Al nome sia dello onipotente Dio e de la sua benedetta e santissima madre vergine Maria e di tutti santi e sante de la cielesstiale chorte de rengno di paradiso, e quagli con riverenzia tutti preghiamo che ci chonciedino pacie e honore e che ci donino grazia di fare si in questo mondo che a le nosstri fini ci chonciedino parte nel loro santo rengno di paradiso. Amen.

Quessto libro e el memoriale de la biccherna del comune di Siena nel quale scrivarremo e faremo memoria di tutti devitori e creditori del nosstro tempo del comune di Siena, per tempo di sei mesi cominciati a di primo del mese di gennaio anno MCCCLXXXIII e dee finire a di ultimo del mese di giungno 1383, al tempo de savi huomini.

Giovanni di Iacomo Ghiandaroni chamarlengho
Maestro Lucha di Tomme dipentore
Spinello di Niccoluccio Chodennacci
del terzo di Città
Nani di Petro Giovannini
Domenico d'Andrea Boldoni
del terzo di San Martino
Ghoro di Ghoro Sansedoni
Petro di Giovanni Tenducci lanaiuolo
del terzo di Chamollia
Chamarlengho e quattro provedito[ri] d'essa bicherna per lo detto tempo e Niccholò di Franciesco d'Andrea scrittore per lo sessto suo oficio.
Sessto libro

22c

ASS, Biccherna, 266, *Entrata ed Uscità*, fol. 192 [193]v.

30 June 1383.

Escita detta di martedi a di 30 di giugno 1383
A maestro Lucha di Tomme a Spinello di Niccholuccio a Nanni di Petro Giovannini a Domenico di Andrea Boldroni a Ghoro di Ghoro Sansedoni e a Petro di Giovanni Tenducci quattro di bicherna, fiorini trentasei, netti di cabella, per loro salario de detti sei mesi, a ragione di fiorini l al mese per ciascuno; secondo l'ordine e detti denari demo in loro mani a ciascuno fiorini 6, a uscita detto fo.191. Lire .CXXXIII., soldi 0.

22d

ASS, Biccherna, 267, *Entrata ed Uscità*, fol. 192v.

31 December 1383.

Escita detta de giovedi 31 di decembre 1383
. . .

A Giovanni di Iacomo Ghiandaroni e a maestro Lucha di Tomme e compagni nostri camarlengo e quattro anteciessori, fiorini semiglia trecento vinticinque, lire undicimiglia cinquecento novantadue, soldi dicienove, denari otto, e quagli ci significaro che noi paghassimo a più creditori di comune, come per partito apare al nostro memoriale in due faccie a fo. 44 e fo. 45. m Lire.XXXIII.VIIII. LXXXXV.[?], soldi VIIII, denari VIIII

The four documents indicate that Luca di Tommè served as a leading official of the *Biccherna* representing the *terzo* of the Città from January 1, 1383, until June 30, 1383.

23

ASS, Lire, 20, fol. 9v.

1384.

Terzo di San Martino
Parrocchia di San Pietro alle Schale
Maestro Luca di Tome dipintore 11d.
per uno denaro.

During the year 1384, the artist was required to pay the sum of 1 *denaro*.

24a

AODS, 705, *Libro Nero Dal 1349 al 1404*, fols. 103r–104r.

13 March 1388.

Al nome di Dio amen. 1388
Sia manifessto a chi vedra quessta iscritta, che con ciòsia chosa che a di .XXV. di settembre 1387 Buonsignore di Fazio, oparaio dell'uopara sante Marie di Siena e Bindo di Bartalomeio suo chamarlengho de la detta huopara abino dato affare a Mariano di Angniolo Romanelgli, orafo, cittadino di Siena, tutte le fighure grandi e picchole entranno overo bisogniaranno ne le testiere et tabernacogli; aviamo date a fare i[n] questo di a maestro Iacomo del maestro Franciescho del Tonghio, le quali testiere e tabernacogli si debbono fare nel coro nuovo di duomo, con questi patti e condizioni.
. . .

VIIII. Qui di sotto so'nomi de consiglieri.
Maestro Neri Ranuccioli de legniame
Maestro Lucha di Tomme dipentore
Maestro Iachomo di Castello del vetro
Francieschi di Vannuccio de la Vaccha
Crisstofano del Maestro Bindoccio dipentore
Maestro Iacomo del Pellicciaio dipentore
Pietro di Bandino orafo
Maestro Martino de la pietra
Giovanni di Iacomo, detto Giovanni d'Ongaria, dipentore
Maestro Bertino di Pietro de la graticole

Nanni di Cicchia de legniame
Pavolo di Giovanni Fei dipentore
Maestro Lucha di Giovanni de legniame
Giusaffa di Filippo dipentore
. . .

Ed io Mariano d'Angniolo Romanelgli so'contento alla so-pradetta iscritta de sopra e aloghagione, com'e iscritto qui di mano di Domenicho Venturini al presente camarlengho e cosi prometto pienamente d'oservare eccetera. A di 18 di marzo anno 1388.

Bibliography: Milanesi, 1854, vol. I, pp. 363–68.

Under the date March 13, 1388, the terms of a competition for the making of stalls and tabernacles for the choir of the cathedral were announced. The two contestants were Mariano di Agnolo Romanelli, a Sienese goldsmith, and Jacomo di Francesco del Tognio. Each was to submit designs by June 13, which were to be judged by a committee of 15 artisans together with the cathedral authorities. Luca di Tommè was among the councillors chosen. The results of the vote were given and Mariano's scheme was selected over Jacomo's. The terms of the contract by which Mariano was to work were precisely established. The artist was to be given 30 months to complete the work and paid at the rate of 30 gold florins for each stall completed with an additional allowance for the painting of each. The design of the initial proposal was to be scrupulously adhered to and the selection of appropriate decorative figures and scenes was to be left to the discretion of the artist with the exception of the figures of Saints Peter and Paul and the four patron saints of Siena, Ansanus, Crescentius, Savino and Victor, which were specifically stipulated. In addition the contract called for twelve scenes of the Credo to be included.

24b

AODS, 640, *Memoriale*, fol. 9r.

13 June 1388.

Memoria che sabbato adi .XIII. di giugnio Buonsignore di Fazio, operaio, tenne uno consiglio del duomo, di volere di maestro Iacomo del Tonchio e di Mariano d'Angnolo, e ine propose l'operaio dinanzi agl'infrascritti di sotto e dimandò a loro consiglio; avendo udito maestro Iacomo e Mariano detti, come dovessero fare le testiere grandi e picole dinanzi al coro nuovo, e come dovessero essere fatte. E veduto el disengnio di maestro Iacomo in tavole diliberaro e partiro quale disengnio più lo piacesse.
Prima partiro se lo piacesse el disengniamento di Mariano; ricolto el partito, furo quindici lupini bianchi tutti di concordia senza niuno ischordante.
Secondo partiro se lo piacesse el disengnio di maestro Iacomo; ricolto el partito, che ebe uno lupino bianco, e quattordici lupini neri.

Questi so'nomi de consiglieri.
 Crisstofano del maestro Bindoccio dipentore
 Maestro Neri di Ranucciuoli di legniame
 Maestro Lucha di Tomme dipentore
 Francischo di Vannuccio de la Vaccha
 Maestro Iacomo di Castello del vetro
 Maestro Barna di Turino de legniame
 Pietro di Bandino orafo
 Maestro Iacomo del Pelicciaio dipentore
 Nanni di Iacomo dipentore
 Maestro Bertino di Pietro fa le graticole e uriuoli
 Maestro Giovanni del Chichia de legniame
 Pavolo di Giovanni Fei dipentore
 Maestro Lucha di Giovanni de legniame
 Maestro Lartino del maestro Luca de la pietra
 Giusaffa di Filippo dipentore

Bibliography: Milanesi, 1854, vol. I, p. 354.

On June 13, 1388, Buonsignore di Fazio sought the counsel of 15 men among whom was Luca di Tommè. These painters, carpenters, stone and stained glass workers were to select one of two designs proposed for the stalls for the new choir in the Siena Cathedral. The competition was between Mariano di Agnolo Romanelli, a Sienese goldsmith, and Jacomo Francesco del Tognio, and a vote was taken on each of the plans presented. Mariano's was accepted by a vote of 15 for and none against, while Jacomo's was rejected by a vote of 1 for and 14 against.

25a

AODS, 705, *Libro Nero dal 1349 al 1404*, fol. 89r.

21 August 1386.

Anno .MCCCLXXXVI.
Memoria che a dì .XXI. d'agosto anno sopra detto io Buonsignore di Fazio Pichogliuomini, operaio de l'uopera Sante Marie, Simone di Nicholò chamarlengho, Ventura d'Andrea, Buonaventura di Latinuccio de' Rossi e Pietro di Bartolomeo Chonsiglieri de la sopra detta uopera, faciemo composizione e patto con l'università de chalzolari di cierte chose che l'uopera è tenuta a far a loro ed eglino a l'uopera. In prima che l'uopera è tenuta di dare a la sopradetta università un luogho ne le sue chase, la due la sopradetta università si possa ragunare per fare el loro rettore in loro chonsiglio. Anco è tenuta la sopra detta uopera a darlo una chappella, cioè quella che si chiama la chappella di santa Gniesa e achonciarla di muro e di scialbo, chome sta quella di sotto e lato a essa, cioè quella de' Malavolti. E la sopradetta università è tenuta e deba ogni anno in perpetuo offerrire a la sopra detta chappella, ne la festa di sancta Maria di settembre, un ciero per uno si veramente che de la sopra detta offerta deba rimanere a la sopra detta Huopera cinquanta livre di ciera, e de risiduo de la sopra detta offerta deba pervenire a le mani del chamarlengo de la sopradetta università, si veramente ch'el sopra detto chamarlengho deba ogni anno spendere tutto e risiduo de la sopra detta offerta in achoncio et in adorno de la sopra detta chappella; e che l'operaio e chamarlengho de la

sopradetta uopera deba ogni anno rivedere la ragione del cha-
marlengho de la sopra detta università, se degli à speso el so-
pra detto risiduo in achoncime e in adorno de la sopradetta
chappella. Di questo n'apare charta per mano di ser Francie-
scho di ser Bartalomeo Ciogli, nel di e anno scritto di sopra.
Fattone ricordamento a libro rosso a fo. 8
[In the margin]: Misser Matteo rettore di Santo Antonio
chalonacho del duomo.
Pacti et composizioni che ha l'uopera co' l'università dell'arte
de' chalzolari.

Bibliography: Lusini, 1911, vol. I, p. 320 n. 67.

On August 21, 1386, the Siena Cathedral authorities
allocated the shoemaker's guild the chapel of Saint
Agnes in the fabric of the cathedral. In exchange the
guild was obligated to provide 50 pounds of wax to the
cathedral in perpetuity on the Feast of the Virgin in
September. They were to adorn the chapel at their own
expense. This agreement was subject to review each
year.

25b

AODS, 640, *Memoriale*, fol. 89v.

23 April 1389.

Memoria che addi 23 d'aprile Buonsignore di Fazio operaio
e missere Cristofano Cieretani e Bernardino di Franciescho e
Taddeo di Bartolo suoi consiglieri deliberaro e furo di con-
cordia che a volontà de'rettori de'calzolai promettesi in fino
la quantità di 130 fiorini d'oro al dipignitore a chui aloga-
ranno la loro tavola de la loro chapella di Duomo e pagarli a
cierti temini, e iscriversi essa promessa nel libro nero de l'uo-
para, si veramente e calzolari s'ubrigassono ongni anno di
rendere XII. fiorini d'oro o più de la loro offerta, oltre a
quella offerta deba avere l'uopara, come partitamente sara
inscritto nel libro nero. Meso a libro nero a fo. 108 per di 25
d'aprile, presente l'operaio.

On April 23, 1389, Buonsignore di Fazio, together
with Cristofano Cieretani, Bernardo di Francesco and
Taddeo di Bartolo met and concurred with the desire
of the rectors of the shoemaker's guild that the sum of
130 gold florins be promised to the painters selected by
the guild for the making of the altarpiece for their
chapel in the cathedral. The cathedral authorities were
to advance the funds for the project, and the guild was
obligated to repay the cathedral at least 12 gold florins
annually over and above their yearly offering already
established.

25c

AODS, 705, *Libro Nero dal 1349 al 1404*, fol. 108v.

25 April 1389.
8 December 1389.

Al nome di Dio amen. 1389.

Sia manifesto a chi vedrà questa iscritta che a di .XXV.
d'Aprile 1389 che Buonsignore di Fazio, operaio de l'uopare
Sancte Marie e suoi consiglieri, assente Iacomo di Conte Ar-
malei, diliberaro di concordia che per onore e per adorno de
la chiesa di duomo, che con ciò sia cosa che l'università de
l'arte de chalzolari anno per lloro riverenzia fatta una cappella
in duomo e sossi ubrigati a l'uopare, come appare in questo
libro indietro affo. 89. Ora al presente vogliono far fare, cioè
dipengniare, la tavola d'essa cappella; à diliberato l'operaio
essuo consiglio, come di sopra è detto, che la detta università
de' calzolari e l'uopare Sancte Marie prometti a dipentori che
fanno essa tavola ciento trenta fiorini in quatro paghe, cioè in
questo modo: trenta e due fiorini e mezo di darli per questo
mese di settembre 1389 e poi l'altre tre paghe di quatro mesi
in quatro mesi, come veranno. E cosi sia tenuto l'operaio e
camarlengo che so'al presente e per li timpi saranno pagare
come detto. E l'università de' calzolari promette a la detta
uopare Sante Marie rendare e restituire e detti ciento trenta
fiorini in questo modo: che in calende settembre prosimo che
viene, per la festa di Santa Maria, darà dodici fiorini o più se
montarà la loro ciera de l'offerte che faranno a loro, avendo
auta l'uopara la sua parte, come stanno e patti a fo.89, ch'essi
patti non si rinovano di niuana cosa. E se la loro ciera di la
loro parte montasse più, debbano dare e dodici fiorini per la
detta festa, e cosi ogni anno debbono dare e detti dodici fio-
rini insino abbino pagati e detti ciento trenta fiorini. E cosi la
detta università de' calzolari s'ubrigano a l'uopare di pagare
carta per mano di ser Giovanni di ser Pierino da Siena notaio,
di volere del loro consiglio e in presenzia di Domenico di
Pietro del Terzo di Città e di Giovanni di Neri del Terzo di
San Martino e di Bartalo di Vannino del Terzo di Camollia,
calzolari rettori de la detta università de' calzolari, e di Ia-
como calzolaio loro chamarlengo. E detti rettori e loro cha-
marlengho diliberaro questo di promettessimo per loro e
detti ciento trenta fiorini a maestro Luca di Tomme e a mae-
stro Bartalo del maestro Fredi e Andrea suo figliuolo, dipen-
tori, e so' posti debbino avere inanzi a fo. 109. E cosi si mette
fuori la somma di questo foglio; l'università de' calzolari de-
bono dare e detti 130 fiorini, iscrito per me Domenico Ven-
turini camarlengo de l'uopare el detto di ed anno di sopra
iscritto, di volere de l'operaio e del suo consiglio et in presen-
zia de' detti rettori e camarlengho de' calzolari . . . CXXX.
fiorini

Annone dati esso di di sopra iscritto otto fiorini. Giovanni di
Ciecho calzolaio detto pagha a me Domenico Venturini ca-
marlengo de l'uopare a mia entrata a fo.14., e quali diè a
maestro Luca dipentore e compagni, apare a fo. 109. E detti
otto fiorini pregiudicano che calzolari debano dare ogni anno
e detti XII. fiorini di sopra per la festa detta, insino abino
pagata la somma di 130 fiorini. . . . VIII. fiorini

Annone date a di 8 di diciembre fiorini 12. E diè Giovanni
soprascritto a me . . . d'Agustino camarlengo, come apare
al mio memoriale, a mia entrata fo.4 nel 1389 . . . fiorini
XII.

Bibliography: Lusini, 1911, vol. I, p. 320 n. 67.

On April 25, 1389, the terms established two days pre-
viously among the cathedral, the guild and the painters

were reiterated but in greater detail. The names of the rectors of the guild together with their treasurer were included. The names of the painters Luca di Tommè, Bartolo di Fredi and Andrea di Bartolo were also cited. It was agreed that 8 gold florins be paid immediately to the artists.

25d

AODS, 705, *Libro Nero dal 1349 al 1404*, fol. 109r.

25 April 1389.
8 December 1389.

Maestro Luca di Tomme et maestro Bartalo del maestro Fredi et Andrea suo figliuolo, dipentori, dieno avere a di 25 aprile 1389, ciento trenta fiorini d'oro, in questo modo e termini: ora al presente otto fiorini d'oro e per Santa Maria di settembre prossima che viene, vinti e quattro fiorini d'oro e mezo, e poi de la detta festa a .IIII. mesi debba avere trenta e due fiorini d'oro e mezo; e cosi l'altre due paghe di .IIII. mesi in quattro mesi, 32 fiorini d'oro e mezo, che sarà la somma 130 fiorini d'oro. E questi denari lo promettemmo per l'università de calzolari, per una tavola debbono dipengniare, de la loro capella di duomo. Apare e chalzolari debono dare, indietro, in questo libro, a la composizione fatta col loro a fo.108, iscritto per me Domenico Venturini camarlengo de l'uopara di volere de l'operaio e suo conconsiglio. Annone auti a di detto di sopra otto fiorini d'oro in loro mani di tutti e tre contanti, otto fiorini d'oro. diei io Domenico Venturini e so' messi a mia iscita a foVIII. fiorini d'oro

E annone auti a di 8 di dicembre 1389 fiorini vinticinque d'oro; portò Nani nostro e de' contanti a maestro Lucha e a maestro Bartalo. . . . XXV. fiorini d'oro

Bibliography: Milanesi, 1854, vol. II, p. 36n.

The terms of payment for the altar itself were established by the cathedral authorities. Luca and his colleagues were to receive eight gold florins at once; on the Feast of the Virgin in September, 1389, 24½ gold florins were to be advanced; four months later 32½ gold florins were to be paid; subsequently, two more payments each of 32½ gold florins were to be rendered at four-month intervals.

25e

AODS, 369, *Entrata ed Uscità*, fol. 52v.

25 April 1389.

A maestro Lucha di Tomme e maestro Bartalo del maestro Fredi e Andrea suo figliuolo dipentori che fano la tavola de la università de chalzolari a di 8 di dice[m]bre fiorini vinticinque den., portò Nani nostro e di volontà degli altri a mano di maestro Lucha e di maestro Bartalo sopradetti,

chome al mio memoriale fo. 23 posti a libro nero fo. 109. Fior.XXV.

Bibliography: Borghesi and Banchi, 1898, p. 28n; Lusini, 1911, vol. I, p. 321 n. 70.

It was noted on April 25, 1389, that Luca, Bartolo and Andrea were to receive 25 gold florins on December 8 of the same year.

25f

AODS, 368, *Entrata ed Uscità*, fol. 162r.

25 April 1389.

A maestro Luca di Tomme e a maestro Bartolo del maestro Fredi e Andrea suo figliuolo dipentori, a di 25 d'aprile, otto fiorini per parte de la promessa lo fecie l'uopara per la tavola dipengono de l'arte de calzolari e so posti a loro ragione a libro nero a fo.109, apare al mio memoriale a fo. 90 .VIII.fiorini, o lire, o soldi, o den.

Bibliography: Lusini, 1911, vol. I, p. 321 n. 70.

A record was made on April 25 that 8 gold florins were paid on account to Luca di Tommè, Bartolo di Fredi, and Andrea di Bartolo toward the altarpiece for the shoemaker's guild.

25g

AODS, 640, *Memoriale*, fol. 90r.

25 April 1389.

Giovanni di Ciccho detto Palglia calzolaio die avere a di 25 d'aprile otto fiorini di oro, disse gli desimo per l'università de calzolari a mestro Luca e compagni dipentori dipengono la loro tavula de la loro cappella. .VIII.fiorini den.

Annone auti esso di otto fiorini, gli ponemo a la ragione de calzolari a la composizione fatta col loro come appare a libro nero a fo. 108 e so messe a entrata a fo. 14. .VIII.fiorini den.

Maestro Luca di Tome e compagni dipentori dieno dare a di 25 d'aprile, ebero contanti in loro mano tutti ettre presenti otto fiorini per fare la tavola de calzolari .VIII. fiorini den.

Annone dati esso di, chesso possti al loro ragione al libro nero a fo.109, otto fiorini e messe a scita a fo. 162. .VIII. fiorini den.

Bibliography: Milanesi, 1854, vol. I, pp. 28–29n.

A further record of the payment of 8 gold florins to Luca and his colleagues for the shoemaker's altarpiece was made.

26

ASS, Arte, 59, *Breve dell'Arte de' Pittori Senesi*, fols. 23v, 24r.

1389.

...

Jacomo di frate Mino
Lucha di Tome
Fede di Nalduccio
Bartalo di maestro Fredi

...

Bibliography: Della Valle, 1782, vol. I, p. 158; Gaye, 1839, vol. I, p. 29; Milanesi, 1854, vol. I, pp. 1–56; Manzoni, 1904, p. 109; Bacci, 1927, p. 56; Fehm, 1972, p. 198.

In 1389, the artist's name was enrolled following the statutes of the Sienese painter's guild together with those of several colleagues.

27

ASS, Lira, 24, fol. 80r.

1390.

Terzo di Kamollia, contrada di Sant'Andrea Maesstro Luca di Tomme dipentore a 3 ricci fol. 363 ii den.

During 1390, Luca paid the sum of 2 *denari* to the commune of Siena. At the time he was a member of the district of Sant'Andrea in the *terzo* of the Camollia.

28

ASS, *Diplomatica* (Spedale Santa Maria della Scala)

5 May 1390.

In nomine Domini amen. Anno eiusdem Domini ab eius incarnatione millesimo trecentesimo nonagesimo, indictione tertia decima secundum ritum, mores et consuetudinem notariorum civitatis Senarum, die quinta mensis maii, tempore pontificatus sanctiximi in Christo patris et domini domini Bonifatii divina providentia pape noni, Romanorum imperatire vacante. Pateat omnibus manifeste hoc presens testamentum publicum inspecturis, quod vir prudens Marchus quondam Bindi Gini, mercator de Senis, populi Sancti Iohannis, terzerii Civitatis, in contrata Vallis Piatte, per gratiam Domini nostri Iesu Christi sanus mente, corpore et intellectu, se quandoque moriturum considerans, diem mortis nesciens neque horam, que sunt solum a Deo nota, cuius evenctus mortis nil certius et nil incertius hors eius, unde sempre vigilare opportet ne, cum Dominus noster venerit, nos non dormientes sed inveniat vigilantes; queve considerans diligenter dictus Marcus, volensque dum lucem habet ambulare et saluti anime sue super omnia diligende providere, bonaque sua disponere per presens nuncupativum testamentum, quod dicitur sine scripturis, in hunc modum providere et facere procuravit.

Imprimis quidem animam suam creatori suo devotixime commendavit, ipsum rogans tenerissime quod sui misereatur maximi peccatoris, iudicans corpus suum sepelliendum ab anima segregatum apud locum fratrum Minorum de Senis, sive prope Senis, in suo tumulo existente in sua cappella quam fieri fecit ipse testator in Ecclesia nova convenctus dictorum fratrum Minorum. Item iudicavit et reliquid domino Senensi episcopo pro sua canonica portoni viginti soldos denariorum et plus de suo non possit petere vel habere.

Item iudicavit ed reliquid, voluit et mandavit quod per infrascriptos suos heredes vel suos fideicommissarios expleatur et expleri faciant, teneantur et debeant ipsi sui heredes vel fideicommissarii dictam suam cappellam, quam fieri fecit ut dictum est, de quadam tabula pro dicta cappella, que ad presens pingitur pro altari ipsius cappelle et quam pingere facit ipse testator a magistro Luca pictore. Ac etiam teneantur et debeant dicti infrascripti sui heredes vel fideicommissarii fulciri et facere dictum altarem dicte sue cappelle uno paramento fulcito omnibus, opportunis costi et valoris quadraginta florenorum auri. Nec non fulciant dictum altare tovaglis et aliis opportunis, valoris et costi viginti florenorum auri.

...

Factum et conditum fuit dictum testamentum per dictum Marcum Bindi testatorem in domo sua, in et super quadam loggia superiori dicte domus site Senis in populo Sancti Iohannis, in contrata Valle Piate, cui ante et retro via, ex alio Iacobi et Nicholai ser Francisci Bruni et ex alio Luce Berti, coram Sano Machi sensario, Symone Nicholi cartario et Iohanne Francisci de Rossis, omnibus de Senis, testibus presentibus et a dicto testatore et me notario infrascripto rogatis.

...

(S.T.) Ego Cristoforus quondam Gani Guidini de Senis, imperiali auctoritate notarius et iudex ordinarius condictioni dicti testamenti et dictorum chodicillorum et omnibus et singulis suprascriptis interfui et ea rogatus a dicto testatore scripsi et publicavi.

Bibliography: Lisini, 1927, p. 303.

On May 5, 1390, Marco Bindi Gini, a Sienese merchant from the district of San Giovanni in the *terzo* of the Città, made his last will and testament. He wished to be buried in his chapel in the new Franciscan church in Siena. Further he provided 40 gold florins for an altarpiece for this chapel to be executed by Luca di Tommè.

Bibliography

Books and Articles

Aldenhoven, G., and Schaeger, K. *Geschichte der Kölner Malerschule*. Lubeck, 1923.

Antal, F. *Florentine Painting and Its Social Background*. London, 1947.

Antiquarian, The XIV (1931).

Ardinghi, G., *La Provincia di Lucca*. Lucca, 1965.

Artistic Guide to Siena. Florence, 1911.

Aurenhammer, H. *Lexikon der Christlichen Ikonographie*. Vienna, 1959.

Bacci, P. "Una tavola inedita e sconosciuta di Luca di Tommè con alcuni ignorati documenti della sua vita." *Rassegna d'arte senese e del costume* I (1927): 51–62.

———. "La Regia Pinacoteca di Siena." *Bollettino d'arte* T. 26 (1932): 177–200.

———. *Dipinti inediti e sconosciuti di Pietro Lorenzetti, Bernardo Daddi, etc.* Siena, 1939.

———. "L'Elenco delle pitture, sculture e architetture di Siena compilato nel 1625–26 da Mons. Fabio Chigi poi Alessandro VII." *Bollettino Senese di Storia Patria* X (1939): 197–213 and 297–337.

———. *Fonti e commenti per la storia dell'arte senese*. Siena, 1944.

Bargagli-Petrucci, F. *Montepulciano, Chiusi e la Val di Chiana Senese*. Bergamo, 1907.

———. *Pienza, Montalcino, la Val d'Orcia Senese*. 1st ed. Bergamo, 1911.

———. *Pienza, Montalcino e la Val d'Orcia*. 2nd ed. Bergamo, 1933.

Battisti, E. *Cimabue*. University Park, Pennsylvania, 1967.

Becker, F. *Herzoglich Sachsen-Altenburgisches Museum (Lindenau-Stiftung), Beschreibender Katalog der Gemäldesammlung*. Altenburg, 1898.

———. *Herzoglich Sachsen-Altenburgisches Museum (Lindenau-Stiftung), Beschreibender Katalog der alten Originalgemälde, Revidierter Neudruck des Katalogs von 1898*. Altenburg, 1915.

Bellini-Pietri, A. *Guida di Pisa*. Florence, 1923.

———. *Catalogo Museo Civico di Pisa*. Pisa, 1926.

Bellosi, L. "Jacopo di Mino del Pellicciaio." *Bollettino d'Arte* LVII (1972): 73–77.

Bellucci, A. *Notizie d'arte da un libro dei conti del Convento di S. Domenico di Rieti in Umbria*. Estratto, 1901.

Bennett, B., "Lippo Memmi, Simone Martini's 'Fratello in Arte': the Image Revealed by His Documented Works." Ph.D. diss., University of Pittsburgh, 1977.

Berenson, B. *The Central Italian Painters*. 1st ed. London, 1897.

———. *The Central Italian Painters*. 2nd ed. London, 1909.

———. "Due nuovi dipinti di Lippo Vanni." *Rassegna d'arte* XVII (1917): 97–100.

———. "Quadri senza casa. Il Trecento Senese." *Dedalo* XI (1930): 263–84 and 329–62.

———. "Missing Pictures of the Sienese Trecento." *International Studio* 97 (1930): October 1931, 31–35, January 1931, 29–35.

———. *Italian Pictures of the Renaissance*. Oxford, 1932.

———. *Pitture Italiane del Rinascimento*. Spoleto, 1936.

———. *Italian Pictures of the Renaissance: Central Italian and Northern Italian Schools*. London, 1968.

Biblia Sacra, Juxta Vulgatum Clementinam. Rome, 1947.

Bologna, F. "Due dipinti di Niccolò Tegliacci." *Paragone* 35 (1952): 37–40.

———. *Simone Martini, Affreschi di Assisi*. Milan, 1968.

———. *Novità su Giotto*. Turin, 1969.

Bonaini, F. *Memorie inedite interno alla vita e ai dipinti di Francesco Traini*. Pisa, 1846.

Borghesi, S., and Banchi, L. *Nuovi documenti per la storia dell'arte senese*. Siena, 1898.

Borsook, E. "The Frescoes at San Leonardo al Lago." *Burlington Magazine* XCVIII (1956): 351–58.

———. *The Mural Painters of Tuscany*. London, 1960.

———. *Ambrogio Lorenzetti*. Florence, 1966.

———. *Gli affreschi di Montesiepi*. Florence, 1969.

Boschetto, A. *La Collezione Roberto Longhi*. Florence, 1972.

Boskovits, M. *Early Italian Panel Paintings*. Budapest, 1966.

———. "Ancora su Spinello: Proposte e inediti." *Antichità viva* V (1966): 23–28.

———. *Giovanni da Milano*. Florence, 1966.

———. "Orcagna in 1357—and in Other Times." *Burlington Magazine* CXIII (1971): 244–47.

———. "Cennino Cennini—Pittore Nonconformista." *Mitteilungen des Kunsthistorischen Institutes in Florenz* XVII (1973): 201–22.

———. Mojzer, M., and Mucsi, A. *Christian Art in Hungary: Collections from the Esztergom Christian Museum*. Budapest, 1965.

Bowsky, W. "The Sienese Archive and the *Pubblicazioni degli Archivi di Stato.*" *Manuscripta* V (1961): 67–77.

————. "Ferdinand Schevill and the History of Mediaeval Siena: A Critical Essay." Introduction to *Siena*, by F. Schevill, viii–xxxviii. New York, 1964.

————. "The Impact of the Black Death upon Sienese Government and Society." *Speculum* XXXIX (1964): 1–34.

————. *The Finance of the Commune of Siena, 1287–1355* Oxford, 1970.

————. *The Black Death: A Turning Point in History.* New York, 1971.

Brandi, C. "Una crocifissione inedita di Luca di Tommè a Montepulciano." *Bollettino senese di storia patria* II (1931): 17–18.

————. "Niccolò di ser Sozzo Tegliacci." *L'Arte* II (1932): 222–36.

————. *La Regia Pinacoteca di Siena.* Rome, 1933.

————. *Duccio.* Milan, 1951.

Braunfels, W. *Die heilige Dreifaltigkeit.* Düsseldorf, 1954.

————. *Mittelalterliche Stadbaukunst in der Toscana.* 2d ed. Berlin, 1959.

Brigidi, E. *La nuova guida di Siena e de' suoi dintorni.* Siena, 1922.

Brogi, F. *Inventario generale degli oggetti d'arte della provincia di Siena.* Siena, 1897.

Bucci, M. "Proposte per Niccolò di ser Sozzo Tegliacci." *Paragone* 16 (1965): 51–60.

Bulletin of the Associates in Fine Arts at Yale University XV (1946).

Burlington Magazine LXXXXIX (1957): 176.

Bush, L. "Bartolo di Fredi." Ph.D. diss., Columbia University, 1947.

California Arts and Architecture (1931): 8.

Cämmerer-George, M. *Die Rahmung der toskanischen Alterbilder im Trecento.* Strasbourg, 1966.

Carli, E. "La data degli affreschi di Bartolo di Fredi a San Gimignano." *Critica d'arte* VIII (1949): 75–76.

————. *La tavolette di Biccherna.* Florence, 1950.

————. *Dipinti senesi del contrado e della maremma.* Milan, 1955.

————. *La pittura senese.* Milan, 1955.

————. "Recent Discoveries in Sienese Paintings of the Thirteenth and Fourteenth Centuries." *The Connoisseur* CXXXVI (1955): 176–83.

————. *Vetrata duccesca.* Milan, 1956.

————. *Guida della Pinacoteca di Siena.* Milan, 1958.

————. *Duccio.* Milan, 1959.

————. *Pittura pisana del Trecento.* 2 vols. Milan, 1961.

————. *Musei Senesi.* Novara, 1961.

————, ed. *Arte senese nella Maremma grossetana.* Exhibition Catalogue. Grosseto: Museo d'arte Sacra, 1964.

————. *Bartolo di Fredi a Paganico.* Florence, 1968.

————. *Pittori Senesi.* Milan, 1971.

————. *Lippo Vanni a San Leonardo al Lago.* Florence, 1971.

————. *Montalcino.* Bologna, 1972.

Catalogo della Galleria del Regia Istituto di Belle Arti di Siena. Siena, 1860.

Catalogo della Galleria del Regia Istituto Provinciale di Belle Arti di Siena. Siena, 1864.

————. Siena, 1872.

Catalogo della Galleria del Regia Istituto Provinciale di Belle Arti in Siena. Siena, 1895.

————. Siena, 1903.

————. Siena, 1909.

Catalogue, The National Trust, Polesden Lacey. London, 1950.

————. London, 1960.

————. 2nd ed. London, 1964.

Cavalcaselle, G. B., and Morelli, G. "Catalogo delle opere d'arte nelle Marche e nell'Umbria," *Le Gallerie Nazionali Italiane* II (1896): 191–349.

Cecchi, E. *Les Peintres Siennois.* Paris, 1928.

————. *I Trecentisti Senesi.* Rome, 1928.

————. *Pietro Lorenzetti.* Milan, 1930.

Cecchini, G. Review of Meiss, M., *Painting in Florence and Siena after the Black Death.* *Bollettino Senese di Storia Patria* LX (1953): 277–79.

————. *Foligno, Bevagna, Cannara, Montefalco, Nocera, Spello, Trevi.* Foligno, 1958.

Charland, P. *Madame Sainte Anne et son culte au Moyen-Age.* Quebec, 1911.

————. *Le culte de Sainte Anne en Occident.* Quebec, 1921.

Chelazzi Dini, G. *Jacopo della Quercia fra Gotico e Rinascimento.* Florence, 1975.

Colasanti, A. *Italian Painting of the Quattrocento in the Marches.* Perugia, 1932.

Cole, B. *Sienese Painting from Its Origins to the Fifteenth Century.* New York, 1980.

Coletti, L. *I Primitivi.* 3 vols. Bergamo, 1947.

Comstock, H. "Luca di Tommè in American Collections." *International Studio* 89 (1928): 57–62.

————. "The Yale Collection of Italian Paintings." *The Connoisseur* CXVIII (1946): 45–52.

Cooper, F. "A Reconstruction of Duccio's *Maestà.*" *The Art Bulletin* XLVII (1965): 155–72.

Corpus Scriptorum Ecclesiasticorum Latinorum. See Hanslik.

Crowe, J. A., and Cavalcaselle, G. B. *A New History of Italian Painting.* 2 vols. London, 1864.

————. *A History of Painting in Italy.* 6 vols. Vol. 3, *Umbria, Florence, and Siena from the Second to the Sixteenth Century.* L. Douglas, ed. London, 1908.

Dalli Regoli, G. *Miniatura Pisana del Trecento.* Vicenza, 1963.

Dami, L. *Siena e le sue opere d'arte.* Florence, 1915.

————. *La Galleria di Siena.* Florence, 1924.

Davenport, W. *Art Treasures in the West.* Menlo Park, 1966.

De Angelis, L. *Ragguaglio del Nuovo Istituto delle Belle Arti Stabilito in Siena.* Siena, 1816.

De Benedictis, C. "Sull'attività giovanile di Niccolò Tegliacci." *Paragone* 291 (1974): 51–61.

————. "Per il catalogo di Niccolò Tegliacci." *Paragone* 311 (1974): 74–76.

————. "I Corali di San Gimignano—Le miniature di Niccolò Tegliacci." *Paragone* 313 (1976): 103–20.

————. "I Corali di San Gimignano—Il secondo miniatore." *Paragone* 315 (1976): 87–95.

————. "I Corali di San Gimignano—Le miniature di Lippo Vanni." *Paragone* 321 (1976): 67–78.

————. *La pittura senese 1330–1370.* Florence, 1979.

Della Valle, G. *Lettere senese.* 3 vols. Rome, 1786.

Denny, D. "Simone Martini's *The Holy Family*," *Journal of the Warburg and Courtauld Institutes* XXX (1967): 138–49.

DeWald, E. "Pietro Lorenzetti." *Art Studies* VII (1929): 131–66.

————. *Pietro Lorenzetti.* Cambridge, 1930.

Donati, P. *Taddeo Gaddi.* Florence, 1966.

Douglas, R. *A History of Siena.* London, 1902.

Earp, F. *A Descriptive Catalogue of the Pictures in the Fitzwilliam Museum.* Cambridge, 1902.

Edgell, G. H. *A History of Sienese Painting.* New York, 1932.

European Paintings in the Collection of the Putnam Foundation, Timken Art Gallery, Balboa Park, San Diego, California. San Diego, 1977.

Faison, S. "Barna and Bartolo di Fredi." *The Art Bulletin* XIV (1932): 285–315.

Faluschi, F. *Breve relazione delle cose notabili della città di Siena.* Siena, 1815.

Fattorusso, G. *Wonders of Italy.* Florence, 1930.

Fehm, S. "A Pair of Panels by the Master of Città di Castello and a Reconstruction of Their Original Altarpiece." *Yale University Art Gallery Bulletin* XXXI (1967): 14–27.

————. "Notes on the Exhibition of Sienese Paintings from Dutch Collections." *Burlington Magazine* CXI (1969): 574–77.

————. "Luca di Tommè." Ph.D. diss., Yale University, 1971.

————. "Notes on the Statutes of the Sienese Painters Guild." *The Art Bulletin* LIV (1972): 198–200.

————. *The Collaboration of Niccolò Tegliacci and Luca di Tommè.* Malibu, Calif., 1973.

————. "A Reconstruction of an Altarpiece by Luca di Tommè." *Burlington Magazine* CXV (1973): 463–64.

————. "Luca di Tommè's Influence on Three Sienese Masters: The Master of the Magdalen Legend, The Master of the Panzano Triptych, and the Master of the Pietà." *Mitteilungen des Kunsthistorischen Institutes in Florenz* XX (1976): 333–50.

————. "Attributional Problems Surrounding Luca di Tommè." In *Essays Presented to Myron P. Gilmore*, Vol. 2, 155–165. Florence, 1978.

Feldges-Henning, U. "A Pictorial Programme of the Sala della Pace: a New Interpretation." *Journal of the Warburg and Courtauld Institutes* XXXV (1972): 145–62.

Francastel, G. "Simone Martini, interprète de la politique française en Italie." *L'Arte* V (1969): 41–54.

Franchi, A. "Di alcuni recenti acquisti della Pinacoteca di Belle Arti di Siena." *Rassegna d'arte senese* II (1906): 111–17.

————. "Di altri recenti acquisti della Pinacoteca di Belle Arti." *Rassegna d'arte senese* III (1907): 103–4.

Francia, A. *Pinacoteca Vaticana.* Milan, 1960.

Frankfurter, A. "Fine Italian Paintings from the Kress Exhibition." *Art News* 32 (March 3, 1934): 8–9.

Fredericksen, B. *Catalogue of the Paintings in the J. Paul Getty Museum.* Malibu, Calif., 1972.

————, and Zeri, F. *Census of Pre-Nineteenth Century Italian Paintings in North American Public Collections.* Cambridge, Mass., 1972.

Friedman, H. *The Symbolic Goldfinch.* Washington, D. C., 1946.

Fumi, L. *Il Duomo di Orvieto e i suoi restauri.* Rome, 1898.

Gardner, J. "S. Paolo fuori le Mura, Nicholas III and Pietro Cavallini." *Zeitschrift für Kunstgeschichte* XXXIV (1971): 240–48.

————. "The Decoration of the Baroncelli Chapel in Santa Croce." *Zeitschrift für Kunstgeschichte* XXXIV (1971): 89–114.

————. "Pope Nicholas IV and the Decoration of Santa Maria Maggiore." *Zeitschrift für Kunstgeschichte* XXXVI (1973): 6–35.

————. "Copies of Roman Mosaics in Edinburgh." *Burlington Magazine* CXV (1973): 583–91.

Gaye, G. *Carteggio inedito d'artisti dei secoli XIV, XV, XVI.* Florence, 1839.

Gazette des Beaux Arts. Supplement no. 1092 (January, 1960), "La Chronique des Arts."

Gerevich, T. "Esztergomi Mükincsek." *Primàs Album* (Budapest) 1927: 179–263.

Gielly, L. *Les primitifs Siennois.* Paris, 1926.

Gigli, G. *La Città diletta di Maria.* Rome, 1716.

————. *Diario Senese.* 2 vols. Lucca, 1723.

Giotto e il suo tempo. Atti del Congresso Internazionale per la Celebrazione del VII Centenario della nascita di Giotto. Rome, 1971.

Gilbert, C. "When did a man in the Renaissance grow old?" *Studies in the Renaissance* 14 (1967): 7–32.

Gnoli, U. "La quadreria civica di Rieti." *Bollettino d'arte* V (1911): 325–40.

————. "Perugia Galleria-Notizie." *Rassegna d'Arte Umbria* III (1921), fasciolo I, 22–23.

————. "Recesione a van Marle, *Simone Martini.*" *Rassegna d'Arte Umbria* III (1921), fasciolo III, 95–96.

Gnudi, G. *Giotto.* Milan, 1958.

Goodison, J. W., and Robertson, G. H. *Fitzwilliam Museum, Cambridge, Catalogue of Paintings.* Cambridge, 1967.

Grassi, R. *Descrizione storica e artistica di Pisa.* 3 vols. Pisa, 1836–1838.

Gregori, M. "Dipinti e sculture—Biennale Internazionale dell'Antiquariato—Firenze." *Arte Illustrata* II (1969).

Gronau, H. *Andrea Orcagna und Nardo di Cione: eine stilges-chichtliche Untersuchung.* Berlin, 1937.

Guardabassi, M. *Indice-Guida dei Monumenti dalla Provincia dell'Umbria.* Perugia, 1872.

Guida Artistica. Florence, 1912.

Guida della Pinacoteca Vaticana. Rome, 1914.

———. Rome, 1933.

Guldan, E. *Eva und Maria.* Graz/Vienna, 1966.

Hager, H. *Die Anfänge des italienischen Altarbildes.* Munich, 1962.

Handbook of the Gallery of Fine Arts. New Haven, 1931.

Hanslik, Rudolphus, ed. *Corpus Scriptorum Ecclesiasticorum Latinorum.* Vienna, 1960.

Hecht, J. "Die frühesten Darstellungen der Himmelfahrt Mariens." *Das Munster* (1951): 1–12.

Held, J. S. "The New Museum in Ponce." *The Art Quarterly* XXVII (1964): 25–30.

Hetherington, P. "Mosaics of Pietro Cavallini in Santa Maria in Trastevere." *Journal of the Warburg and Courtauld Institutes* XXXIII (1970): 84–106.

———. "Pietro Cavallini, Artistic Style and Patronage in Late Medieval Rome." *Burlington Magazine* CIV (1972): 4–10.

Heywood, W., and Olcott, L. *Guide to Siena: History and Art.* Siena, 1903.

———. *Guide to Siena: History and Art.* Rev. ed. Siena, 1924.

Hueck, I. "Frühe Arbeiten des Simone Martini." *Münchner Jahrbuch der bildenden Kunst* XIX (1968): 29–60.

Hyde, J. *Society and Politics in Medieval Italy.* New York, 1973.

Il Brucaiolo (June 1967).

Ilari, L. *La Biblioteca Pubblica di Siena.* 7 vols. in 3. Siena, 1848.

International Studio 99 (1931). "H. A.," "Madonna Enthroned Between Saints Nicholas and Paul Acquired by Los Angeles Museum."

Jacobsen, E. *Sienesische Meister des Trecento in der Gemäldegalerie zu Siena.* Strasbourg, 1907.

Jarves, J. J. *Descriptive Catalogue of "Old Masters" Collected by James J. Jarves.* Cambridge, 1860.

———. *Art Studies.* New York, 1861.

Jugie, M. *La Mort et l'Assomption de la Sainte Vierge.* Vatican City, 1954.

Kaftal, G. *Iconography of the Saints in Tuscan Painting.* Florence, 1952.

Kermer, W. *Studien zum Diptychon in der sakralen Malerei.* Neunkirchen-Saar, 1967.

Kiel, H. *Bernard Berenson, Homeless Paintings of the Renaissance.* Bloomington, 1970.

Kirfel, W. *Die dreikopfige Gottheir.* Bonn, 1948.

Kirschbaum, E. *Lexikon der christlichen Ikonographie.* 6 vols. Rome, 1968.

Klesse, B. *Seidenstoffe in der italienischen Malerei des vierzehnten Jahrhunderts.* Bern, 1967.

Kunstle, K. *Ikonographie der christlichen Kunst.* 2 vols. Freiburg, 1926.

Labarte, J. "L'Eglise Cathédrale de Sienne et son Trésor d'après un inventaire de 1467." *Annales archéologiques* XXV (1865): 280f.

Lanzi, L. *Storia pittorica dell'Italia.* Florence, 1752.

Larner, J. *Culture and Society in Italy, 1290–1420.* New York, 1971.

Larsen, E. "The Samuel H. Kress Collection at the M. H. de Young Memorial Museum, San Francisco." *Apollo* LXI (June 1955): 172–77.

Lavagnino, E. "Pittori pisani nel XIV secolo." *L'Arte* XXVI (1923): 33–43, 71–83.

Lisini, A. "Elenco dei pittori senesi vissuti nei secoli XIII e XIV." *La Diana* II (1927): 295–306.

Liuzzi, F. *La Lauda e i primordi della medolia italiana.* Rome, 1935.

Longhi, R. "Giudizio sul Duecento." *Proporzioni* II (1948): 5–54.

———. "La Mostra di Arezzo." *Paragone* 15 (1951): 50–63.

Los Angeles County Museum of Art. *The Gothic Room.* Los Angeles, 1930.

———. "The Beginnings of a Great Collection," *Los Angeles County Museum of Art News Bulletin* 3 (1931).

———. *Illustrated Handbook of the Los Angeles County Museum of Art.* Berlin, 1965.

Lupi, C. "L'Arte senese a Pisa." *Bollettino Senese di Storia Patria* XI, nos. 1–2 (1904): 355–425.

Lusini, V. *Il Duomo di Siena.* 2 vols. Siena, 1911–1939.

Maginnis, H. "Pietro Lorenzetti and the Assisi Passion Cycle." Ph.D. diss., Princeton University, 1975.

Malavolti, O. *Dell'Historia di Siena.* 2 vols in 1. Venice, 1599.

Mallory, M. "Paolo di Giovanni Fei." Ph.D. diss., Columbia University, 1965.

———. "A Lost *Madonna del Latte* by Ambrogio Lorenzetti." *The Art Bulletin* LI (1969): 41–47.

Manning, B. S. "A Panorama of Italian Painting." *Apollo* CXI, no. 217 (1980): 181–95.

Manzoni, L. *Statuti e Matricole dell'Arte dei Pittori della Città di Firenze.* Rome, 1904.

Marabottini, A. *Giovanni da Milano.* Florence, 1950.

Marle, R. van. *Simone Martini et les peintres de son école.* Strasbourg, 1920.

———. *Recherches sur l'iconographie de Giotto et de Duccio.* Strasbourg, 1920.

———. *The Development of the Italian Schools of Painting.* 9 vols. Vol. 2, *The Sienese School of the 14th Century.* Vol. 3, *The Florentine School of the 14th Century.* The Hague, 1924. Vol. 5, *The Local Schools of Central and Southern Italy of the 14th Century.* The Hague, 1925.

———. "Ancora quadri senesi." *La Diana* VI (1931): 3–11.

———. *Le Scuole della pittura italiana.* Vol. 2. The Hague, 1934.

———. "La Pittura all'Esposizione d'Arte Antica Italiana di Amsterdam." *Bollettino d'Arte* XXVIII (1935): 293–312.

Mather, F. J. "The Jarves Collection." *Yale Alumni Weekly* XXIII (1914).

———. *A History of Italian Painting*. New York, 1923.

Mazzini, F. "Resti di un ciclo senese trecentesco in San Domenico d'Urbino." *Bollettino d'Arte* XXXVII (1952): 61–66.

Mazzolai, A. *Maremma Storia e Arte*. Florence, 1967.

Meiss, M. "Ugolino-Lorenzetti." *The Art Bulletin* XIII (1931): 376–397.

———. "The Problem of Francesco Traini." *The Art Bulletin* XV (1933): 97–173.

———. "Bartolommeo Bulgarini altrimenti detto 'Ugolino-Lorenzetti'?" *Rivista d'Arte* XVIII (1936): 113–36.

———. "Italian Primitives at Konopiště." *The Art Bulletin* XXVIII (1946): 1–16.

———. *Painting in Florence and Siena after the Black Death*. Princeton, 1951.

———. "A New Early Duccio." *The Art Bulletin* XXXIII (1951): 95–103.

———. *Giotto and Assisi*. New York, 1960.

———. "Notes on Three Linked Sienese Styles." *The Art Bulletin* XLV (1963): 47–48.

"Meister von Panzano." In *Allgemeines Lexikon der bildenden Kunstler*, edited by Ulrich Thieme and Felix Baecker, vol. 37, 263–64. Leipzig, 1950.

Micheli, E. *Siena e il suo territorio*. Siena, 1862.

———. *Breve istoria della Galleria nell'Istituto di Belle Arti in Siena*. Siena, 1872.

Milanesi, G. *Catalogo della Galleria dell'Istituto di Belle Arti di Siena*. Siena, 1852.

———. *Documenti per la storia dell'arte senese*. 3 vols. Siena, 1854–56.

———. *Katalog der Gemälde alter italienischer Meister in der Sammlung des Conservator J. A. Ramboux*. Cologne, 1862.

Ministero dell'Interno, Pubblicazioni degli Archivi di Stato, V, VI. *Archivio di Stato di Siena, Guida-Inventario dell' Archivio di Stato*. 2 vols. Rome, 1951.

Modigliani, E. "Un polittico di Luca di Tommè recuperato da Siena." *Rassegna d'arte* VI (1906): 104–5.

Mongan, A., and E. *European Paintings in the Timken Art Gallery*. San Diego, 1969.

Monti, G. *Le confraternite medievale dell'Alta e Media Italia*. Venice, 1927.

Moran, G., and Fineschi, S. "Niccolò di Ser Sozzo—Tegliacci or di Stefano?" *Paragone* 321 (1976): 58–63.

Morisani, O. *Pittura del Trecento*. Naples, 1947.

Mortari, L. *Museo Civico di Rieti*. Rome, 1960.

Muller, N. "Observations on the Painting Technique of Luca di Tommè." *Los Angeles County Museum of Art Bulletin* XIX (1973): 12–21.

Muratori, L. *Rerum Italicarum Scriptores*. 25 vols. Mediolani, 1738–1742.

Neumeyer, A. "The Samuel H. Kress Collection of the M. H. de Young Museum in San Francisco." *The Art Quarterly* XVIII (Autumn 1955): 272–82.

Nicholson, A. "The Roman School at Assisi." *The Art Bulletin* XII (1930): 270–300.

Nicola, G. De. "Arte inedita in Siena e nel suo antico territorio." *Vita d'Arte* V (1912), no. 55: 1–16; no. 56: 41–58.

Nicolosi, C. *La montagna maremmana*. Bergamo, 1911.

Niessen, J. *Verzeichnis der Gemälde-Sammlungen des Museums Wallraf-Richartz in Köln*. Cologne, 1869 (reprinted in 1873, 1875, 1877, 1888).

Nygren, O. *Barna da Siena*. Stockholm, 1963.

Oertel, R. *Fruhe italienische Malerei in Altenburg*. Berlin, 1961.

———. *Early Italian Painting to 1400*. New York, 1968.

Offner, R. *Italian Primitives at Yale*. New Haven, 1927.

———. *A Critical and Historical Corpus of Florentine Painting*. Section III, vols. 1–6; section IV, vols. 1–5. New York, 1930–.

———. "The Works and Style of Francesco di Vannuccio." *Art in America* XX (1932): 88–114.

Os, H. W. van. "A Choir Book by Lippo Vanni." *Simiolus /Kunsthistorisch Tijdschrift* II (1968): 117–33.

———. *Sienese Paintings in Holland*. Groningen, 1969.

———. *Marias Demut und Verherrlichung in der sienesischen Malerei 1300–1450*. 's-Gravenhagen, 1969.

Paccagnini, G. *Simone Martini*. Milan, 1957.

Palumbo, G., ed. *Giotto e i giotteschi in Assisi*. Rome, 1969.

Pecci, G. *Storia del vescovado della città di Siena*. Lucca, 1748.

———. *Relazione delle cose più notabili della Città di Siena*. Siena, 1752.

Perkins, F. Mason. "Pitture senesi negli Stati Uniti." *Rassegna d'arte senese* I (1905): 74–78.

———. "Note su alcuni quadri del 'Museo Cristiano' nel Vaticano." *Rassegna d'arte* VI (1906): 104–21.

———. "Alcuni appunti sulla galleria delle Belle Arti di Siena." *Rassegna d'arte senese* IV (1908): 48–61.

———. "Tre dipinti inediti di Luca di Tommè." *Rassegna d'arte senese* IV (1908): 79–84.

———. "Alcuni dipinti italiani in America." *Rassegna d'arte* IX (1909): 145–48.

———. "Un affresco di Luca di Tommè." *Rassegna d'arte senese* V (1909): 49.

———. "Ancora de' dipinti di Luca di Tommè." *Rassegna d'arte senese* V (1909): 83–84.

———. "Ancora un dipinto di Luca di Tommè," *Rassegna d'arte senese* V (1909): 80.

———. "Appunti sulla Mostra Ducciana a Siena." *Rassegna d'arte* XIII (1913): 5–9 and 35–40.

———. "Some Sienese Pictures in American Collections." *Art in America* VIII (1920): 195–210 and 272–92.

———. "Altre pitture di Luca di Tommè." *Rassegna d'arte senese* XVII (1924): 12–15.

———. "La pittura alla Mostra d'Arte di Montalcino." *Rassegna d'arte senese* XVIII (1925): 51–71.

———. "Nuovi appunti sulla galleria delle Belle Arti di Siena." *La Balzana* II (1928): 99–115 and 143–61.

———. "Two Unpublished Pictures by Bartolo di Fredi."

Art in America XVI (1928): 210–17.

———. "Luca di Tommè." In *Allgemeines Lexikon der bildenden Kunstler*, edited by Ulrich Thieme and Felix Baecker, vol. 18. Leipzig, 1929.

———. "Su alcuni dipinti di Giacomo di Mino del Pellicciaio." *Bollettino senese di storia patria* I (1930): 243–67.

———. "Pitture senesi poco conosciuti." *La Diana* VI (1931): 10–36, 90–109, and 244–60.

———. "Taddeo di Bartolo." In *Allgemeines Lexikon der bildenden Kunstler*, edited by Ulrich Thieme and Felix Baecker, vol. 32. Leipzig, 1938: 339–397.

———. "Pitture senesi poco conosciuti." *La Diana* VII (1932): 44–55.

———. *Pitture senesi*. Siena, 1933.

———. "Niccolò di Ser Sozzo Tegliacci." In *Allgemeines Lexikon der bildenden Kunstler*, edited by Ulrich Thieme and Felix Baecker, vol. 32. Leipzig, 1938: 501–502.

Péter, A. "Pietro és Ambrogio Lorenzetti egy elpusztult freskó-ciklusa." *Az Országos Magyar Szépművéeszeti Múzeum Évkönyvei* VI (1929/1930): 2–36.

Petrini, C. "Un politico di Scuola senese a Rieti." *Rivista d'arte* II (1904): 178–81.

Pettazoni, R. "The Pagan Origins of the Three-Headed Representations of the Christian Trinity." *Journal of the Warburg and Courtauld Institutes* IX (1946): 135–51.

Pini, C. *Catalogo delle Tavole dell'antica Scuola senese riordinato nel corrente anno 1842*. Siena, 1842.

Polzer, J. "The Anatomy of Masaccio's *Holy Trinity*." *Jahrbuch der Berliner Museen* 13 (1971): 18–59.

Pope-Hennessy, J. *Sassetta*. London, 1939.

———. "Barna, the Pseudo Barna and Giovanni d'Asciano." *Burlington Magazine* LXXXVIII (1946): 35–37.

Preliminary Catalogue of the National Gallery, Washington. Washington, D. C., 1941.

Previtali, G. *Giotto e la sua bottega*. Milan, 1967.

Principal Pictures in the Fitzwilliam Museum, Cambridge, The. 1st ed. Cambridge, 1912.

———. 2d ed. Cambridge, 1929.

Procacci, U. "Opera sconosciute d'arte toscana, II." *Rivista d'arte* XIV (1932): 341–53 and 468–75.

Professione, A. *Siena e le compagnie di ventura*. Civitanova-Marche, 1898.

Pullan, B. *A History of Early Renaissance Italy*. New York, 1972.

Rankin, W. "Some Early Italian Paintings in the Jarves Collection of the Yale School of Fine Arts at New Haven." *American Journal of Archaeology* X (1895): 137–51.

———. *Notes on the Collection of Old Masters*. New Haven, 1905.

Rassegna d'Arte di Umbria (1911).

Rassegna Marchigiana III (1924).

Repetti, E. *Dizionario geografico-fisico storico della Toscana*. 5 vols. Florence, 1833–1835.

Ricci, C. *Il Palazzo Pubblico di Siena e la mostra d'antica arte senese*. Bergamo, 1904.

Rigatuso, L. "Bartolo di Fredi." *La Diana* IX (1934): 214–67.

Robb, D. "The Iconography of the Annunciation in the Fourteenth and Fifteenth Centuries." *The Art Bulletin* XVIII (1936): 480–526.

Rosini, G. *Storia della pittura italiana*. Pisa, 1839–1847.

Rothes, W. *Die Blütezeit der sienesischen Malerei*. Strasbourg, 1904.

Rotili, M. *La miniatura gotica in Italia*. 2 vols. Naples, 1968–1969.

Rowley, G. *Ambrogio Lorenzetti*. 2 vols. Princeton, 1958.

Rubinstein, N. "The Political Significance of the Frescoes of Ambrogio Lorenzetti and Taddeo di Bartolo." *Journal of the Warburg and Courtauld Institutes* XXI (1958): 179–207.

Rubinstein-Block, S. *George and Florence Blumenthal Collection*. 2 vols. New York, 1926.

Salmi, M. "Simone Martini e i pittori della sua scuola in una recente pubblicazione." *Rassegna d'arte senese* XV (1922): 9–20.

———. "Gli affreschi della cappella Dragondelli in San Domenico d'Arezzo." *Rivista d'arte* XII (1930): 1–8.

———. "Contributi fiorentini alla storia dell'arte, I: Maso di Banco a Napoli." *Atti dell'Accademia fiorentina di scienza morale la Colombaria* XII (1947): 415–532.

———. "Postille alla Mostra di Arezzo." *Commentari* III–IV (1951): 93–97.

Salvini, E. *L'Arte di Agnolo Gaddi*. Florence, 1936.

European Works of Art in the M. H. de Young Memorial Museum (San Francisco). Berkeley, 1966.

Sandberg-Vavalà, E. *Sienese Studies: The Development of the School of Painting in Siena*. Florence, 1953.

Santi, F. *The National Gallery of Umbria in Perugia*. Rome, 1956.

———. *La Galleria Nazionale dell'Umbria in Perugia*. Rome, 1968.

———. *Galleria Nazionale dell'Umbria*. Rome, 1969.

———. *La Galleria Nazionale dell'Umbria in Perugia*. 7th ed. Rome, 1979.

Schaumkell, E. *Der Kultus der Hl. Anna am Ausgang des Mittelalters*. Freiburg, 1893.

Schevill, F. *Siena*. New York, 1909.

Schilderijen, Centraal Museum. Utrecht, 1933.

Schilderijen, Aartsbisschoppelijk Museum. Utrecht, 1948.

Schiller, G. *Iconography of Christian Art*. 2 vols. Eng. trans. from 2d German ed. Greenwich, Conn., 1971.

Schlegel, U. "Observations on Masaccio's Trinity Fresco in Santa Maria Novella." *The Art Bulletin* XLV (1963): 19–33.

———. "The Christchild as a Devotional Image in Medieval Italian Sculpture: A Contribution to Ambrogio Lorenzetti Studies." *The Art Bulletin* LII (1970): 1–10.

Schlosser, J. *La Letteratura Artistica*. 3d ed. Florence, 1964.

Serra, L. "Elenco delle Opere d'Arte Mobili delle Marche." *Rassegna Marchigiana* III (1924–25): 362–448.

———. "L'arte nelle Marche, VII. La Pittura Gotica." *Rassegna Marchigiana* VI (1928): 165–92.

————. "Elenco delle Opere d'Arte Mobili delle Marche." *Rassegna Marchigiana* VII (1928): 27–40.

————. *L'arte nelle Marche.* Pesaro, 1929.

Seymour, C., Jr. *Early Italian Paintings in the Yale University Art Gallery.* New Haven, 1970.

Shapley, F. *Paintings and Sculpture from the Samuel H. Kress Collection.* Raleigh, N.C., 1960.

————. *Paintings from the Samuel H. Kress Collection, Italian Schools XIII–XV Century.* London, 1966.

Shorr, D. *The Christ Child in Devotional Images in Italy during the XIV Century.* New York, 1954.

Siena e il suo territorio. Siena, 1862.

Sinibaldi, G. *I Lorenzetti.* Siena, 1933.

Sirén, O. *Lorenzo Monaco.* Strasbourg, 1905.

————. "Notizie critiche sui quadri sconosciuti nel Museo Cristiano." *L'Arte* XI (1906): 321–35.

————. *Catalogue of the Jarves Collection.* New Haven, 1916.

————. "Alcuni note aggiuntive a quadri primitivi nella galleria Vaticana." *L'Arte* XXIV (1921): 24–28 and 97–102.

Smart, A. *The Assisi Problem and the Art of Giotto.* Oxford, 1971.

Southard, E. "The Frescoes in Siena's Palazzo Pubblico, 1289–1539: Studies in Imagery and Relations to other Communal Palaces in Tuscany." Ph.D. diss., Indiana University, 1978.

Staedel, E. *Ikonographie der Himmelfahrt Mariens.* Strasbourg, 1935.

Steegmuller, F. *The Two Lives of James Jackson Jarves.* New Haven, 1951.

Stefanini, P. "La Chiesa e i beni dei Cavalieri di Malta in Cascina." *Archivio Storico di Malta* IX (1938): 1–41.

Steinweg, K. *Andrea Orcagna: Quellengeschichtliche und stilkritische Untersuchung.* Strasbourg, 1929.

Stubblebine, J. *Guido da Siena.* Princeton, 1964.

————. "Cimabue's Frescoes of the Virgin at Assisi." *The Art Bulletin* XXXXIX (1967): 330–37.

————. "The Angel Pinnacles on Duccio's *Maestà*." *Art Quarterly* XXXII (1969): 130–52.

————, ed. *Giotto: The Arena Chapel Frescoes.* New York, 1969.

————. "The Role of Segna di Buonaventura in the Shop of Duccio." *Pantheon* XXX (1972): 272–82.

————. "Duccio's Maestà of 1302 for the Chapel of the Nove." *Art Quarterly* XXXV (1972): 239–68.

————. "Cimabue and Duccio in Santa Maria Novella." *Pantheon* XXXI (1973): 15–21.

————. "Duccio and His Collaborators on the Cathedral Maestà." *The Art Bulletin* LV (1973): 185–204.

————. *Duccio Buoninsegna and His School.* 2 vols. Princeton, 1979.

Sturgis, R. *Manual of the Jarves Collection.* New Haven, 1868.

Suida, W. *The Samuel H. Kress Collection, Italian Art.* Seattle, 1952.

————. *European Paintings and Sculpture from the S. H. Kress Collection, Seattle Museum.* Seattle, 1954.

————. *The Samuel H. Kress Collection, M. H. de Young Memorial Museum.* San Francisco, 1955.

Sutton, D. "Robert Langton Douglas, Part II: X. The Tribulations of an Editor." *Apollo* (May 1979): 348–65.

Symeonides, S. *Taddeo di Bartolo.* Siena, 1965.

T. C. I. *Firenze.* 4th ed. Milan, 1950.

————. *Firenze.* 5th ed. Milan, 1964.

————. *Firenze.* 6th ed. Milan, 1974.

————. *Italia Centrale.* Milan, 1923.

————. *Lazio.* 2d ed. Milan, 1935.

————. *Lazio.* 3d ed. Milan, 1964.

————. *Marche.* 2d ed. Milan, 1937.

————. *Marche.* 3d ed. Milan, 1962.

————. *Toscana.* 2d ed. Milan, 1935.

————. *Toscana.* 3d ed. Milan, 1959.

————. *Toscana.* 4th ed. Milan, 1974.

————. *Umbria.* 2d ed. Milan, 1938.

————. *Umbria.* 3d ed. Milan, 1950.

————. *Umbria.* 4th ed. Milan, 1966.

Thode, H. "Pitture di maestri italiani nelle gallerie minori di Germania, I. Il Museo di Colonia." *Archivio storico dell'arte* II (1889): 49–56.

Toesca, P. *Il Trecento.* Turin, 1951.

Tommasi, G. *Dell'Historia di Siena.* 2 vols. in 1. Venice, 1625–1626.

Torriti, P. *La Pinacoteca Nazionale di Siena. I dipinti dal XII al XV secolo.* Genoa, 1977.

————. *La Pinacoteca Nazionale di Siena. I dipinti dal XV al XVIII secolo.* Genoa, 1978.

Ugurgieri, I. *Le Pompe Sanesi.* Pistoia, 1649.

Vasari, G. *Le Vite de' più eccellenti architettori, pittori e scultori italiani, da Cimabue insino a'tempi nostri* (1550). Edited by C. Ricci. Florence, 1928.

————. *Le Vite de' più eccellenti pittori, scultori e architettori . . .* (1568). Edited by V. Marchese, C. Pini, and C. and G. Milanesi. 14 vols. Florence, 1846–1870.

————. *Le Vite de' più eccellenti pittori, scultori e architettori . . .* (1568). Edited by G. Milanesi. 9 vols. Florence, 1878–1885.

Vavassour-Elder, I. "Su certi dipinti poco conosciuti di Bartolo di Maestro Fredi." *Rassegna d'arte senese* IV (1908): 89–93.

————. "Spigolature di Val d'Elsa." *Rassegna d'arte* IX (1909): 159–63.

Ventroni, S. *Barna da Siena.* Pisa, 1972.

Venturi, A. *Storia dell'arte italiana.* 11 vols. in 25 parts. Vol. 5, *La pittura del trecento e le sue origini.* Milan, 1907.

Venturi, L. "A traverso Le Marche." *L'Arte* XVIII (1915): 10f.

————. *Pitture Italiane in America.* Milan, 1931.

Verdier, P. "International individuals in the roaring 1400's: distinguished exhibitions in Vienna and Baltimore." *Art News* 61 (1962): 24–26 and 51–52.

Vertova, L. "The New Yale Catalogue." *Burlington Magazine* 115 (1973): 159–63.

Vigni, G. *Pitture del Due e Trecento nel Museo di Pisa.* Pa-

lermo, 1950.

Volpe, C. "Una crocifissione di Niccolò Tegliacci." *Paragone* 21 (1951): 39–41.

———. "Precisizione sul 'Barna' e sul 'Maestro di Palazzo Venezia'." *Arte Antica e Moderna* 3 (1960): 149–58.

———. "Nuove proposte sui Lorenzetti." *Arte Antica e Moderna* II (1960): 1–15.

Wehle, H. "Madonna by Luca di Tommè." *Bulletin of the Metropolitan Museum of Art* XXIV (1929): 9–10.

———. *Metropolitan Museum of Art: A Catalogue of Italian, Spanish and Byzantine Paintings.* New York, 1940.

Weigelt, C. *Duccio di Buoninsegna.* Leipzig, 1911.

———. *La pitture senese del Trecento.* Bologna, 1930.

Wescher, P. *Catalogue of Collection at Los Angeles.* Los Angeles, 1954.

White, J. *Art and Architecture in Italy, 1250–1400.* Baltimore, 1966.

———. *The Birth and Rebirth of Pictorial Space.* 2d ed. London, 1967.

———. "Measurement, Design and Carpentry in Duccio's Maestà." *The Art Bulletin* LV (1973): 333–66 and 548–56.

Wieruszowski, H. "Art and the Commune in the Time of Dante." *Speculum* XIX (1944): 14–33.

Wilkins, D. "Maso di Banco and Cenni di Francesco: A Case of Late Trecento Revival." *Burlington Magazine* CXI (1969): 83–85.

Zeigler, P. *The Black Death.* London, 1969.

Zeri, F. "Sul problema di Niccolò di Ser Sozzo Tegliacci e Luca di Tommè." *Paragone* 105 (1958): 3–16.

———. "Angelo Puccinelli a Siena." *Bollettino d'Arte* III (1964): 229–35.

———. "Italian Primitives at Messrs. Wildenstein." *Burlington Magazine* CVII (1965): 252–56.

———. "Sull'ipotesi pisana del Tegliacci." *Quaderna di Emblema* 2 (1973): 9–12.

———. *Italian Paintings in the Walters Art Gallery.* 2 vols. Baltimore, 1976.

———. *Sienese and Central Italian Paintings in the Metropolitan Museum of Art.* New York, 1981.

Zucchi, A. *S. Domenico di Rieti.* Pistoia, 1935.

Exhibition Catalogues

Amsterdam, Stedelijk Museum. *Italiaansche Kunst in Nederlandsch Bezit.* July 1–October 1, 1934.

Arezzo. *Mostra d'Arte Sacra.* 1950.

Atlanta, Art Association Galleries. *An Exhibition of Italian Paintings in the Collection of Samuel H. Kress.* October 1932–June 1935.

Baltimore, The Walters Art Gallery. *The International Style: The Arts in Europe Around 1400.* October 23–December 2, 1962.

Boston, Williams and Everett's Gallery. *Jarves's Collection of Old Masters.* 1861–1862.

Charlotte, North Carolina, Mint Museum of Art. *Italian Paintings Lent by Samuel H. Kress.* October 1932–June 1935.

Claremont, California, Scripps College. *Scripps Christmas Exhibit.* November 13, 1952–January 15, 1953.

Cortona, Fortezza del Girifalco. *Arte in Valdichiana.* August 9–October 10, 1970.

Florence, Palazzo Strozzi. *Mostra Mercato Internazionale dell'Antiquariato.* September 20–October 19, 1969.

Grosseto, Museo d'Arte Sacra. *Arte senese nella Maremma grossetana.* E. Carli, ed. Summer 1964.

Hartford, Connecticut, The Wadsworth Atheneum. *An Exhibition of Italian Panels and Manuscripts from the Thirteenth and Fourteenth Centuries in Honor of Richard Offner.* April 9–June 6, 1965.

London, Royal Academy. *Old Masters.* 1885.

London, Burlington Fine Arts Club. *Pictures of the School of Siena.* 1904.

London, Goldsmiths' Hall. *Treasures of Cambridge,* 1959.

London, Royal Academy. *Italian Art and Britain.* Winter 1960.

London, Wildenstein's. *The Art of Painting in Florence and Siena from 1250 to 1500.* February 24–April 10, 1965.

Long Beach, California, Municipal Art Center. *Religious Art.* January 22–February 19, 1966.

Montalcino, Museo Civico. *Arte Antica.* July–September 1925.

New Haven, The Yale University Art Gallery. *Italian Primitives.* April–September 1972.

New York, Century Association. *Exhibition of Italian Primitive Paintings Selected from the Collection of Maitland F. Griggs.* February 15–March 12, 1930.

New York, Derby Gallery. *Old Masters.* 1860.

New York, The Metropolitan Museum of Art. *The Great Age of Frescoes.* September–November 1968.

New York, The New-York Historical Society. *Old Masters.* 1863.

New York, Newhouse Galleries. *Richard M. Hurd Collection of Italian Primitives.* May 1937.

Perugia, Galleria Nazionale dell'Umbria. *Quattro secoli di pitture in Umbria—Mostra celebrativa del V centenaria della nascita di Pietro Perugino.* B. Calosso, ed. 1945.

Perugia, Galleria Nazionale dell'Umbria. *Mostra di dipinti restaurati.* F. Santi, ed. 1953.

Pisa, Museo Nazionale di San Matteo. *Mostra del Restauro.* September 26–November 5, 1972.

Rieti, Museo Civico. *Opere d'Arte in Sabina dall' XI al XVII secolo.* 1957.

Rome, Palazzo Venezia. *Mostra storica nazionale della miniatura.* 1954.

Saint Petersburg, Russia. *Les anciennes écoles de peinture dans les palais et collections privées russes représentées à l'exposition organisée à St. Petersbourg en 1909 par la Revue d'art ancien.* 1909.

Siena, Palazzo Pubblico. *Mostra di Antica Arte Senese.* April–October 1904.

Siena, Pinacoteca Nazionale. *Mostra di Opere d'Arte Restaurate nelle Province di Siena e Grosseto.* June–November 1979.

Tucson, Arizona, University of Arizona. *Paintings and Sculpture from the Kress Collection*. 1951.

Washington, D. C., National Gallery. *Paintings and Sculpture from the Kress Collection*. 1951.

Sales Catalogues

Berlin, *R. von Kaufmann Collection*. December 4–5, 1917.

Boston, *The James Jackson Jarves Collection*. 1871.

Cologne, *Catalogue des Collections d'Objets D'Art de M. Jean Ant. Ramboux, vente publique à Cologne le 23 mai, 1867*. J. M. Heberle, ed. May 23, 1867.

Florence. *Catalogue de tableaux, meubles et objets d'art. Formant la Galérie de Mr. Le Chev. Toscanelli dont la vent. Aura Lieu à Florence le 20 Avril, 1883*. G. Milanesi, ed. April 20, 1883.

London, Christie's. *Fine Pictures by Old Masters*. March 24, 1972.

————. *Thomas Blaydes Collection*. January 31, 1849.

London, Sotheby's. *Catalogue of Old Master Paintings . . .* May 17, 1961.

London, Sotheby, Parke Bernet and Co. *The Robert von Hirsch Collection*. Vol. 1 of 4 vols. June 20–21, 1978.

New Haven, Yale Art Gallery. *Catalogue of the Jarves Collection*. 1871.

New York, American Art Galleries. *Catalogue of the Ercole Canessa Collection*. January 24–25, 1924.

New York, Kende Galleries. *Richard M. Hurd Collection*. October 29, 1945.

Paris, Charpentier. *Braz Collection*. May 12, 1938.

Manuscripts

d'Angelis, L. Miscellanea. MS. A.VIII.5, Biblioteca Comunale, Siena.

Benvoglienti, U. Miscellanea. MS. C.IV.6, Biblioteca Comunale, Siena.

Carapelli, P. A. M. Notizie delle chiese e cosè più reguardevoli di Siena. MS. B.VII.10, Biblioteca Comunale, Siena.

Carli, C. G. Notizie di belle arti. MS. C.VII.20, Biblioteca Comunale, Siena.

L'Elenco delle pitture, sculpture e architetture di Siena (compiled for F. Chigi, later Pope Alexander VII). MS. Chigiano I.1.11, Biblioteca Apostolica Vaticana, Rome.

Faluschi, G. Aggiunte al diario sanesi di Girolamo Gigli. MS. C.II.12, Biblioteca Comunale, Siena.

————. Chiese senesi. MS. E.V.14, Biblioteca Comunale, Siena.

————. Memorie d'artisti. MS. E.VI.11, Biblioteca Comunale, Siena.

Landi, A. Racconto di piture e di statue ed altre opera eccellenti che si retrovano ne' templi e negli altri luoghi pubblici della città di Siena. MS. L.IV.14, Biblioteca Comunale, Siena.

Libro del Consigli del 1776. "Consigle del Convento." Fondo di S. Domenico, Archivio Comunale, Rieti.

Mancini, G. Breve ragguaglio delle cosè di Siena. MS. Barberino Latino #4315, Biblioteca Apostolica Vaticana Rome.

Piccolomini, G. Siena illustre per antichità. MS. C.II.23, Biblioteca Comunale, Siena.

Romagnoli, E. Biografia cronologica de' bellartisti senesi. MS. L.II.1–9, Biblioteca Comunale, Siena.

Titio, S. Historiarum senensium. MS. B.III.8, Biblioteca Comunale, Siena.

Photographic Credits

The author and publisher wish to thank the following agencies, individuals, and institutions for kindly permitting us to reproduce the photographic materials in this book:

Artini, Florence, Pls. 8, 19-1–19-3, 32-3–32-4, 39-1–39-4, 41-3–41-4, and 50; Fototeca Berenson, Settignano, Pls. 21, 23-2, 29, 31-1–31-2, 43, 65, and Figs. 13 and 15; Frick Art Reference Library, New York, Pls. 3-1–3-2, 35, 62, 63-1–63-2, 66, and Fig. 9; Grassi, Siena, Pls. 13-4–13-5, 51, and Figs. 1-1–1-2, 2-1–2-2, 7, and 23; Samuel H. Kress Collection, New York, Pls. 7, 37, 40, 54; Reali, Florence, Pls. 17-1–17-4, 46, 67-2, and Fig. 45; Soprintendenza alle Gallerie, Florence, Pls. 47-1–47-7 and 48-2–49, and Figs. 4-6-3 and 21; Soprintendenza per i beni artistici e storici per le province di Siena e Grosseto, Siena, Pls. 10, 13-1, 18, 22-1–22-2, 30-2–30-3, 32-1, 36, 38, 41-1–41-2, 48-1, 58-1–58-2, 59-1–59-4, 56, and 57; Yale University Art Gallery, Pls. 15-1–15-5, 20-1–20-5, and 55; Alinari, Florence, Pls. 13-6, 27, and 44; Anderson, Rome, Figs. 10–11; Art Museum, Princeton University, Princeton, New Jersey, Fig. 22; Brogi, Florence, Pl. 53; Christian Museum, Esztergom, Hungary, Pl. 42; Cooper, London, Pl. 52; De Benedictis (*La pittura senese 1330–1370*), Pl. 67-1; Deutsche Fotothek, Dresden, Pl. 2; Fehm, Figs. 61-1–61-2; Fitzwilliam Museum, Cambridge, Pl. 34; Fogg Art Museum, Cambridge, Massachusetts, Pls. 4-2–4-9 and Fig. 19; Free Library, Philadelphia, fig. 20; Gabinetto Fotografico Nazionale, Rome, Pls. 24-1–24-3 and 27; von Hirsch Collection (formerly), Pl. 6; Ideal Studios, Edinburgh, Pls. 11-2–11-5; Instituut voor Kunstgeschiedenis, Groningen, Fig. 17; Los Angeles County Museum of Art, Pls. 1 and 33; Metropolitan Museum of Art, New York, Pl. 14; *Mostra del Restauro* (1972), Pisa, Pl. 28; *Mostra Mercato Internazionale dell'Antiquariato* (1969), Florence, Pl. 64; Mt. Holyoke College Art Museum, South Hadley, Massachusetts, Pl. 60; Museo Vaticano, Pl. 12; National Trust, Polesden-Lacey, Surrey, Pl. 18; Passerini, Siena, Pls. 13-2–13-3 and 22-3–22-5; Perotti, Milan, Fig. 12; Pierpont Morgan Library, New York, Fig. 18; Rheinisches Bildarchiv, Cologne, Pl. 23-1; Rijksmuseum, Amsterdam, Pl. 5; Rijksmuseum Het Catharijneconvent, Utrecht, Pl. 16; Soprintendenza per i beni artistici e storici, Naples, Fig. 16; Steinkopf, Berlin, Figs. 8–9; Thomas, Oxford, Pls. 25-1–25-4. Timken Art Gallery, San Diego, Pl. 4-1; Walters Art Gallery, Baltimore, Fig. 3; Welker Collection (formerly), Eastbourne, Sussex, Pl. 45; Zeri, Rome, Pls. 26-1–26-2.

Index of Illustrations

Index

Note: Primary references to illustrations are listed by title of work in the Index of Illustrations.

Abbreviated names: Luca = Luca di Tommè; Niccolo = Niccolò di Ser Sozzo

Aaron detail (Luca), 49, *Pl. 47-5. See also Annunciation with Saints Francis, Nicholas of Bari, Thomas, and Matthew* polyptych (Luca)

Adoration of the Magi (Bartolo di Fredi, 4

Adoration of the Magi (Luca), in Lugano, 13, *Cat. 6, Pl. 6*

Adoration of the Magi detail (Luca), in San Diego, 11, 12, *Cat. 4, Pls. 4-1, 4-6*

Altarpiece (Luca), lost work (formerly Arezzo), 54, *Cat. 68*

Altarpiece for *Calzolai* guild (Luca, with Bartolo di Fredi and Andrea di Bartolo), lost work, 51, 54, 193, *Cat. 71, Docs. 25a–g*

Altarpiece for Marco Bindi Gini (Luca), lost work (formerly Siena), 51, 54, 194, *Cat. 72, Doc. 28*

Ambrosi, Pietro di Giovanni, 25–26

Amos (Luca), 29, *Cat. 17, Pl. 17-1*

Angel (shop of Luca), 26, *Cat. 53, Pl. 53*

Angel detail (Luca), 31, *Pl. 15-4. See also Assumption of the Virgin* (Luca)

Angel Gabriel (Luca, in Paris, 37–38, *Cat. 26, Pl. 26-1*

Angel Gabriel detail (Luca), in San Diego, 11, 12, *Cat. 4, Pls. 4-1, 4-3*

Angels detail (Luca), 28, *Pl. 15-5. See also Assumption of the Virgin* (Luca)

Annaselbdritt imagery, 35–36

Annunciation (shop of Duccio), 13, *Fig. 7*

Annunciation (shop of Luca), 42, *Cat. 63, Pl. 63-1*

Annunciation detail (Luca), 49. *Pl. 47-2. See also Annunciation with Saints Francis, Nicholas of Bari, Thomas, and Matthew* polyptych (Luca)

Annunciation with Saints Francis, Nicholas of Bari, Thomas, and Matthew polyptych (Luca), 49, 50, *Cat. 47, Pls. 47-1–47-7*

Assumption imagery, 27–28

Assumption of the Virgin (Duccio?), 27, *Fig. 15*

Assumption of the Virgin (Luca), 1–2, 12n.23, 26–27, 28–29, 30, 31, 33, *Cat. 15, Pls. 15-1–15-5*; attribution of, 52, 53

Assumption of the Virgin (Niccolò, in *Caleffo dell'Assunta*, 16–17, 21, 27, *Fig. 10*

Assumption of the Virgin with Saints Thomas, Benedict, Catherine of Alexandria, and Bartholomew (Niccolò), 17, 20, 25, 28, *Fig. 11*

Attributions, problems in, xi

Bacci, Pèleo: archival study on Luca, xi, 191

Bartolo, Andrea di, 4, 51, 193, *Docs. 25a–g*

Beheading of Saint Paul (Luca), 45, 46, 53, *Cat. 42, Pl. 42*

Berenson, Bernard, xi, 21, 52, 53

Birth of the Virgin (Paolo di Giovanni Fei), 5

Birth of the Virgin (Pietro Lorenzetti), 8

Brandi, Cesare, xi, 18, 19, 34, 53

Brunelleschi, 6

Bulgarini, Bartolommeo, 192

Buonaguida, Pacino di, 32, 34

Caleffo dell'Assunta, 16–17, 21, 27

Cappellucci (Company of the Hat), 41, 44–45, 193, *Docs. 18a, 18b*

Carmel, Judith, 18n.13

Catherine of Alexandria (shop of Luca), 29, 37, *Cat. 59, Pl. 59-4*

Christ as the Man of Sorrows (shop of Luca), 14, *Cat. 51, Pl. 51*

Christ Blessing (Luca, 1367), 35, *Cat. 23, Pls. 23-1, 23-2*

Christ Blessing (luca), 44, *Cat. 39, Pl. 39-1. See also Madonna and Child Enthroned with Saints John the Baptist, Peter, Paul, and Apollinaris* polyptych (Luca)

Christ Blessing (shop of Luca), in Raleigh, 26, *Cat. 54, Pl. 54*

Christ Blessing (shop of Luca), in Rapolano, 42, *Cat. 57, Pl. 57*

Christ Blessing (shop of Pacino di Bonaguida), 32, *Fig. 18*

Christ Blessing and Two Angels, the Angel Gabriel, Saints Paul and Bartholomew, and the Virgin Annunciate (Luca), 50. *Cat. 49, Pl. 49*

Conversion of Saint Paul (Luca), 45, 46, 53, *Cat. 40, Pl. 40*

Coronation of the Virgin (Bartolo di Fredi, 4

Coronation of the Virgin (shop of Duccio), 13, *Fig. 7*

Crucified Christ processional crucifix (Luca), 9, 10–11, *Cat. 3, Pls. 3-1, 3-2*

Crucifix (shop of Luca), 34, *Cat. 58, Pls. 58-1, 58-2*

Crucifixion (Luca), in Altenburg, 9–10, 11, 22, 33, *Cat. 2, Pl. 2*

Crucifixion (Luca), in London, 34, *Cat. 21, Pl. 21*

Crucifixion (Luca), in Pisa: 2, 7, 19, 30, 31, 33, 46, *Cat. 19, Pls. 19-1–19-3*; attribution of, 52, *Doc. 8*

Crucifixion (Luca), in Rome, 18–19, 21, 23, 49, *Cat. 12, Pl. 12. See also Saint Thomas* alterpiece (Niccolò and Luca)

Crucifixion (Luca), in San Francisco, 1, 13–14, 22, 46, *Cat. 7, Pl. 7*

Crucifixion (Pietro Lorenzetti), in Cortona, 10–11, *Figs. 6-1–6-3*

Crucifixion (Pietro Lorenzetti), in Siena, 7–8, 11, 14, *Figs. 2-1, 2-2*

Crucifixion (shop of Duccio), 13, *Fig. 7*

Crucifixion detail (Luca), 34, *Pl. 20-4. See also Saint Francis, the Virgin, Crucifixion, Saint John, and Saint Dominic* predella panel (Luca)

Crucifixion imagery, 9, 10

Crucifixion processional banner (Luca), 14, 53, *Cat. 8, Pl. 8*

Crucifixion, Saint John, and Saint Domnic predella panel (Luca)
Saint John the Baptist (Luca), in Florence, 47, Cat. 44, Pl. 44
Saint John the Baptist (Luca), location unknown, 40–41, 42, Cat. 31, Pl. 31-1. See also *Mystic Marriage of Saint Catherine* polyptych (Luca)
Saint John the Baptist (shop of Luca), 26, Cat. 52, Pl. 52
Saint John the Baptist detail (Luca), 18–19, Pl. 13-2
Saint John the Evangelist (Luca), 40–41, Cat. 31, Pl. 31-2. See also *Mystic Marriage of Saint Catherine* polyptych (Luca)
Saint John the Evangelist (Pietro Lorenzetti), 10, Fig. 5
Saint John the Evangelist detail (Luca, 1366), 2, Pl. 19-3. See also *Crucifixion* (Luca), in Pisa
Saint John the Evangelist detail (Luca, 1367), 37, Pl. 22-5. See also *Madonna and Child with Saint Anne* polyptych (Luca)
Saint Lawrence detail (Luca), 50, Pl. 48-2. See also *Madonna and Child with Saints Vincent, Peter, Paul, and Lawrence* (Luca)
Saint Leonard detail (Luca), 44, Pl. 39-3. See also *Madonna and Child Enthroned with Saints John the Baptist, Peter, Paul, and Apollinaris* polyptych (Luca)
Saint Lucy detail (Luca), 44, Pl. 39-4. See also *Madonna and Child Enthroned with Saints John the Baptist, Peter, Paul, and Apollinaris* polyptych (Luca)
Saint Mark detail (Luca), 34–35, Pl. 22-4. See also *Madonna and Child with Saint Anne* polyptych (Luca, 1367)
Saint Michael with Saint Peter (Luca), 47–48, Cat. 46, Pl. 46
Saint Nicholas of Bari detail (Luca), 49, Pl. 47-3
Saint Paul and a Prophet (Luca), 2, 37, 39, 45, Cat. 25, Pl. 25-2. See also *Madonna and Child* polyptych, reconstructed (Luca)
Saint Paul Being Led to His Martyrdom (Luca), 45, 46–47, 53, Cat. 41, Pls. 41-2, 41-4
Saint Paul detail (Luca), 44–45, Pl. 39-2. See also *Madonna and Child Enthroned with Saints John the Baptist, Peter, Paul, and Apollinaris* polyptych (Luca)
Saint Paul Preaching Before the Areopagus (Luca), 45, 46, 53, Cat. 41, Pls. 41-1, 41-3

Saint Peter (shop of Luca), location unknown (formerly in Siena), 48, Cat. 66, Pl. 66
Saint Peter (shop of Luca), location unknown (stolen from Buonconvento), 48, Cat. 65, Pl. 65
Saint Peter and a Prophet (Luca), 37, Cat. 25, Pl. 25-1. See also *Madonna and Child* polyptych, reconstructed (Luca)
Saint Peter detail (Luca), 39, 40, Pl. 32-4. See also *Madonna and Child, Bishop Saint, John the Baptist, Gregory, and Francis* polyptych (Luca)
Saints Bartholomew and Blaise detail (Luca), 40, Pl. 30-2. See also *Mystic Marriage of Saint Catherine* polyptych (Luca)
Saints Catherine, Anthony Abbot, Leonard, and Lucy (Luca), 44, Cat. 39, Pl. 39-1. See also *Madonna and Child Enthroned with Saints John the Baptist, Peter, Paul, and Apollinaris* polyptych (Luca)
Saint Stephen (Luca), 47, 50, Cat. 43, Pl. 43
Saint Stephen detail (Luca), 18–19, Pl. 13-4
Saint Thomas altarpiece (Niccolò and Luca), 1, 7, 10; attribution of, 16, 18, 19, 22, 53; inscription on, 192, Doc. 4; Luca's contributions to, 20–23, 30; Niccolò's contributions to, 20–21; reconstruction of, 18–20, 22–23, 46, Pl. 11-1. See also *Crucifixion* (Luca), in Rome; *Madonna and Child Enthroned with Saints John the Baptist, Thomas, Benedict, and Stephen* (Niccolò and Luca); *Scenes from the Life of Saint Thomas* (Niccolò and Luca)
Saint Thomas detail (Luca), 18–19, Pl. 13-3
Saint Thomas detail (Luca), 49, 50, Pl. 47-4
San Gimignano: frescoes by Bartolo di Fredi in, 4, 5
Scenes from the Life of Saint Thomas (Niccolò and Luca), 18, 19, 22, 23, 49, Cat. 11, Pl. 11-1–11-5. See also *Saint Thomas* altarpiece (Niccolò and Luca)
Ser Sozzo, Niccolò di: follower of, 25; influence of Ambrogio Lorenzetti on, 18; influence of Simone Martini on, 5, 18, 20, 23; partnership with Luca, xi, 1, 8, 15, 18, 19–20, 23, 30, 43. See also Names of Individual works
Siena: Archivo dell'Opera del Duomo (AODS), 191; Archivo di Stato

(ASS), 191; Luca's presence in, 1; contemporary artists of Luca in, 3–5; rivalry with Florence, 6
Siena, Barna da, 7, 52
Stephano, Cristofano di, 15, 192

Technical evidence for reconstruction, 24n.28
Three-headed Trinity (Niccolò), 33, Fig. 20
Three-headed Trinity detail (Lippo Vanni), 33, Fig. 19
Tommè, Luca di: chronology of paintings by, xi, 24, 52, 53–54, 191–94; collaboration with Bartolo di Fredi and Andrea di Bartolo, 51, Docs. 25a–g; early history of, 6, 191–92; early style of, 1, 2, 7, 8, 15; frescoes by, 15, 192, 194; influence of the Lorenzetti on, 1, 3, 7–8, 9, 10, 14, 15, 23, 29, 33; influence of Martini on, 7, 26–27; influence of Masaccio on, 2; as innovator, 2; later style of, 2, 44, 45–46, 49; lost works by, 15, 51, 54; mature style of, 2, 26, 29–30, 31, 34, 36, 42–43; as mentor to younger painters, 2, 36, 39, 40, 53; in painters' guild, 1; partnership with Niccolo, xi, 1, 8, 15, 18, 19–20, 23, 30, 43; relationship to Lippo Vanni, 3–4; training of, 1, 7; Vasari on, 7, 52; wives of Docs, 6, 20a, 20b. See also Names of individual works
Triani, Francesco, 36
Trinity imagery, 11, 32–33
Trinity with Virgin, John the Evangelist, and Magdalen (Paolo di Giovanni Fei), 31, Fig. 16
Two Apostles (shop of Luca), 26, Cat. 53, Pl. 53
Two Prophets, God the Father, and the Holy Spirit detail (Luca), 49, Pl. 47-6

Umbria, Luca in, 1

Van Marle, Raimond: on Luca's oeuvre, xi, 52, 53
Vanni, Andrea, 3, 4, 5, 32, 44
Vanni, Lippo, 3–4
Vannuccio, Francesco di, 39
Van Os, Hendrick W., xi, 49
Vasari, Giorgio: on Luca, 7, 52
Virgin and Child Enthroned (Pietro Lorenzetti), 3
Virgin and Child imagery, 24
Virgin and Child with Saint Anne (Francesco Triani), 36, Fig. 22
Virgin and Child with Saint Anne (unknown fourteenth-century Tuscan artist), 36, Fig. 21